ALSO BY MILES J. UNGER

Machiavelli: A Biography

Magnifico: The Brilliant Life and Violent Times of Lorenzo de' Medici

The Watercolors of Winslow Homer

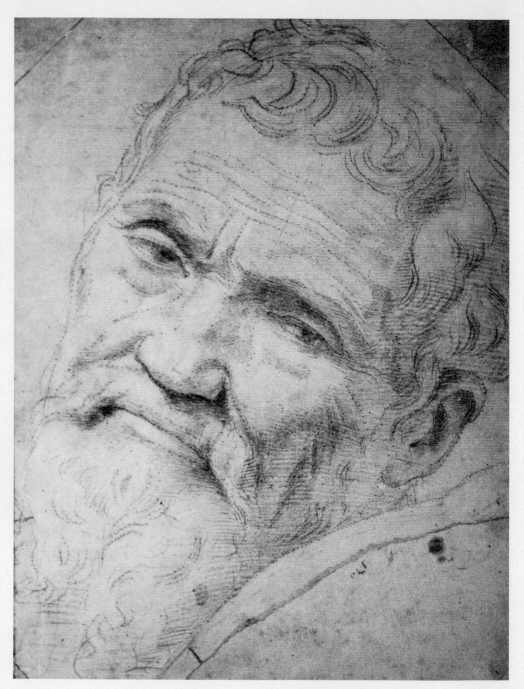

Daniele da Volterra, *Portrait of Michelangelo.*

MICHELANGELO

A Life in Six Masterpieces

MILES J. UNGER

SIMON & SCHUSTER

New York London Toronto Sydney New Delhi

Simon & Schuster
1230 Avenue of the Americas
New York, NY 10020

First Simon & Schuster hardcover edition July 2014

SIMON & SCHUSTER and colophon are
registered trademarks of Simon & Schuster, Inc.

For information about special discounts for bulk purchases,
please contact Simon & Schuster Special Sales at
1-866-506-1949 or business@simonandschuster.com.

The Simon & Schuster Speakers Bureau can bring authors
to your live event. For more information or to book an event,
contact the Simon & Schuster Speakers Bureau at
1-866-248-3049 or visit our website at www.simonspeakers.com.

Interior design by Ruth Lee-Mui
Maps by Paul J. Pugliese
Jacket design by Michael Accordino
Jacket art by Michelangelo Buonarroti © Scala/Art Resource, NY;
street sign © Hedda Gjerpen/Getty Images

Manufactured in the United States of America

1 3 5 7 9 10 8 6 4 2

Library of Congress Cataloging-in-Publication Data

Unger, Miles.
Michelangelo : a life in six masterpieces / Miles J. Unger.
pages cm
Includes bibliographical references and index.
1. Michelangelo Buonarroti, 1475–1564. 2. Artists—Italy—Biography. I. Title.
N6923.B9U54 2014
709.2—dc23
[B] 2013045778

ISBN 978-1-4516-7874-1
ISBN 978-1-4516-7880-2 (ebook)

To Emily and Rachel,
my pride and joy

Contents

V

THE DEAD

187

VI

THE END OF TIME

257

VII

BASILICA

312

MICHELANGELO

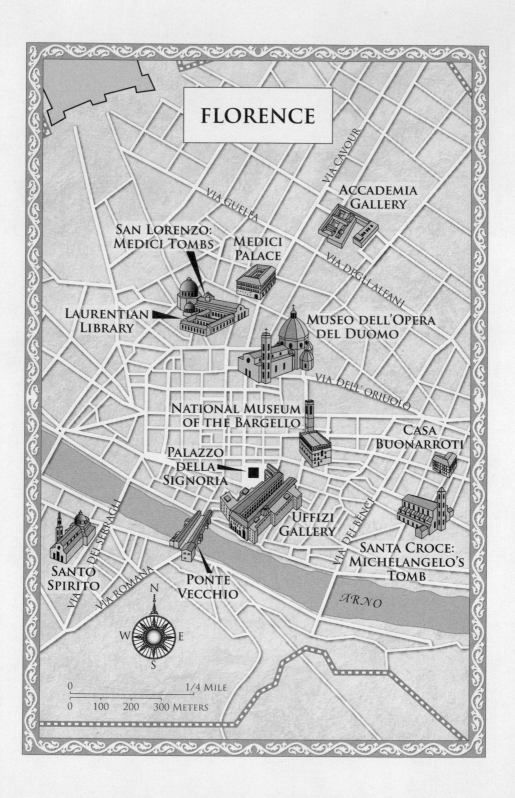

FLORENCE

ACCADEMIA GALLERY

VIA CAVOUR

VIA GUELFA

SAN LORENZO: MEDICI TOMBS

MEDICI PALACE

VIA DEGLI ALFANI

MUSEO DELL'OPERA DEL DUOMO

LAURENTIAN LIBRARY

VIA DELL'ORIUOLO

NATIONAL MUSEUM OF THE BARGELLO

CASA BUONARROTI

PALAZZO DELLA SIGNORIA

UFFIZI GALLERY

VIA DEL BENCI

SANTA CROCE: MICHELANGELO'S TOMB

SANTO SPIRITO

VIA DEL SERRAGLI

VIA ROMANA

PONTE VECCHIO

ARNO

N
W E
S

0 1/4 MILE
0 100 200 300 METERS

ROME

SISTINE CHAPEL:
SISTINE CEILING
AND THE
LAST JUDGMENT

PIETÀ

VATICAN

ST. PETER'S

VIA CRESCENZIO

VIA DELLA
CONCILIAZIONE

TIBER

PALAZZO
FARNESE

VIA GIULIA

SANTA MARIA
SOPRA MINERVA:
THE RISEN CHRIST

VIA DELLA SCROFA

VIA DI TORRE ARGENTINA

VIA DEL PLEBISCITO

CAMPIDOGLIO

VIA DEI
FORI IMPERIALI

SAN PIETRO IN VINCOLI:
JULIUS'S TOMB (MOSES)

VIA DEL CORSO

VIA DI
CONDOTTI

VIA DUE MACELLI-TRAFORO

VIA SISTINA

VIA DELLE QUATTRO FONTANE

VIA NAZIONALE

N
E
W
S

1/4 MILE
400 METERS
0 200
0

Portrait of Michelangelo Buonarroti by Jacopino del Conte *Scala/Art Resource, NY*

I

Michelangelo:
The Myth and the Man

Michael, more than mortal man, angel divine . . .

—Ariosto, *Orlando Furioso*

I. MICHAEL, MORE THAN MORTAL MAN, ANGEL DIVINE

In the spring of 1548, Michelangelo Buonarroti dashed off a brief note to his nephew Lionardo in Florence. As was often the case with the seventy-three-year-old artist, he felt aggrieved. "Tell the priest not to write me any longer as 'Michelangelo sculptor,'" he wrote in a huff, "because here [in Rome] I'm known only as Michelangelo Buonarroti, and if a Florentine citizen wants to have an altarpiece painted, he must find himself a painter. I was never a painter or a sculptor like one who keeps a shop. I haven't done so in order to uphold the honor of my father and brothers. While it is true that I have served three popes, that was only because I was forced to."

One reason for his annoyance was practical. As he suggests at the end of the letter where he enlists his nephew in a little deception—". . . as to what I've just written, don't say anything to the priest because I wish him to think

that I never received your letter"—there are other sculptors in Rome with similar names and any imprecision in the form of the address is likely to cause his mail to go astray. But the real explanation lies elsewhere. The priest has not only been careless: worse, he has misunderstood the nature of his calling. Michelangelo bristles at being mistaken for one of those daubers who hangs out a shingle advertising Madonnas and portraits to order and priced by the square foot. Nothing could be further from the truth, he tells Lionardo, as if he too needed to be reminded of the kind of man his uncle is. He is an *artist,* a visionary whose unique gift sets him apart from ordinary mortals.

In this petulant note—written in haste by an old man whose crankiness was exacerbated by a recent attack of kidney stones—we can sense the frustration that came from a lifetime spent battling those who viewed his profession with contempt. In the face of the skeptics and the scoffers, Michelangelo promoted a new conception of the artist, one in which the crass demands of commerce and the demeaning associations of manual labor have been sloughed off to reveal a creature as yet ill-defined but still thoroughly magnificent.

"I was never a painter or a sculptor like one who keeps a shop," he insists. But if not, what kind of artist is he? Implicit in Michelangelo's outburst is a radical claim: the painter or sculptor was no longer just a humble craftsman but a shaman or secular prophet, and the work of his hands was akin to holy writ.

Michelangelo's letter to his nephew offers a telling insight into the artist's state of mind, one that's all the more valuable for being private and unrehearsed. Precisely because there's so little at stake, and because the people involved were of no particular importance, we get the feeling we are peeking through the curtains and seeing the man as he really was when no one was looking, in his robe and slippers, his hair uncombed. The touchiness and fragile vanity Michelangelo displays are perhaps surprising, since by the time he wrote the letter he had already achieved a worldly success almost unparalleled for any artist in any age. "[W]hat greater and clearer sign can we ever have of the excellence of this man than the contention of the Princes of the world for him?" asked Ascanio Condivi, his friend and biographer. Courted

by the greatest lords of Europe who begged for even a minor work from his hands, why bother to respond to a tactless Florentine nobody?

The truth is that the priest had touched him where he was most tender. Michelangelo's peevish response is a farcical echo of those epic battles with popes and princes who were often just as blind to the nature of his achievement. In fact, Michelangelo's entire life was a rebuke to those who thought the artist's job was to supply pretty images to order for anyone with a few ducats in his pocket. Michelangelo insisted that the purpose of art, at least when practiced at the highest level, was to channel the most profound aspirations of the human spirit. These could not be summoned at will or purchased like melons in the market. By stubbornly, even pugnaciously, pursuing this ideal, Michelangelo transformed both the practice of art and our conception of the artist's role in society.

Michelangelo's long, illustrious career marks the point at which the artist definitively transcends his humble origins in the laboring class and takes his place alongside scholars and princes of the Church as an intellectual and spiritual leader. As Michelangelo's fame spread, some of his patrons persisted in treating him as little more than a household servant—albeit of a particularly eccentric and disobedient sort—but many contemporaries acknowledged that he was a new kind of artist, indeed a new kind of man, a secular saint who was to be exalted but also feared. Even someone as powerful as Pope Leo X was daunted by the prospect of employing him, grumbling, "[H]e is terrible, as you see. It is impossible to work with him." Leo's cousin, Pope Clement VII, was more amused than outraged at his servant's insubordination. "When Buonarroti comes to see me," he said, laughing, "I always take a seat and bid him to be seated, feeling that he will do so without leave."

Michelangelo's determination to chart a new course embroiled him in endless quarrels as his claim of superiority clashed with his employers' own considerable egos. While patrons tended to regard him and his colleagues as, at best, highly trained professionals tasked with carrying out their vision, Michelangelo insisted on an unprecedented degree of freedom to pursue his own vision, on his own terms. Cardinal Cervini (soon to be elected Pope Marcellus II), in charge of overseeing the rebuilding of St. Peter's, was one of many who discovered how difficult it was to control the headstrong artist.

When he asked Michelangelo to inform him of his plans, the artist snapped; "I am not obliged, nor do I intend to be obliged to say either to your highness or to any other person what I am bound or desirous to do." Even when his relationship with a patron was one of mutual respect, Michelangelo chafed at any restrictions placed on his freedom. "If Your Holiness wishes me to accomplish anything," he wrote to Pope Clement VII, "I beg you not to have authorities set over me in my own trade, but to have faith in me and give me a free hand. Your Holiness will see what I shall accomplish and the account I shall give of myself."

Michelangelo's greatest achievement was to fuse the artist and his work. He was the prototype of the temperamental genius, beholden to no one and responsible only to the dictates of his own inspiration. The term *terribilità*—the power to inspire awe and terror—was transferred by some subtle alchemy from the artist to his paintings and sculptures, and then back again, so that the man and his work became one. Michelangelo himself tended to blur the line between life and art. Asked why he never married, he responded, "I have too much of a wife, which is this art that has always given me tribulation, and my children will be the works that I shall leave." In a sonnet, he took this analogy one step further, writing of his unforgiving muse:

> *This savage woman, by no strictures bound,*
> *Has ruled that I'm to burn, die, suffer. . . .*
> *My blood, however, she drains pound by pound;*
> *She strips my nerves the better to undo*
> *My soul. . . .*

Fueled by his outsized ambition and stamped by his outsized personality, these epic paintings and monumental sculptures reflect their creator; they are an expression of his will and a mirror held up to his turbulent soul. It required a leap of faith to commission a work from such a master, since it was certain to defy convention. When finally unveiled to a curious public, the work was likely to challenge not only artistic precedent but often orthodoxy itself. In the case of *The Last Judgment,* the outcry from indignant Christians

was so loud that even the pope could not resist their calls to cover up the most offensive parts. Those who preferred to play it safe simply hired more pliant servants.

Even in an age of towering giants, Michelangelo was the first artist to be the subject of a cult of personality. His character was as much a matter for public speculation as the meaning of the works he created, and it was impossible to understand the one without the insight provided by the other. It has become a cliché to say that an artist must express himself in his work, but this commonplace was largely Michelangelo's invention. To be an artist in the new sense of the word, it was not sufficient to possess supreme skill. Skill was only the means to an end, which was to make the work embody the self.

This explains why the private lives of his great rivals—Leonardo, Raphael, and Titian, to name only the most prominent—were never subject to the same kind of scrutiny that routinely followed Michelangelo. Most focused on his eccentricities, his preference for solitude, his melancholy, his ill temper. Even his personal hygiene became a matter of public comment. "[W]hile a man of so great genius," an early chronicler observed, "he was by nature so coarse and wild as to inform his domestic life with an incredible shabbiness."

But rather than diminish his reputation, these observations merely heightened Michelangelo's mystique. Michelangelo was the first truly modern artist, emancipated not only from a slavish subservience to his patrons but from social norms altogether. His brooding temperament and contempt for social norms was a crucial aspect of a mythologizing that began in his own lifetime. As a youth, recalled Condivi, "he almost withdrew from the fellowship of men, only consorting with a few. So that by some he was held to be proud, and by others odd and eccentric . . . company not only did not please him but even annoyed him, as interrupting his meditations; he was never less solitary than when alone."

Because his contemporaries were fascinated with details of his private life, Michelangelo, even after the passage of five centuries, comes across as a fully formed human being: driven, passionate, mercurial, irascible, devoted to his few close friends but also quick to accuse them of betrayal. He could inspire fierce loyalty, but also an intense aversion, particularly among those who felt

the bite of his anger or the sting of his ridicule. To some of his employees he acted like an indulgent father, nursing them when they were sick or providing generously for their families after they died. But he could also treat his underlings harshly, dismissing them for minor offenses and then publicizing their faults so they had difficulty finding any other work. He was generous to those he considered the deserving poor, but his tendency to pocket his commissions and then fail to deliver what he'd promised led to charges of greed and even outright fraud.

Even so, one must be careful not to accept everything at face value. Both he and his allies recognized that even a "warts-and-all" depiction could work to his advantage. In flouting norms he merely confirmed his originality, and it was originality that distinguished the true artist from the humble craftsman, the creative genius from the hack. Who's ever heard of a tormented carpenter? Or a mercurial glass blower? Of course, these skilled trades have their share of neurotics, but no one believes it's part of the job description.

Michelangelo, by contrast, deliberately broke down the barriers between life and art, setting up a paradigm—most fully embraced by the Romantic movement in the nineteenth century—in which suffering is regarded as the basis of creativity. In his poetry, Michelangelo lays bare his troubles, his vaunting pride and crippling doubt, the exaltation of desire and the crushing burden of shame. "I live to sin," he despaired in an unfinished madrigal,

> *for the soul that living dies,*
> *my life being no more mine,*
> *but to wickedness enslaved.*

Works like the famous *Captives* or the late pietàs are almost equally confessional. Even when the artist does not appear onstage, we can feel him lurking in the background, dominating the action through the force of his will.

Michelangelo was fully complicit in the project to turn his life into legend. His earliest biographers, Condivi and Vasari, were younger colleagues who stood in awe of the great man and were only too happy to promote him as a demigod who trafficked in only the most profound truths. The writer Anton

Francesco Doni remarked, as if it were common knowledge: "And certainly I take you to be a God," though he added the disclaimer, "but with license from our faith." Others took up the torch as well. In his epic poem *Orlando Furioso*, Ludovico Ariosto puns on the artist's name, calling him *"Michel, più che mortale, Angelo divino"* (Michael, more than mortal man, angel divine), though what began as praise could be turned by his enemies into a source of derision. The equally distinguished Pietro Aretino, smarting from a perceived insult at the hands of the artist, wrote a letter in which he sneered at "that Michelangelo of stupendous fame . . . who since you are divine do not deign to consort with men," proving that a social-climbing man of letters could be every bit as touchy as an insecure artist.

Michelangelo's conception of himself as a superior being was not based solely, or perhaps even principally, on his immense talent. As his letter to his nephew reveals, it sprang initially from his pride in belonging to an ancient and noble lineage. "[H]ere I'm known only as Michelangelo Buonarroti," he boasts, as if it is the family name rather than his profession that best defines him. Obsessed with upholding the family honor, he cannot embrace the title of sculptor or painter, which he associates with degraded manual labor. The priest's error is not that he looked down on the great majority of artists, but rather that he associated *him* with that lowly breed.

Driven to become an artist, a profession he knew was beneath his dignity, Michelangelo simply redefined the term. Ironically, the new reality Michelangelo himself helped bring about makes his anxiety about the family pedigree seem faintly ridiculous. The Buonarroti would long ago have faded into obscurity were it not for the famous artist who bore that name, a reversal of the natural order to which Michelangelo never fully reconciled himself.

II. THE PAINTER'S APPRENTICE

Michelangelo's decision to become an artist sprang from a deep need, but his restless ambition and his irritable pride were fueled as much by the circumstances of his birth, or at least the circumstances as he understood them, since the basis of his family's claims to nobility was as much a product of

hope as of cold-eyed realism. Michelangelo di Lodovico di Buonarroti Simone* was born on March 6, 1475, in the provincial village of Caprese, where his father, Lodovico, was serving a term as the mayor. In a typically dry entry, Lodovico marked the momentous occasion in his *Ricordanza:* "I record that today, this 6th day of March, 1474,† a son was born to me. I named him Michelangelo. He was born on Monday morning 4 or 5 hours before daybreak while I was *Podestà* at Caprese. . . . He was baptized on the 8th day of said month in the Church of Santo Giovanni at Caprese."

Michelangelo was the second of what would ultimately grow into a brood of five boys, each of whom would come to depend on their famous brother to one degree or another.‡ It is ironic that the child who defied his father to become an artist turned out to be the one effectual breadwinner among the lot. It was Michelangelo's wealth and fame that sustained the family when those who chose more conventional careers faltered.

Lodovico was both proud and poor, traits that left an indelible mark on his second son. It was from his father that Michelangelo inherited an obsession with the dignity of the family name and a horror of anything that could be seen as dragging the Buonarroti down to that low estate to which outward appearance suggested they already belonged. Early on, the young Michelangelo and his four brothers learned that, though they were barely scraping by, the Buonarroti were not only a distinguished Florentine clan, but that they were descended from perhaps the most famous dynasty in all of Tuscany: the counts of Canossa. Throughout his long life Michelangelo set great store by this connection. Ironically, Michelangelo's fame in a socially suspect profession meant that the current head of the clan, Count Alessandro, was only too happy to acknowledge the dubious connection, addressing his correspondence to "my much beloved and honored kinsman *messer* Michelangelo

* Florentines distinguished themselves from their kinsmen by adding their father's name to their own. Thus, Michelangelo was Michelangelo di Lodovico—Michelangelo, son of Lodovico—while Lodovico himself was Lodovico di Lionardo—Lodovico, son of Lionardo.

† According to the Florentine calendar, the year began on March 25, the Feast of the Annunciation marking the moment of Christ's conception.

‡ Michelangelo's older brother, Lionardo, was born in 1473.

da Canossa worthy sculptor." Near the end of his life Michelangelo tried to impress upon his nephew the importance of this honor, recalling how the count "once came to visit me in Rome as a relative."

Though kinship with the counts of Canossa seems to have been based on little more than family lore, the Buonarroti were in fact members of the Florentine ruling class and could boast many ancestors serving in the highest levels of government. In bourgeois, mercantile Florence, it was participation in elective office rather than an ancient landed title that defined the ruling elite, and on this basis alone the Buonarroti had a more-than-respectable lineage. By staking so much on the more aristocratic pedigree of the counts of Canossa, Michelangelo revealed himself to be not only a snob but one of a particularly conservative stripe.

A sounder claim to highborn status came via Michelangelo's mother, Francesca, daughter of Neri di Miniato del Sera and Bonda Rucellai. The Rucellai family was one of the richest and most powerful in Florence. Merchants who had grown prosperous by importing a plant used to create a prized purple dye, they were staunch allies of the ruling Medici clan and flourished along with that powerful family. This connection, rather than the spurious kinship with the descendants of Countess Matilda, could have paid real dividends, but Lodovico never seems to have turned it to his advantage.

For all their pretensions, however, at the time of Michelangelo's birth the Buonarroti were barely clinging to respectability. This had nothing to do with ancestry but rather with the lack of cold, hard cash, the other critical measure of status in mercantile Florence. Michelangelo's grandfather Lionardo had been so poor that he could not scrape together enough money to provide his daughter with a dowry and had to pledge his house on the Piazza dei Peruzzi to secure a suitable groom. Failure to provide for a marriageable daughter was a source of shame to a Florentine patrician as well as a practical obstacle, since dowerless women could not be deployed to forge the connections with other successful families necessary to rise in the world.

This blow to family pride occurred in 1449, but neither Lodovico nor his brother had done anything in the interim to improve their situation. Michelangelo's uncle, Francesco, was a small-time money changer who kept

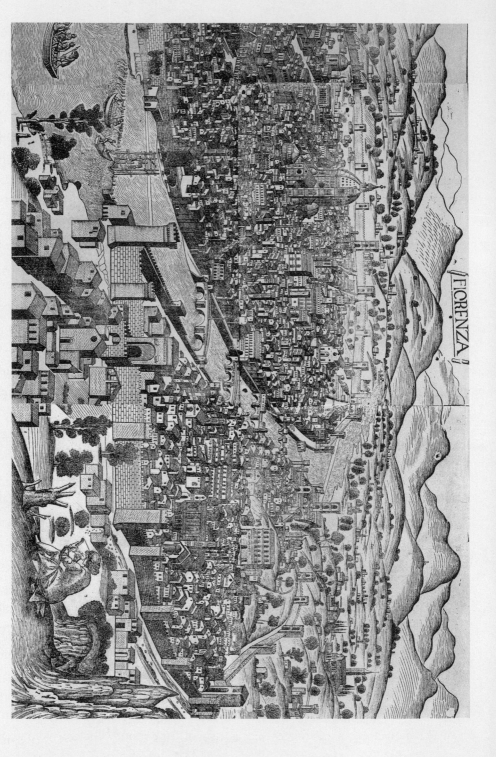

Large City View of Florence (Catena Map). C. 1500/1510. bpk, Berlin/Kupferstichkabinett, Staatliche Museen, Berlin, Germany/Jörg P. Anders/Art Resource, NY

a table in the New Market, but unlike the vast majority of his compatriots he seemed to possess little aptitude for turning a profit. Lodovico's attempts at restoring the family's fortunes were even more halfhearted. For the most part, he preferred life as a gentleman of modest means. Lacking the drive to get ahead in business, he and his growing family had to be content to live off the income derived from a modest property in Florence and a small farm in the neighboring village of Settignano, supplemented by an occasional stint as a minor civil servant.

Michelangelo was less than a month old when Lodovico and his family returned to his native city of Florence at the end of his term in office. In 1475, about 50,000 people lived within the Tuscan capital's high walls; at least an equal number lived in the *contado,* the surrounding countryside where for thousands of years a large number of peasants and a smaller number of gentleman farmers had cultivated wine, grain, and olives in the rocky hillsides. The city itself was a crowded maze of streets and alleyways hugging either side of the Arno River. From the surrounding hills of Fiesole, Bellosguardo, and Settignano, the city was a sea of terra-cotta roofs overtopped by magnificent basilicas and bristling towers. Much of the city was given over to fetid slums filled with crowded tenements, home to the workers who were the muscle behind the thriving textile industries, but there were plenty of gracious homes fronting wide boulevards and spacious piazzas where merchant princes lived in opulent splendor. It was these successful men of business who, along with the Church, gave steady employment to the city's many artists.

Florence was a city built by merchants and run by merchants, equally suspicious of the proud feudal nobility and the downtrodden masses, both of whom would like nothing better than to plunder the wealth they had so patiently accumulated over the centuries. Every banker or wealthy trader lived in fear of having his throat slit in the night, a not unreasonable concern given Florence's history of murder and riot. This history was built into the architecture itself, with leading families—and even the Signoria, the collective lordship of Florence—residing in fortresslike structures with high stone walls, crenellations, and narrow windows.

In theory, the form of government was republican. Middle-class artisans

and wealthy merchants were all eligible for public office, though not the urban proletariat, who, however long they resided in Florence, were not considered citizens. Frequent elections made for a lively political scene as Florentines competed for the honor and power that came from winning a place among the Tre Maggiori, the three most prestigious offices in the state. In reality, effective control remained in the firm grasp of the Medici family and their allies. For decades they had skillfully played one faction off against another and, through a combination of intimidation and bribery, had managed to grasp the levers of power while retaining the outward forms of democracy. The current head of the family, Lorenzo—known to history as Il Magnifico—the Magnificent—for both his legendary wealth and his patronage of artists and writers—reconciled the people to their loss of freedom by staging splendid pageants for their amusement and generally keeping the city in peace and prosperity.

Though still ruling over an extensive empire—in which Lodovico played a small part as *podestà* for the towns of Chiusi and Caprese—Florence was already falling behind other Italian states. The Duchy of Milan and the Republic of Venice in the north, the Papal States surrounding Florentine territory on three sides, and the Kingdom of Naples in the south, could all deploy more men and resources. And compared to the rising nation-states of Spain and France, hungrily eyeing the rich but politically divided Italian peninsula, Florence was little more than a tasty morsel.

The one area where Florence was still preeminent was in the arts, building on a tradition that extended back centuries, to Cimabue and Giotto in painting, to Donatello in sculpture, and to Dante and Boccaccio in literature. In the final years of Lorenzo de' Medici's reign, his good friend Marsilio Ficino could still write: "This is an age of gold, which has brought back to life the almost extinguished liberal disciplines of poetry, eloquence, painting, architecture, sculpture, music, and singing to the Orphic Lyre. And all this in Florence!" This proud history was one of the reasons that Michelangelo remained loyal to his native land. No matter how long he lived outside its walls, Michelangelo always thought of himself as a Florentine, celebrating its victories and mourning its defeats. He maintained these ties even beyond

the grave, insisting, much to the chagrin of the Romans who felt they had contributed more to his everlasting fame, that his body be returned to his native land for burial.

For the first few years, Michelangelo did not live under his father's roof in the modest house on the Via de' Bentaccordi; as was customary for Florentine children, the infant boy was shipped out to live with a wet nurse. He was taken in by a stonecutter's wife in Settignano, a town located in the hills just to the northeast of Florence where the Buonarroti owned a small farm. Crucially for Michelangelo's development as a sculptor, this village was the site of ancient quarries that for centuries had been home to many of Florence's most skilled stoneworkers.* Michelangelo viewed this early environment as providential, telling his friend Vasari: "Giorgio, if I have anything of the good in my brain, it comes from my being born in the pure air of your country of Arezzo [near Caprese], even as I sucked in with my nurse's milk the chisels and hammer with which I make my figures."

This remark was more than a literary conceit. There is very little in Michelangelo's formal training as an artist to suggest how he mastered the difficult art of stone carving. His skill in a medium that had all but died out in Florence by the time of his birth, his natural affinity for the material and affection for the humble quarrymen who excavated the marble blocks from which many of his masterpieces were carved, all point to the formative experience of a youth spent clambering among the rocky hills and consorting with the *scarpellini* (stonecutters) of Settignano. Michelangelo's admiration for these workers was genuine. He respected not only the skilled artisans who carved the columns and decorative moldings of Florence's churches and palaces, but also the brawny, illiterate laborers who at great risk to life and limb actually hacked the blocks from the quarries. This generosity stands in marked contrast to the disdain he felt for those who called themselves artists and claimed to be his equals.

* Settignano also produced at least two famous sculptors, Antonio Rossellino (c. 1427–78) and Desiderio da Settignano (c. 1430–64), demonstrating that the gulf separating the lowly stonecutter from the famous sculptor was not always that wide.

In addition to the arrival of three younger brothers—Buonarroto (1477), Giovansimone (1479), and Gismondo (1481)—the first event of note in the life of young Michelangelo was the death, when he was only six, of his mother, Francesca. Not surprisingly, the impact of this early bereavement has given rise to much forensic psychoanalysis. The mother-and-child motif is the single most common theme in all of Michelangelo's art, from his earliest known work, the *Madonna of the Stairs*, to his last, the so-called *Rondanini Pietà*, left incomplete in his studio at the time of his death. Could it be that his almost obsessive engagement with the theme reflects a grown man's response to a childhood loss? While Michelangelo was certainly preoccupied with the intense, psychologically fraught maternal bond, it would be simplistic to attribute his fascination primarily to this experience. Not only is the mother-and-child a universal theme, but it was particularly popular in the Renaissance when the Virgin Mary and her son—shown either as an infant, or after his descent from the Cross—was perhaps the most common subject of religious art. Indeed, while it is tantalizing to speculate about the effect of such a loss on a young, impressionable boy, there is no indication that Michelangelo was permanently scarred by his mother's early death.

A more critical factor in Michelangelo's development was the Oedipal struggle with his father over his decision to become an artist. In 1485, the same year that Lodovico remarried (to Lucrezia Ubaldini), he sent Michelangelo to the grammar school of Francesco da Urbino, where he was expected to acquire a facility with reading and writing in his native Italian before moving on to master Latin letters, essential for any Florentine who wished to pursue a respectable career. At the same time, Michelangelo struck up a friendship with the sixteen-year-old Francesco Granacci, an apprentice in the studio of the painters Domenico and Davide Ghirlandaio, one of the busiest and most successful shops in all of Florence. Michelangelo was bored by the instruction he received at Master Francesco's school, though he later regretted his lack of Latin and was embarrassed when contracts had to be translated so that he could read them. It was his friendship with Granacci that would prove more consequential, for it was this amiable youth—the sort of good-natured, unambitious man the always competitive Michelangelo preferred to surround himself with—who introduced Michelangelo to the

delights of drawing and painting and to the studio where he was to take his first steps toward becoming an artist himself.

Michelangelo's decision to become an artist was clearly the fulfillment of a deep-seated compulsion. "[T]he heavens and his nature," Condivi wrote, "both difficult to withstand, drew him towards the study of painting, so that he could not resist, whenever he could steal the time, drawing now here, now there, and seeking the company of painters." Late in life, Michelangelo still vividly recalled what happened when he was discovered neglecting his studies to spend his time in the studio: "[H]is father and his uncles, who held the art in contempt, were much displeased, and often beat him severely for it," Condivi recorded; "they were so ignorant of the excellence and nobility of art that they thought shame to have her in the house." This tale, in which the idealistic young man defies his parents to pursue his dream of becoming an artist, has a familiar ring; it's been a staple of the mythology since at least the time of the Renaissance. But in Michelangelo's case the story is particularly powerful since the artist himself shared some of his father's doubts about his chosen career, a conflicted attitude that spurred his ambition and compelled him to raise the status of his profession to new heights. Indeed, eradicating the taint of manual labor became something of an obsession on his part. Condivi explained that "he has always desired to cultivate the arts in persons of nobility, as was the manner of the ancients, and not in plebeians." All the pride his father invested in the family name, Michelangelo hoped to recoup through his immortal fame, demonstrating that art could be a noble pursuit proudly pursued by noble men.

As it turned out, father and son were engaged in an unequal contest. The willful boy soon broke down Lodovico's resistance, perhaps in part because even the small salary he would draw as an apprentice in Ghirlandaio's bustling atelier meant that he would be adding to the family coffers. The 24 gold florins the Ghirlandaio brothers were to pay Lodovico to acquire Michelangelo's services for three years could make a real difference to a family barely keeping its head above water.* From this day forward, and increasingly with

* The florin was the Florentine money of account and worth about the same amount as the commonly used Venetian ducat. While it is difficult to fix an exact equivalent in

the passage of years, the artist will become the principal support for his feck-less relatives.

Later in life Michelangelo sought to conceal the truth about his initiation into the artistic profession. One of the most telling examples of the artist altering his biography comes in Condivi's discussion of his earliest training. In 1550, Michelangelo's younger friend and colleague Giorgio Vasari pub-lished the first edition of his *Lives of the Most Excellent Painters, Sculptors, and Architects* (usually shortened to *Lives of the Artists*), a magisterial collec-tive biography of the greatest Italian masters of the last three centuries. The work, in many ways an homage to his famous friend, culminated in a life of Michelangelo himself, the first time such an honor had been accorded a living artist. Here, Vasari offered an effusive portrait of the great man. "The most blessed Ruler of the Universe," he wrote,

> seeing the infinite futility of all that toil, the most ardent studies without fruit and the presumptuous opinions of men—farther from the truth than shadow is from the light—and to relieve us of such errors, took pity by sending to us here on earth a spirit with universal mastery of every art. . . . And he chose to endow this man as well with true moral philosophy and with every ornament of sweet poetry, so that the world might admire him and hold him up as a model to be followed, in life, in work, in holiness of character and all human striving, so that we believed him heaven-sent rather than of this world.

Despite this treatment more appropriate to the life of a saint than of an artist, Michelangelo was unhappy with some of the details contained in Vasari's biography, and prevailed upon Ascanio Condivi to "correct" the

terms of today's purchasing power, it is clear that 8 florins per year was hardly a lavish sum. A skilled artisan might expect to earn about 40 to 50 florins per annum, while a high government official like the chancellor took home a salary of about 130. When Michelangelo was contracted to paint the Sistine Ceiling, he hired assistants at the rate of 10 ducats per month, and when he signed the initial contract for the tomb of Pope Julius II, he was to be paid the princely sum of 10,000 gold ducats. But given the impov-erished state of the Buonarroti clan, even 8 florins a year helped.

record. Perhaps the most telling change has to do with Michelangelo's relationship to his first teacher, Domenico Ghirlandaio, a prolific frescoist beloved by Florentine patricians who enjoyed seeing themselves flatteringly portrayed in the religious scenes with which he covered walls and ceilings of the city's churches.* Directly contradicting Vasari's account, Condivi insists that Michelangelo "received absolutely no assistance from him," claiming instead that Ghirlandaio's attitude toward the talented young artist was one of "envy."

Denying Ghirlandaio's role in launching Michelangelo's career was such a transparent deception that even the usually accommodating Vasari balked, going to great lengths in the second edition of his *Lives* (1568) to rebut Condivi's claims by quoting at length from the actual contract.

Why did Michelangelo try so hard to alter the record? One explanation is that throughout his career Michelangelo claimed sculpture as his principal art; admitting that his formal training was as a painter in the shop of the era's most successful practitioner of this medium tended to undercut that argument. More significantly, the narrative of his apprenticeship reveals that he began his career like any other youth wishing to become an artist, grinding colors, preparing brushes, doing all the menial chores associated with an entry-level position. Far from suggesting an aristocrat pursuing independently a high and cerebral calling, the true story of his apprenticeship betrayed the artisanal origins of Michelangelo's glorious career.

In fact, the kind of *bottega* Ghirlandaio ran was antithetical to everything Michelangelo stood for: it was an art factory, turning out panel paintings and frescoes almost like an assembly line, with apprentices and assistants suppressing their own individuality in order to produce a uniform product. When Michelangelo said he never kept a shop, he must have had in mind his own introduction to the art world, an initiation he still regarded with contempt.

* The frescoes he painted for Santa Trinità, depicting scenes from the life of St. Francis, and in Santa Maria Novella (on which the young Michelangelo may well have worked), depicting the lives of the Virgin and St. John the Baptist, provide a delightful look into the fashions and mores of wealthy Florentines at the end of the fifteenth century.

III. IN THE GARDEN

If Michelangelo's initiation into the world of art turns out to have been more prosaic than he claimed, the next phase of his career has become the stuff of legend. For two years Michelangelo learned the rudiments of his craft in Ghirlandaio's studio, working alongside Francesco Granacci as the studio cranked out portraits, devotional paintings, and the large-scale fresco series for which the shop was famous. At the time, the Ghirlandaio brothers were at work on frescoes in the Dominican Church of Santa Maria Novella, specifically the chapel of the Tornabuoni family depicting the lives of the Virgin and St. John the Baptist. While no one has successfully identified the hand of the young Michelangelo in the work, it is probable that the artist helped in such tasks as preparing the smooth coat of wet plaster that was to be painted on by the masters, and perhaps even composing some of the secondary figures and backgrounds. Though Michelangelo refused to admit his debt to his first master, he was fortunate to have this training to fall back on when he was commissioned to paint monumental frescoes of his own, summoning skills he claimed he never learned from a master he was reluctant to acknowledge.

Both Vasari and Condivi confirm the young Michelangelo's precocious talent, Condivi (rather inconsistently) claiming that Ghirlandaio was jealous of his abilities even though they ostensibly had no working relationship. Curiously, the two biographers agree that one of the young Michelangelo's greatest talents was as a forger. Not only did he make copies from drawings that the studio kept on hand for the edification of its young students, but, according to Vasari, "he counterfeited sheets by the hands of various old masters, making them so similar that they could not be detected, for, tinting them and giving them the appearance of age with smoke and various other materials, he made them so dark that they looked old, and, when compared with the originals, one could not be distinguished from the other." Emphasizing his skill in mimicking the work of others fits awkwardly into a narrative that was meant to highlight Michelangelo's originality, but stories of a neophyte putting the master to shame is a common motif in Vasari's work. In his life of Leonardo, Vasari recounts that Andrea Verrocchio was so star-

tled upon first seeing his young pupil's efforts that he never painted again, "dismayed that a child knew more than he." Similarly, Vasari claimed to have in his possession a drawing by Ghirlandaio to which Michelangelo had made a few judicious alterations, "showing the excellence of a mere lad who was so spirited and bold, that he had the courage to correct the work of his master."

Beating the master at his own game was, in fact, almost a rite of passage for the aspiring genius. One doesn't need to accept Condivi's dismissive account of Ghirlandaio's contribution to believe that Michelangelo quickly learned all he could from that pleasing but uninspired master. After only two years in the Ghirlandaio shop, the fifteen-year-old painter's apprentice was looking for new horizons to conquer. Happily, at the very same moment Florence's leading citizen, Lorenzo Il Magnifico, was combing the studios of the city in search of talented artists willing to learn the sculptor's craft by studying in his garden filled with ancient statues. Vasari explained Lorenzo's motives: "Given the great love he had for both painting and sculpture, he despaired that in his time one could not find famous or noble sculptors to equal the many great painters of note, and so he determined . . . to create a school."

Few episodes in the history of art have stirred as much debate. Some scholars have sought to diminish the significance of this so-called school of sculpture, insisting it was little more than an informal gathering of dilettantes with no real program; others have gone even further, claiming that the myth of Lorenzo's sculpture garden was invented out of whole cloth by Vasari himself as a means of flattering another Medici, his patron and Lorenzo's distant relative, Duke Cosimo de' Medici. Contemporary documents, however, confirm its existence. Not only did Michelangelo recall the time he spent there with great affection, but the garden itself, located off the Piazza San Marco near the Medici Palace, was marked as a notable site on a map made by one Piero del Massaio. It is even possible to trace the origin of Lorenzo's project to a specific moment in 1489 when the Duke of Milan wrote to the ruler of Florence requesting help with the bronze equestrian statue of his father. Much to his chagrin, Lorenzo was forced to admit, "I cannot find any master who satisfies me . . . and this pains me no end." Lorenzo was acutely aware of how much Florence's prestige in the world depended

upon its reputation as a home for the muses, and his inability to honor Duke Sforza's request must have spurred him to action. Offering up his vast collection of ancient and modern statuary as models and using his clout to persuade the leading masters to lend some of their most promising students, Lorenzo set out to reverse the decline of an art form that had once been the pride of Florence.

If Lorenzo's motive for establishing a training ground for young sculptors is straightforward, less clear is the exact nature of the school. Even more obscure is what Michelangelo actually learned there. Bertoldo di Giovanni, an accomplished modeler in bronze who had been a pupil of the great Donatello himself, was apparently hired to provide instruction, but it is unlikely that students there received anything like the rigorous training available at Ghirlandaio's shop. By 1489, when Michelangelo first began to attend sessions at Lorenzo's garden, Bertoldo was a sickly old man (he would die two years later), and he worked almost exclusively in bronze, a medium Michelangelo famously despised.

It is probable that at first Michelangelo divided his time between Ghirlandaio's studio and Lorenzo's sculpture garden. Sketching alongside him among the cypresses and laurel hedges were not only his friend from Ghirlandaio's atelier, Francesco Granacci, but also Giovanfrancesco Rustici (the man who would later realize some of Leonardo's sculptural designs), Giuliano Bugiardini, and Pietro Torrigiano. It was in Lorenzo's garden that Michelangelo made his first sculpture, a head of a faun based on an ancient model in Lorenzo's collection. As Condivi tells the story, the sculpture, though little more than a student exercise, transformed Michelangelo's life:

> One day, [Michelangelo] was examining among these works the *Head of a Faun,* already old in appearance, with a long beard and laughing countenance, though the mouth, on account of its antiquity, could hardly be distinguished or recognized for what it was; and, as he liked it inordinately, he decided to copy it in marble. . . . He set about copying the *Faun* with such care and study that in a few days he had perfected it, supplying from his imagination all that was lacking in the ancient work, that is, the open mouth as of a man laughing, so that the hollow of the mouth and all the teeth could be seen. In the midst

of this, the Magnificent, coming to see what point his works had reached, found the boy engaged in polishing the head and, approaching quite near, he was much amazed, considering first the excellence and then the boy's age; and although he did praise the work, nonetheless he joked with him as with a child and said, "Oh, you have made this *Faun* old and left him all his teeth. Don't you know that old men of that age are always missing a few?"

To Michelangelo it seemed a thousand years before the Magnificent went away so that he could correct the mistake; and, when he was alone, he removed an upper tooth from his old man, drilling the gum as if it had come out with the root, and the following day he awaited the Magnificent with eager longing. When he had come and noted the boy's goodness and simplicity, he laughed at him very much; but then, when he weighed in his mind the perfection of the thing and the age of the boy, he, who was the father of all *virtù*, resolved to help and encourage such great genius and to take him into his household; and, learning from him whose son he was, he said, "Inform your father that I would like to speak to him."

At first, Condivi tells us, Lodovico was appalled, "lamenting that his son would be led astray . . . moreover, that he would never suffer his son to become a stonemason." As much as he loathed the idea of his son becoming a common artisan, he was equally upset by the thought (and not without reason) that Michelangelo would be corrupted by the loose morals of that famously libertine crowd. But in the end he could not resist a summons from the uncrowned ruler of Florence. The meeting between the proud but poor Lodovico Buonarroti di Simone and Il Magnifico in the intimidating surroundings of the Medici Palace has a slightly comic tinge. When Lorenzo asked Michelangelo's father what he did for a living, Lodovico replied, "I have never practiced any profession; but have always lived upon my meager income looking after the small property left to me by my ancestors. . . ." Face-to-face with the powerful Medici lord, Lodovico's resolution crumbled. Of course, he declared, "not only Michelangelo, but all of us, with our lives and all our best faculties, are at the service of your Magnificence." All he asked in return was to be named to a post in the customs house. Upon hearing this modest request, "[t]he Magnificent put his hand upon his shoulder

and, smiling, said: 'You will always be poor,' for he expected that he would ask for some great thing."

It is possible that Condivi embellished this story, but the basic outlines are not in dispute. In 1490, Michelangelo left his shabby paternal home in the quarter of Santa Croce and moved into the magnificent Medici Palace, where, again according to his own account, Il Magnifico provided "a good room in his own house with all that he needed, treating him like a son, with a seat at his table."

In light of Michelangelo's tendency to burnish his biography, it is reasonable to treat this last characterization with caution, if not outright skepticism. Being treated like a son by the magnificent Lorenzo de' Medici would place Michelangelo in rarefied company and remove any suspicion that he was little more than a glorified household servant. It also helped erase the embarrassing facts of his humble origins. But while the story is certainly self-serving, there is in fact plenty of evidence to suggest that in this case Michelangelo did not stray too far from the truth. Years later, when Lorenzo's second son, Giovanni, was sitting on the throne of St. Peter as Pope Leo X, he recalled the happy period when Michelangelo lived at the palace. "When he speaks of you," reported the painter Sebastiano del Piombo, "it is almost with tears in his eyes, because as he told me, you two were raised together. . . ."

No doubt there was an element of noblesse oblige in Lorenzo's kindness. He worked hard to cultivate his image as a simple citizen of Florence even as he consolidated his hold over the government, and his generosity toward talented men was a large part of the mystique that earned him the title Il Magnifico. Lorenzo's "court" was filled with men of great gifts and small means, men like the poets Luigi Pulci and Angelo Poliziano. Not only did he genuinely enjoy their company, but these eloquent and influential figures repaid his generosity in full by broadcasting his virtues to the world.

It is difficult to overstate the significance for Michelangelo of the two years he spent under Lorenzo's roof. In a very real sense, Il Magnifico was the father he wished he had and felt he deserved, a man not only of unquestioned pedigree but one who, unlike the dour Lodovico, held artists and writers in high regard. Where Lodovico cut a shabby figure, Lorenzo was magnificence

itself; while Lodovico expressed his contempt for art and artists, Il Magnifico demonstrated their true worth by showering them with riches.

By focusing on his two-year residence at the Medici Palace rather than his equally brief stint as a lowly apprentice in Ghirlandaio's studio, Michelangelo created a new origin story for himself as an artist. In the palace, Michelangelo was tutored by the brilliant Poliziano and scholarly Ficino, men whose reputations as intellectuals elevated them above artists who worked with their hands. Conversing with these cultivated men, he became convinced that painting and sculpture were not merely crafts but tangible philosophy.

Of the two sculptures Michelangelo executed while in residence at the Medici Palace, one of them at least was inspired by Poliziano, who had taken the young artist's education in hand. The so-called *Battle of the Centaurs* depicts an obscure mythological theme of the kind beloved by the humanists in Lorenzo de' Medici's circle. The battle between the Lapiths and the savage centaurs is an allegory of Man overcoming his bestial nature; happily

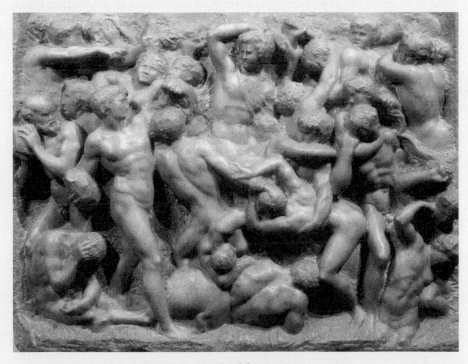

Michelangelo, *Battle of the Centaurs,* c. 1492.

for Michelangelo, it also offered an opportunity to depict the male nude in action, the theme he will explore in most of his greatest works. Michelangelo himself believed this early work contained the seeds of all he would later accomplish. Seeing this youthful exercise again after many years, he told Condivi "how much wrong he had done to his nature in not following promptly the art of sculpture, judging by that work how well he might have succeeded. . . ."

The small-scale relief also recalls the work of his first sculptural master, Bertoldo di Giovanni, whose most accomplished piece was a bronze battle scene modeled on an ancient Roman sarcophagus. Bertoldo's influence can also be detected in Michelangelo's earliest extant sculpture, the small relief known as the *Madonna of the Stairs,* which probably dates from 1491, the first year Michelangelo spent at the Medici Palace. The small marble of the Virgin with the infant Jesus is done in a technique that Michelangelo rarely employed, what Italians call *rilievo schiacciato,* or flattened relief. The form was pioneered by Donatello in the early fifteenth century and would have been familiar to his pupil Bertoldo. It is, in effect, a form of drawing in stone in which the depth of the carving does not so much correspond to three-dimensional forms as suggest them through subtle modulations of light and shadow. Vasari deems the technique, which he traces back to ancient cameos and coins, "very difficult . . . demand[ing] great skill and invention. . . ." Though the depth of the actual carving can be measured in mere millimeters, Michelangelo has managed to pack a lot into a little: a monumental Virgin Mary seated stoically on her blocklike throne; the baby Jesus twisting in her arms; and a staircase leading to another room sufficiently commodious to serve as the perch for three cherubs carrying a sheet (symbolizing the shroud that will drape the dead Christ's body).

Michelangelo has depicted Mary in a style that recalls classical Greek funerary monuments and reflects the erudite humanism of the Medici Palace, where Lorenzo was constantly adding to his collection of ancient statues, cameos, and vases and where the wisdom of the ancients was examined with the reverence of Holy Scripture. Even her profile is distinctively "Greek," with her brow and nose forming a single, unbroken line, in keeping with classical canons of beauty. The most original (and nonclassical) element

is the Christ child himself. He is seen from the back, his head protectively buried in the folds of his mother's dress. His pose is curious. Is he turning to take his mother's breast, or recoiling in fear as he sees his own fate foreshadowed in the form of the burial shroud? There is an uncomfortable psychological distance between the mother and her child, whom she envelops but largely ignores. She tends to him distractedly, her gaze drawn by the *putti*, whose activities seem to rehearse the sorrow of the Passion. Jesus, for his part, appears to simultaneously burrow into the protective folds of his mother's garments, while struggling to free himself from her suffocating embrace. Michelangelo will employ the same complex, twisting pose— suggestive of struggle and internal contradictions—in mature works like the famous *Night* from the Medici tombs.

The technique of *rilievo schiacciato* that Michelangelo employed in the *Madonna of the Stairs* would prove to be an artistic dead end. Even when he worked in two dimensions, he usually strived for three-dimensionality. His paintings exhibit a brittle quality that some contemporaries compared unfavorably to the atmospheric subtleties of Leonardo, Raphael, and Titian. Indeed, Michelangelo, rebutting Leonardo's claim that painting was superior to sculpture, famously remarked: "[I]t seems to me that painting may be held good in the degree in which it approximates to relief, and relief to be bad in the degree in which it approximates to painting"—a standard that if applied to the *Madonna of the Stairs* would brand it an utter failure.

The two years Michelangelo lived in Il Magnifico's palace reinforced his sense of superiority and his faith in the natural affinity of art and other more refined pursuits. The works he created there, especially the *Battle of the Centaurs*, were philosophical allegories realized in three dimensions. Poliziano, Ficino, Pico, and Lorenzo himself all encouraged him to think of art in rarefied terms, as a product of the mind rather than of the hands. At a later period in his life, when he was beset by many cares, he excused his dilatoriness by reminding his correspondent, "you work with your mind and not with your hands," an attitude that reflected the cultured atmosphere of the Medici Palace but would have been considered laughable in the busy atelier of the Ghirlandaios, where no distractions could be allowed to interfere with productivity.

Michelangelo's pretensions did not always sit well with his colleagues, who

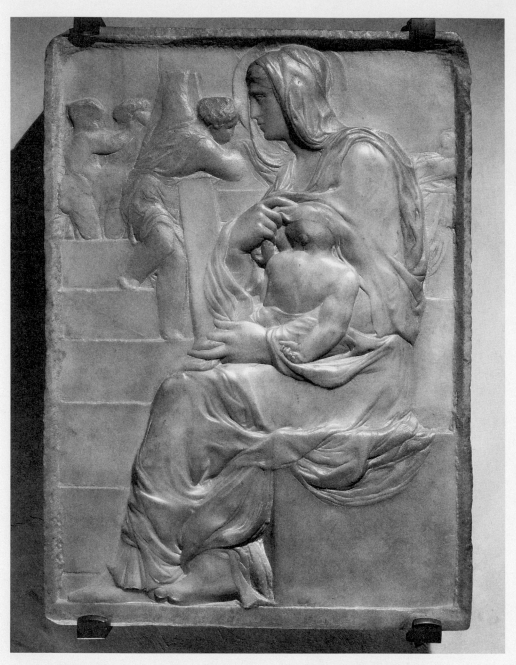

Michelangelo, *Madonna of the Stairs*, c. 1490–92. *Scala/Art Resource, NY*

believed—rightly, as it turns out—that he looked down on them. Michelangelo's privileged position as Il Magnifico's favorite created a rift between him and his fellow students. Granacci accepted his junior partner's promotion with good humor, but others were less willing to put up with his arrogance. Matters came to a head one day while the students, on a field trip from the garden, were sketching from the frescoes of the great quattrocento master Masaccio in Santa Maria del Carmine, in the Oltrarno district of Florence.* Vasari wrote of the incident: "It is said that Torrigiano, after contracting a friendship with [Michelangelo], mocked him, being moved by envy at seeing him more honored than himself and more able in art, and struck him a blow of the fist on the nose with such force, that he broke and crushed it very grievously and marked him for life; on which account Torrigiano was banished from Florence. . . ."

Torrigiano himself offered a slightly different version of events many years later to the sculptor Benvenuto Cellini, recalling: "Buonarroti and I used to go as boys to the Church of the Carmine where there's a chapel painted by Masaccio: and because it was Buonarroti's habit to mock everyone who was drawing there, one day when he was irritating me more than usual, I made a fist and gave him such a sock on the nose that I felt bone and cartilage crumble like a cracker. He will bear that mark of mine as long as he lives."

The accuracy of Torrigiano's prediction can be proved by portraits of Michelangelo, all of which show the crooked, flattened nose he acquired as a result of this assault. Torrigiano has never escaped the infamy of having disfigured the great Michelangelo, but one can't help feeling a certain amount of sympathy for the assailant who never achieved for his work in bronze or marble the notoriety that came from his one attempt at a composition in living flesh and bone. The truth is that Michelangelo was insufferable, par-

* The frescoes in the Brancacci Chapel are among the masterpieces of early Renaissance art. Standing before these works, with their compelling narratives told through a few monumental and expressive figures, it is easy to see Michelangelo's debt to the older artist. Masaccio's influence can be seen most clearly by comparing Masaccio's *Expulsion* with Michelangelo's version of the same story from the Sistine Ceiling.

ticularly as a youth when his sense of superiority had not yet been matched by any great achievement.

Michelangelo did not lament his misfortune, embracing his homeliness as a paradoxical revelation of an inner beauty. In one of his poems he admits, "I know I am ugly," and in a madrigal of the 1530s he writes, "I pray my body, though/ so homely here on earth, would rise to paradise." Like the famously pug-nosed Socrates, Michelangelo's outward flaws signal an inner perfection. This tension between interior and exterior informs much of his work and is often expressed as an eternal battle between the soul and the body. In his poetry, this duality is captured in the image of a snake shedding its old skin, as in this poem of 1530:

> So accustomed am I to sin, that heaven has denied me
> the grace that falls like rain.
> As an old serpent squeezing through a narrow slot
> I shall pass, and leave behind my discarded skin,
> old habits gone,
> my soul restored to life and to every earthly thing,
> now protected by a stronger shield—
> for compared with death, the world is less than nothing.

Michelangelo's focus on his own homeliness seems more metaphorical than real, an external manifestation of inner demons. Vasari, who knew him as an older man, has left us a detailed description of his friend that suggests a somewhat plain but by no means displeasing appearance:

[T]he master's constitution was very sound, for he was lean and well knit together with nerves, and although as a boy he was delicate . . . he could always endure any fatigue. . . . He was of middle stature, broad in the shoulders, but well proportioned in the rest of the body. . . . His face was round, the brow square and spacious, with seven straight lines, and the temples projected considerably beyond the ears; which ears were somewhat on the large side, and stood out from the cheeks. The body was in proportion to the face, or rather on the large side; the nose somewhat flattened, as was said in the Life of

Torrigiano, who broke it for him with his fist; the eyes rather on the small side, of the color of horn, spotted with blueish and yellowish gleams; the eyebrows with few hairs, the lips thin, with the lower lip rather thicker and projecting a little, the chin well shaped and in proportion with the rest, the hair black, but mingled with white hairs, like the beard, which was not very long, forked, and not very thick.

IV. THE FORGER

With the death in April 1492 of Lorenzo de' Medici, an idyllic interlude in Michelangelo's life came to a close. For many years the uncrowned ruler of Florence had been suffering from gout and other chronic illnesses, and his death at the age of forty-three—while tragic both for Michelangelo personally and for his fellow citizens, who would now have to take their chances with his son, the twenty-year-old Piero—was not entirely unexpected. The two years Michelangelo spent at the Medici Palace were perhaps the happiest of his long life. Never again would he find a patron as sympathetic as Il Magnifico, and the unrealistic expectations set by this relationship made the deficiencies of subsequent ones all the more apparent. While in residence at the Medici Palace on the Via Larga he met many of his future patrons, including not only Giovanni de' Medici, later Pope Leo X, and his cousin Giulio, the future Pope Clement VII, but also Alessandro Farnese who, when he was elevated to the throne of St. Peter many years later, remembered the young boy he'd met at the palace and turned to him for some of his most important commissions.

More important, time spent mingling with the brilliant company assembled in Lorenzo's palace broadened Michelangelo's conception of what art could be and inflated his sense of his own worth. Walking around town in the silks and brocades provided courtesy of Lorenzo's generosity, Michelangelo seemed miles apart from his former colleagues toiling away in Ghirlandaio's studio. The touchy pride he inherited from his father was confirmed by his new circumstances, and the compliments he received from the greatest man in Florence assured him he was on the right track.

Shortly after Lorenzo's death, Michelangelo returned to his father's house.

It was an unhappy reunion for the young artist forced to trade a room in the most magnificent palace in the city for the crowded homestead in Santa Croce. Even more difficult than the loss of material comforts was the unpleasant task of explaining to his father how he was going to make his way in the world. His older brother, Lionardo, had taken up holy orders and attached himself to the fire-and-brimstone preacher Savonarola, which placed added responsibilities on the shoulders of Michelangelo as the future leader of the Buonarroti clan. How many "I told you sos" Michelangelo had to endure at home can only be imagined, but there is no doubt the cantankerous Lodovico leapt at every opportunity to point out how badly he'd blundered in his choice of profession.

The new head of the Medici household—and now de facto ruler of Florence—was the far less capable Piero, the spoiled son of a great man with none of the brilliance or political skills of his father. When Michelangelo again took up residence in the palace on the Via Larga for a brief period, Piero was overheard praising the artist as one of the two most cherished members of his household, the other being his Spanish groom, who was not only handsome but so fleet of foot that he could outpace him as he galloped on horseback. Such a lack of judgment was typical of the arrogant youth, who quickly squandered the goodwill of his compatriots. Florentines were willing to submit to Lorenzo's tyranny because it was so artfully disguised; Piero, by contrast, loved the trappings of power and traveled about the city with a large retinue more fit for a prince than a citizen. The only work Piero was known to have commissioned from Michelangelo at this time was a snow lion in the courtyard of the palace during a particularly severe winter storm.

Michelangelo completed another work a year or so after leaving the Medici Palace: an eight-foot-high Hercules in marble that he carved from an old, weather-beaten block—the only kind he could afford to purchase. The origins of this now lost work are somewhat mysterious. It is not known if it was commissioned and, if so, by whom; it ended up in the courtyard of the Strozzi Palace, home to bankers second only to the Medici in wealth and power, but it is not clear whether they paid the sculptor for the work or acquired it at some later date. Another theory is that it was made at the behest

of Piero de' Medici as a monument to his father, a project that Michelangelo would certainly have welcomed. Hercules, along with the biblical hero David, was a traditional symbol of the Florentine Republic and would have made a fitting tribute to the man who led the state so ably for so many years.

If, as seems possible, Michelangelo sculpted the Hercules simply for his own pleasure, it would have been a rarity in an age when almost every work was made on commission. This was especially true of a large-scale sculptural work, since marble was expensive and the commitment in time and energy even more costly. The fact that Michelangelo devoted a year of his life to such an unrewarding project (at least from the financial point of view) shows that he was at loose ends. Too proud to submit to the drudgery of a workshop, he cast about for a means to earn his living, not only to provide for his family but also to prove to them that he was not the failure they believed him to be.

The struggle of these lean years demonstrates Michelangelo's strength of will. With little encouragement and no obvious way forward, he continued to push himself as an artist, acquiring on his own the knowledge and technical skills essential to his later triumphs. Without a formal master, and with no potential patrons in sight, Michelangelo set out to teach himself everything he needed to know to create works that matched his outsized ambition, confident that the time would come when the greatest lords of Europe would come knocking on his door.

The one surviving sculpture from this period in his life throws an interesting light on the young sculptor's studies. It is a life-size crucifix carved in soft poplar wood and painted in realistic flesh tones, the only work Michelangelo is known to have executed in this medium. Michelangelo presented the sculpture to Niccolò Bichiellini, prior of the Church of Santo Spirito, in gratitude for allowing him to dissect the cadavers of those who had died in the adjacent hospital. In taking this scientific approach, Michelangelo was following the recommendations set down by Leon Battista Alberti in his treatise *On Painting*: "Before dressing a man we first draw him nude, then we enfold him in draperies. So in painting the nude we place first his bones and muscles which we then cover with flesh so that it is not difficult to understand where each muscle is beneath." Michelangelo found the gruesome

work upsetting, and it is a testament to his will to perfect his art that he persevered, despite the fact that it "turned his stomach so that he could neither eat nor drink with benefit."

The fruits of these late-night sessions are apparent in almost all Michelangelo's subsequent works. With the possible exception of Leonardo da Vinci—whose investigations were as much scientific as they were artistic—Michelangelo possessed an unmatched understanding of human anatomy. His nudes are not superficial approximations of the human form but seem to pulse with an inner life, an illusion conjured by his unmatched knowledge of the dynamic mechanism of the human body. The articulation of joints, the structure of muscle and tendon working together to produce motion, the branching networks of veins suffusing flesh with vital nutrients and nerves linking mind to body—all these are articulated with a deep understanding of how each contributes to the whole.

Michelangelo's anatomical studies were not simply a means to an end. His two years at the Medici Palace had confirmed his faith in the nobility of art, but with prestige came responsibility. To fulfill its promise, art must do more than reflect the appearance of things: it must delve beneath the surface to deliver profound truths. Leonardo began his *Paragone* by asking whether or not painting was a science, answering in the affirmative by employing an argument that must have appalled his more bookish colleagues: "[A]ll sciences are vain and full of errors that are not born of experience, mother of all certainty, and that are not tested by experience, that is to say that do not at their origin, middle, or end pass through any of the five senses." From this he derives the postulate that "painting, which arises in the mind but cannot be accomplished without manual operation," is more science than craft since it is, first and foremost, a means of investigating the world through the visual faculty, the most powerful tool we have for apprehending reality.

Though Michelangelo's interests were never as purely academic, or nearly as wide-ranging, as Leonardo's, he shared with his older colleague a conviction that art is a tool for making sense of the world. Studying the body with the precision of an anatomist, uncovering its deep structure, allowed Michelangelo to probe human nature more thoroughly than any artist before him

and to create figures in which every gesture expresses an inward state and every pose is fraught with possibility.

The Santo Spirito crucifix is unique in Michelangelo's oeuvre. Not only is it in an unusual medium for the artist (a fact easily explained by his straitened circumstances), but it is an oddly flaccid figure for an artist more often criticized for going to the opposite extreme. Compared to the magnificent drawing of Christ on the Cross from the 1540s, the wooden sculpture lacks all dramatic tension and any sense of dynamic movement. Christ hangs limply, as if already dead, his body not only unmoving but apparently incapable of movement. All these flaws can be attributed to Michelangelo's youth and immaturity. He was an artist still in search of himself, dissatisfied with the models he had available to him but as yet uncertain how to impose his individual stamp on conventional themes. The one element that hints at an original mind at work is the figure's startling nudity, a foreshadowing of a bold, even iconoclastic imagination. Though at the time he carved the crucifix the young artist was presumably elbow-deep in gore, he had yet to learn how to make full use of his discoveries.

For Michelangelo the two apparently uneventful years following Lorenzo de' Medici's death were crucial to his evolution as an artist. He was not discouraged by the lack of gainful employment (though he must have tired of his father's constant carping), since it allowed him the freedom to develop in his own way without having to cater to demanding patrons. The fact that he neither second-guessed his decision nor settled on the easier path of returning to Ghirlandaio's studio demonstrates his resolve to achieve success on his own terms.

Given his youth, inexperience, and lack of affiliation with a recognized master, it's not surprising that he received no important commissions. But Michelangelo was not the only underemployed artist in Florence. These were difficult days for the profession as a whole, particularly for those wishing to pursue the expensive and time-consuming medium of sculpture. In the years following Il Magnifico's death, the Medici hold on power grew more tenuous. As Piero's power waned, the influence of the firebrand preacher Girolamo Savonarola waxed. Railing against greed and corruption from the

Portrait of Savonarola by Fra Bartolomeo, c. 1500.

pulpits of San Marco and the Cathedral, he called for Florentines to turn away from worldly pleasures and return to the simple virtues of the Gospels. "O Florence, O Florence, O Florence," he cried, "for your sins, for your brutality, your avarice, your lust, your ambition, there will befall you many trials and tribulations." These jeremiads tended to have a chilling effect, since art, unless specifically made for devotional purposes, was among those vanities Savonarola condemned as distractions from the holy life. "I want to give you some good advice," he lectured the people of Florence. "Avoid those artifacts that belong with the riches of this world. Today they make figures in churches with such art and such ornamentation that they extinguish the light of God and of true contemplation, and in these you are not contemplating God but the artifice of the figures."

Emblematic of the new age was Sandro Botticelli. He had thrived under the patronage of the pleasure-loving Medici, painting joyous and sensual masterpieces like the *Primavera* and *The Birth of Venus*. But moved by the passion of the friar and frightened by his apocalyptic visions, Botticelli disavowed his earlier work. Turning his back on his former life, he joined the Piagnoni (Weepers), becoming "such a partisan of that sect that he abandoned painting and, having nothing to live on, fell into very great distress."

On a practical level, the austerity imposed by Savonarola meant that artists had fewer and less ambitious commissions. The Bacchanalian celebrations that were a feature of Florentine life during Lorenzo's reign and that had given steady work to artists like Botticelli, who designed the elaborate floats and decorations, gave way to more pious demonstrations. Savonarola's most famous innovation was the so-called Bonfire of the Vanities, a spectacle vividly described by one eyewitness: "There was made on the *Piazza de' Signori* a pile of vain things, nude statues and playing-boards, heretical books . . . mirrors and many other things, of great value, estimated at thousands of florins . . . the boys . . . set it on fire and burnt everything. . . ." Among those participating was Botticelli, who was reported to have tossed some of his own paintings onto the pyre.

Michelangelo himself remained ambivalent toward the charismatic preacher. He was a pious Christian and shared, at least in his later years, Savonarola's gloomy vision of the world as a place of suffering and sin. In his

funeral oration for the artist, the humanist Benedetto Varchi asked rhetori-
cally: "Who ever was more religious? Who ever lived a more godly life? Who
ever died a more Christian death than Buonarroti?" But this picture tells
only half the story. Like many deeply religious men, Michelangelo wrestled
with his faith. His relationship with God was never comfortable; salvation
never seemed assured as he contemplated how often he fell short of His
commandments, as he confessed in this sonnet of 1534:

> I want to want, O Lord, what I don't want:
> Between the flame and this icy heart a veil descends
> that extinguishes the fire.

Filled with doubt and tormented by what he regarded as sinful desires, his
piety was intense but never complacent. He did not scoff, like so many of the
intellectuals he came across at the Medici Palace, at the simple superstition
of peasants. But there were aspects of Savonarola's worldview, including his
disdain for art and beauty not directly in the service of promoting piety, that
appalled him. Like many Florentines, Michelangelo was torn, attracted to
Savonarola's spirituality but made uneasy by his single-minded focus.

In October 1494, with a massive French army descending on Tuscany on its
way to conquer the southern Italian kingdom of Naples, Piero de' Medici
panicked, conceding without a fight the republic's strategic fortresses and
allowing the subject city of Pisa to throw off the Florentine yoke. Returning
to Florence on November 9, the son of Il Magnifico found the city in open
revolt. Piero and his brothers barely escaped with their lives, fleeing through
the northern gates, pursued by armed mobs filled with a rage that had built
up over years of frustration.

Fortunately for the artist closely associated with the now-disgraced
family, he was no longer in Florence. A month earlier Michelangelo had
attended a sermon by Savonarola in the Duomo where the preacher ex-
pounded on Genesis 6, in which God sends a great deluge to punish the
wicked human race. "I shall spill flood waters over the earth," the Dominican

friar thundered from the pulpit, insisting that Florentines would suffer the same fate as Noah's contemporaries unless they quickly turned to the Lord. Pico della Mirandola, who was also in the crowd that day, confessed that this dismal revelation was so frightening that it made "his hair stand on end."

Like all prophets of doom, Savonarola welcomed signs of the Lord's displeasure. "[I]t is known to all Italy that the chastisement hath already begun," he proclaimed, viewing with satisfaction the depradations of the vast host that had just crossed the Alps. More concerned with physical than with metaphysical dangers, in early October Michelangelo and a few companions took to their horses and headed north, leaving the anxious city behind. This will prove to be a recurring theme in the artist's life: a precipitous flight undertaken at the first sign of trouble. During another period of civil unrest, he pleaded with his brother Buonarroto to "do as you would in the case of the plague—be the first to flee." When it came to his own safety or that of his family, Michelangelo always opted for discretion over valor, a trait that his enemies called cowardice but that he would have called prudence.

Fleeing as if a deadly disease were raging in the streets was the policy he apparently adopted in the fall of 1494, but, embarrassed by his less-than-heroic conduct, he concocted an implausible scenario to excuse his behavior. It involves a dream told to him by a musician in Piero de' Medici's employ named Cardiere, in which Lorenzo's ghost, dressed in rags, appears and warns him that his son will soon be driven from Florence. While Piero apparently laughed at this supernatural apparition, Michelangelo was more easily spooked, setting out on the road to Venice.

This improbable tale is obviously a justification after the fact of a move that could be interpreted not only as cowardly but as disloyal. Though he was never close to Piero, Michelangelo owed the Medici a great deal, and bolting the city just as their fortunes were beginning to turn seems, at the very least, ungrateful. Indeed, Michelangelo had some reason to be concerned at the sudden downfall of a family with which he was strongly identified. As it turned out, it's unlikely his life would have been threatened, since the revolution was largely bloodless, but things might have gotten more than a bit uncomfortable. Given the fact that there was little keeping him at home,

acting on a sudden urge to see the world might have seemed the most sensible course.

Little is known of Michelangelo's journey, particularly his brief stay in Venice, one of the glittering capitals of Europe and a city famous for its wealth and beauty. One intriguing possibility is that while in town he paid a visit to the Church of the Servi, where the sculptor Tullio Lombardo was at work on a magnificent funerary monument to Doge Andrea Vendramin. Among the statues he carved for the tomb were depictions of Adam and Eve, the first life-size nudes in marble since antiquity. It is likely that Michelangelo at least stopped by to take a look at the most talked-about sculptural ensemble in Venice. When Michelangelo set out to carve his even more revolutionary *David,* he almost certainly had Lombardo's example in the back of his mind.

After a few days in La Serenissima he was back on the road again, though not apparently in any hurry to return to his native land. While stopping in Bologna, Michelangelo attracted the attention of one of its leading citizens, Gianfrancesco Aldovrandi. According to most accounts, the two met while Michelangelo and his traveling companions were detained for not possessing the proper paperwork to enter the city. Hearing the youth's Florentine accent, and perhaps learning of his connection with the great Lorenzo Il Magnifico, Aldovrandi intervened on his behalf and invited the sculptor to stay with him in his palace. The purity of Michelangelo's Italian particularly appealed to him since he was an aficionado of Dante's poetry. During the months he spent at Aldovrandi's palace, Michelangelo was often called on to read aloud from *The Divine Comedy* so that the master of the house might enjoy the sound of the verses coming from the mouth of one who spoke the same Tuscan dialect as his hero.

Michelangelo remained in Bologna for almost a year, enjoying the hospitality of a merchant prince whose wealth and cultivation reminded the young sculptor of his first patron. Though the Aldovrandi Palace could not compare to the cosmopolitan court of Lorenzo de' Medici, his host proved to be a generous and congenial patron. And while he was neither as rich nor as powerful as Il Magnifico, he did all he could to further the budding sculptor's career. He even managed to secure for him a commission to contribute

three statuettes to the tomb of St. Dominic, an ensemble begun in the four-teenth century by Niccolò Pisano.

The three small statues—one of St. Proclus, another of St. Petronius, and the third a kneeling angel holding a candelabra—are not particularly distin-guished. One would be hard-pressed to single them out from the other fig-ures on the tomb, though the young St. Proclus exhibits a certain vehemence that, with hindsight, hints at the taut concentration of the *David* or the *ter-ribilità* of the *Moses.* The fact that the figures are clothed does not help, since Michelangelo had not yet mastered the art of draping a body in such a way as to reveal its structural logic and heighten its dramatic impact.

Perhaps the most important result of his Bologna sojourn was the op-portunity it afforded to make a close study of the sculpture of Jacopo della Quercia, an artist whose massive, athletic figures strongly impressed the young artist. Michelangelo's debt to his early-fifteenth-century predecessor is evident particularly in the Sistine Ceiling, where the scenes of *The Creation of Adam* and *The Temptation* and *Expulsion* contain strong echoes of the re-liefs della Quercia carved for the Church of San Petronio. The qualities that appealed to Michelangelo in della Quercia's work were similar to those he had already gleaned from Masaccio's paintings—the ability to tell a power-ful, dramatic story through a few monumental figures.

According to Condivi, Michelangelo's stay in Bologna was cut short when a local sculptor accused the Florentine of stealing work that should have gone to native artisans and threatened to beat him unless he left town. This was neither the first nor the last time Michelangelo provoked a violent outburst in a less talented colleague. The frequency with which such clashes took place suggests the arrogance that marred not only his relationships with his fellow artists but with patrons who found him insubordinate and difficult to work with.

Returning to Florence in the winter of 1495, he found conditions for an aspiring artist no more promising than they had been before his departure. Following the revolt against Piero and a monthlong French occupation, Florentines were ready to reclaim the liberties they had lost during the years of Medici ascendance. The secretive committees packed with Medici cronies were abolished and power was vested in the new Great Council, a body of

about 3,000 citizens with executive and legislative power. But the dominant figure in the city remained Savonarola, who had shepherded the city through the crisis with both wisdom and courage.

A sign of how drastically things had changed in the months Michelangelo was away was the fact that the junior branch of the former ruling family—descended from Lorenzo's great uncle—changed its name from Medici to the more politically correct Popolano. It was one of these Medici cousins who next took on the role of Michelangelo's benefactor. Lorenzo di Pierfrancesco de' Medici was almost as remarkable a patron of the arts and sciences as his more famous cousin, having earlier purchased from Botticelli his famous *Primavera* and *Birth of Venus* and launched the explorer Amerigo Vespucci on his remarkable career.*

Despite the prevailing mood of austerity imposed by Savonarola, Lorenzo di Pierfrancesco, wishing to encourage a young man of such evident talent, commissioned two works from the sculptor. The statue of St. John the Baptist was unobjectionable even by the strict standards of the Prior of San Marco. The second commission, a life-size *Sleeping Cupid*, might have proved more controversial, since it was exactly the kind of pagan work against which Savonarola railed in his sermons. But for a man who already had hanging at his villa in Castello the delightfully sensual *Primavera* and *Birth of Venus*, a naked Cupid was apparently not deemed unduly provocative, as long as it remained hidden from the public so that its charms would not distract the common people from their religious duties.

Little is known of the missing *St. John*, but the *Cupid*—described by Condivi as "a god of Love, between six and seven years of age, lying asleep"—has prompted a good deal of curiosity because of the crucial role it played in shaping Michelangelo's career. Less important than the work itself, which was probably based on an antique original in the Medici Garden, was the clever *coup de théâtre* that brought the young sculptor to the attention of the greatest collectors and connoisseurs in Italy. According to Condivi, the

* Amerigo's famous letter to Pierfrancesco describing his voyages along the coast of South America was an international sensation, causing the mapmaker Waldseemuller to name the newly discovered continent after him rather than Columbus.

ruse was actually initiated by Lorenzo di Pierfrancesco who, after seeing the nearly completed work, made a rather peculiar proposal. "If you can manage to make it look as if it had been buried under the earth I will forward it to Rome," he told Michelangelo, "[where] it will be taken for an antique and you will sell it much better." It is possible that Lorenzo simply wished to help out his protégé, who was having a hard time finding commissions in Savonarolan Florence. More plausible is that the idea was originally Michelangelo's, and that he invented the conversation to show he had the great man's blessing for what might otherwise appear to be a self-serving trick.

Indeed, Michelangelo was an old hand at perpetrating such frauds, having made copies of old-master drawings that he "antiqued" with smoke and passed off as originals. While Vasari insists that he did this only because "he admired them for the excellence of their art and sought to surpass them in his own practice," the fact is that he loved tripping up so-called experts, particularly those who insisted that only artists centuries in their graves could do anything worthwhile. If he could fool those snobs, he would prove not only that a modern artist could compete with the ancients but would win the renown he so desperately craved.

Of course this could happen only if the fraud was discovered. The *Cupid* was sold in Rome as an antique for the handsome sum of 200 ducats to Raffaele Riario, Cardinal di San Giorgio, a connoisseur who had already amassed one of the world's best collections of ancient sculpture. He bought the piece from a somewhat shady dealer named Baldassare del Milanese who, perhaps suspecting the fraudulent nature of the work, sent only 30 ducats to Michelangelo and pocketed the difference. How the forgery was initially discovered is unclear, though it seems likely that Michelangelo was involved since his intention was to advertise his skill to potential patrons, a goal that would have been thwarted had it gone undetected.

According to Condivi's account, the Cardinal di San Giorgio was initially angry at "being made a fool," and, hoping to discover the author of the hoax, "sent one of his gentlemen [to Florence], who pretended to be looking for a sculptor to do some work in Rome." Vasari scolds the cardinal for his lack of discernment, saying "he did not recognize the value of the work, which consisted in its perfection: for modern works, if only they be excellent, are

as good as the ancient." When the agent turned up at the sculptor's house posing as a potential customer, Michelangelo readily admitted his role. (Years later, the great patron of the arts Isabella d'Este, Marchesa of Mantua, remembered the excitement surrounding the *Cupid* and pursued it for her own collection, calling the statuette "without a peer among the works of modern times.")

In the short run, the exposure of Michelangelo's little ruse cost him some much-needed cash, but failing in his immediate goal, he gained far more in the long run. Apparently, the cardinal's pique was not too severe, since it was quickly replaced—as Michelangelo surely intended—by admiration for the man who'd managed to pull off such a stunt. "Now this event brought so much reputation to Michelangelo," Vasari recalled, "that he was straightaway summoned to Rome and engaged by the Cardinal of San Giorgio. . . ." This was exactly the result Michelangelo had hoped for all along. With customers in short supply in Savonarolan Florence, the prospect of seeking his fortune on the grander stage of Rome proved irresistible. And so in June of 1496, the young Florentine sculptor, burning with ambition and his head filled with as-yet-unrealized masterpieces, passed through the Porta San Piero Gattolino and out onto the road that led to Rome.

It was with some apprehension that the young man left his native land behind and set out for the teeming metropolis, but he had every reason to be hopeful. Not only had the Cardinal di San Giorgio effectively promised him a major commission once he arrived, but there were plenty of other princes of the Church, cultivated men with deep pockets, who could supply him with years of gainful employment. If all went well, he might even come to the attention of the pope himself, one of the few men in the world with the resources and thirst for public display that matched Michelangelo's own ambition.

II

Pietà

The said Michelangelo will make this work within one year, and . . . it will be the most beautiful marble that there is today in Rome, and . . . no other living master will do better.

—Contract for the *Pietà*, August 27, 1498

Michelangelo, *Pietà*, 1498–99.

I. THE DRUNKEN GOD

In exchanging Florence for Rome, Michelangelo was leaving behind a provincial capital for a rough-and-tumble city with a well-earned reputation for violence and corruption. Florence's greatest triumphs lay in the past, while Rome, seething with pent-up energy, was poised to reassert its ancient greatness. The current ruler was the larger-than-life Rodrigo Borgia, Pope Alexander VI, whose outsized appetites seemed to match the temper of the city. In addition to the pope himself, Romans had to contend with Alexander's irrepressible children, including the beautiful Lucrezia and mercurial Cesare. It was a sign of the times that the pope not only openly acknowledged his offspring but lavished on them money and titles, enriching his family by confiscating the estates of various cardinals who often seemed to meet an unfortunate end shortly after paying a visit to the papal apartments.

Some decades earlier, a visit to Rome by a fellow Florentine, Poggio Bracciolini, inspired a famous meditation on the fickleness of fortune:

> You may turn all the pages of history [Bracciolini wrote], you may read all the long drawn-out record of the authors, you may examine all the historical annals, but you will find that fortune offers no more striking example of her own mutability than that of Rome, the most beautiful and magnificent of all those that either have been or shall be. . . . Surely this city is to be mourned over which once produced so many illustrious men and emperors, so many leaders in war, which was the nurse of so many and such great virtues, the mother of so many good arts. . . . She who was once mistress of the world is now, by the injustice of fortune which overturns all things, not only despoiled of her empire and her majesty, but delivered over to the basest servitude, misshapen and degraded, her ruins alone showing forth her former dignity and greatness.

Bracciolini was writing shortly after the return of the papacy from its century-long exile in Avignon, and over the following decades a succession of popes had spent heavily to turn the ruined city into a fitting capital for the resurgent Church. But even as opulent palaces and grand basilicas rose among the rubble and the sheep pastures, Rome remained an unruly,

ramshackle place, at once more vibrant and more hard-edged than the city Michelangelo had left behind.

Worse than the evidence of physical decay was the stench of moral depravity. Four years earlier, when Lorenzo de' Medici sent his son Giovanni off to take up his position as cardinal, he described Rome as "that sink of all iniquities" and warned him "not to slide into the same ditch into which [your colleagues] have fallen. . . ." The fact that Lorenzo, who was no prude, felt it necessary to gird his son against the debauchery he was likely to encounter, gives some indication of how low the Holy City had sunk in the estimation of devout Christians. Nor had matters improved in the two years since Rodrigo Borgia had taken the throne. "[E]very evening," wrote a friend of Machiavelli's, describing the scenes he'd witness at the papal residence, "from vespers to seven o'clock, twenty-five or more women are brought into the palace riding pillion with some people, to the point where the entire [Vatican] palace has evidently become the brothel of every obscenity."

Under Rodrigo Borgia, Rome, not exactly a site of monastic virtue before his arrival, had devolved into Bacchanalian excess, corruption, and violence. Luther put it bluntly. "If there is a hell," he reported after visiting the Holy City in 1511, then Rome is built upon it." An anonymous pamphlet of 1501 paints a horrific portrait of its dissipated ruler: "These are the days of the Antichrist, for no greater enemy of God, Christ, and religion can be conceived. . . . Rodrigo Borgia is an abyss of vice, a subverter of all justice, human and divine. God grant that the Princes may come to the tottering Church, and steer the stinking barque of Peter out of the storm and into the haven! God grant they may rise up and deliver Rome from the destroyer who was born to be her ruin, and bring back justice and peace to the city!"

Michelangelo was certainly aware of what awaited him in the Eternal City. For years Savonarola had been denouncing the pope and the city he presided over in his Sunday sermons. "Flee from Rome," he urged, "for Babylon signifies confusion, and Rome hath confused all vices together." If Michelangelo instead chose to head in the opposite direction, he went with his eyes open. And while he was prepared to overlook a great deal in pursuit of his art, he was not oblivious to the corruption he found all around him. After only a

View of Rome, c. 1490.

few years in the city he wrote a poem as harshly critical as anything ever penned by Luther himself:

> *Here one sees chalices beaten into helmet and sword,*
> *and the blood of Christ sold by the gallon,*
> *so that even His patience wears thin.*

But for Michelangelo, Rome had one undeniable advantage over Florence. It was, as the agent for Cardinal Riario pointed out, "the widest field for a man to show his genius in"—a quality that more than made up for its drawbacks in the eyes of a young man anxious to make his way. Like many a provincial who seeks his fortune in a great capital, Michelangelo was simultaneously fascinated and dismayed. He railed against the corruption he saw while simultaneously seeking to profit from the fruits of that corruption. In his heart he remained a Florentine, born of its stony soil and heir to its glorious traditions, but Rome was filled with men whose resources could satisfy his ambition.

Michelangelo arrived in Rome on June 25, 1496, finding quarters near the still-unfinished residence of the Cardinal di San Giorgio, the Casa Nuova, which Riario intended as a showcase of princely living. It had been eight years since Michelangelo first signed on as an apprentice in Ghirlandaio's studio, and six since his precocious talent was first recognized by the uncrowned lord of Florence. Now twenty-one, he was no longer a callow youth blessed only with raw talent and brimming with enthusiasm. He was already an experienced sculptor with a handful of private commissions from prominent clients to his credit, along with a more-than-respectable contribution to an important religious monument in Bologna. His abilities had already won him the admiration of the kind of men he would need if he were to make a successful career, and the minor scandal over the fake *Cupid* had brought him to the attention of many more. From Lorenzo de' Medici to Cardinal di San Giorgio, those who knew about such things took notice of the brash young man with the piercing eyes and quick temper. But, as the cardinal's man noted, Rome was a far grander stage than any on which he had yet performed. Here, a man might win the greatest applause, but if he stumbled, it would be with the eyes of the world upon him.

The circumstances surrounding Michelangelo's journey to Rome, like the details of his apprenticeship with Ghirlandaio, are among the events most thoroughly distorted by the artist himself. Michelangelo complained to Condivi that "the Cardinal di San Giorgio understood little and was no judge of sculpture." Not only did he "not give him a single commission," but, "still smarting under the deceit," he prevented him from collecting the money that was owed him for the *Cupid*. Given the fact that it was the cardinal who invited him to Rome in the first place, the notion that he was still angry with Michelangelo is implausible. In fact, the artist's version of events is contradicted by a letter he wrote to his patron, Lorenzo di Pierfrancesco de' Medici, a week after his arrival:

> *Magnificent Lorenzo, etc.—This is to let you know that we arrived safely last*
> *Saturday and paid a visit to the Cardinal di San Giorgio, to whom I presented*
> *your letter. He seemed pleased to see me and immediately asked me to go*
> *look at certain statues. . . . [H]e asked me what I thought of what I'd seen.*
> *I responded that I thought he had many beautiful things. Then the Cardinal*
> *asked me whether I had the spirit to attempt something as fine. I replied that*
> *I might not be able to do anything quite as beautiful, but that he should see*
> *what I could accomplish. We have purchased a piece of marble for a living*
> *figure and on Monday I'll begin to work. . . . I gave Baldassare his letter and*
> *asked for the cupid, telling him I'd return the money he'd given me. He replied*
> *very angrily, saying he'd smash it in a hundred pieces, that he had bought the*
> *cupid and it was his.*

Far from suggesting that the cardinal wanted to punish Michelangelo for the fraud, the letter confirms what was evident from the start—that the artist had come to Rome at the invitation of San Giorgio and that he'd been promised a commission for a major sculptural work. The fact that Michelangelo later chose to portray San Giorgio as a vindictive and uncultivated man tells us more about the artist than about the cardinal. Michelangelo's letter proves that the relationship began well, and that whatever misunderstandings occurred must have come later. As he explained in his letter to Lorenzo di Pierfrancesco, the two men quickly agreed on a subject, and Michelan-

gelo, as always anxious to get to work, set about carving the marble almost immediately.

Though the subject is not mentioned in the letter, the cardinal's own account books name the sculpture as the *Bacchus,* now in the Bargello Museum in Florence. The pagan god of wine was exactly the kind of subject that would have appealed to the high-living cardinal with a taste for classical statuary, and it was clearly what he had in mind when he summoned the young man to Rome. Michelangelo was not being hired for his originality, but because he had already demonstrated a talent for aping the manner of the ancients. The cardinal could not have known that Michelangelo was temperamentally incapable of suppressing his personality to conform to the demands of his patron; perhaps even Michelangelo himself did not yet fully understand his need for self-expression. He had not yet gained a reputation for being a difficult customer. The *Bacchus* was the first sculpture in which he demonstrated the power of his wayward genius, and the first occasion on which he clashed with a patron who had anticipated a conventional work and was dismayed to discover he had conjured something entirely original.

Against all the evidence, Condivi claims that the *Bacchus* was not in fact commissioned by Cardinal Riario but by Jacopo Gallo, "a Roman gentleman of good understanding." Michelangelo met the banker Gallo through the firm of Baldassare and Giovanni Balducci, who handled the cardinal's finances. Gallo would soon become Michelangelo's chief advisor and champion in Rome, and it is not surprising that the artist would wish to give him credit for his first major work. And while Condivi's version of events is untrue, the *Bacchus* did in fact end up in Gallo's garden, strongly suggesting that the banker stepped in after the cardinal rejected the work he had commissioned. This interpretation is reinforced by another letter Michelangelo wrote to his father almost exactly one year after he began the sculpture, in which he complains: "I have not yet been able to settle up my affairs with the Cardinal and I do not want to leave without first receiving satisfaction and being remunerated for my pains." He follows this up with a more general observation as to the nature of these relationships that foreshadows countless difficulties to come. "With these grand masters," he grumbles, "one has to

go slowly, because they cannot be coerced"—words that could equally well be applied to Michelangelo himself.

The explanation that best conforms to the available evidence is that the cardinal who purchased Michelangelo's services was disappointed in the final result. His account books showed that he ultimately paid the artist in full, but Michelangelo's complaints about the delay strongly hint at his patron's displeasure. It was only after the work was completed and paid for that Gallo, more discerning than the cardinal, stepped in to take the work off his hands.

It's not difficult to guess why Cardinal di San Giorgio rejected the sculpture. While superficially resembling the work of the ancients he so admired, Michelangelo's version of a pagan god is radically different from anything that could have come from the imagination of a Greek or Roman artisan—or from any of his contemporaries, for that matter. Unlike the *Cupid*, which easily passed for an ancient work, this sculpture must have struck the cardinal as a perversion of a classical ideal. With the *Bacchus*, Michelangelo revealed himself to be an artist of unparalleled technical ability and startling originality, but not an accommodating craftsman adept at realizing his master's vision.

Michelangelo has given an ancient subject a modern twist (literally), showing the god of wine teetering after having sampled too freely his own invention. He lurches unsteadily on his feet, his balance precariously maintained as he steadies himself with the aid of the satyr who sits behind him greedily stuffing grapes into his mouth. The god raises his cup to his slack lips, his small head lolling uncertainly on a slender neck. His handsome, boyish features have been rendered stupid with drink; his eyes are heavy with sleep.

The *Bacchus* is less a god than a fallen (or falling) idol, soft, effeminate, and singularly unheroic. The dissections Michelangelo conducted in the morgue at Santo Spirito have paid dividends as he renders the difficult pose with an assurance absent in the statuettes for the altar of St. Dominic. But, as Leonardo tended to do, he envelops muscle and sinew in seductive, yielding flesh. Every movement seems organic, each limb responding to its partner in a languid ballet. Bacchus is not one of those overmuscled titans

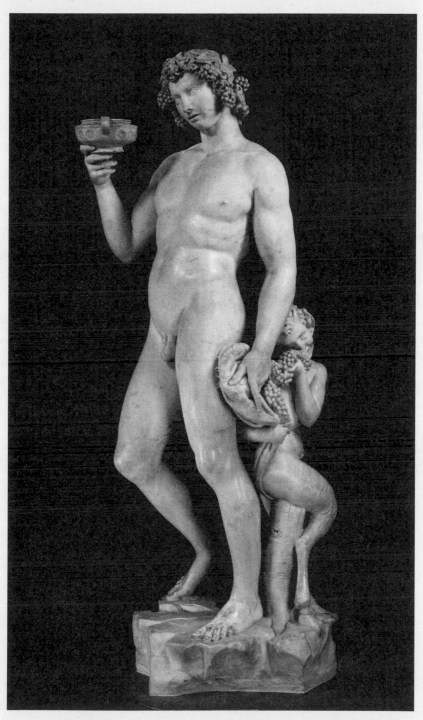

Michelangelo, *Bacchus*, 1496–97. *Scala/Art Resource, NY*

for which Michelangelo would soon become famous, but a beautiful, epicene youth of somewhat dissipated habits, his soft curves indicating a life of self-indulgence.

Unlike the famous *Captives* of his later years, there are no knotted muscles or rope-taut tendons to suggest Man at odds with himself and at war with fate. Bacchus epitomizes listlessness; he is incapable of resisting anything, least of all temptation. What ties this work to Michelangelo's later masterpieces is not the specific treatment of the body but the fact that form is fully at the service of a larger idea. Bacchus is not master of the intoxicating grape, he is mastered by it. Everything about his pose, from the bent right leg to the subtle twist of his torso to the forward lean of the neck, reinforces the message that this is someone who has succumbed to his sensual nature.

Perhaps the cardinal rejected Michelangelo's sculpture not because he failed to understand its meanings but because he understood them all too well. It is hard to avoid seeing in the *Bacchus* a subtle rebuke of the cardinal and other princes of the Church who coveted pagan artifacts and were slaves to sensual pleasures. In the *Bacchus,* Michelangelo has turned the cult of the antique on its head, offering up a paragon of androgynous male beauty only to treat it with almost Savonarola-like contempt.

Riario may have also detected in the soft effeminacy of the god a troubling homoeroticism; his beauty seduces even as it repels. Michelangelo shows the god as both desirable and wanton, an object of lust and of disdain, conflicting emotions that no doubt reflect the artist's own conflicted sexuality. Michelangelo was attracted to handsome young men, but carnal lust was almost always accompanied by feelings of pollution and unworthiness. Accusations that Michelangelo engaged in activities that were still officially criminal were so prevalent in his lifetime that Condivi was forced to refute them in print. "He has also loved the beauty of the human body, as one who best understands it," he insisted, "and in such wise that certain carnal-minded men, who are not able to comprehend the love of beauty unless it be lewd and shameful, have taken occasion to think and speak evil of him, as if Alcibiades, a youth of perfect beauty, had not been purely loved by Socrates, from whose side he arose as from the side of his father." A less

naïve take on this ancient story was offered by Baldassare Castiglione, who in his sixteenth-century bestseller *The Courtier* casts a cynical eye on such supposedly innocent relationships. "[I]t was a strange place and time," he writes facetiously, "—in bed and by night—to contemplate the pure beauty which Socrates is said to have loved without any improper desire, especially since he loved the soul's beauty rather than the body's, though in boys and not in grown men, who happen to be wiser."

Even had the term been available to him, it is unlikely that Michelangelo would have considered himself gay. Rather, he thought of himself as a sinner, prone to impure thoughts and illicit urges, some of which he no doubt acted upon. This attitude was reinforced by the prevailing ethic that deemed all sexual desire as sinful, a necessary evil rather than a healthy expression of human nature. A devout Christian, Michelangelo was often tormented by what he regarded as his moral weakness. Love consumed him, in more ways than one; as much as he felt the pull of desire, he longed to free himself from sin and make himself worthy of God's love. "I want to want, O Lord, what I don't want," he wrote, the *cri de coeur* of a man at war with his own nature.

On a more mundane level, he was harassed throughout his life by accusations of sexual impropriety. It was one form of eccentricity he could not embrace openly for fear that the taint of scandal would hurt his career and embarrass his family. But it's clear that his attempts to protect himself were not always successful and that his proclivities were a source of gossip, no matter how strenuously he denied them. Sometimes this could lead to hilarious misunderstandings. Once Michelangelo was accosted on the street by a man who wished to apprentice his son to him, telling the sculptor "that if I were but to see him I should pursue him not only into the house, but into bed." Michelangelo, communicating through a mutual acquaintance, responded to the proposal with biting sarcasm, saying "I assure you that I'll deny myself that consolation, which I don't want to filch from him." On another occasion, when a friend accused him of a romantic entanglement with a young man named Febo di Poggio, Michelangelo protested: "You are quite wrong in supposing that my interest in the young man is sexual, because it is nothing of the kind."

But despite his protestations, there are indications that he often suc-

cumbed to temptation and that his close associates were aware of the fact. A letter written by his friend Leonardo Sellaio in 1539, when the artist was well into his fifties, warns him "not to go out at night and to abandon those habits that are harmful to both soul and body." If Sellaio felt called upon to act as his friend's conscience, he could have saved himself the trouble since no one was more aware of his failings than Michelangelo himself.

II. THE CONTRACT

Cardinal Riario's rejection of the *Bacchus* was a blow to the ambitious young artist. Michelangelo had come to Rome certain that he would vault to stardom with the backing of one of the city's great princes. But now he had lost his patron's confidence and was set adrift in a hypercompetitive and uncongenial world. Writing to his father in July 1497, he speaks of his intention to return to Florence as soon as his business with the cardinal is wrapped up, but there is no indication he actually made any preparations to leave Rome. To do so now would be to admit defeat, and the prospect of having to listen to Lodovico's recriminations was more than enough motivation to stay put.

This letter also records an early instance of what was to become a recurring theme in Michelangelo's life. Sometime in June, his older brother Lionardo showed up at the artist's house penniless, having fled from Viterbo for some unexplained reason. Despite the fact that he was short of money himself—largely because of Cardinal Riario's reluctance to pay him the full amount he'd been promised—Michelangelo gave his brother a gold ducat and sent him on his way.

Unfortunately, Lionardo was not the only relative currently in financial straits. In July of 1497, Michelangelo's stepmother, Lucrezia, died, probably of the plague, which had been raging in the city during the hot, dry summer. Adding to Lodovico's woes, he was simultaneously threatened with arrest by his brother-in-law if he did not repay a debt of 90 florins. Michelangelo did his best to help, writing that "[a]lthough I have very little money, as I've told you, I'll contrive to borrow it." With each passing year Lodovico grew increasingly dependent on his one successful son. It was a burden Michelangelo shouldered willingly, if not graciously. Throughout his life he remained

devoted to his kin, though his patience was sorely tried by relatives who were full of advice about how he should live his life but could never manage to earn a steady income themselves. "You must realize," he told his father, "that I too have expenses and burdens. But whatever you ask I will send to you, even if I must sell myself into slavery."

Michelangelo's first attempt at making a name for himself in Rome had proved to be something of a fiasco. The brilliant polymath Leon Battista Alberti—who in addition to being one of the foremost architects of the fifteenth century was the author of the seminal books *On Painting* and *On the Art of Building*—would have been quick to spot the problem. "It often happens that the rich, moved more by amiability than by love of the arts, reward first one who is modest and good, leaving behind another painter perhaps better in art but not so good in his habits," he wrote in his primer for the aspiring artist. "Therefore the painter ought to acquire many good habits—principally humanity and affability." Michelangelo, not known for either his modesty or his easygoing nature, had trouble following this advice, assuming his brilliance absolved him from having to cultivate the social graces.

Fortunately, he was able to inspire fierce devotion as well as fierce antipathy. For all those who found him difficult to deal with, there were almost an equal number who saw through the awkwardness and knew that the young man with the flashing eyes and quick temper had something special to offer the world. After Jacopo Gallo snapped up the *Bacchus* for his own collection, he recommended Michelangelo to another member of the Sacred College, the French Cardinal of St. Denis, Jean Bilhères de Lagraulas. This great prelate—who was not only a cardinal but the French ambassador to the Holy See—was casting about for a sculptor to carve his tomb in the shrine of Santa Petronilla, an ancient mausoleum attached to the Basilica of St. Peter that had long been patronized by the French monarchy. The fact that Michelangelo was considered for and then entrusted with such an important commission suggests that the difficulties surrounding the *Bacchus* had not tarnished his reputation among the princes of the Church who could make or break the sculptor's career. It is probable that the cardinal had seen the *Bacchus* and arrived at a very different verdict than his colleague, but he was

still taking a chance on a young sculptor with a thin résumé. In any case, the sculpture he had in mind was almost the polar opposite of Riario's commission: a pious work meant for a holy site, not a pagan idol for a pleasure garden. While he undoubtedly admired Michelangelo's previous effort, it's unclear what convinced the Cardinal of St. Denis to commission a work that demanded a far different skill set and a radically different sensibility.

The contract, which was not formally signed until the following year, reveals no lack of confidence on the part of either the artist or the man who hired him:

> Let it be noted and made manifest to he who reads this document, that the Most Reverend Cardinal di San Dionisio has agreed with Michelangelo, Florentine sculptor, that the said master will create a Pietà out of marble at his expense, that is a Virgin Mary clothed with the dead Christ in her arms, as large as a true man, for the price of 450 gold papal ducats, at the end of a year from the day the work is begun.* . . . And I, Iacobo Gallo, promise to the Most Reverend Monsignore that the said Michelangelo will make this work within one year, and that it will be the most beautiful marble that there is today in Rome, and that no other living master will do better. And vice versa, I promise to Michelangelo that the Most Reverend Cardinal will make payment according to what is written above.

The 450 ducats Michelangelo was to receive for the commission was a handsome sum for the artist, three times the amount he'd been paid just a year earlier for the *Bacchus*. The most interesting clause is the promise that the finished sculpture would be "the most beautiful marble that there is today in Rome, and that no other living master will do better"—a proud

* In 1508, the young Raphael was given 100 ducats to fresco a room in the pope's palace. Raphael was just beginning his rise to fame (as was Michelangelo when he received the commission for the *Pietà*) and sculpture was generally more costly to produce, but the far larger sum Michelangelo received is a mark of the high esteem in which the cardinal held him. The evidence to be gleaned from the account books of the Balducci brothers, who handled Cardinal Riario's finances, suggest Michelangelo was paid a total of 160 ducats for the *Bacchus,* including ten to purchase the stone.

boast for a sculptor who had yet to make his mark. It is a testament to Michelangelo's achievement that neither the cardinal nor anyone else ever claimed that he had not fulfilled to the letter the terms of the contract.

The document also reveals that the most important esthetic decision, the one upon which Michelangelo's triumph was ultimately based, was made not by the artist but by the cardinal who commissioned "a Pietà out of marble at his expense, that is a Virgin Mary clothed with the dead Christ in her arms, as large as a true man." It is highly doubtful that Michelangelo altered the commission in any significant way; even the choice of medium was the cardinal's. In fact, the Pietà, while not entirely unknown, was not yet a popular theme in Italian art. The depiction of the dead Christ in his mother's arms had originated in Germany at the end of the fourteenth century. It quickly grew in popularity, spreading to the Low Countries and eventually to France. But before Michelangelo, the Pietà was a rarity in his native land, and the choice of subject no doubt reflected the tastes and traditions of the man who hired him.

Even before he selected the block he was to carve, Michelangelo worked out the basic forms in a series of drawings, using live models who would pose for him, often for hours at a time, in his studio. Though none of these drawings survive, we know from other works that these would have included rapid sketches in which he worked out the basic structure, as well as detailed studies of individual parts. Once he arrived at a satisfactory composition, he would have created a small-scale model in wax or clay. Vasari explained the process: "Sculptors, when they wish to make a figure in marble, are accustomed to make what is called a model* for it in clay or wax or plaster; that

*It is unclear whether Michelangelo made both small-scale and life-size models for his early sculptures. The small three-dimensional "sketch" was known as a *bozzetto*, while the more finished full-scale model was known as a *modello*. Benvenuto Cellini, who knew Michelangelo and was a great admirer of his, recalled that "the marvelous Michelangelo Buonarroti . . . has worked both ways; but having recognized that he could not long satisfy his good talent with little models, ever after he set himself with great obedience to make models exactly as large as they had to come out of the marble for him: and this we have seen with our own eyes in the sacristy of San Lorenzo." (Quoted in Hartt, *David by the Hand of Michelangelo*, 64.)

is, a pattern, about a foot high, more or less, according as is found convenient, because they can exhibit in it the attitude and proportion of the figure that they wish to make, endeavoring to adapt themselves to the height and breadth of the stone quarried for their statue."

Only after determining the statue's overall composition and proportions could Michelangelo begin the search for a suitable piece of marble. In November 1497, more than half a year before the contract was actually signed, Michelangelo set out for the quarries of Carrara to obtain the flawless block from which his figures would emerge. This hands-on approach was exceptional; sculptors usually purchased blocks from dealers or issued instructions to *scarpellini* on site who would do the dangerous, time-consuming work of cutting the stone from the mountain. Michelangelo had followed this procedure himself in his earlier sculptures, but this hands-off approach had not always yielded happy results. In the case of the *Bacchus*, he had purchased the marble from a dealer in Rome for 10 ducats, but in the course of carving it had discovered flaws that spoiled the finish. While working on a later project, Michelangelo told his stonecutter that the marble must be "white and without any veins, spots, or flaws whatsoever"—exacting standards that he certainly demanded for this most important project. That he succeeded in finding just what he was looking for is indicated not only by the near-flawless finish of the completed sculpture but by the fact that he returned to the same spot years later in search of equally fine specimens.

Michelangelo set out for Carrara on a dapple-gray horse he purchased for 3 gold ducats from the cardinal's advance; he withdrew another 5 for expenses along the way. The fact that he undertook the arduous journey reveals a character trait that will contribute to his difficulties with patrons and colleagues: Michelangelo was a perfectionist. He was willing to sacrifice comfort and profit, indeed almost any tangible benefit, for the sake of the work itself; he not only demanded enormous exertions from himself but anticipated, no doubt correctly, that others were less particular. He insisted on being intimately involved with aspects of a project that other artists would have considered menial. This inability to delegate, to trust others to carry out his vision even when it came to minor details, helps explain the large num-

ber of projects he left unfinished and that caused him no end of difficulties with his patrons.

It is also true that having spent his formative years among the stonecutters of Settignano, Michelangelo had a feel for the material rare among artists and a respect for the laborers who actually did the backbreaking work of quarrying the stone. He was able to spot minute imperfections that would ruin the finished work, and to judge the density and consistency of the crystalline structure that would determine how the chisel would bite into the stone.* Though Michelangelo did more than any other artist before him to lift the profession above the humble status of the artisan, he understood that such a leap into the stratosphere could not be launched without a firm grounding in craftsmanship. He was something of a paradox, a conjurer of cosmic ideas who fussed over the slightest details of his trade, knowing that only the most perfect forms were adequate vessels to contain the vastness of his imagination.

Michelangelo traveled to Carrara accompanied by Piero d'Argenta, the first in a long line of assistants who would, for the most part, serve him faithfully. The rivalry that marked his relations with his equals rarely extended to his underlings, who, as long as they were loyal and hardworking, were treated with kindness and generosity by their master. He carried with him a letter of safe conduct from the Cardinal of St. Denis:

> We have recently agreed with Master Michele Angelo di Ludovico Florentine
> sculptor and bearer of this, that he make for us a marble tombstone, namely
> a clothed Virgin Mary with a dead Christ naked in her arms, to place in a
> certain Chapel, which we intend to found in St. Peter's in Rome on the site of
> Santa Petronilla; and on his presently repairing to those parts to excavate and
> transport here the marbles necessary for such a work, we confidently beg your

* After the early missteps with the *Bacchus*, only rarely was his judgment betrayed. An exception is the *Risen Christ*. In the process of carving the face, the artist's chisel exposed a black vein in the marble, requiring him to throw out the almost completed statue and start again.

Lordships out of consideration for us to extend to him every help and favor in
this matter.

Michelangelo spent the better part of four months in the mountains of western Tuscany, taking only a short break to visit his family in Florence during the Christmas season. Quarrying was difficult and dangerous, and Michelangelo was not one to stand aside while others did all the work. Though he left no account of these months, letters written in 1518 while he was excavating stone for the façade of the Church of San Lorenzo detail the extent to which he was involved in the most arduous tasks. "As to the marbles," he wrote to the project supervisor in Florence,

I've got the excavated column safely down to the channel, about fifty braccia
from the road. It's been harder than I'd imagined to haul it down. The harness
was badly made, and someone broke his neck and died on the spot. I myself was
almost killed. . . . The excavation site is very rugged, and the men ignorant in
such matters. Thus, we will have to show patience for many months, before the
mountains are tamed and the men brought up to speed. Then it will go more
quickly. You must know that I'll accomplish what I promised and produce the
most beautiful work ever made in Italy, if only with God's help.

Though Michelangelo was back in Rome by March, the marble did not arrive until June, having been held up by customs, and it took another two months before it was hauled from the docks on the Tiber to his studio. As he examined more closely the stone he had labored so long to acquire, he must have been pleased. The beauty of the material he would soon transform into his first masterpiece was proverbial. More than two decades later, the *scarpellini* of the region still recalled the stone's perfection, writing to the sculptor excitedly to tell him they had just excavated a piece "as beautiful . . . as that used for the Pietà you made in Rome."

As he stood before the rough-hewn block, Michelangelo already had in mind the forms he would "liberate" from the white stone as he probed the mass with drill and chisel. As he had learned from his master Bertoldo, he had already worked out the basic composition in rough sketches, finished

drawings, and finally in clay models. But for Michelangelo the true art of sculpture was subtractive, a process of removing excess material and exposing forms latent in the mass. "By sculpture I mean that which is fashioned by the effort of cutting away, that which is fashioned by the method of being built up being like unto painting," he wrote in 1547.

The paradox of carved sculpture is that form and matter are in conflict: the more there is of one, the less there is of the other. Meaning comes only through a process of reduction, through a stripping away of matter until all that is left is pure spirit. In his poetry Michelangelo most often deploys the image of the sculptor's art as a metaphor for the tension between body and soul, between carnal love and divine love—the block standing for the earthly body while the form that emerges slowly beneath the chisel represents the soul struggling to free itself from its material prison:

> *Just as by removing, my lady, one forms*
> *from hard mountain stone*
> *a living figure,*
> *which grows more as stone grows less;*
> *so the little good that I possess*
> *trembles 'neath the body's fleshy form,*
> *imprisoned in its hard carapace.*
> *Only you can free me*
> *from my bonds,*
> *since in me there's neither force nor will.*

Or again in this sonnet of 1538:

> *The greatest artist has no concept*
> *not already present in the stone*
> *that binds it, awaiting only*
> *the hand obedient to mind.*

The metaphor of the body as the prison of the soul—the *carcere terreno*—has deep roots in both Greek philosophy and Christian theology. It was a

theme Michelangelo heard elaborated at great length during his years at the Medici Palace, where, under the guidance of Marsilio Ficino and Pico della Mirandola, Neoplatonism was very much in vogue. "[O]nce our souls leave this prison, some other light awaits them," Ficino wrote in a typical passage from his *Platonic Theology*. "Our human minds, 'immured in darkness and a sightless dungeon,' may look in vain for that light. . . . But I pray that as heavenly souls longing with desire for our heavenly home we may cast off the bonds of our terrestrial chains . . . and with God as our guide, we may fly unhindered to our ethereal abode. . . ." For the sculptor probing for meaningful form within the rough-hewn block, such philosophic flights provided a compelling metaphysical analogy for his craft.

III. DAUGHTER OF THE SON

We have no account that allows us to peek inside the studio and watch as Michelangelo "found" the figure of the Virgin Mother and her divine son inside the stone. Michelangelo was notoriously secretive and resented any intrusions or interruptions while he was at work. Until the moment the sculpture or painting was finished, he did his best to keep prying eyes away, as if to maintain the illusion that the artwork had emerged miraculously from the artist's mind like Athena from the head of Zeus.

Given his reluctance to let anyone observe his methods, we are fortunate to have a description of the artist at work on a similar piece, one of the last sculptures he ever created, the so-called *Florentine Pietà*, which he intended for his own tomb. The almost reckless abandon described in this later account no doubt reflects a confidence gained from a lifetime's experience, but even at the age of twenty-four Michelangelo possessed a remarkable faith in his own powers:

[I]n a quarter of an hour [the visitor wrote] he caused more splinters to fall from a very hard block of marble than three or four masons in three or four times as long . . . he attacked the work with such energy and fire that I thought it would fly into pieces. . . .

With one blow he brought down fragments three or four fingers in breadth,

and so exactly at the point marked that if only a little more marble had fallen he would have risked spoiling the whole work.

It was fortunate that Michelangelo was a quick worker, since the contract stipulated that the piece be completed "at the end of a year from the day the work is begun." Given the complexity of the composition and the high degree of finish he was striving for, this was an almost impossible task. And, in fact, it is unlikely that Michelangelo actually met this unrealistic deadline, which meant that the man who commissioned the work didn't live to see the finished product, since the Cardinal of St. Denis died early in August of 1499.

The completed statue was placed as the cardinal had requested above his tomb in Santa Petronilla, where it was immediately acclaimed a masterpiece. Vasari recalls that from this work "he acquired very great fame," while Condivi confirms that Michelangelo "gained great fame and reputation by it, so that already, in the opinion of the world, not only did he greatly surpass all others of the time and of the times before, but also he challenged the ancients themselves."

It is impossible to reconstruct precisely the *Pietà*'s original setting, since the old Chapel of Santa Petronilla was destroyed in 1505 during Bramante's rebuilding of St. Peter's. The statue was moved twice more, to the Chapel of the Madonna della Febbre in St. Peter's and then to the choir of Sixtus IV, before being brought in 1749 to its present location in an ornate Baroque chapel on the north side of the aisle of the great basilica. It is clear, however, that current viewing conditions are far from what Michelangelo intended, and certainly far from ideal. Not only are we forced to look at the *Pietà* from a distance, through a thick plate of bulletproof glass—installed after a 1972 attack on the sculpture—but it has been placed too high and tilted forward so that both the Virgin's face and Christ's body are obscured. Not the least of the problems is the busy backdrop of multicolored marble that overwhelms the subtleties of Michelangelo's carving.

In fact the *Pietà* is one of those artworks—like the *Mona Lisa,* which is similarly protected to death in the Louvre—that is better appreciated in reproduction where, with the aid of a good photograph, the eye can linger

on the exquisite finish and intricacy of the carving. The level of skill and the care he took in executing every detail remains unsurpassed in Michelangelo's oeuvre. This is the work of a precocious young man showing off, hoping to astound his contemporaries with his preternatural ability to render every vein and sinew in the dead Christ's body, and every pleat in the Virgin's cloak and headdress. It is a tour de force, a work by someone who felt he had still to prove himself. Yet for all its superficial tricks, its bravura passages meant to excite our admiration rather than contribute to the overall emotional impact, the *Pietà* remains a masterpiece of observation marshaled in the service of a larger expressive idea.

Here for the first time Michelangelo has taken full advantage of the knowledge he acquired at such great cost to his well-being in the morgue of Santo Spirito. Particularly in the body of the dead Christ, he shows an unrivaled command of anatomy. His is not simply a static textbook knowledge, but an understanding of the human body as an organism in which each part responds to every other, working in harmony for a common purpose. Ironically, the dead Christ appears more vital than perhaps any figure in the history of art, his limp form more responsive to actual physical conditions than depictions of living, breathing humans by other sculptors. The rise of Jesus's right shoulder where Mary's hand reaches around to support him beneath the armpit, the shift of the joint and the flex of his muscles, is unsurpassed both in terms of its truth to nature but also in the way such a subtle observation contributes to the overall narrative. It allows us to feel the weight of Christ's body, the suppleness of his now lifeless flesh. As some critics have pointed out, those Pietàs where Jesus lies across his mother's lap like a board, his body rigid from rigor mortis, are actually more realistic than Michelangelo's. But how much less poignant! As Michelangelo has conceived the scene, though Jesus has ceased breathing, he has only just crossed the threshold from life to death.

Michelangelo's *Pietà* marks a quantum leap over both the Santo Spirito *Crucifix* and even the *Bacchus* in terms of his ability to tell a profound story using only the human form. Due to the nature of the subject, Christ's body in the *Pietà* is utterly passive, but unlike the flaccid form of the *Crucifix* or the deliberately discombobulated pose of the *Bacchus,* Michelangelo has

learned how to transform what could have been either brutal or insipid into something powerfully evocative. He nestles in his mother's capacious and accommodating lap in a sinuous S-curve. There is a sensuous languor to the pose. He gives himself up to Mary's embrace with abandon, slumped, spent, with no sign of his recent agony to intrude on our meditations.

To some extent, Michelangelo reprises the theme of the *Bacchus* in order to infuse it with an entirely new meaning. Both figures are characterized by an enervation so unlike the heroic struggle we associate with Michelangelo's nudes. Bacchus is listless as he succumbs to his carnal nature; Jesus is literally lifeless, signaling his complete renunciation of the flesh. Both figures are yielding, unresistant, but for very different reasons. Where the Greek god of wine sags downward as he abandons the higher faculties in pursuit of base desires, Christ sloughs off his earthly nature in his climb to the heavens.

Michelangelo was famously averse to showing anything that marred the perfection of the human form, even in scenes like this where gruesome details would not be out of place and might, in fact, heighten the pathos. Christ's delicate, almost feminine features retain no trace of his recent ordeal. Michelangelo even minimizes the signs of Christ's wounds; the gash in his side where he was stabbed with a spear is barely noticeable, as are the holes where his hands and feet were pierced by nails. All artists who depict Jesus must grapple with his dual nature, human and divine, conveying his otherworldly spirit within a body that is wholly flesh and blood. Michelangelo implies this through a beauty that is unconquerable even in death, a beauty that foreshadows the Resurrection still to come.

In depicting Mary, Michelangelo was faced with a similar challenge. Mary is not divine. She represents the pinnacle of *human*, and more specifically female, nature, but as an emblematic figure, vessel of all that is good and pure, she must also be free to some extent from the ills that plague mere mortals. This led Michelangelo to one of the more controversial decisions he made in carving the *Pietà*—to depict Mary as a young woman, perhaps even younger than the child she supports. There is in fact some precedent for this approach, as suggested by the famous lines of Dante, "Virgin mother, daughter of thy Son," but Michelangelo's interpretation was controversial even in his own lifetime. Decades later, Condivi still felt it necessary to defend his hero

from the barbs of critics who believed the sculpture was not only implausible but perhaps even impious. When a copy of Michelangelo's famous statue was made for Santo Spirito in Florence by Giovanni Lippi, the sculptor reworked the original to show the Virgin at an appropriately matronly age. But even thus altered, the new and improved version did not meet with universal acceptance. "[I]t derives from that inventor of obscenities, Michelangelo Buonarroto," wrote one anonymous critic, "who is concerned only with art, not with piety," claiming such unorthodox images "undermine faith and devotion."

It is easy to condemn the anonymous critic as a hopeless philistine, but he was actually sensitive to a subtly subversive subtext that the loyal Condivi either failed to see or simply ignored. Michelangelo shows Mary as an adolescent, while depicting Jesus as a young man, so that each appears to be the age at which Italians of the Renaissance usually got married. Jesus seems to have collapsed in her arms in what, if one didn't know better, could be interpreted as a postcoital swoon. Thus the Virgin appears to be both mother and bride, a dual role that contributes to an uncomfortable and slightly morbid eroticism.

Condivi's explanation for why Michelangelo chose to depict Mary as a teenage girl, clumsy as it is, goes some way toward explaining what the artist had in mind: "Do you not know [he quoted Michelangelo as saying] that chaste women retain their fresh looks much longer than those who are not chaste? How much more, therefore, a virgin in whom not even the least unchaste desire that might work change in her body ever arose?" Naïve as this sounds to modern ears, this account does suggest that Michelangelo was not about to let the facts stand in the way of deeper Truth. Just as Christ's body retains its perfection even in death, so Mary's face remains unmarked by time.

Michelangelo renders the scene removed from the temporal, contingent realm where physical forms are subject to growth and decay. Even as Mary supports her Son's body with her right hand, she makes a rhetorical gesture with her left, as if to say: "Behold! This is my beloved child who offered Himself up for the sake of all mankind." Michelangelo represents Jesus's death

not as an incident occurring at a particular time and place, but as the Eucharist, the miraculous reenactment of Christ's sacrifice and Man's redemption. Mary presents his body much as the priest at Mass holds up the consecrated host, miraculously transformed by ritual into the flesh of the Redeemer.

This symbolic function helps explain Mary's calm demeanor, for Michelangelo's *Pietà* is not meant to conjure the moment in history when Christ's body was taken down from the Cross and placed on his mother's lap, but rather the entire arc of history in which Man's fall was redeemed through the death that makes possible our eternal life.

The Virgin's rhetorical gesture acknowledges our presence, inviting us to participate in this most sacred mystery, but her implicit acknowledgment is subverted by the direction of her gaze. She avoids confronting us directly. She averts her eyes, turning inward to meditate on the same mystery that she invites us to contemplate. These gently contradictory gestures constitute perhaps the most profound and profoundly moving aspect of the piece. Mary looks neither at us nor at the face of her beloved child, apparently absorbed in her own thoughts, aware of the immensity of Jesus's sacrifice and her own particular loss. But if through the death of her Son she has lost more than we, she recognizes that we too have a role to play, both to mourn but also to pay homage to Him who gave his life for us. We come reverently, on tiptoe, careful not to disturb her in her sorrow, but also reassured by her quiet gesture that we are not intruders, that, in fact, without us—the recipients of grace—the circle of meaning cannot be closed.

Mary is as physically remote as Christ is physically present. If He is divinity incarnate, she is all ethereal spirit. This despite a certain mountainousness that allows her to take the body of a full-grown man effortlessly on her lap. It is a measure of Michelangelo's brilliance that we barely notice this incongruity. He has concealed it not only by the voluminous pleats that fall in great sweeping cascades but also by the serpentine contour of Jesus's body that allows him to nestle comfortably within these capacious folds. In lesser hands, Mary's sweet, girlish face might seem wholly inadequate to the monumental body below, but so dazzled are we by the billowing fabric—hanging in thick swags in her skirts, in more delicate ripples in her blouse so that

the whole has an effect of upward movement—that, again, we blithely pass over the improbability of it all. Such deviations from mere fact are typical of Michelangelo's mature work as he searches for a truth more elevated, truer, than prosaic reality.

The contrast between the clothed Virgin and her almost naked son allows Michelangelo an opportunity to show off his bravura technique. The architectonic quality of the drapery—as structurally important as the rocky outcropping on which she sits—shows a remarkable advance over the statues of Saints Proclus and Petrónius and the kneeling angel for the Bologna altar carved only four years earlier. In those earlier sculptures, Michelangelo struggles to find a meaningful relationship between the clothing and the bodies beneath. In the *Pietà,* Mary's garments have a dynamism and structural function all their own. They conceal far more than they reveal, but the dramatic diagonal sweep of her skirt hem and the gathered folds at her knees provide essential visual support for the body above, while the delicate tracery of her blouse—like the ripples on a windswept lake—leads the eye upward before coming full circle in the headdress that envelops Mary's delicate features in soft folds. If, instead, our eyes start at the top, those pleats and folds read as flowing water, beginning in nervous little rivulets above and becoming mighty cascades as they reach the bottom.

The statue Michelangelo carved for the tomb of the Cardinal of St. Denis is the first of three versions of the *Pietà* he carved during his lifetime—he left the other two unfinished in his studio at his death—but it is not his first treatment of the Virgin holding her Son in her lap. In fact his earliest extant work, the *Madonna of the Stairs,* depicted the same two figures at the beginning of their journey together, and the quietly mournful tone of that piece already contains a premonition of what's to come.

The Roman *Pietà* is probably the best loved of Michelangelo's works, more approachable than the epic Sistine Ceiling and conceived on a more human scale than the *David,* whose grandeur and supreme self-confidence inspire awe rather than tenderness. The almost universal affection comes despite the fact that Michelangelo holds us at arm's length; the *Pietà* is a work of silence and of mystery, of contemplation rather than raw feeling.

To some extent, Michelangelo is deliberately working against type by eschewing obvious dramatic effects. The image of a mother grieving for her dead son is one that touches everyone on a visceral level. No parent can witness this mournful scene without terror, but though Michelangelo presents us with a theme that exposes our deepest fears, he does so in a way that reassures as well. Mary is overcome but not overwhelmed by her sorrow, grave but not despairing. One of the many consequences of depicting Mary as a young girl is to blunt the emotional impact of the scene: she does not look like the mother, nor does Jesus look like her child. Rather than tugging on our heartstrings, Michelangelo seeks out a higher spiritual plane. Mary's dignity at this most trying moment evokes the theological message of Jesus's sacrifice, the paradoxical mystery at the heart of Christianity. Through His death we gain eternal life; our greatest sorrow is the prelude to our greatest joy.

Michelangelo's approach defies expectation and runs against the grain of history. The Pietà has become such a common motif in Christian art—due in no small measure to the popularity of Michelangelo's version—that it is surprising to learn that it is a scene for which there is no basis in the Gospels. The popularity of the Pietà originally stemmed from its appeal to our emotions; no one, no matter how theologically ignorant or spiritually indifferent, is immune to its universal message.

The theme first emerged during a wave of religious fervor that gripped central Europe at the end of the fourteenth century, when a new iconography was invented to speak more directly to the spiritual longing of the faithful. In one of those periodic religious revivals—akin to the various Great Awakenings that have been a feature of American religious life—the faithful of late medieval Europe sought a more direct connection to the divine. Rite and ceremony lost their monopoly as vehicles for salvation. To supplement these stale observances, men and—especially—women sought out stories that touched their hearts and brought the supernatural within the realm of everyday experience. This impulse often manifested itself in a form of mystical ecstasy in which the devout imagined scenes of Christ's Passion playing out before their eyes or, in the most extreme instances, in which they them-

selves endured Christ's agony on the Cross. The fourteenth-century German nun Mechtild of Hackeborn wrote an account of her visions, a kind of spiritual ecstasy so intense as to induce hallucinations: "At Vespers, one saw the Lord taken down from the cross. One also saw the Virgin Mary hold him in her lap and the prayerful Mother spoke to him: Come hither and kiss me my holy wonder, my beloved Son, whom I love so much."

The early German Pietàs combine wild expressiveness with stark realism. Artists spared their viewers nothing, focusing with relish on the gruesome injuries and contortions of Christ's brutalized body. Mary herself is not merely grief-stricken but unhinged. These images were meant to do more than arouse our empathy; they were calculated to evoke a powerful response in the viewer who could be excited to such a degree as to actually feel Our Lord's suffering or his mother's sorrow, much as if the viewer herself had undergone the ordeal. Like St. Francis receiving the stigmata, a man or woman of sufficient piety could be expected, through the sympathetic magic of art, to participate in the suffering that leads to redemption.

And it *was* a form of magic, tapping into that current of wonder that lies behind all art and whose ultimate source can be traced back to the shamanistic rites of our Stone Age ancestors. The primitive notion that a depiction bears some deep connection to the thing depicted—a notion that lies behind magical practices like voodoo—accounts for much of art's power to move us and explains why icons and idols have always been vital props for the world's major religions. A kind of sympathetic vibration is set up between the sculpture and the sacred theme to which it refers, so that the faithful might kneel down before an image of a saint and expect their prayers to be heard.

When Michelangelo set out to create his own version of the Pietà, it is clear he was determined to take a more cerebral approach. He eschews the histrionics typical of the subject in favor of a dignified reserve. One needn't assume he was less religious than the anonymous craftsmen who carved the humble wooden effigies before which the faithful prostrated themselves, but his attitude toward his work was profoundly different, not the least because the prospect of anonymity was appalling to him. Fame, not piety, was his primary motivation, and he would measure the success of the sculpture by

how effectively it reminded viewers of his unique genius.* His ego would never permit him to create any work that required a ritual setting to complete its meaning. Michelangelo's *Pietà* is entirely self-sufficient, the proud creation of a single man and a bravura performance intended to excite the admiration of the crowd. Whatever magic was present would be conveyed through the perfection of its form and the power of the artist's singular vision, his ability to solve difficult problems of composition and to render contrasting materials of billowing fabric and bare flesh. It was a showpiece, a technical tour de force, made all the more remarkable, as Condivi pointed out, because it was carved from a single block of stone.† His masterpiece was meant to attract the eye and stimulate the mind; there was never any question of Michelangelo creating a cult object like those carried around the villages of Germany and Flanders in solemn procession. He was creating, first and foremost, a work of art.

Another way to put it was that Michelangelo was divesting the Pietà of its medieval trappings and reimagining the theme for a new age. The approach he shared with his contemporaries—and that characterizes the Renaissance as a whole—was not quite the "art for art's sake" ideology popular in the late nineteenth century, but the stress placed on autonomous values of beauty and form over functional or ritualistic imperatives launched us on the journey toward that very modern conception. Michelangelo transformed a cult object—made by an anonymous artisan and intended for use in a ritual setting—into a work of art whose spiritual efficacy was a by-product of its formal properties. Carved in gleaming white Carrara marble, a medium that was both self-consciously "arty" and devoid of any superficial resemblance to the hair, flesh, and fabric it depicted, Michelangelo's masterpiece exists on an ideal plane, far removed from the messy contingencies of life, revers-

* The art theorist Hans Belting has characterized the Renaissance as the age in which "the old aura of the sacred" was replaced by the "new aura of the masterpiece." [Quoted in Campbell, "Fare una Cosa Morta Parer Viva," *Art Bulletin*, vol. 84, no. 4: 606.]

† Carving a complex group from a single block was considered to be a mark of a great craftsman. According to Pliny, the famous *Laocoön* group had been one such masterpiece, but when it was excavated from a field in Rome in 1506, Michelangelo—who was one of the first to inspect it—determined it had actually been made in five pieces.

ing the original function of the Pietà as the site in which the sacred and the mundane commingled.

IV. THE SIGNATURE

The conceptual distance between Michelangelo's version of the Pietà and its medieval predecessors can be measured by one element in particular, perhaps the most controversial feature of the sculpture: the presence of the artist's signature chiseled on the strap that crosses Mary's breast. Like the decision to depict the Virgin as a young girl, Michelangelo's decision to place his name so boldly in such a visible—not to say intimate—location stirred controversy from the beginning. In his *Lives of the Artists*, Vasari includes an anecdote in order to justify what would otherwise have been condemned as a presumptuous act:

> Such were Michelagnolo's love and zeal together in this work, that he left his name—a thing that he never did again in any other work—written across a girdle that encircles the bosom of Our Lady. And the reason was that one day Michelagnolo, entering the place where it was set up, found there a great number of strangers from Lombardy, who were praising it highly, and one of them asked one of the others who had done it, and he answered, 'Our Gobbo from Milan.'* Michelagnolo stood silent, but thought it something strange that his labors should be attributed to another; and one night he shut himself in there, and, having brought a little light and his chisels, carved his name upon it.

Vasari's tale is easily disproved by the evidence of the work itself. The strap was an integral part of the original composition. It presses down on the Virgin's blouse, tugging slightly at the material around her breasts to expose, if only demurely, what lies beneath. It is an unusual accessory that seems to have no function other than to carry the artist's signature. Clearly, this was

* This nickname, meaning "hunchback," belonged to Cristoforo Solari (1460–1527), a well-known sculptor from Milan who was closely associated with Leonardo da Vinci.

not an afterthought but rather something Michelangelo had planned from the moment he began to work the block with mallet and chisel. The fact that Vasari felt compelled to concoct this improbable story is a sign of how uncomfortable Michelangelo's champions were with this intrusion of artistic ego into a sacred tableau.

Since Vasari's story is so obviously an invention, one must look elsewhere for an explanation of Michelangelo's cheeky bit of graffiti. On the most obvious level it was an assertion by a young man who knew he'd accomplished something remarkable. At the very least, Vasari's story shows a budding artist afraid that someone else might take credit for his work. Michelangelo was always accusing others of stealing his ideas, and this fear must have been particularly acute at this point in his career, when he was still little known to the general public. Indeed, Michelangelo had good reason to worry, since it was commonplace for artists to copy each other's work and unusual for them to credit the source. As we've seen, Michelangelo himself was not above perpetrating similar frauds, though he thought himself so superior to his contemporaries that he was willing to be confused only with the ancient masters.

In fact, the form of the signature is itself a kind of fraud or pun, deliberately meant to evoke the ancients. Carved in shallow letters on the strap are the words MICHEL.A[N]GELVS.BONAROTVS.FLORENT.FACIEBA[T], literally "Michelangelo Buonarroti the Florentine was makin[g]." The final "T" is blocked out by Mary's blouse, heightening the illusion that the signature was not added by the artist but actually inscribed on the Virgin's garment. The unusual use of the imperfect tense is actually a learned allusion to the Roman writer Pliny and comes from the preface of his *Natural History*:

> I should like to be accepted on the lines of those founders of painting and sculpture who . . . used to inscribe their finished works, even the masterpieces . . . , with a provisional title such as *Faciebat Apelles* or *Polyclitus,* as though art was always a thing in process and not completed, so that when faced by the vagaries of criticism the artist might have left him[self] a line of retreat to indulgence, by implying that he intended, if not interrupted, to correct any defect noted.

In alluding to this passage—which Michelangelo almost certainly heard about from Angelo Poliziano—he adopted a phrase originally intended to express the artist's humility in order to show he deserved to be included among the greats. The shallowness and deliberate sloppiness of the letters is also a kind of visual pun. Had Michelangelo wished, he could easily have worked it out so that the letters were all the same size and fit perfectly on the strap. The elisions, like the grammatical syntax, represent a studied carelessness, as if, as Vasari asserts, they were merely an afterthought, softening the arrogance implied by scrawling his name across the Virgin's bosom.

By brazenly signing his name on a sacred work, Michelangelo was following a trend that had already begun among Renaissance artists. As early as the fourteenth century, Giovanni Pisano inscribed his pulpit for the Cathedral of Pistoia: "Giovanni carved it who performed no empty work, born of Nicolà but blessed with greater skill, Pisa gave him birth, endowed with learning in all things visual." Two tombs carved by his fellow Florentine Antonio Pollaiuolo for Popes Sixtus IV and Innocent VIII, provided a more likely source of inspiration, particularly since they were both in St. Peter's Basilica, near where his own funerary monument was to be erected. Pollaiuolo's signature on the tomb of Pope Innocent in particular was prominently placed. Inscribed on the armrest in which the pontiff sits, it reads: "Antonio Pollaiuolo, famous in gold, silver, bronze, and painting, he who finished the sepulcher of Sixtus here by himself brought to an end the work that he had begun."

Michelangelo's signature, while less overtly boastful, is far more prominently placed, exposing him to the charge not only of hubris but impiety. Through this bold declaration of authorship, Michelangelo interjects himself into the sacred communion between the worshiper and the icon. He not only calls attention to himself but also to the fact that this is a work of art, made by a mortal man. If anything miraculous is taking place, he wants to make sure he receives the credit.

Nothing evokes the soul of the Renaissance more than this imperative to make one's mark on the world. Along with an appreciation for Man in general came a renewed appreciation for men as individuals, each of whom was seen to possess unique qualities and a unique set of skills for which he

demands to be rewarded. Giorgio Vasari chronicles this slow-moving revo-
lution in his *Lives of the Artists,* a magisterial work that covers more than
two and a half centuries of innovation, from Cimabue and Giotto at the end
of the thirteenth century to the death of Michelangelo in 1564. It is not so
much a history of art as of artists, a treasure trove of revealing anecdotes
and quirky personalities, of individual triumphs and collective progress. He
reaches back into what for him was the dim past, but he reflects the concerns
of his own day: the thirst for fame and the desire to be recognized as a dis-
tinctive personality. As he proclaims in the preface:

> It was the wont of the finest spirits in all their actions, through a burning
> desire for glory, to spare no labor, however grievous, in order to bring their
> works to that perfection which might render them impressive and marvelous
> to the whole world; nor could the humble fortunes of many prevent their en-
> ergies from attaining to the highest rank, whether in order to live in honor or
> to leave in the ages to come eternal fame for all their rare excellence.

To some extent, Vasari was projecting the obsessions of his own day onto
an earlier age, but he was the first to clearly articulate what was distinctive
about the cultural moment he lived through and to seek its origins in the
triumphs of those long-dead masters. Dante, writing some two centuries
earlier, felt the first stirrings of this new egotism, though he uses an artistic
rivalry to make a typically medieval point about the vanity of all worldly
striving:

> *O empty glory of human powers!*
> *how briefly lasts the green on its top,*
> *unless it is followed by an age of dullness!*
> *In painting Cimabue thought to hold the field*
> *and now Giotto has the cry, so that the other's fame is dim.*

"Seeking the bubble reputation," as Shakespeare put it, became a Renaissance
obsession. The competition for fame and honor that had long animated
the ruling class now filtered down to the writers, scholars, and artists who

served them, spurring them to new creative heights and rewarding those who could stamp their work with their own unique personality.

These pioneers were not simply moving the story of art forward; they were inventing the very concept of art as a specialized field of endeavor and of the artist as a man with a particular gift and distinctive point of view. The medieval craftsman was necessarily self-effacing. The more his personality came to the fore, the less the work served its essential function of mediating between the earthly and heavenly realms. A thirteenth-century miracle-working panel from Santissima Annunziata, with which Michelangelo as a native of Florence was intimately familiar, perfectly illustrates the medieval mindset. It was begun, so the story goes, by a monk from the church's cloister who threw the painting aside in frustration at not being able to capture the sacred scene. But while he slept, it was completed by an angel—a provenance that assured its healing power.

By contrast, the Renaissance work of art, even if not actually signed, proclaims its very human maker through distinctive marks of style and handling. If Leonardo had an angel whispering in his ear while he painted or Michelangelo one guiding the chisel, neither was letting on. The superhuman power behind Michelangelo's works is the man himself, who has combined in his person the role of both artist and angel, an individual fully capable of working miracles in his own right.

Vasari proclaimed Michelangelo the culminating figure in a centuries-long journey that began with Giotto. He was the man "sen[t] down to earth" by God, "a spirit with universal ability in every art." But while Michelangelo may have been heaven-sent—divine, in the words of his admirers—his work has lost some of its primitive talismanic power. His sculptures and paintings excite the admiration of all who see them, but they fall short in terms of eliciting the prayers of the faithful. It is safe to say that among the thousands who stream through the Sistine Chapel each day, few are moved by purely religious emotions. The tension between esthetics and spirituality is particularly acute in the case of the *Pietà* precisely because of the subject's history as a site where the faithful came in contact with the divine. In this most poignant, human moment, the miracle of the God-made-flesh becomes visible. But Michelangelo's work is self-consciously artistic, almost unapproachable in its perfection. We

are meant to contemplate these sacred figures from a distance—both spatial and emotional—rather than to engage on a more visceral level.

Of all Michelangelo's masterpieces, the *Pietà* in St. Peter's is the least Michelangelesque, the least imbued with those qualities—grandeur, heroism, struggle—that we've come to associate with the artist's work. It is also, and not coincidentally, the most finished. Each detail is lovingly rendered, down to the pleated folds of Mary's blouse and the individual hairs in Christ's beard, and each exquisitely polished surface gleams in the dim light of the cathedral.*

The level of detail and high degree of finish are exceptional in Michelangelo's work. In fact, over the course of his long and productive career, he left so many works at various stages of incompletion that the unfinished has taken on an esthetic life of its own. The row of half-carved *Captives* in the Accademia in Florence perhaps speaks more eloquently to modern viewers than the undisputed star of the museum, the *David*. After watching as these muscular figures wrestle to free themselves from the matrix of stone, *David* can seem a bit too self-assured, too complacent.

In retrospect, and for all the jaw-dropping skill it displays, the *Pietà* is still the work of a young man burning to show what he can do. It is a showpiece of the sculptor's art, like a Paganini cadenza that's meant to impress the audience with the violinist's superb technique. After two years of squandered opportunities and frustration, the twenty-three-year-old artist set out to prove to the world what he was capable of. His signature, brazenly scrawled across the Virgin's bosom, leaves no doubt that he felt he had succeeded. But it was also a mark of insecurity. The next time, he was certain that everyone would know who had made the work without being told.

* This high finish was achieved, so Vasari informs us, "with points of pumice stone [the sculptor] rub[s] all over the figure to give that flesh-like appearance that is seen in marvellous works of sculpture." [*Vasari on Technique,* no. 50, pp. 151–52] The *Pietà* is not in fact finished at every point. Since it was originally placed inside a niche and was meant to be seen only from the front, the back has been left completely unresolved. In fact, the sculpture is not conceived in the round but is basically a very high relief. But the *visible* portions are more finely finished than any of his other sculptures.

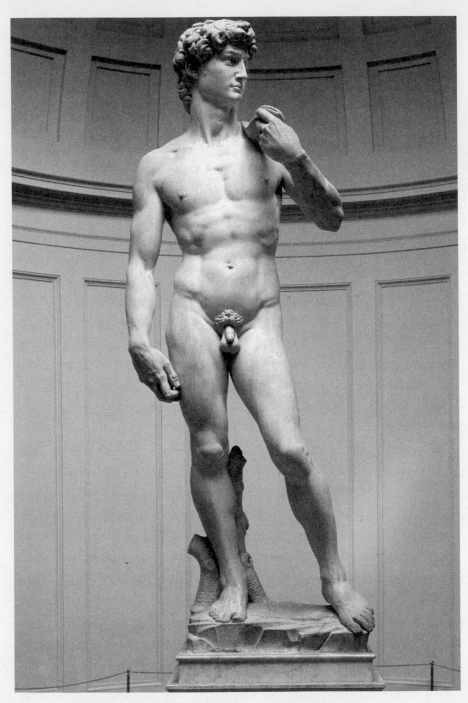

Michelangelo, *David*, 1501–4. *Nicolo Orsi Battaglini/Art Resource, NY*

III

The Giant

Michelangelum Lodovici Bonarroti, citizen of Florence, is to make and carry out and to finish perfectly a figure, the so-called Giant . . . nine *braccie* tall, already present in the Opera [the cathedral works] . . . within two years, beginning next September, and with salary and wages each month of six gold florins.

—Contract for the *David*, August 16, 1501

I. MONOLITH

The massive block of Carrara marble had lain in the courtyard of the cathedral workshop for over thirty years. Exposed to the wind and rain, surrounded by weeds and covered in grime, the abandoned monolith was a monument to frustrated ambition and humbled pride. On close inspection, the weathered column resembled an ill-formed man, though one would be hard-pressed to say what sort of figure the sculptor had in mind when he began hacking away with inexpert blows. Florentines simply referred to it as "the Giant," only dimly recalling the intention of the obscure artist who'd abandoned the project he'd barely begun.

In the summer of 1501, the overseers of the cathedral began to take a renewed interest in the neglected block. Measuring nine *braccie* (almost

eighteen feet) from end to end, such a massive piece of stone—excavated from the mountainside by teams of *scarpellini* and carted some eighty miles along narrow, rutted roads—represented a substantial investment of time and money. Those charged with the upkeep and decoration of the city's chief religious shrine were thrifty men, not the sort to spend a penny more than was absolutely necessary, even for the greater glory of God. They were prominent merchants, men who had prospered in part by keeping a sharp eye on the bottom line. When commissioning a statue to adorn the exterior of the cathedral, it seemed irresponsible to purchase new material when there was perfectly serviceable material already on hand.

Though Santa Maria del Fiore, as the cathedral of Florence was officially known, was already over two hundred years old, it was still a work in progress. Construction had begun during the boom at the end of the thirteenth century, a period of explosive growth in Florence that also saw the building of the Palazzo della Signoria, the fortresslike capitol building at the heart of the city,* and the two great basilicas of Santa Maria Novella and Santa Croce, home respectively to the mendicant orders of the Dominicans and the Franciscans, as well as a vast encircling wall that protected the vibrant metropolis from hostile neighbors. In 1436, after more than a century in which the interior of the church was exposed to the elements, Filippo Brunelleschi succeeded in capping the vast opening at the center with his remarkable dome, an engineering feat that made the Cathedral of Florence a wonder of the world.

As with most great medieval building projects, progress on the cathedral of Florence was slow and subject to the vicissitudes of fortune. Civil strife, economic upheaval, and the devastation left in the wake of the Black Death of 1348 all forced delays, but after each crisis the citizens of Florence renewed their plodding march into the future. From the beginning there was a yawning chasm between the ambition of its original conception and the limited financial and technical resources available to the commune. The enormous dome was only the most glaring example of this mismatch; more

* The Palazzo della Signoria (the Palace of the Lordship) was the capitol of the Florentine Republic, located on the piazza of the same name that served as the city's main public square. It is also known as the Palace of the Priors and the Palazzo Vecchio (Old Palace).

than a century elapsed before Florentines discovered in Brunelleschi a man with the genius to solve the engineering problems posed by erecting a vault over such a wide drum.

Responsibility for ensuring that this emblem of civic pride and religious fervor was suitably adorned fell to the Arte della Lana (the wool guild) and its board of overseers, the Opera del Duomo. (The smaller but equally prestigious Baptistery was under the purview of the Arte di Calimala, the guild of international cloth merchants.) This type of public-private partnership served Florence well as each guild vied with its rivals in beautifying the city. The Opera had purchased the marble column in the middle of the last century as part of a program to place colossal statues along the exterior roofline of the cathedral. The series was to include twelve biblical prophets, Old Testament figures like David, Isaiah, and Joshua who combined spiritual strength with patriotic ardor. These monumental figures would emphasize a point dear to the hearts of most Florentines—that they, like the ancient Israelites, were a people favored by God.

As was often the case, however, dreams had to be scaled back when reality intruded. The technical difficulties involved in raising tons of marble high atop the tribunes and stabilizing them against the wind and weather proved more daunting than anticipated. In 1412, the city's most celebrated sculptor, Donatello, did succeed in mounting a massive Joshua on the eastern tribune, but he was forced to substitute lightweight terra-cotta (whitewashed to resemble stone) for the more durable and precious marble.

The column that now lay abandoned in the courtyard had arrived in Florence in 1464, during a renewed burst of enthusiasm for the project. Contemporary documents record that the task of carving a monumental figure of David from the block was given to one Agostino di Duccio, a pupil of Donatello. Since Agostino had no experience in carving such large-scale figures, it may well have been that this lesser talent was merely hired to assist the now elderly Donatello. In fact, the great sculptor died in December 1466 at the age of eighty, which could explain why the project was once again abandoned. Another attempt was made a decade later as the *Operai* brought in Antonio Rossellino to take up where Agostino had left off. But he too quickly determined he could do nothing with the roughed-out block.

Despite this discouraging history, in 1501 the officers of the Arte della
Lana made yet another attempt to resuscitate the moribund project. As was
often the case in Florence, the decision was driven as much by political as by
artistic considerations. This latest attempt at civic improvement was under-
taken at a time of deep anxiety and was calculated to project a confidence in
the state most citizens no longer shared. Three years earlier the fickle citizens
of Florence had turned on Girolamo Savonarola, the fire-and-brimstone
preacher whom they had recently proclaimed the savior of the Republic.
Disillusionment with his erratic foreign policy and frustration with his
austere regime, combined with unrelenting pressure from Pope Alexander—
the chief target of Savonarola's sermons denouncing the corruption of the
Church—helped turn public opinion against the self-proclaimed prophet.
On April 8, 1498, the Prior of San Marco was arrested by the authorities
and dragged to a cell in the Palazzo della Signoria. Tortured, Savonarola was
forced to confess that his prophecies were the product of worldly ambition
rather than divine inspiration. After an ordeal lasting almost two months, he
was finally hanged in the square in front of the Signoria.

The form of the republic Savonarola had promoted after the expulsion
of the Medici in 1494 remained intact, but the wealthy bankers and traders
who now ran things in Florence lacked legitimacy in the eyes of many. They
suffered from a lack of leadership and charisma. Locked in a protracted and
badly managed war with neighboring Pisa, the current government was both
weak and unpopular. Ever-higher taxes increased the burden on ordinary
citizens while contributing little toward bringing the war to a successful
conclusion. To make matters worse, Florentines were now faced with the
prospect of war on a second front, this time with Cesare Borgia (aka Duke
Valentino), the brutal and brilliant son of Pope Alexander, who was cur-
rently menacing their borders with his army.

Thus it was under gathering storm clouds that the project to carve a giant
David was revived. Adorning the great religious and civic monuments of the
city with precious artworks was Florence's preferred method of meeting a
crisis. A hundred years earlier when the city was similarly threatened—this
time from the army of Giangaleazzo Visconti, the Duke of Milan—the city
fathers had staged a competition to furnish the Baptistery with a new set of

bronze doors, hoping both to win divine protection and reassure an anxious populace. The same crisis also provoked a war of words between the Chancellor of Florence, Coluccio Salutati, and his counterpart in Milan in which Salutati conveyed the plucky spirit of his compatriots who placed their faith in something less tangible than the number of men mustering under their banners. "You say," wrote the Chancellor, "that you do not see in us strength enough to oppose four cavalry legions. . . . [W]e are aware that victory lies not in the number of soldiers but in the hands of God . . . we know that our ancestors have often resisted against overwhelming enemy forces, and with small ranks . . . obtained . . . the victory beyond their hope."

A century later the city fathers hoped to revive the spirit of 1401 in which a badly overmatched city defied and ultimately turned back a great tyrant. And as before, artists were expected to play a key role. In this context the symbolism of David seemed particularly apt. The tale of the shepherd boy who defeated the Philistine giant Goliath was particularly dear to Florentine hearts, a stirring narrative of an underdog emerging victorious in the face of long odds.* Commissioning a colossal image of the young hero would signal a confidence in the future and remind a skittish citizenry how they had overcome similar crises in the past.

It is not clear how or when Michelangelo first learned of the project. According to Vasari, he was still in Rome when he first heard rumors of the prestigious commission: "From Florence, some of his friends urged him to return so that he might be awarded the carving of the marble that had lain ruined in the yard of the Opera del Duomo, which Gonfaloniere Piero Soderini then had in mind to give to Leonardo da Vinci." Nothing was more apt to light a fire under Michelangelo more quickly than the thought that somebody else would reap the glory he felt entitled to himself. The mere mention of Leonardo's name in association with this project would have driven him to distraction. At the time, the forty-nine-year-old painter was

* Images of David were common in Florentine art. Donatello made at least three statues of the youthful warrior, and Verrocchio contributed another famous version, the David now in the Bargello. Painters like Andrea del Castagno and Antonio Pollaiuolo also depicted David, never the king but always the youthful hero.

the most famous artist in Europe. He had returned to Florence a year earlier, after almost two decades away, during which time he had served not only the Duke of Milan but also the notorious Cesare Borgia as his chief military engineer. Though known more as a painter than a sculptor, Leonardo had modeled a monumental equestrian monument depicting the former Duke of Milan, Francesco Sforza, and the notion of awarding a large-scale work in marble to a man of such obvious gifts was not altogether farfetched. The prospect that an occasional sculptor would steal a commission in a field in which he tolerated no rivals would have been more than incentive enough for Michelangelo to rush back to Florence.

But Vasari's narrative is inaccurate on at least one count. Piero Soderini, whom he claims as Leonardo's champion in this matter, was not elected Gonfaloniere until 1502. It is also not clear that the Operai had decided to revive the project by the time Michelangelo left Rome. Rumors to that effect might have begun to swirl months before their official inspection in July 1501, but no contemporary documents prove such an assertion.

Still, it's hard to believe that Michelangelo set out for Florence in March of 1501 without some expectation that major commissions would come his way. He had left Florence for Rome almost five years earlier, and it's unthinkable that he would have abandoned the prospects of the burgeoning capital for the provincial comforts of Florence unless he thought he could build on what he'd already achieved. The possibility that he'd caught wind of the new project is hinted at by a letter he received from his father in December 1500, assuring Michelangelo he would have important work to do in Florence.

There were, in fact, plenty of reasons to remain where he was. Whatever the possibilities opening up in his native land after Savonarola's downfall, Michelangelo was now all but certain that a brilliant career awaited him in Rome. The success of his *Pietà* secured his reputation as the most promising sculptor of his generation, and nowhere were the opportunities richer or more varied than in the seat of the papacy. Having made a successful debut on the most important stage in Europe, the twenty-five-year-old sculptor found himself in an enviable position. His latest patron had just died, but there were numerous princes of the Church willing and able to take his

place, worldly men disposing of vast incomes who would have been thrilled to have such an accomplished sculptor immortalize them in gleaming Carrara marble.

But Michelangelo was homesick. He loved his native city and, despite frequent quarrels with his father and brothers, was deeply attached to his family. Even before securing the commission for the *Pietà*, he had assured Lodovico he would soon be leaving for Florence, though at the time he made little effort to follow through on his promise. In fact, shortly after completing the sculpture for the cardinal's tomb, he signed a contract to paint an altarpiece for a chapel in Sant'Agostino in Rome, another commission facilitated by Jacopo Gallo, who was among the building's supervisors. Scholars have identified the painting (for which he was paid the rather modest sum of 60 ducats) as *The Entombment*, now in the National Gallery of London. Even in its half-completed state it is a work of remarkable inventiveness, particularly when one considers how little it has in common either in feeling or composition with the nearly contemporary *Pietà*. Here the transfer of Christ's body from the Cross to the Tomb is a muscular, athletic event, far removed from the ethereal mood of the *Pietà*. It's as if the sculpture had been turned inside out, transforming a contemplative moment into a drama played out in terms of physical stresses and strains.

We don't know for certain why Michelangelo never completed the project, but it's plausible that he abandoned the painting once he heard rumors of more exciting opportunities awaiting him in Florence. Michelangelo often signed on to a project only to discard it when something better came along, a habit that infuriated those left in the lurch who believed (with some justification) that he was acting in bad faith. Often the ink on one contract barely had time to dry before he was pursuing another, more attractive offer. Some of these jilted patrons even accused him of trying to defraud them, though Michelangelo never acted out of mercenary impulses. It was not the money that caused him to put aside whatever he was working on in favor of something more compelling, though he appreciated large fees as a sign of his growing stature as an artist. Rather, it was the excitement of a new challenge that made him seek out the next horizon. Creative restlessness, not greed for

gold, contributed to a long string of unfulfilled promises and half-realized masterpieces.

Michelangelo was in fact notoriously uninterested in material possessions, or at least creature comforts. He was so absorbed in his work that he often let the rest of his life fall into shambles. For the three commissions he received in Rome, he earned more than 650 ducats, a sum on which he might have lived comfortably, even luxuriously. But a letter from his father—written in December 1500 after a visit from his younger brother, who had gone to Rome to celebrate the Pope's Jubilee—paints a scene at odds with his recent success: "Buonarroto tells me how you live there with great frugality or rather squalor: frugality is good, but squalor is bad because it is a vice that displeases both God and men, and besides it will do damage to both your soul and your body. Since you are young, you can tolerate discomfort for awhile, but when the vigor of youth has gone you will discover the ills that come from living miserably. . . . [L]ive moderately and do not deny yourself. . . . Above all care for your head, keeping it warm, but never bathe. . . ."

Even in his old age, when he had grown wealthy through his art and owned considerable property in both Rome and Florence, Michelangelo adopted an ascetic lifestyle. As he told his biographer, "Ascanio, rich man as I have made myself, I have always lived as a poor one," a theme on which Condivi elaborated: "All through his life Michael Angelo has been very abstemious, taking food more from necessity than from pleasure, especially when at work, at which time, for the most part, he has been content with a piece of bread, which he munched whilst he labored."

Such austerity might seem peculiar in someone so invested in his aristocratic pedigree, but Michelangelo's snobbery was not of the sort that required him to ape the dress and manners of the nobility to which he claimed to belong. His superiority to his fellow man was expressed not through fine clothes and courtly bearing but through an inner fire that blazed forth in his work. Late in life when he complained that his brother Gismondo was living like a peasant, his anger was aroused not by the material but by the intellectual poverty of his brother's existence and the general lack of ambition it bespoke.

II. I WITH THE BOW

In March 1501, with the fame of his *Pietà* spreading to all corners of Italy and beyond, Michelangelo returned to Florence with a full purse and his head held high. The fact that his finances were now on a solid footing helped ease his homecoming, but one shouldn't discount the psychological impact of his recent triumph. He would set foot on native soil a conquering hero rather than a failure.

In Florence, Michelangelo moved back into the crowded, ramshackle house on the Via de' Bentaccordi, close by the church of Santa Croce. There he found himself once more in the bosom of his large, quarrelsome family, something he regarded as at best a mixed blessing. Michelangelo's relationship with his father had undergone a radical transformation since the days of his adolescence, when Lodovico and his uncle beat him when he told them he wanted to become an artist. Now that he had proven himself, it was the son who exuded confidence while the father seemed diminished. Lodovico was no less ornery than before, but instead of bullying his son he tended to whine and play on Michelangelo's guilt. Shortly before he returned, Lodovico sent his second-oldest son a letter filled with self-pity:

> It seems to you that I am unhappy; it seems to me with good reason; when it comes to God, I am happy and content, but when it comes to my sons I am less satisfied, because I have five sons and, now 56 years old, and thanks to God I have no one who will give me so much as a glass of water. Instead, in my old age, I must stay with relatives who ask 22 quattrini a day to cover their expenses, and in addition to this I have to do my own cooking, wash the dishes, bake the bread, and provide everything for myself, despite my aches and pains. . . .

Lodovico's grousing was not entirely unjustified, but it also reflected his prickly personality. The loss of his second wife and an unpayable debt weighed heavily, but he was a man whose pride outstripped his ambition so that he was always bemoaning his poverty without lifting a finger to alleviate it. He felt aggrieved at the world in general and by his children in particular,

who always fell short in his eyes. His only successful son took on most of the burden of caring for him and bore the brunt of his complaints. But no matter how much Michelangelo sacrificed for his sake, it was never enough. Toward the end of his life, after decades in which Michelangelo had been his primary support, Lodovico accused his son of cheating him, an outrageous charge that hurt Michelangelo deeply and almost provoked a permanent rift.

In spite of everything, Michelangelo was devoted to his father. His need to please this dour man, to show him that his choice of career would not bring disgrace to the Buonarroti name, fueled his fierce ambition. Returning to the paternal hearth as an acknowledged success was crucial to his sense of himself, but it would not have been possible without the prospect of gainful employment.

From the beginning Michelangelo's name topped the list of sculptors being considered by the overseers of the cathedral; few men had both the skill and the desire to tackle the difficult task of carving the monumental column. Despite Vasari's claim that Michelangelo hurried home to forestall Leonardo capturing the prize, there's no evidence the older artist pursued it for himself. On August 16, 1501, four months after the initial inspection, the secretary for the Opera del Duomo drew up a contract "declaring that Michelangelum Lodovici Bonarroti, citizen of Florence, is to make and carry out and to finish perfectly a figure, the so-called Giant . . . nine *braccie* tall, already present in the Opera . . . within two years, beginning next September, and with salary and wages each month of six gold florins."

Curiously, only three months earlier Michelangelo had traveled to Siena to accept the commission from Cardinal Piccolomini to provide fifteen statues for a monument in the local cathedral honoring his uncle, Pope Pius II. The contract not only stipulated that "they are to be of greater quality, better made, and finished with greater perfection than the modern sculptures that are in Rome today," but Michelangelo also promised "not to undertake any other work in marble or anything else that will delay him." Michelangelo violated the terms of that contract when he agreed to carve the *David,* demonstrating his almost compulsive need to set his sights on the next artistic summit before he had even scaled the first. The proof that he was biting off more than he could chew is that after many years of procrastination he com-

pleted only four of the proposed statues, and these only with considerable help from assistants.

It was the commission for the *David* that really excited him, and Michelangelo was willing to risk angering the cardinal in order to carve a figure that would rival the great colossi of the ancient world and assure his fame both in Florence and abroad. In deceiving the cardinal, Michelangelo was also deceiving himself. His faith in his own abilities encouraged him to promise more than he could possibly deliver, a habit at once dishonorable and self-defeating. Pursuing the *David* while neglecting the Piccolomini monument was a typically questionable business decision since he'd been promised 500 ducats to complete the latter, while he was originally promised only six gold florins a month for the former, an amount less than half as great.

The most generous explanation for Michelangelo's behavior was that he was keen to help out his country in its hour of need. The *David* was a potent symbol of Florence's will to endure, while the Piccolomini monument was just another vanity project for a wealthy prince of the Church. No matter how many years he lived abroad, Michelangelo was always devoted to Florence, and the patriotic aspects of the commission would certainly have appealed to him. But he was also seduced by the purely artistic challenge of carving a giant figure in the round. Michelangelo was not only personally ambitious but determined to elevate his profession. How better to achieve this goal than by creating a monumental figure that would astound, inspire, and amaze?

Interest in the project was already high. Florentines took their art seriously and clung to their cultural heritage even when their fortunes in other areas were in decline. Earlier that year Leonardo had opened his studio to display his latest creation, a drawing of the Madonna and St. Anne for an altarpiece he was painting at Santissima Annunziata. According to Vasari, "men and women, young and old, continued for two days to flock for a sight of it to the room where it was, as if to a solemn festival, in order to gaze at the marvels of Leonardo, which caused all those people to be amazed." Among those making his way to the studio was Michelangelo himself, whose admiration for the work was tempered by jealousy of a man who now enjoyed the acclaim he craved.

Despite his thirst for glory, Michelangelo made little attempt to ingratiate himself with the public. For most of the period he was carving the monumental statue, the citizens of Florence were effectively shut out. He built around his worksite "an enclosure of planks and masonry" to discourage visitors and conceal what he was doing from prying eyes. As always, Michelangelo preferred to work in solitude, springing his masterpiece on a populace whose excitement would have been primed by months, even years, of waiting.

According to a note inserted into the margin of the contract, "Michelangelo began to work and carve the said giant on 13 September, 1501, a Monday; although previously, on the 9th, he had given it one or two blows with his hammer, to strike off a certain [nodule] that it had on its breast. But on the said day, that is the 13th, he began to work with determination and strength."

Hacking away at an upright column more than three times the height of an average man posed particular logistical problems. The massive block had already been raised to a vertical position by the Operai del Duomo before their initial inspection, but before he could begin to work, a scaffolding had to be erected to allow the artist to reach every part of the column with ease. Michelangelo began cutting away at the block with the *subbia*, a heavy, pointed tool made of iron that was used to rough out the principal masses, before employing the shorter blade known as the *calcanguolo*. By the time he reached for the *gradina*, the claw-toothed chisel whose marks are clearly visible in many of Michelangelo's unfinished sculptures, the basic form of the statue was already emerging from the surrounding matrix like a bather rising from the tub.* It was with the *gradina* that the statue began to come to life, as muscle and sinew, protuberant bone, and supple flesh were defined by the caress of the iron blade wielded by a skilled hand. In the case of the *David*—and on every occasion when he was actually able to complete the

*One can see the marks left by the toothed *gradina* in many of Michelangelo's works, including the *Pitti Tondo* and the *Taddei Tondo*, as well as his unfinished *Captives*. In highly finished works like the *Pietà* and the *Bruges Madonna*, almost all such traces were eliminated in the final polishing.

work—the forms would be refined further with rounded files and straight rasps, before receiving the final polish with pumice stones.

It was, as the courtly Leonardo sniffed, grubby work, "a very mechanical exercise, causing much perspiration which mingling with the grit turns into mud . . . and [the sculptor's] dwelling is dirty and filled with dust and chips of stone." Adding to the usual difficulties of carving such a monumental sculpture, Michelangelo had to extract his masterpiece from a damaged block. Vasari, for one, stressed the sorry state of the column in order to highlight the miracle of Michelangelo's achievement, though his credibility is undercut by the fact that he mistakenly attributed the initial bungled attempt to one Maestro Simone da Fiesole, rather than Agostino di Duccio. Condivi's account is more laconic. He simply notes that the previous artist "was not so skillful as he ought to have been."

Vasari's exaggerations aside, it is clear that Michelangelo was confronting less-than-ideal conditions. The Operai themselves noted that the stone "had been badly blocked," and even had the job been competently done, Michelangelo would still have been forced to fit his own figure into contours meant for a very different form. The officers themselves recognized the hurdles he faced, and before offering the contract to the young sculptor they requested from him a small-scale model in wax to demonstrate how his ideas could be realized. In fact, for all its beauty, the *David* still shows some of the constraints imposed by the unusual dimensions of the roughed-out piece of marble, particularly in the shallow space into which Michelangelo had to squeeze his hero's massive frame.

Michelangelo worked at his usual furious pace and by February 1502 he had made such progress that the officers of the Arte della Lana agreed to pay him an advance of 400 gold florins, far more than the fee originally proposed. He might have completed the statue earlier but for the fact that six months later progress was stalled when Michelangelo took on another project—to produce a life-size David in bronze for the politically well-connected Pierre de Rohan, the Maréchal de Gié. This time it was not a question of Michelangelo shirking his duty; in fact, he made it clear he had no interest in the new commission, which was far more conventional than the monumental *David* he was already carving and required him to work

in what for him was the uncongenial medium of bronze. The contract was practically forced on him by Florence's Dieci di Balia (the Ten of War), who wanted to remain on friendly terms with the French marshal, one of the most important figures at the court of King Louis, Florence's chief foreign protector. The *maréchal* had been contemplating the commission since 1494 when, in the company of his master, King Charles, he resided at the Medici Palace during the French occupation of the city. During those weeks he had fallen in love with Donatello's bronze *David*, which stood in the courtyard. Recalling the exquisite sculpture eight years later, he wrote to the Dieci expressing his great desire to obtain a version of that famous work for his own collection. Given the importance of French goodwill for the continued survival of the Republic, Michelangelo was obliged to comply with his government's urgent request.

This incident illustrates once again the vital link between art and politics in sixteenth-century Italy. Particularly in Florence, as culturally vibrant as it was militarily feeble, art was a powerful tool of diplomacy and statecraft. Politicians and the governments they led were second only to princes of the Church as patrons of the kind of large-scale commissions that excited Michelangelo, and he could ill afford to offend those who ruled the state.

Unlike the famous *David* in marble, this smaller version in bronze—like the Donatello upon which it was modeled—showed the shepherd boy standing on the severed head of Goliath—that is, *after* the victory is already won. Michelangelo was forced to adhere to this traditional iconography because the French marshal expected the new work to follow, if not to replicate, the one he admired, a restriction that further diminished the artist's enthusiasm for the project. Michelangelo's bronze has long since vanished, so we can only guess at its appearance, but one clue may be found on a sheet of sketches in Michelangelo's hand that includes a figure resembling available descriptions. It shows a young David posing jauntily with his right foot on the head of his defeated foe. One hand rests on his outthrust hip, the other—which appears to hold the knife with which he has just hacked through Goliath's neck—rests on his right thigh. Whether this drawing represents his initial conception of the monumental marble or a sketch for the lost bronze,

Michelangelo, *Studies for the David*, c. 1501. © *RMN-Grand Palais/Art Resource, NY*

it possesses little of the nobility, poise, and grandeur the world has come to associate with Michelangelo's colossus.

Since paper was expensive, Michelangelo often reused the same sheet for multiple sketches. In addition to the rapid sketch of the victorious David, this particular sheet also includes a much more careful drawing of the marble *Gigante*'s right arm, the one that clutches the stone he will soon launch at Goliath to deadly effect. Next to these studies Michelangelo inscribed a brief couplet that offers some insight into the artist's state of mind: *"Davicte cholla fromba,/e io choll' arco/Michelagnolo"* (David with his sling, I with the bow. Michelangelo.) The meaning, at least on the surface, is clear: Just as David slays the Giant with his sling, so do I, Michelangelo, slay him with my bow. The bow almost certainly refers to the *trapano*, the bow-shaped hand drill that was a common tool in the sculptor's kit. But who is the giant he intends to overcome? On the most obvious level he represents the herculean task the artist has set himself, one in which he expects to emerge victorious despite difficult circumstances and in the face of skeptics. Michelangelo identifies with the biblical hero, casting himself as a patriotic warrior who uses his particular gifts not only to advance his art but as a weapon in the virtuous struggle of Florence against its enemies.

But there is more to these lines than mere chest-thumping. Michelangelo always conceived the sculptor's craft as a metaphysical quest. This most material of art forms becomes in Michelangelo's conception a means of probing for pure spirit beneath a shell of gross matter, one that defines the artist as well as the matter upon which he works his will. This was not merely an abstract conceit: Michelangelo saw the art of sculpture as, crucially, a process of *self*-discovery, of *self*-actualization. In a passage that was almost certainly known to him, the late classical philosopher Plotinus* used the art of sculp-

*Plotinus was a third century C.E. Roman philosopher whose mystical teachings were crucial for the development of Christian theology. Though a pagan himself, his idea of the "transcendent One" was easily adapted to a monotheistic religion. Michelangelo may well have been familiar with his works since Marsilio Ficino was translating his *Enneads* in the same years the artist was living in the Medici Palace. The role of Neoplatonism in Michelangelo's art is still a controversial topic, but there is no doubt that the artist was at least familiar with its basic tenets—including the central notion that behind the world

ture as a metaphor for the means by which we perfect our moral selves: "Withdraw into yourself and look. If you do not see beauty within you, do as does the sculptor of a statue that is to be beautiful; he cuts away here, he smoothes it there, he makes this line lighter, this one purer, until he disengages beautiful lineaments in the marble. Do you do this too. . . ." Reversing the analogy, the artist, discovering form within the mass, experiences release from his own carnal nature. The giant slain by the sculptor's bow, then, is in some sense Michelangelo himself, or at least the grosser aspects of his nature that he defeats through the redemptive power of his art.

III. PATRIOTIC HERO

When Michelangelo returned to Florence and accepted the commission for the *David*, he was taking on a public role. In Rome he was employed by various princes of the Church, but as a foreigner he was insulated from the poisonous political atmosphere of that most violent and conspiratorial city. In republican Florence, he could not separate himself from political intrigues or insulate himself from the changing fortunes of his native land—nor was there any indication he wished to. He was a Florentine patriot, eager to serve in any way he could on behalf of his beleaguered compatriots. He might have grumbled when the Signoria saddled him with an unwelcome commission, but he was more than willing to take on the role of his people's champion and chief propagandist.

By the beginning of 1504, the *David* was nearly finished and Michelangelo could no longer ignore demands by leading officials to see for themselves what he was up to behind the high walls of the shed behind the Duomo. Vasari's account of the Gonfaloniere's visit gives the author an opportunity to poke fun at those who thought they could teach the artist his trade:

It happened at this time that Piero Soderini, having seen it in place, was well pleased with it, but said to Michelangelo, at a moment when he was retouch-

apprehended by the senses lies a more profound reality, one that reflects the mind of God.

ing it in certain parts, that it seemed to him that the nose of the figure was too thick. . . . [I]n order to satisfy him [Michelangelo] climbed upon the staging, which was against the shoulders, and quickly took up a chisel in his left hand, with a little of the marble-dust that lay upon the planks of the staging, and then, beginning to strike lightly with the chisel, let fall the dust little by little, nor changed the nose a whit from what it was before. Then, looking down at the Gonfaloniere, who stood watching him, he said, "Look at it now." "I like it better," said the Gonfaloniere, "you have given it life." And so Michelangelo came down, laughing to himself at having satisfied that lord, for he had compassion on those who, in order to appear full of knowledge, talk about things of which they know nothing.

Whether or not the scene occurred exactly as Vasari described, it's the kind of tale Michelangelo relished, since it illustrated his belief that patrons were officious busybodies whom artists were free to ignore. The flesh-and-blood Michelangelo—as opposed to the Apollonian hero of Vasari's imagination—would doubtless have greeted the Gonfaloniere's interference with something more pungent than gentle laughter, but the tensions hinted at in the story were very real. To traditionalists the notion that the artist was a visionary who should follow his own unique genius, without regard to those who employed him, was a novel and somewhat disconcerting concept—not least of all because it reversed the natural social order in which great lords dictated to menial laborers and in which intellectual achievement was the monopoly of men who never dirtied their hands. This was a world turned upside down, a world in which the creative contribution of the artist was increasingly decisive while the role of those who initiated and paid for the work was belittled. Vasari's anecdote was one more salvo in an ongoing struggle between artists and patrons over who controlled the making and the meaning of art. It was a war in which Michelangelo himself was the most able general, a leader whose charisma and tactical brilliance scattered his adversaries in headlong flight.

Soderini's visit also suggests that the project had undergone a profound transformation since Michelangelo first signed the contract two years earlier. The first indication of the change occurred on June 23, 1503, the "vigil of

St. John the Baptist," when a public viewing of the still-unfinished statue was arranged by city leaders. The viewing reflected intense curiosity on the part of both high officials and ordinary citizens, and Michelangelo reluctantly bowed to the pressure. Since the Feast of St. John was the equivalent of our July 4th—the desert preacher was the city's patron saint, and Florence was known as the City of the Baptist—the date was fraught with symbolism, an indication, perhaps, that the project had already been taken out of the hands of the Opera del Duomo and co-opted by the politicians.

Given that *Il Gigante* was now apparently viewed as a kind of public trust, a reappraisal of its intended location was in order. As a biblical hero, the future king of Israel was eminently suited to the sacred context of the cathedral, a powerful symbol of virtue triumphing over a godless enemy. But throughout Florentine history, David had been explicitly linked in the public's mind to the city's political and military fate. He was the defender of his people against an implacable foe, a citizen-soldier taking up arms in a moment of crisis. The crucial symbolic role of David in Florentine political life is captured in an inscription placed on the base of Donatello's bronze statue: "The victor is whoever defends the fatherland. God crushes the wrath of an enormous foe. Behold! a boy overcame a great tyrant. Conquer, o citizens! Kingdoms fall through luxury, cities rise through virtues. Behold the neck of pride severed by the hand of humility."

Michelangelo's colossus had the potential to embody this civic imperative far more effectively than Donatello's epicene figure, particularly since the earlier work was associated with the hated Medici, in whose palace it stood before being brought to the courtyard of the Palazzo della Signoria in 1494. But *Il Gigante* could play a starring role in the civic arena only if he were released from the decorative fabric of the Cathedral where, 40 feet high above the street, his impact would be negligible.

The leading citizens now clamoring for a change of venue may well have been encouraged by an almost century-old act of artistic abduction, one with obvious parallels to the current situation. In 1416, a marble *David* carved by Donatello for the Opera del Duomo and intended for the interior of the Cathedral was relocated to the Palace of the Priors, where it took its place alongside other civic monuments. Driving home the political symbol-

ism of this change of venue, the city fathers added a patriotic inscription to the pedestal: "To those who fight bravely for the fatherland the gods will lend aid even against the most terrible foes."

It's difficult to know the precise role Michelangelo played in the decision to move the *David* off his perch just below Brunelleschi's soaring dome, but there can be little doubt he approved of the change. In fact, it seems likely that shortly after signing the contract with the Opera del Duomo he was already casting about for an alternative. Having studied the prospective site, Michelangelo would have realized how unsatisfactory it was, since viewers at street level would receive only the vaguest impression of the work. As Vasari noted, when a sculpture is "to be placed at a great height . . . the finish of the last touches is lost." In the *Pietà*, despite the impeccable finish given to the visible portions, Michelangelo only roughed out those parts that would have been hidden from viewers, or left them out altogether; it's unlikely he would have expended enormous effort on the *David* to render details no one would ever have seen. The delicacy of Michelangelo's carving—particularly the treatment of the abdomen and chest, where David's graceful *contraposto* is realized with a subtlety that relies on a deep knowledge of anatomy—would have been wasted on those craning their necks to see the figure silhouetted against the Tuscan sky.

Of course it's possible that Michelangelo brought his statue to a high degree of finish late in the game, only after learning of the change in plans, but it seems likely that he never anticipated his statue being exiled atop the northeastern buttress of the Duomo. He might well have assumed that as soon as the city fathers had a chance to see the masterpiece taking shape in the shed behind the Duomo they would realize it was worthy of a more prominent site. As Michelangelo himself surely recognized, the power of his conception simply rendered the original project obsolete, demanding a new context and a new conceptual framework. Though there is no documentary evidence to prove it, Michelangelo himself was surely a driving force behind the change, as would be the case for the Sistine Ceiling, where a relatively modest commission was transformed at the artist's insistence into the awe-inspiring panorama we see today.

The debate went public on January 25, 1504, when the Signoria convened

a *pratica*—a kind of ad hoc committee called to resolve particularly thorny issues—to discuss the fate of *The Giant*. Thirty experts and assorted dignitaries assembled in the offices of the Opera del Duomo. Among them were artists, officials, and leading citizens, including such famous names as Leonardo da Vinci, Filippino Lippi, Piero di Cosimo, and Sandro Botticelli, as well as humble artisans like the woodworker Bernardo della Ciecha. "Seeing that the statue of David is almost finished," the official account declared, "and desiring to install it and to give it an appropriate and acceptable location . . . and because the installation must be solid and structurally sound according to the instructions of Michelangelo, master of the said Giant, and of the consuls of the *Arte della Lana* . . . they decided to call together . . . competent masters, citizens, and architects."

The fact that so few speakers called for placing *David* on the buttress of the cathedral suggests that a decision to move the statue had been reached even before the *pratica* was assembled. This was the belief of at least one participant, the architect Francesco Monciatto. Though he was inclined to favor the original site because "it was made to be placed on the external pilasters or buttresses around the church," he admits he's fighting a losing battle. "I advise that since it is quite apparent that you have given up the first plan," he concludes, "then [consider either] the palace or the vicinity of the church."

In all, nine possible locations were considered, but from the beginning the vast majority preferred a site either on the platform in front of the Palazzo della Signoria or in the adjacent Loggia dei Lanzi, the vaulted gallery that formed the southern border to the square in front of the capitol. In either case, most had already concluded that the *David* should be located in the civic rather than religious heart of the city.

Michelangelo himself did not attend the meeting, but his interests were well represented. Numerous speakers, including Filippino Lippi and a jeweler named Salvestro, insisted that the artist was in the best position to know where the work should go. "I believe that he who made it can give the best location," Salvestro said, "and I think that it would be best in the vicinity of the Palazzo, and he who has made it, without a doubt, knows better than anyone else the place most suitable for the appearance and manner of the figure." The notion that the artist should control the presentation of

his work reinforces the point Vasari was making in his anecdote about the Gonfaloniere's visit to Michelangelo's workshop. The humble jeweler, even more than the art historian, articulates the modern belief that it was the artist who determined the meaning of his work—a view with which Michelangelo himself heartily agreed and for which he advocated vociferously throughout his career.

On the surface, the debate involves matters that are largely esthetic and practical: some prefer the loggia, where the statue will be protected from the elements, while others object that in the cramped space the giant figure will be diminished and interfere with the public ceremonies that were held beneath the arcade. But these bland utterances mask a deeper controversy, one that is no less bitter for being largely invisible. Every Florentine knew that the meaning of a work of art was largely determined by its context— something modern audiences, accustomed to viewing paintings and sculptures in the neutral site of the museum, can hardly appreciate. By shifting the locus of meaning from the sacred to the political heart of the city, the panelists were plunging headlong into the maelstrom, rejecting a site marked by consensus in favor of one marred by partisan rancor.

The change of venue meant that the *David* would now participate in the rough-and-tumble of Florentine politics, an emblem not simply of the people as a whole but of a particular party and a specific ideology. Since the fall of the Medici in 1494, the city had been riven by faction. Besieged on every side, the republican government headed by Piero Soderini clung precariously to power, threatened not only by the great powers whose armies marched back and forth across the peninsula but also by domestic malcontents who hoped to overthrow or at least discredit the current regime. The fortresslike Palace of the Priors with its dungeons, bristling crenellations, and high tower, home to the Signoria and the apartments of the Gonfaloniere himself, was a reminder that the government feared civil war almost as much as foreign invasion. The decision to transform a charismatic symbol of the Florentine state into one that stood for distinctly republican values was a courageous act, but one that also underscored the weakness of a regime that felt itself under siege.

Reading between the lines spoken by the various panelists, one can sense

Palazzo della Signoria (Palazzo Vecchio), late thirteenth, early fourteenth century.

a pervasive, almost superstitious anxiety, as if the fate of the republic really did hinge on the correct positioning of Michelangelo's statue. Oddly enough, this attitude is most explicitly reflected in the remarks of Filarete, the Herald of the Signoria, who urged that the *David* be placed on the *ringhiera* of the Palace of the Priors, the platform from which official proclamations were read to the people of Florence. The reasons he gives sound peculiar to modern ears, but they reveal the extent to which the Renaissance imagination was still in thrall to medieval superstition and the belief that works of art possessed powerful magic, for good or ill. If it were located on the *ringhiera* by the main door leading to the palace, the statue would replace Donatello's *Judith and Holofernes*, a good thing according to Filarete "because Judith is a deadly sign and inappropriate in this place because our symbol is the cross as well as the lily, and it is not fitting that the woman should slay the man, and, worst of all, it was placed in its position under an evil constellation because, since then, things have gone from bad to worse, and Pisa has been lost."

What Filarete leaves unsaid, but what all his listeners knew, was that the *Judith* was a Medici commission and, like Donatello's bronze *David*, had stood in the courtyard of their palace until 1495 when it was confiscated by the reconstituted Republic. In fact, the original inscription read: "Piero Son of Cosimo Medici has dedicated the statue of this woman to that liberty and fortitude bestowed on the republic by the invincible and constant spirit of its citizens"—a dedication removed along with many other reminders of the detested family after the revolution of 1494. By raising an astrological objection, the representative of the Signoria disguised his real motive, which was to purge this very public site of anything associated with the former ruling family.

Supernatural and political anxieties tended to flow together; many fretted that the talismanic power of the image would tempt opponents to attack it. The goldsmith known as Il Riccio urged that the *David* be placed in the courtyard of the Palazzo, saying that it "would here be most highly regarded and most carefully watched against acts to damage it." Giovanni the fife player also rejected both the loggia and the platform outside the Palazzo where the statue will be unprotected and "where some wretch may attack it with a bar."

Despite these concerns, Filarete's views won out: Michelangelo's statue would be placed on the *ringhiera* of the Palace, just to the left of the door through which the citizens of Florence passed on their way to argue over great affairs of state.

As it turned out, fears of vandalism were well founded. The apothecary Luca Landucci provides a detailed account in his diary of the statue's progress from the shed behind the Duomo to its final destination. He notes that on May 14, 1504,

> [t]he marble giant was taken out of the *Opera*; it was brought out at 24 in the evening [that is about 8 P.M. since the Florentine day ended at sunset], and they had to break down the wall above the door so that it could come through. During the night stones were thrown at the giant to injure it, therefore it was necessary to keep watch over it. It went very slowly, being bound in an erect position, and suspended so that it did not touch the ground with its feet. There were immensely strong beams, constructed with great skill; and it took four days to reach the Piazza, arriving there on the 18th at 12 in the morning. It was moved along by more than 40 men. Beneath it there were 14 greased beams, which were changed from hand to hand; and they labored until the 8th July, 1504, to place it on the *ringhiera*, where the "Judith" had been, which was now removed and placed inside the *Palagio* in the court. The said giant had been made by Michelangelo Buonarroti.

The four youths arrested in connection with the stone-throwing incident by the Otto di Guardia—the Florentine security committee that dealt with political crimes—all belonged to families affiliated with the Medici, a confirmation that Michelangelo's statue was now regarded not simply as an emblem of the Florentine state but as the standard-bearer of the republican regime. It is no coincidence that at exactly the same time the *David* was being installed in front of the Palazzo della Signoria, the Second Chancellor of the Republic, Niccolò Machiavelli, was preparing his controversial bill to establish a citizen militia. For centuries Florence had fought its wars with mercenary armies, expending treasure rather than blood in defense of the nation. By calling on her own citizens rather than hired guns to do their

fighting, Machiavelli was imitating the example of the ancient Romans and hoping to renew the sense of obligation to the state that led them to greatness. Unfortunately, the brilliant civil servant—whose office was located on the second floor of the Palazzo—left no account of his feelings as he passed this giant statue each day on his way to work, but he would certainly have approved of its belligerent message.

Installed on the *ringhiera* in front of the Palace, *David* stood for sacrifice on behalf of the public good, courage in the face of adversity, and strength in the service of a just cause. He was a reminder that if Florence were to defeat her enemies it would not be through superior numbers but through superior virtue. "It is most foolish . . . to suppose," wrote another famous Florentine, the poet Dante Alighieri, "that the forces of one combatant can be inferior, if God is on his side." Just as David vanquished a stronger foe by placing his faith in the Lord, so Florentines would triumph if they remained true to their values.

IV. THE FELICITY OF MAN

Modern viewers can still get some sense of the statue's original impact by visiting the full-scale copy that stands at the entrance to the Palazzo della Signoria. Of course those descending on Florence these days are tourists rather than armies bent on mayhem, but one can still feel *Il Gigante*'s awesome presence in the square, which still looks very much as it did in Michelangelo's day. Unfortunately, the copy conveys little of the original's exquisite beauty. To appreciate Michelangelo's supreme artistry, we must travel a few blocks north, to the Accademia Gallery, where the original now stands flanked by neoclassical columns beneath an elegantly coffered dome. It is hard to say which is more true to Michelangelo's vision, the pedestrian copy that still provides some sense of how the colossus participated in the civic life of Florence, or the lovingly rendered original that has been taken out of context and turned into a gorgeous object resplendent inside its bland, climate-controlled conceptual bubble. To gain a full appreciation of Michelangelo's achievement, one must imaginatively merge the two, and then cast oneself back five hundred years to a time when the very survival of a nation

teetered in the balance and a work of art could mean the difference between salvation and destruction.

The *David* took its place in a city already chock-full of sculptural masterpieces, from Ghiberti's *Gates of Paradise* on the eastern façade of the Baptistery to Donatello's *St. George* standing vigilant outside the shrine of Orsanmichele. For Florentines, art was not mere decoration but the means by which they projected their values and proclaimed their virtues. Patriotism, piety, and prosperity were all on display, from the humble parish church with its smoke-darkened frescoes to the great civic structures whose hulking forms reminded the citizens of the power and paranoia of the state.

But even in this crowded cityscape the *David* loomed large. This was not only because of his gargantuan size, though this was impressive enough, but because he seemed to proclaim, unabashedly, the new attitude toward Man and his place in the universe. Not since ancient times had an artist conceived a figure as bold, as confident in his own capacities, so certain of his destiny, and so comfortable in his own skin. Michelangelo strips his hero down to (literally) bare essentials. David has no need of the usual tools of warcraft; he is armed with the spirit of righteousness and that is enough. Even his sling is barely noticeable, and certainly not a weapon to take down a giant—unless, that is, propelled by a force that is more divine than human. It is as if David prepares to meet his opponent armed only with the strength of his will, a resolve registered in the slight furrowing of his brow as he peers over his left shoulder in response to the heavy tread of his approaching foe.

Here for the first time, and in spectacular form, is the New Man celebrated by Renaissance writers like Pico della Mirandola. "O highest and most wonderful felicity of man!" Pico wrote in his famous oration. "To him it was granted to have what he chooses, to be what he wills."* Like the ancients they admired, Renaissance artists and philosophers contemplated the human animal and saw in him an almost infinite potential. He is no longer

* This oration is echoed in Hamlet's famous speech: "What a piece of work is a man, How noble in Reason, how infinite in faculties, in form and moving how express and admirable, In action how like an Angel! in apprehension how like a god, the beauty of the world, the paragon of animals." (*Hamlet*, II, 2.)

the weak, sinful creature of the medieval imagination cowering before the harsh judgment of an awesome God. He has come into his own. No longer are we expected to shrink from the world or mortify our flesh, to reject the here and now in hopes of something better to come, but to embrace life and revel in our marvelous faculties. The time we have on earth is no longer dismissed as merely the prelude to life everlasting but an arena in which to prove ourselves worthy of He who made us in His image.

The new conception of Man spelled out in Pico's "Oration" and embodied in Michelangelo's *David* shares much with the worldview articulated by the Greeks and Romans, particularly its celebration of Man's essential dignity. But the differences are as profound as the similarities. Pico was steeped in classical philosophy, ethics, and literature, but his celebration of human achievement was filtered through a thousand years of Christian belief and couched in metaphysics. Critically for Pico, Man's place in the universe was not fixed but determined through the choices he made, for good or ill. In fact, Man's unique attribute was his capacity to shape his own destiny. "Neither an established place, nor a form belonging to you alone, nor any special function have We given you, O Adam," says God the architect,

> and for this reason, that you may have and possess, according to your desire and judgment, whatever place, whatever form, and whatever functions you shall desire. The nature of other creatures, which has been determined, is confined within the bounds prescribed by Us. You who are confined by no limits, shall determine for yourself your own nature, in accordance with your own free will, in whose hand I have placed you. I have set you at the center of the world, so that from there you may more easily survey whatever is in the world. We have made you neither heavenly nor earthly, neither mortal nor immortal, so that, more freely and more honorably the molder and maker of yourself, you may fashion yourself in whatever form you shall prefer.

In Pico's worldview, free will is key to our essential dignity, since without it there is no meaningful way to participate in our own redemption. Mankind's fall derives from Adam's disobedience, but each of us through the way we live our own lives can chart a different course.

Michelangelo's *David* embodies the abstract notion of Man as the architect of his own destiny. His grandeur is conveyed by his enormous size, but there is nothing clumsy about him. He carries himself with ease, in full command of his outsized limbs. He is ready for action, certain that when the time comes he'll be ready for the task at hand. He strikes a relaxed pose, his weight shifted easily to his straight right leg, allowing the left to flex ever so slightly, his torso to twist, in the classic *contraposto*. Only his face conveys the tension of the moment, but even here his expression is one of resolve rather than doubt.

David's poise is reminiscent of the *Apollo Belvedere*, the masterpiece of Hellenistic sculpture that Michelangelo studied during his time in Rome. But the boy hero possesses a dimension lacking in the ancient figure of the god. Both register supreme self-assurance, but while Apollo is almost bland in his superiority to mere mortals, David achieves greatness through action, exhibiting grace under pressure rather than timeless perfection. There is an alertness, a taut expectancy, in the *David* that appears nowhere in the ancient masterpiece. Apollo seems almost disdainful in his eternal beauty. Immortal, he has no need to strive since, to a god, everything is given. He strives for nothing because he lacks for nothing. David, for all his self-assurance, is a verb, not a noun; he represents a state of becoming rather than of being, defined by a supreme act of will. His identity is not complete but forged in battle driven by a fierce spirit.

Of course not all Greek statues convey pure *being* rather than *doing*. The ancients had their warriors and their athletes, men defined by sweat and toil. One thinks immediately of Myron's *Discobolus*, his body a taut spring set to uncoil in a furious burst of purposeful energy. But this latent motion is not animated by a spark of consciousness, much less a deeper spiritual purpose. David, the Lord's warrior, embodies consciousness, moral awareness. He turns his head, looking over his left shoulder. The tendons of his neck stiffen as he responds to some sight or sound that tells him the critical moment is at hand. He knits his brow, his eyes shift in the direction from which his enemy approaches; his nostrils flare ever so slightly. He is not a creature of the placid heavenly realms, nor of the gymnasium, but a spiritual athlete, a man whose identity was forged the moment he took up arms on

behalf of the Lord. Like Pico's Adam, David is the "molder and maker" of himself.

In a sense, Michelangelo's *David* is everything his *Bacchus* was not: firmly in control of himself while the god of wine was teetering on the brink of dissolution; his senses heightened while Bacchus's are dulled. Where one is taut, the other is flaccid. David's toned, athletic body contrasts with Bacchus's effeminate form, illustrating the dichotomy in Michelangelo's mind between the active masculine force and the passive feminine. It is man's role to master fate, and woman's to succumb. David is the supreme example of the masculine principal, the embodiment of mind in complete control of matter.

While Michelangelo's *Pietà* stands outside time, an image of an eternal idea, the *David* achieves its power by squeezing an entire narrative into a single critical moment. Depicting the youthful shepherd on the verge of battle, Michelangelo heightens the dramatic tension. Of course we all know how the story ends, but so much more seems to hang in the balance than in the traditional depiction of the victorious warrior. Compare Michelangelo's *David* to Donatello's wistful champion or Verrocchio's smirking boy, and the genius of his conception is immediately apparent. In those earlier prototypes nothing is at stake: the crisis has already passed; the victor reflects on his triumph with varying degrees of introspection or bemusement, unsure what to do next or what it all means. Michelangelo's *David*, by contrast, seems to stare down not only Goliath but the future, determined to give his all, confident in his cause but as yet uncertain of his fate. It is determination in the face of uncertainty that defines true heroism, a trait nowhere more eloquently portrayed than in Michelangelo's *Gigante*.

Florentines immediately embraced the *David* as their *insegna*, the emblem of the resurgent Republic. Michelangelo's hero was not responsible for the wave of patriotic fervor that swept the city at this time, but the colossus became a visible manifestation of that civic pride and a rallying point for those who pinned their hopes on a government chosen by the people themselves. Like the just-completed Hall of the Great Council in the Palazzo—where citizens engaged in raucous debate about the pressing issues of the moment—he

stood not only as the champion of Florence but of its republican institutions. A few months after his installation on the platform in front of the seat of government, Machiavelli's citizen militia paraded across the piazza "each [in] a white waistcoat, a white cap, shoes and an iron breastplate. . . ." It was, wrote Luca Landucci, catching the euphoric mood, "the finest thing that had ever been arranged for Florence." While Michelangelo's masterpiece functioned on a symbolic level, Machiavelli's squadrons made a practical contribution as they added their considerable weight to the forces besieging Pisa.

But this starring role on the public stage did not last long. The *David* was born at a time of anxiety about the survival of the Republic, in response to a military and political crisis. His air of steely resolve gave renewed hope to an anxious people, but from the beginning the *David* seemed bigger than the cause he served. Like Machiavelli's *The Prince*, written nine years after its installation in the piazza, the *David* reminded Florentines of their glorious past in order to prod them to future greatness, while largely ignoring the grim realities of the present. Florence, in fact, was already a city in decline. It took only another quarter century for the Republic to vanish altogether following a doomed struggle against a Medici pope. In an odd twist of fate, the *David* was severely damaged in this last spasm of civic idealism when, during an anti-Medici riot, a stone bench tossed from the upper floors of the Palazzo broke off its left arm.* By the time the statue was repaired, the Republic he represented no longer existed.

Over the years, the *David* has been domesticated. He has been shorn not only of his specifically ideological connotations but of his place in the civic arena. Writing from half a century's remove, Vasari downplayed the sculpture's partisan dimension, focusing instead on its "beautiful contours" and its "harmony, design, and excellence of artistry." Insofar as he retained any political significance, the *David* had become a generic symbol, urging those in power to "defend her [Florence] valiantly and govern her justly" rather than a specifically republican device. Vasari's whitewashing of his-

* The pieces of the broken left arm were salvaged by a young Giorgio Vasari, along with his friend Francesco de' Rossi, and stored until they were eventually reassembled.

tory is not surprising given the fact that, as a servant of Grand Duke Cosimo de' Medici, the statue's republican origins might prove embarrassing to his employer. Long before 1873, when the *David* was finally removed from the Piazza della Signoria, it had ceased to function as a symbol of the independent Republic. Its placement beneath the coffered dome of the Accademia merely confirmed an evolution centuries in the making, from embodiment of republican virtue to *objet d'art*, defanged, estheticized, universalized.

If this transformation has weakened the impact of the statue, Michelangelo himself was complicit in this neutering. More than any other artist before him, he stood for the proposition that art formed a distinct realm of meaning, that it should be insulated from the noise of civic or doctrinal debate and from the petty demands of those who paid his salary. Throughout his long career he fought with patrons who interfered in his creative process and bridled at the notion that his work served any cause beyond art itself. No matter who commissioned the work, and for whatever purpose, Michelangelo demanded the freedom to do as he pleased, insisting that art followed its own rules and served its own purposes.

In the case of the *David*, Michelangelo knew that his work would long outlast the fragile state that had given it life. He was too proud, too much the consummate craftsman, ever to sacrifice his art for the sake of a cause, no matter how much he may have believed in it. The *David* shares the fate of most artifacts created at a particular time and place and made for a particular purpose: plucked from its original setting, function gave way to pure form. Vasari is both a witness to and a participant in this process, inscribing the *David* firmly within the history of style rather than in the dramatic story of a people clinging to their ancient liberties.

From a twenty-first-century perspective, the *David* belongs securely to the world of art rather than politics. To art historians, he represents perhaps the most eloquent expression of what is called the High Renaissance, that brief moment lasting from the 1480s when Leonardo painted his first masterpieces to the death of Raphael in 1520. The greatest works of this era are characterized by a grandeur of utterance and a perfection of means, by unmatched technique in the service of eternal truths. A delicate balance is

maintained between the Real and the Ideal. The greatest works of this era exude confidence, a heroic vision of Man as not only the measure of all things (as the Greek philosopher Protagoras believed) but as the summit of God's Creation.

Such moments are rare and difficult to sustain. The search for perfection is inherently quixotic, undermined by internal contradictions. One can see this in the *Pietà*, where harmony is achieved only through a distortion of plausible fact, a distortion so artfully concealed that we barely notice the trick. The *David* is likewise poised precariously between plausible realism and aspirational idealism. In fact, many have criticized the statue for erring on the side of prosaic fact, describing the biblical hero as awkward, gangly, his hands and feet too large and his features lacking in nobility. And it's true that he doesn't exhibit those ideal proportions as set down by the architect Vitruvius and espoused in the Renaissance by Leonardo in his famous "Vitruvian Man," a system by which "the famous painters and sculptors of antiquity attained to great and endless renown." Compared to Leonardo's famous figure, the *David* is long and lean, his proportions determined intuitively rather than according to a predetermined mathematical formula. Michelangelo adheres to the less rigid approach favored by Vasari: "the eye must give final judgment, for, even though an object be most carefully measured, if the eye remain offended it will not cease on that account to censure it."

But while the *David* exhibits traces of a prosaic realism (the last vestige, perhaps, of immaturity on the part of a still youthful artist), he is also an ideal—Man as the hero of his own narrative. Indeed, realistic touches like the tousled hair and knobby knees that recall an adolescent model more than a Greek god save the work from sterile formalism. They breathe life into the gargantuan figure, as if one can still see the shepherd boy in the holy warrior. Compared to the *Apollo Belvedere*, David appears a bit uncouth, but that merely heightens our appreciation of his nobility and steadfastness of purpose. He is a boy, but a boy imbued with the spirit of the Lord. No one can contemplate his alert yet confident pose and not come away with a renewed faith in human potential.

In the *David*, Michelangelo unabashedly celebrates the beauty of the male

form without reserve, without remorse.* There is none of the morbidity, the sense of shame and wracking guilt that characterizes much of his later work and that is apparent in much of his poetry. David is not a figure at war with himself; there are none of those contortions that bespeak inner turmoil or metaphysical discomfort. The *David* is fully in command of himself, untroubled by doubt. This is the work of a young man who surveys the horizon and believes there is nothing he cannot achieve. "David with his sling, I with the bow." The artist and his subject are perfectly matched, each supremely confident, each out to conquer the world. This unclouded view of the future will not long endure, either in the artist's work or in the work of his colleagues, but for a brief moment both the artist and his creation seem capable of carrying the world on their shoulders.

V. TWO BATTLES

With the installation of the *David*, Michelangelo became the most celebrated sculptor in Europe, his reputation as an artist surpassed only by that of Leonardo. The presence of the two great artists in Florence at the same time was bound to stoke competitive fires in these ambitious men, particularly the younger Michelangelo, who felt he had more to prove. Their rivalry was as much a product of their contrasting temperaments as their common genius. As a youth, Leonardo was known for his beauty, gracious manner, and multifaceted talents (he had a fine singing voice and improvised brilliantly on the lute), while Michelangelo was famously homely, antisocial, and narrowly focused on perfecting his art. The "celestial" Leonardo was cool, elegant, and aloof; Michelangelo was intense, disheveled, and irascible. These differences, in turn, determined the nature of their interaction. While Leonardo's instinct was to ignore or gently mock his younger colleague, Michelangelo lashed out at his rival.

Leonardo had just turned fifty-two when the *David* made its debut in

* The authorities, however, were not so open-minded. Upon installation, a garland of twenty-eight copper leaves was draped around his waist to conceal his private parts.

the Piazza della Signoria. He was already the grand old man of Italian art, a legendary figure whose actual achievements never quite seemed to measure up to the brilliance of his mind. "[S]o great was his genius," wrote Vasari, "and such its growth, that to whatever difficulties he turned his mind, he solved them with ease." Unfortunately, Leonardo constantly turned to new difficulties before he had brought the old ones to a satisfactory conclusion, leaving behind a catalogue of uncompleted or ruined projects even more disappointing than that compiled by Michelangelo. One frustrated patron complained: "This man will never do anything. Here he is thinking about finishing the work before he even starts it!"

In 1500, Leonardo had returned to his native Florence, where he offered his services as a military engineer in the war with Pisa, then in its sixth year and apparently going nowhere. With the support of the Second Chancellor of the Republic, Niccolò Machiavelli, he launched an ill-conceived project to divert the Arno River, but like so many of Leonardo's grandiose projects, this one ended in failure when sabotage and a sudden rainstorm caused the weirs so laboriously constructed to collapse.

Da Vinci's artistic efforts during these years met with better success. Taking time out from his military responsibilities, Leonardo produced a few panel paintings on commission from private citizens and religious institutions. While Michelangelo was hard at work on the *David*, Leonardo began his portrait of the wife of a prominent Florentine businessman, Francesco del Giocondo, incorporating into the background those landscape studies he made while pursuing the pipe dream of diverting the Arno River. The origins of this portrait, now known as the *Mona Lisa*, are shrouded in mystery, but for the most part Leonardo, always a showman, was happy to let the public follow his progress. While he threw open the doors to his studio, allowing the crowds to gawk at his latest creations, Michelangelo built high walls to shut them out.

One incident in particular reveals the depth of Michelangelo's animosity. It comes from an anonymous account of 1544, one that could be dismissed as apocryphal except for the fact that it corresponds so closely to other well-documented outbursts. One day, so the story goes,

Leonardo . . . was walking by the benches at Palazzo Spini, where there was a gathering of gentlemen . . . debating a passage of Dante. They hailed said Leonardo, saying to him that he should discourse to them on this passage. And by chance at this point Michelangelo passed by and was called over by one of them, and Leonardo said: "Michelangelo will explain it to you." It seemed to Michelangelo that Leonardo had said this to mock him, and he replied with anger: "You explain it yourself, you who have made the design of a horse to be cast in bronze but who was unable to cast it and abandoned it in shame." And having said this, he turned his back on them and left. Leonardo remained there, made red in the face by his words.

The clash between the haughty Leonardo and the insecure Michelangelo has the ring of truth, but the rivalry between the two great men was far more fruitful than the pettiness of this incident would suggest. Surprisingly, the most explicit case of one artist quoting the other comes in a drawing by Leonardo that is both an homage to Michelangelo's *David* and a subtle critique, as he "corrects" some of the perceived flaws of the original, including, most tellingly, its un-Vitruvian proportions.*

But for the most part, the influence flowed in the other direction. Michelangelo was too dedicated to his craft to ignore the achievement of the older man, though he was reluctant to admit a debt to any artist, particularly one he disliked. Three works Michelangelo made during these years in Florence show him responding directly to the challenge posed by Leonardo. Two relief sculptures, the *Taddei Tondo* and the *Pitti Tondo*, as well as a panel painting of the Holy Family known as the *Doni Tondo*, reflect Michelangelo's attempt to grapple with and, he surely hoped, to surpass Leonardo's powerful legacy. In paintings like *The Last Supper, The Madonna of the Rocks*, and *The Madonna and Child with St. Anne*, as well as the drawings of the same subject, Leonardo had imbued his figural groupings with a psychological depth and formal coherence unmatched in the history of art. Each figure

* Leonardo's so-called Neptune is clearly a version of Michelangelo's *David*, but he is far stockier than the original. Since Leonardo, unlike Michelangelo, showed his working drawings in public, the younger artist may well have seen this "improved" version.

responds to the others with the sympathy of an instrument in a string quartet as Leonardo weaves a richly textured score made up of minute gestures and subtle expressions. His characters are as fully realized as characters in a novel by Tolstoy, appearing to possess deep inner lives marked by both joy and sorrow. Compared to these works, Michelangelo's *Madonna of the Stairs*, his earliest exploration of the mother-child relationship, seems crude and unconvincing, and even his *Pietà* falls short in terms of conveying a fully rounded subjective experience.*

Michelangelo was perceptive enough to know that he could not simply dismiss Leonardo's achievement; instead, he hoped to find an equivalent using his own distinctive vocabulary of forms. The three *tondi*† Michelangelo made in the years 1503–5 represent his fullest response to his rival, but in challenging Leonardo on his own turf Michelangelo demonstrates the limitations of his own art. In none of these works does he achieve the psychological penetration of Leonardo at his best. The two relief sculptures in particular feel unresolved (as well as incomplete, as if Michelangelo realized they were not entirely successful). In the *Taddei Tondo* the figures seem to fly apart rather than cohere, tugged at by centrifugal forces, while in the *Pitti Tondo* the distracted gaze of the Madonna induces a psychological discomfort that recalls the *Madonna of the Stairs*.

The *Doni Tondo* (also known as the *Holy Family*), painted in 1503–4 to commemorate the wedding of Michelangelo's friend Agnolo Doni to Maddalena Strozzi, is Michelangelo's most powerful and fully realized response to Leonardo. As the only finished panel painting from Michelangelo's hand, the work is a particularly precious document, but, like the reliefs with which it is closely associated, it reveals both his strengths and his weaknesses as an artist. No one, not even Leonardo, could have conceived a composition of such striking originality. The figure of the Virgin Mary reaching back to

* From this same period comes the so-called *Bruges Madonna*, commissioned by Flemish merchants in Florence. Like many of Michelangelo's treatments of the Madonna and Child, the *Bruges Madonna* is characterized by an emotional distance between Mary and her infant son.

† A *tondo* is a painting or relief in the round. The name comes from the Italian word *rotondo*, meaning "round" or "circular."

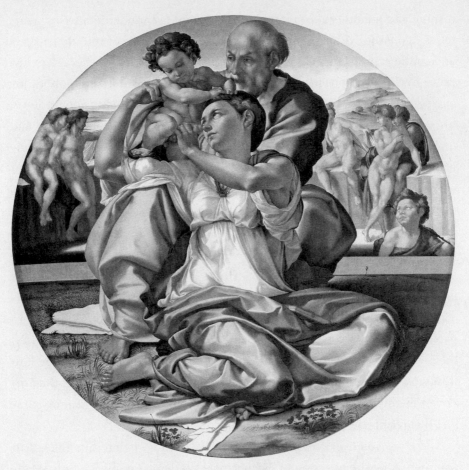

Michelangelo, *Doni Tondo*, c. 1504.

receive her child from the hands of Joseph is particularly audacious, mother
to all those torqued bodies of the Sistine Ceiling and Medici Tombs. Such
strenuous exertion feels awkward in the context of what is meant to be an
intimate family moment, but Mary's serpentine pose demonstrates Michel-
angelo's unmatched gift for eloquent physicality. Leonardo was a brilliant
portraitist, conveying psychological nuance through a twitch of a finger or
a coy, sideward glance, while Michelangelo—who had almost no interest in
individual faces—was a supremely gifted choreographer, forcing his figures
to leap and strut like acrobats across the stage. Leonardo's characters are
introverts, the richness of their interior lives only hinted at in mysterious

half smiles, hooded eyes, and fleeting tremors. Michelangelo's are extroverts, enacting cosmic dramas through vigorous flexions and improbable contortions.*

Leonardo was fascinated with the ephemera of visual perception, the subtle variations of light and weather that transform each moment into a shimmering veils of worm glow and murk. His is a world always in flux, moving from dawn to dusk, from morning mist to evening's shadowed mystery. Michelangelo's is a noontime world where everything declares itself immediately. He had no use for Leonardo's famous *sfumato*, the atmospheric haze that softens every contour and submerges form beneath an enveloping penumbra. Michelangelo deploys shading only sparingly, not to mask contours but to give them greater clarity. Even as a painter Michelangelo is essentially a sculptor, defining each figure in bold relief. He plunks Joseph, Mary, and Jesus down in a spare landscape lit by a probing sun and robes them in acid-hued fabrics, creating jarring dissonances that are the antithesis of Leonardo's muted harmonies. If the complexity of Michelangelo's family grouping ultimately derives from Leonardo's ensembles, in everything else he flees as fast as he can in the opposite direction.

There is something defiant about this painting, even pugnacious, as if Michelangelo were deliberately picking a fight with the older artist. Whether or not he succeeded in beating the master on his own turf is debatable. Even the man who commissioned the painting had second thoughts, apparently, refusing to give Michelangelo the money he'd been promised. When Doni's agent informed the artist he'd only pay 40 ducats instead of the 100 initially agreed to, Michelangelo lost his temper, now demanding 140 ducats in order to punish his friend for his insolence. In the end, Doni paid the higher sum, withering in the face of the artist's wrath.

Despite Agnolo Doni's misgivings, Michelangelo was now an artist very much in demand. Even before completing the *David*, the Arte della Lana

* Michelangelo's approach recalls the one recommended by Alberti in *On Painting*: "[W]e weep with the weeping, laugh with the laughing, and grieve with the grieving. These movements of the soul are made known by movements of the body." (Book 2, 77.)

awarded him another major contract, which, had he fulfilled the terms, would have tied up his services for years to come. Signed in April 1503, it called on Michelangelo to carve for the cathedral twelve life-size statues depicting the Apostles of Christ, at the breakneck speed of one a year. The leaders of Florence apparently recognized what a treasure they had in their gifted son and wished to keep him gainfully employed for the foreseeable future. To sweeten the pot they provided him with a studio on the Borgo Pinti, just to the east of the Duomo, built to his own specifications. Like so many long-term programs, however, it fell victim to changing circumstances. The only relic of this ambitious project is the partially completed *St. Matthew* now in the Accademia, whose muscular build and vigorous pose are harbingers of things to come.

So far the rivalry between Leonardo and Michelangelo was one-sided, confined largely to the imagination of the younger artist. But the contest between the two giants of Italian art was about to be waged on a far grander scale and for stakes that not even the complacent Leonardo could ignore.

Construction of the Hall of the Great Council in the Palazzo della Signoria had been largely completed by 1496, but after seven years the walls of the cavernous chamber had yet to receive suitable decoration. The Great Council was the principal deliberative body of the state, cornerstone of the Savonarolan reforms of 1494, and it was in this hall that the leading citizens gathered to debate the great issues of the day. Thus the blank expanse of unadorned plaster represented both an embarrassment and an opportunity for the current regime.

In the fall of 1503, Piero Soderini approached Leonardo to create for the hall a monumental fresco of a suitably uplifting scene. Like Michelangelo's colossus soon to stand guard at the entrance to the palace, the mural was part of the government's ongoing project to rekindle the patriotic ardor of the Florentine people. And while the two works were too dissimilar in form to invite direct comparisons, both artists—each now a salaried propagandist for the state—were firmly inscribed within the same orbit, where proximity and natural competitiveness made a collision almost inevitable.

The subject of Leonardo's fresco was *The Battle of Anghiari*, depicting a rare victory by Florentine forces over those of Milan. Leonardo set up shop

in the Sala del Papa (Room of the Pope) in Santa Maria Novella, one of the few spaces in town large enough to accommodate the 22-by-54-foot cartoon that would serve as a guide for the actual painting. For Leonardo, one of the many advantages the painter enjoyed over the sculptor was that his more gracious profession afforded an opportunity to hold court. "[T]he painter sits in front of his work at perfect ease," he wrote in his *Paragone*:

> He is well dressed and handles a light brush dipped in delightful colors. He is arrayed in the garments he fancies, and his home is clean and filled with delightful pictures, and he often enjoys the accompaniment of music or the company of men of letters who read to him from various beautiful works to which he can listen with great pleasure without the interference of hammering or other noises. . . .

How different this dandyish lifestyle from Michelangelo's sordid, hermitlike existence! While the sculptor toiled away in secret in his shed behind the Duomo, Leonardo welcomed his fellow citizens. Once again his tidy workroom became a site of pilgrimage for the city's many painters and sculptors who hoped to learn from the master, as well as ordinary citizens who just came to gape in wonder.

And, as before, the great man did not disappoint. Instead of offering up a pompous scene of military pageantry, Leonardo evoked what he called "the beastly madness of war" through a swirling maelstrom of horse and rider caught up in a savage contest where victor and vanquished alike are reduced to madness. "[R]age, fury, and revenge are perceived as much in the men as in the horses," Vasari recalled.* It was hardly the triumphalist celebration his patrons might have hoped for but, as was so often the case with Michelangelo as well, Leonardo's mercurial genius made the outcome of any commission unpredictable.

Soderini was less concerned, in any case, with Leonardo's idiosyncratic

*Ironically, it was Vasari who, half a century later, covered over Leonardo's damaged fresco with his own battle scenes. Recent attempts to find traces of Leonardo's masterpiece behind Vasari's bombastic paintings have so far proven fruitless.

interpretation than he was with his erratic behavior. For all the brilliance
of his conception, da Vinci had difficulty following through, as if after an
initial creative burst he lost interest in the practicalities. "Leonardo da Vinci,"
the Gonfaloniere complained to Jafredo Carolo, Bishop of Paris, "has not
comported himself with this Republic as one should, because he has taken a
good sum of money and given small beginning to a large work that he was
to execute."

While officials nagged, Leonardo put down his brushes, refusing to paint
in the face of what he considered bureaucratic micromanagement. After
withholding payment for some months, on May 4, 1504, officials drew up a
new contract spelling out the obligations of each party, "enacted in the pal-
ace of the aforementioned Lords, in the presence of Niccolò son of Bernardo
Machiavelli, Chancellor of the aforementioned Lords, and Marco, of ser
Giovanni Romenea, citizen of Florence, as witnesses."

In October, Piero Soderini and his advisors decided to fresco the wall
adjacent to Leonardo's *Battle of Anghiari* with a scene taken from an earlier
war between Florence and Pisa. In keeping with the Renaissance belief that
men performed best when engaged in a struggle for fame and fortune, they
assigned this project to the man most likely to treat the commission as an
opportunity to show up his colleague—Michelangelo Buonarroti. Soderini
was certainly aware of the rivalry between the two artists, hiring the younger
man "in competition with Leonardo."

On one level the decision to hire Michelangelo to paint *The Battle of
Cascina* was perfectly understandable. Fresh off the triumphant debut of the
David, Michelangelo had proven his genius as both an artist and propagan-
dist. Not only would the people of Florence profit from employing his talents
once more, but the prospect of the younger artist nipping at his heels might
well provoke the older to reexert himself. But on another level the govern-
ment's choice was bold, perhaps even foolhardy. As Michelangelo was the
first to admit, he was no painter. True, he'd begun his career in the studio
of Domenico Ghirlandaio, one of the most proficient fresco painters of his
generation, but ever since he fled his first master's studio for Lorenzo de'
Medici's sculpture garden, he'd shown a decided preference for work in three
dimensions. Throughout his life he insisted on signing his letters "Michel-

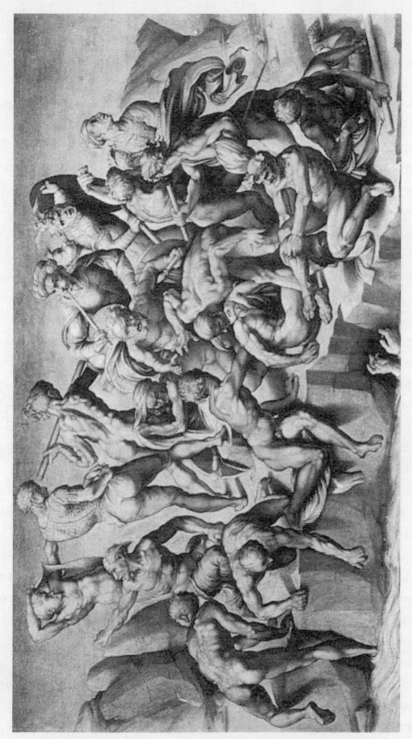

Bastiano (Aristotile) da Sangallo, *Battle of Cascina* (after Michelangelo), c. 1542.

angelo, sculptor," defying the expectations of the day that an artist should
be prepared to employ his talents in varied media. To date, his only sig-
nificant efforts in the medium consisted of two works—the half-completed
Entombment in Rome and the *Doni Tondo*—neither of which could have
given either the Gonfaloniere or the artist himself much confidence. These
modest works would not have prepared him for the notoriously unforgiving
medium of fresco, particularly on such an epic scale.

There is no indication, however, that Michelangelo balked at this assign-
ment as he had over the bronze *David* for the Marechal de' Rohan. No doubt
the prospect of squaring off against the great Leonardo overcame his reluc-
tance. When the public had a chance to view their monumental frescoes side
by side, Michelangelo was certain whose would be judged superior.

As they had for Leonardo, the Signoria provided spacious accommoda-
tions where Michelangelo could prepare the large cartoons for the fresco,
this time at the dyers' hospital attached to the Church of Sant'Onofrio in
the quarter of Santo Spirito. He was soon hard at work making the dozens
of sketches from the live model he would then assemble into the full-scale
cartoon. With the two greatest artists in Italy now hard at work on paintings
of identical size (each was to measure 24 by 54 feet), similar subject matter,
and intended for adjacent walls in the same great hall, art-obsessed Floren-
tines split into two rival camps with all the passion of sports fans before a
championship game.

Both artists played to their strengths. Leonardo, fascinated by fluid dy-
namics, created a swirling vortex of man and beast—horse and rider half
lost beneath a cloud of smoke and dust—a penetrating psychological study
of Man *in extremis.* Michelangelo's composition is more static and more
crisply rendered, in keeping with his tendency to treat painting as if it were
merely a form of low relief. He chose to focus on an episode when a group of
Florentine soldiers were caught by surprise while bathing in a river, a motif
that allowed him to concentrate on his favorite subject, the male nude. The
friezelike arrangement of bodies recalls his earliest sculpture, the *Battle of
the Centaurs*, but now with a far greater command of anatomy and monu-
mental form.

Soon, talk of this clash of Titans spread beyond the borders of Florence,

to Siena, where a young painter was assisting Pinturicchio on his frescoes for the Piccolomini Library. "The reason [Raphael] did not continue at it," Vasari relates,

> was that some painters in Siena kept extolling with vast praise the cartoon that Leonardo da Vinci had made in the Sala del Papa of a very beautiful group of horsemen, to be painted afterwards in the Hall of the Palace of the Signoria, and likewise some nudes Michelangelo Buonarroti in competition with Leonardo, and much better; and Rafaello, on account of the love that he always bore to the excellent in art, was seized by such a desire to see them, that, putting aside that work and all thought of his own advantage and comfort, he went off to Florence.

Michelangelo paid little attention to the arrival in Florence of his future nemesis. Raphael appeared in October 1504, carrying a letter of introduction from Elisabetta Gonzaga, the Duchess of Urbino, to Gonfaloniere Pietro Soderini: "The bearer of this will be found to be Rafaelle, painter of Urbino, who, being greatly gifted in his profession has determined to spend some time in Florence to study. . . . [He] is a sensible and well-mannered young man [and], on both accounts, I bear him great love. . . ."

At twenty-one, Raphael was a handsome youth endowed "with natural sweetness and gentleness . . . agreeable and pleasant to every sort of person." He was also immensely talented—in other words, exactly the kind of man Michelangelo despised, though for the moment he had little to fear from the provincial upstart. Raphael had already shown an immense gift for imitation, aping (and even improving on) the pleasantly old-fashioned manner of his teacher, Perugino, but had not yet given any hint of the originality that would later allow him to challenge the great Michelangelo himself.

The one quality Raphael possessed from the beginning was a gift for profiting from the genius of others. An early drawing of the *David* seen from the back shows him trying to come to terms with a monumentality of form so different from his master's soft, ingratiating style, while a Madonna and Child from this same period offers a striking variation on Michelangelo's *Doni Tondo*. But in these early years Raphael absorbed far more of Leo-

nardo's secrets, creating his own successful formula by painting Madonnas with a sweetness that soon made him a favorite with the city's merchant princes.

Unfortunately, the great contest fizzled even before it began, a victim of circumstance and of the mercurial temperament of the two principals. The hiring of Michelangelo seems, at least for a brief time, to have renewed Leonardo's commitment to the project, but his enthusiasm quickly turned to frustration. Leonardo blamed his failure on the weather, writing: "On Friday, 6 June 1505, at the stroke of one in the morning, I began to paint in the palace. At the moment of picking up the brush, the weather turned bad and the bell began to toll to summon men to their duty, and the cartoon came loose, the water ran, and the jug that held the water broke. And suddenly the weather deteriorated and it poured rain until evening, and it was dark as night."

But the fault had as much to do with the man as with weather. As happened with his ill-fated project to divert the Arno, Leonardo's scheme crumbled when reality refused to cooperate with his grand conception. Dissatisfied with the inherent limitations of the fresco technique, so ill suited to conveying those atmospheric effects he was fond of, he pushed the boundaries of the possible, experimenting (as he had in *The Last Supper*) with techniques that increased the range of expression but failed to stand the test of time. Even before he had completed his vast mural, it began to discolor and even slide from the wall.

Leonardo soon abandoned the project (and the city) in a huff. But while Leonardo's fresco deteriorated rapidly, Michelangelo's never even made it onto the wall. Even before he had completed the cartoon, he was summoned to Rome by the new pope, Julius II:

> [W]hen he sent for me from Florence [he wrote almost two decades after the events he recounts], which was, I believe, in the second year of his pontificate, I had undertaken to execute half the Sala del Consiglio of Florence, that is to say, to paint it, for which I was getting three thousand ducats; and I had already done the cartoon, as is known to all Florence, so that the money seemed to me

*half earned. And of the twelve Apostles that I also had to execute for Santa
Maria del Fiore, one was blocked out, as still can be seen, and I had already
transported the greater part of the marble. But when Pope Julius took me away
from there, I got nothing either for the one or for the other.*

But in his typically self-serving way, Michelangelo was rewriting history. At
the time, he viewed the pope's summons as a splendid opportunity and was
happy to be relieved of his obligations in Florence. Soderini, for his part, was
disappointed, but he could not afford to provoke the new pontiff. He had
no choice but to release the artist, consoling himself for the loss of the great
man's services by calculating how much money he was saving the depleted
treasury.

Despite the twin disasters, both frescoes continued to haunt the imagi-
nation of future generations even as they disappeared from view. Leo-
nardo's fresco was visible for years as a ghostly remnant of a once-great
masterpiece, copied by art students and masters desperate to salvage some-
thing from the wreckage. Michelangelo's cartoon, displayed for many years
in the room where it had been made, was mined by artists who repeated
many of the figures in their own compositions. So influential was this
aborted work that it became "a light to all those who afterwards took pencil
in hand." It was almost literally loved to death as Michelangelo's admirers
tore off pieces and pinned them up in their own studios to learn from at
their leisure. According to Condivi, as late as 1553 one could still see tat-
tered fragments of the great work "preserved with the greatest care like
something sacred."

The prospect of returning to Rome after four relatively peaceful and
productive years in his native land filled Michelangelo with both dread
and excitement. He had no love for the city. The climate was poor, cold and
damp in the winter, suffocating in the summer, and at all times unhealthful,
notorious for the swamps that sickened the inhabitants with malarial fevers
and the crowded slums that were a breeding ground for plague and other
contagions. The dangers imposed by the physical landscape were matched by
those posed by the inhabitants: while the lower classes resorted to banditry
and theft, the great princes indulged in blood feuds and murderous plots.

One resident mourned: "Rome, once queen of the world, is today so fallen that its very inhabitants regard it as only a somber and horrible cave."

But his decision was never really in doubt. The project Pope Julius was proposing was much more to his taste than the fresco he had planned for the Hall of the Great Council, a task he considered unworthy of his talents. What the pope was offering him, in fact, was a commission that finally lived up to his own outsized ambition—an opportunity to create the richest and most spectacular sculptural ensemble ever conceived and executed by a single man.

IV

Creation

[G]ood painting is nothing else but a copy of the perfections of God and a reminder of His painting.

—From Holanda, *Dialogues with Michelangelo*

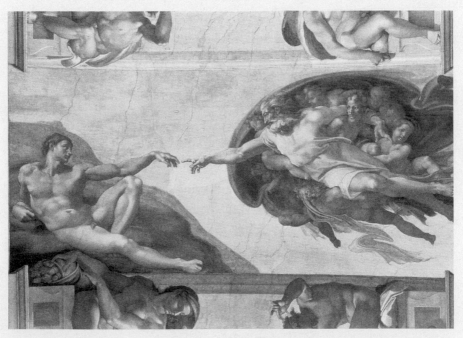

Michelangelo, *Creation of Adam*, Sistine Ceiling, c. 1510–11. *Erich Lessing/Art Resource, NY*

I. IL PAPA TERRIBILE

Michelangelo's new patron was a man whose burning ambition and mer-
curial temperament were more than a match for his own turbulent soul.
Elected pope November 1, 1503, Julius II had already shown himself a far
more energetic and capable leader than any of his recent predecessors.
Known as Il Papa Terribile (the terrifying or awe-inspiring pope), he struck
fear into the hearts of friend and foe alike. Shortly after his elevation, the Ve-
netian ambassador wrote a dispatch to his government in which he painted a
vivid portrait of the latest occupant of St. Peter's throne:

> It is almost impossible to describe how strong and violent and difficult to man-
> age he is. In body and soul he has the nature of a giant. Everything about him
> is on a magnified scale, both his undertakings and passions. His impetuosity
> and his temper annoy those who live with him, but he inspires fear rather than
> hatred, for there is nothing in him that is small or meanly selfish. . . . He has no
> moderation either in will or conception; whatever was in his mind must be car-
> ried through, even if he himself were to perish in the attempt.

The Florentine diplomat Francesco Guicciardini put it more succinctly: "We
have a pope who will be both loved and feared."

Giuliano della Rovere was born in 1443, the son of a poor fisherman in
the village of Albisola near Genoa. Like many bright boys of humble back-
ground, he knew that the Church offered him the best opportunity to rise in
the world. He joined the Franciscans, following in the footsteps of his uncle,
Francesco della Rovere, who himself had risen through the ranks to become
superior general of the order. Giuliano's prospects for a glorious career
improved when his uncle was named a cardinal and again in August 1471,
when Francesco was elected Pope Sixtus IV.

An incorrigible nepotist, Sixtus appointed his nephew to the Sacred
College—bestowing on him his old titular church of San Pietro in Vincoli*—

* As the Cardinal di San Pietro in Vincoli (*ad Vincula,* in Latin), he is often referred to in
contemporary documents as Vincula.

where he was joined by his cousins Pietro and Raffaele Riario. Many of the relatives upon whom the pope lavished his favors were worthless sybarites, but Giuliano was both able and intelligent. Like most of his fellow cardinals, he never let his sacred profession interfere with his enjoyment of life or quench his thirst for worldly glory, but he was genuinely committed to the Church, especially if he could be assured that his fortunes would rise along with those of the institution he served.

In his personal habits Julius was certainly no ascetic. At the dinner table he enjoyed rich foods washed down with strong spirits, and by the time of his elevation he had fathered three daughters by his mistress. But by the lax standards of the day—particularly when compared with the bacchanalian Alexander VI—Cardinal Giuliano was a paragon of sobriety and sexual continence. Power, not carnal pleasure, excited his lust, and he considered militancy on behalf of the Church nothing less than the Lord's work. Early in his uncle's reign he exchanged his scarlet robes for doublet and armor, demonstrating he was more comfortable leading troops in battle than in delivering sermons from the pulpit.

But there was more to Giuliano della Rovere than the rough manners and foul mouth of a soldier. Between campaigns and diplomatic junkets, Giuliano indulged his taste for beautiful things, commissioning original works from the leading artists of the day and vying with collectors like his cousin Cardinal Riario for the latest antiquity unearthed from the farms and vineyards of the *campagna.* Among the masterpieces he acquired for his Roman palace was the *Apollo Belvedere,* once universally acclaimed as the greatest sculpture to survive from the ancient world.

Giuliano's rise to the top was not an uninterrupted string of triumphs. The most serious threat to his career came in August 1492, when he lost out in the papal conclave to his enemy Rodrigo Borgia, who took the throne as Alexander VI. Given the new pope's well-earned reputation for dispatching his opponents with dagger and poison, Giuliano took the prudent course and fled into the protective arms of the French king. He spent the remainder of Alexander's reign in exile, always keeping a watchful eye on the Borgia pope and his formidable son, Cesare.

With the sudden death of his rival in 1503, della Rovere hurried back to

Rome in time to participate in the conclave that elected the doddering Francesco Piccolomini to be Pope Pius III. In fact, Giuliano was instrumental in securing Piccolomini's elevation; during Pius's monthlong pontificate, he worked feverishly to shore up his own support. When Pius fulfilled his part of the bargain by giving up the ghost, Giuliano was ready. On October 31, 1503, in the shortest conclave on record, Cardinal Giuliano finally claimed the prize he'd been seeking all his adult life.

For all his flaws, everyone agreed that Pope Julius was a man of substance. Unlike his nemesis, Pope Alexander—and in contrast to his own uncle—Julius did not place the advancement of his family above the well-being of the Holy Church. "[H]e had gained the reputation of being the chief defender of ecclesiastical dignity and liberty," Guicciardini noted, though the historian also admitted that he had secured his election by "infinite promises which he had made to cardinals and princes and barons, and anyone who might be useful to him in this affair." Perhaps because he had spent decades scheming his way to the top, once there he so thoroughly identified himself with the Church that he viewed its victories as his own and any threats to its prestige as assaults on his person. One can fault him for pursuing a vision that was narrowly focused on worldly rather than spiritual matters, but he was dedicated heart and soul to advancing the faith, at least as he understood it.*

Indeed, Julius saw no contradiction between promoting the greater glory of the Church and promoting himself, particularly now that he had been chosen to lead it. Nowhere was this egotism more apparent than in his plans for his own tomb. Visions of a grand mausoleum must have consoled him during the long years of his exile, and even as the papal miter was being placed on his head, he amused himself by imagining the vast pile of marble that would remind future generations of his greatness. Fortunately, Julius's

* Contemporaries and historians have been almost equally divided on Pope Julius. Some viewed him as the most able of the Renaissance popes, while others condemned him as the epitome of the corrupt prelate. Erasmus wrote a scathing satire of the pope titled "Julius Excluded from Heaven," in which the pope argues (unsuccessfully) for admission to Paradise.

tendency toward bombast was redeemed by a discerning eye: quality was as important to him as quantity, though he preferred not to have to sacrifice one to the other. When it came time to select an artist capable of bringing his grandiose vision to life, his choice naturally fell on the man universally acknowledged as the world's greatest living sculptor: the young Florentine who had already created the exquisite *Pietà* for his former colleague, the Cardinal de San Denis, and whose colossal *David* was deemed a wonder of the modern world. The fact that Michelangelo was currently tied up on at least three major projects for his native city—not to mention the long-delayed monument for the recently deceased Piccolomini pope in Siena—was no obstacle to someone accustomed to getting everything he wanted.

Soderini must have been dismayed when Michelangelo announced his intention to leave Florence and enter the service of the pope, particularly so soon after Leonardo's precipitous departure. Each of these betrayals was a blow to the Gonfaloniere's efforts to revive the city's reputation as a thriving cultural center, confirming the charge often leveled by the regime's critics that on their watch Florence had become, in Machiavelli's memorable phrase, "Sir *Nihil*," Sir Nobody. The eagerness with which Michelangelo leapt at the new offer does not speak well of his character or his patriotism, demonstrating that he placed his art above loyalty or, in fact, any other consideration. The pope was offering him an opportunity to create the most imposing monument since the Tomb of Mausolus, and to achieve this end he was willing to renege on any number of prior commitments. To his credit, he was also perfectly willing to sacrifice personal comfort and even his peace of mind. Thirty years later, the tomb having plagued him with "infinite vexations, troubles and labors . . . and shame, from which he was hardly able to clear himself," Michelangelo would look back on this decision with regret.

The agonizing saga that Michelangelo ultimately referred to simply as "the tragedy of the tomb," began in February 1505, with the transfer of 100 ducats from the papal treasury to his Florentine account. As soon as he had secured the down payment, he packed his bags and set out for Rome. The nearly two-hundred-mile journey on horseback gave him plenty of time to dream up a monument so glorious that it would be, as he put it, a "mirror of all Italy."

Arriving in Rome early in March, Michelangelo was summoned to the

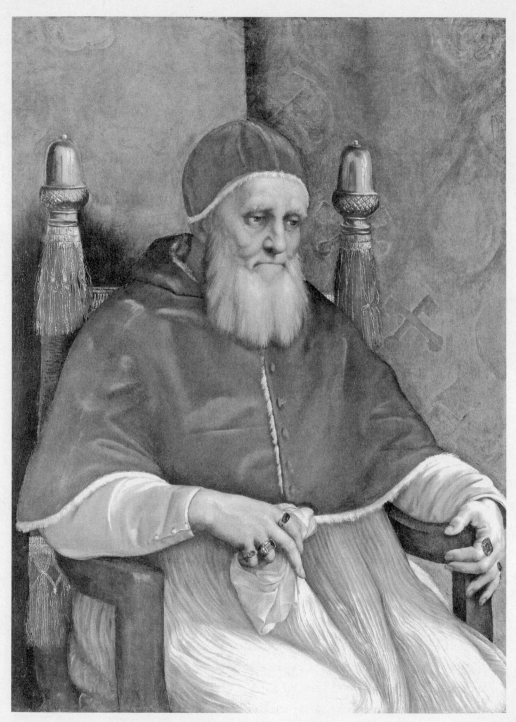

Raphael, *Pope Julius II*, c. 1511.

Vatican. The initial meetings between these two proud and touchy men proved to be surprisingly cordial. Instead of a clash of egos, there was an immediate meeting of minds. Each believed he saw in the other a reflection of himself, a man of relentless drive, ruthless in pursuit of his singular vision. Yoked together in a common purpose, there was no limit to what they might achieve.

The warmth of these early encounters reassured Michelangelo that his decision to abandon provincial Florence for Julian Rome had been the right one. While Florence was in a state of decline—short of money, filled with self-doubt, and beset on all sides by enemies—the Eternal City was enjoying a boom under the new pontiff. Donato Bramante, a rising star in the pope's entourage, was busy ripping down old buildings to make way for new, particularly in the vicinity of the Vatican, where he was transforming the papal apartments in the Belvedere into a splendid new showcase for Julius's art. If all went according to plan, the ramshackle remnants of the medieval city would soon be swept away to make room for grand edifices built on an imperial scale and in a classicizing language that called to mind the Rome of Caesar and Augustus. Talented men from all over Europe flocked to the city, hoping to make a name for themselves or to turn a more tangible profit from the pope's profligacy.

Bramante was typical of the kind of man who thrived in Julian Rome. He was, by all accounts, "a very merry and likable fellow," but he never let his taste for fine living divert him from his goal of re-creating the splendor of Imperial Rome for a new age. He had immigrated five years earlier at the invitation of Alexander VI, though he realized only a few minor projects during his pontificate. But during these fallow years he used his leisure well, clambering about the ancient monuments, measuring them with astrolabe and plumb line to unlock the secrets behind the capacious dome of the Pantheon and the soaring vaults of the ruined Basilica of Maxentius.

Like his compatriot Raphael, Bramante was not only immensely talented but possessed a courtier's ability to ingratiate himself with those in power. He made the most of social skills that Michelangelo so obviously lacked, and his self-confident bluster rubbed the awkward Florentine the wrong way. It was an antipathy that would result in numerous misunderstandings.

At first, Michelangelo could count on at least one ally in the papal court, the Florentine architect Giuliano da Sangallo. Sangallo had been a favorite of Lorenzo the Magnificent, and he and Michelangelo had struck up a friendship during the two years the artist spent at the Palazzo Medici. But the influence of the sixty-two-year-old architect was already on the wane, while Bramante's was on the rise. The majestic style favored by Bramante appealed to Julius, who fancied himself a new Caesar and demanded a capital that reflected his grandiose self-conception.* It was an irony not lost on his contemporaries that in his zeal to recall the Rome of the emperors, Bramante was willing to reduce to rubble any building, no matter how venerable, that interfered with his own projects. His arrogance is captured in a satirical play that describes the architect's arrival at St. Peter's gate. "I think I shall demolish this paradise and make a new one that will provide more elegant and comfortable dwellings for the blessed," he tells the saint. "If you agree, I shall stay; otherwise I shall go straight to Pluto's house, where I shall have a better chance of carrying out my ideas . . . I shall make an entirely new hell and overturn the old one."

There was, in fact, something slightly frenetic in the splendor of Julian Rome. Though the pope had enticed the greatest artists of the day to the Vatican, they resembled a team made up of high-priced free agents rather than one built from home-grown talent. Unlike Florence in the age of Brunelleschi, Donatello, and Masaccio, Rome in the age of Julius was dominated by foreigners drawn by the deep pockets and vaunting ambition of a man who himself had no deep roots in the community. In fact, to all intents and purposes the papal capital lacked a sense of community altogether, or rather, such community as it possessed was a seething, brutish underworld that the princes of the Church, surrounded by armed retainers and secure in their glittering palazzi, did their best to ignore.

As in every place where the opportunity to make money or a name for

* Often he made the link explicit. After one military triumph, the pope had coins struck with the words "Ivlivs Caesar Pont II" (Julius Caesar Pope II) and rode through an arch inscribed with Caesar's famous boast, "Veni, vidi, vici."

oneself was subject to the whim of an autocrat, the rivalries among courtiers begging crumbs from the royal table were fierce. Michelangelo did not immediately spot the perils of circling so close to the sun, or if he did, he allowed the dazzling prospect to overcome his better judgment. In Julius, Michelangelo believed he had at last found a master whose grand vision and immense resources would allow him to reach his true potential; in the Florentine sculptor, the pope believed he had discovered an artist who could match Bramante's audacity. Each of these three immensely talented men, however, lacked a sense of proportion—an appreciation not only for possibilities on paper but for what was achievable given limited time and resources. Each was a visionary, a genius in his own way, who preferred to spin castles in the air rather than build on the solid foundations of fact. But despite this disastrous recipe, and for all its folly and near catastrophes, the ten-year reign of Julius produced more masterpieces in a shorter amount of time than almost any comparable span in history.

By April, Michelangelo was ready to present the pope with four proposals for the tomb. The version Julius selected was as imposing as the man it was intended to memorialize, an architectural ensemble housing over forty more-than-life-size statues in marble and numerous bronze reliefs. Michelangelo's conception—now known only from descriptions made after the fact and a few rough sketches—was for a freestanding pyramid rising over 20 feet, from a rectangular base more than 30 feet in length and 20 feet wide, all crowned by a giant statue of the pope himself. While there is still considerable debate as to its exact form, there is no doubt that had the monument been completed as planned it would have been, as Vasari proclaimed, a work "which in beauty and magnificence, abundance of ornamentation and richness of statuary, surpassed every ancient or imperial tomb." Given the fact that Michelangelo had recently signed a contract to carve twelve life-size statues over the course of twelve years, such a project might well have occupied the artist for the rest of his life.

In the early months, the pope's enthusiasm for the project matched his own. Julius provided Michelangelo a house near his own palace, building a drawbridge to his studio that allowed him to drop in on the artist without

the inconvenience of fighting his way through crowded streets. "[A]gain and again," recalls Condivi, "[Julius] went to see him at his house, and talked with him about the tomb and other things as with his own brother."

Michelangelo's house was located on the Piazza Rusticucci, a bustling square in the shadow of Old St. Peter's crowded with tradesmen's stalls, pawnbrokers, and laborers' tenements. It was dirty, noisy, and cluttered, the kind of grubby atelier that caused Leonardo to disparage the sculptor's craft. Unlike Bramante, Michelangelo did not take advantage of the pope's favor to live in pampered luxury. He had no desire to preside over the type of salon kept by the architect in the Belvedere, where courtiers and colleagues could be entertained with lavish soirees. Michelangelo lived for his work and required only the barest necessities to get by, eating little and often dragging himself to bed late, still in his dust-caked smock and boots. Even lowly apprentices protested when forced to share his dingy quarters and adhere to his punishing schedule, finding the lifestyle of the great artist too sordid for their own comfort.

As in the case of the *Pietà,* Michelangelo was determined to select the marble for the tomb himself. After a thousand ducats was deposited in his account in Florence, he set out for Carrara in April 1505. For the next eight months he toiled like a common laborer, working alongside a team of *scarpellini* to excavate more than a hundred tons of pure white stone from the mountainside. Once he had extracted what he needed, he supervised the teams that dragged the blocks on sleds to the port of Avenza, where barges were waiting to transport them to Rome.

By late November, Michelangelo was back in the Eternal City, eager to pick up his mallet and chisels for the first time since leaving Florence almost a year earlier. But in a preview of things to come, work was delayed by a series of frustrating mishaps. "As to my affairs here," he wrote to his father,

> all would be well if my marbles were to come, but as far as this goes I seem to
> be most unfortunate, for since I arrived there have not been two days of fine
> weather. A barge, which had the greatest luck not to come to grief owing to
> the bad weather, managed to put in with some of them a few days ago; and
> then, when I had unloaded them, the river suddenly overflowed its banks and

submerged them, so that as yet I haven't been able to begin anything; however,
I'm making promises to the Pope and keeping him in a state of agreeable
expectation so that he may not be angry with me, in the hope that the weather
may clear up so that I can soon begin work—God willing.

The elements would prove to be the least of Michelangelo's worries. By the time he managed to get the marble blocks delivered to the piazza in front of his studio, there were troubling signs that the pope's initial enthusiasm had cooled. In February, Michelangelo wrote a letter to his brother Buonarroto painting a rather dismal picture of his circumstances:

I learn from a letter of yours how things are going at home. I am very sorry
about it, and still more so, seeing the need you are in, and particularly
Lodovico, who, you write me, is in need of getting himself something to put on
his back.

A few days ago I wrote and told Lodovico that I have four hundred broad
ducats worth of marble here and that I owe a hundred and forty broad ducats
on it, and that I haven't a quattrino *[cent]. I'm telling you the same thing, so*
that you may see that for the time being I cannot help you, as I have to pay off
this debt and I'm still obliged to live and besides this to pay rent. So that I have
burdens enough. But I hope to be rid of them soon and to be able to help you.

Michelangelo's financial difficulties were caused by the fact that he had dipped into his own purse to procure the necessary marble, and then when he tried to collect what he was owed, he was met by evasions and outright refusals from the papal treasurer. At first he assumed these rebuffs were caused by a staff unfamiliar with the pope's wishes, but eventually it dawned on him that the pope himself was the source of his problems. The Venetian ambassador had already noted a troubling feature of Julius's character: "One cannot count upon him, for he changes his mind from hour to hour. Anything that he has been thinking of overnight has to be carried out immediately the next morning. . . ." Michelangelo had as yet little experience with the pope's famously mercurial temper, but he was about to discover how difficult it was to work for a man as unpredictable as he was impatient.

Julius's apparent indifference to the tomb was particularly galling given the attention he was currently lavishing on Bramante's latest scheme, a megalomaniacal project to tear down the ancient Basilica of St. Peter's and replace it with a magnificent new edifice. Michelangelo was convinced that Bramante, animated by "[f]ear as well as envy," was not only diverting resources from the tomb to the basilica, but was engaged in a campaign to discredit him. This campaign, Michelangelo claimed, was motivated by revenge, since he had recently exposed Bramante's practice of using substandard materials for his buildings and pocketing the difference. A more plausible explanation is that Bramante's vast project simply soaked up resources that, in Michelangelo's opinion, would have been better expended on his own endeavor.

His suspicion that Julius had turned against him seemed to be confirmed when, on one of his repeated visits to the Vatican to obtain the money he was owed, a groom barred him from the pope's chambers. Humiliated by his rough treatment at the hands of a lowly servant, Michelangelo decided he'd had enough. "You may tell the Pope," he snapped, "that, henceforward, if he wants me he must look for me elsewhere." Rushing back to his house, Michelangelo ordered a *scarpellino* in his employ to sell the contents of his house to "the Jews." Packing a few belongings, he hired a post horse and slipped through the Porta San Pellegrino.* Once outside the city walls, he galloped as fast as he could in the direction of Florence, certain that as soon as Julius learned of his flight he would send an armed posse to fetch him back. He was so haunted by the vision of Julius's minions that he didn't rest until, two hours after sunset, he crossed the Tuscan border, where the pope's long arm could no longer reach him.

* Michelangelo offered multiple versions of these events, each of which differs in minor details. In addition to letters written at the time, he wrote at least two others describing in detail the "tragedy" of the tomb, one dated December 1523 and another in October–November 1542. (See *Letters,* vols. I and II.) Condivi's account was based on these recollections. But all of these accounts should be taken with a grain of salt since they were made to justify and explain his actions to the heirs of Julius who were suing him for his failure to fulfill the contracts he'd signed regarding the tomb.

For once Michelangelo had not exaggerated the peril. Late that night, as he was recuperating at a roadside hostelry in Poggibonsi, just within Florentine territory, five armed men burst into his room, demanding he return with them at once to Rome. "But overtaking him in a place where they were unable to offer him any violence," Condivi noted, "Michael Angelo threaten[ed] them with death if they dared lay hands on him." The only concession he made was to pen a letter to Julius in which he explained his behavior. In it he claimed "that his good and faithful service had not deserved this change, to be hunted away from [the pope's] presence like a rogue," and that, "as His Holiness did not wish to have anything more to do with the tomb, he was free and did not wish to bind himself again." Next morning, the papal escort returned to Rome without their quarry while Michelangelo completed the twenty-mile journey to Florence.

For the leaders of Florence, and for Gonfaloniere Soderini in particular, Michelangelo's unexpected return was, at best, a mixed blessing. Though Michelangelo tried to make himself useful, resuming work on the cartoons for the abandoned *Battle of Cascina,* Soderini fretted that harboring a fugitive would only serve to bring the pope's wrath down on their heads. Julius made his feelings known in three official dispatches he sent to the Signoria. Their tone, though not harsh, contained an implicit threat of dire consequences should he find himself thwarted in this matter:

> *Michelangelo, the sculptor, who left us without reason, and in mere caprice, is afraid, we are informed, of returning, though we, for our part, are not angry with him, knowing the humors of such men of genius. In order then that we may lay aside all anxiety, we rely on your loyalty to convince him in our name, that if he returns to us, he shall be uninjured and unhurt, retaining our Apostolic favor in the same measure as he formerly enjoyed.*

But the pope's promises failed to satisfy Michelangelo. A month after his arrival in Florence he sent a long letter to Giuliano da Sangallo—who had reconciled himself with Julius and was back in Rome—in which he set out his version of events:

Giuliano, I understand from your letter how badly the pope took my departure, and how his Holiness is ready to deposit the money and do everything we had agreed upon, and that should I return there would be no cause for concern.

As for my departure, it is true that on Holy Saturday I overheard the Pope, speaking with a jeweler and his master of ceremonies while he was at his table, that he had no wish to spend another cent on either large stones or small. I was distressed at this, but before I left I asked for part of what I needed to continue the work. His Holiness told me to return Monday. I returned Monday, Tuesday, Wednesday, and Thursday as he knows. The last time, Friday morning, I was sent away, that is I was thrown out. And the one who did this said that he knew me but was only following orders.

And I, having heard on Saturday the same words, and seeing what had happened, grew desperate. But this was not the only reason for my departure, but there was another which I don't want to write about. It's enough to say that had I remained in Rome it would be my tomb that would be made before the pope's. And this was the reason for my hasty departure.

Now you write to me on behalf of the pope, and the pope will read my response: that is His Holiness will know that I am more anxious than ever to proceed with the work; and that if he wishes to have the tomb, he should not trouble himself as to where I work on it, providing we are agreed that at the end of five years it will be erected within the walls of St. Peter's, wherever it pleases him, and it will be every bit as beautiful as I promised, and that I am certain there will be nothing like it in all the world.

The bizarre claim that "it would be my tomb that would be made before the pope's" provides a glimpse into Michelangelo's agitated state of mind; the reasonable charge that Bramante had been plotting to ruin his career has now given way to darker, more improbable fantasies of plots on his life. Of course, Michelangelo's suspicions were completely baseless. Bramante was self-serving, but he was neither violent nor vindictive. The worst that can be said of him was that he used his intimacy with the pope to promote his own selfish ends; there is no indication he ever wished any harm to Michelangelo.

• • •

The origins of Michelangelo's greatest fresco are both farcical and confused, discreditable to the reputations of all those involved as well as a testament to the genius of the man who painted it. The earliest clue that Julius was thinking of employing Michelangelo to decorate the vault of the Sistine Chapel comes in a letter written during these difficult days when the pope was attempting to pressure the wayward artist to return to Rome "by fair means or force." Indeed, it is likely that some discussion of the project had taken place before the artist's flight and that it was a factor in his growing disillusionment with Rome and its master. Michelangelo had been lured to the Eternal City with the promise that he would create a magnificent monument in his chosen art; the prospect that he would instead be diverted to a far less prestigious commission in a medium with which he had little experience and for which he had little appetite must have been discouraging in the extreme.

The letter, dated May 10, 1506—eight days after Michelangelo penned the self-pitying missive to Sangallo—came from his friend the artist Piero Rosselli, who was currently in Rome and had taken it upon himself to lobby on his behalf:

Dearest, almost as a brother . . . I must tell you that on Saturday evening, while the pope was dining, I showed him some drawings I had done with Bramante. After he had finished his meal and I had shown them to him, he sent for Bramante and told him: "Tomorrow morning Sangallo will go to Florence and will return with Michelangelo." Bramante responded to the pope, saying, "Holy Father, it will come to nothing, because I know Michelangelo well and he told me many times that he did not wish to work on the chapel, even though you assigned him this task, but that he only wished to work on the tomb and not on the painting." He continued, "Holy Father, I think he lacks the courage, because he has not painted many figures, particularly not figures that are high up and foreshortened, which is far different from painting them at ground level." To this the pope answered, "If he does not come, blame me, because I truly believe he will return." Then, I came forward and in front of the pope gave Bramante a piece of my mind, telling him what I believe you would have said in my place. To this, he did not know how to respond, and he seemed to feel he had spoken

ill. Moreover, I told him: "Holy Father, he never spoke to Michelangelo, and if
what he said just now is true, you can chop off my head . . . , and that I believe
he will return as soon as Your Holiness wishes." And so I left it.

Michelangelo was surely appalled by his friend's meddling, since, despite
what Rosselli told the pope, he had no intention of returning to Rome, par-
ticularly not on the terms being proposed. In fact, Bramante seems far more
perceptive about Michelangelo's actual state of mind than Rosselli, who
practically dared the pope to put the artist's loyalty to the test. Michelangelo
later insisted that the assignment to paint the Sistine Ceiling was all part of
some elaborate scheme on the part of Bramante and his acolytes to discredit
him, but Rosselli's letter suggests that it was the pope who first conceived the
scheme and that Bramante was skeptical from the start. The letter does not
present the architect in a particularly flattering light—his belittling of Mi-
chelangelo's talent seems petty—but he can hardly be accused of undermin-
ing the tomb by promoting the painting.

Throughout the spring Julius increased the pressure on the government
of Florence, while Michelangelo grew increasingly desperate. For a time he
even contemplated sneaking off to Constantinople, where "the Great Turk,"
Sultan Bayezid II, had offered him a position designing a bridge to span the
Bosporus. Nothing came of this plan, but it's a sign of how deeply unsettled
Michelangelo was that he ever contemplated such a journey.

By late summer Michelangelo's position in Florence had become unten-
able. Soderini had initially been sympathetic, but the artist's continued defi-
ance threatened to turn a diplomatic embarrassment into a full-scale crisis.
Summoning Michelangelo to the Palazzo, he urged him to swallow his pride
and submit. "You have braved the Pope as the King of France would not have
done," he told him. "We do not wish to go to war with him on your account
and risk the State, so prepare yourself to return."

Would the pope really have gone to war to lay his hands on the truant art-
ist? Even for someone as bellicose as Julius that seems unlikely, but Soderini
did have some cause for alarm. Even as the pope harassed the government
of Florence with increasingly intemperate letters, he was, according to an
eyewitness in the Vatican, "[l]eaving S. Peter's chair to assume the title of

Mars, the god of battles, to display his triple crown on the field, and to sleep under a tent." On August 26, Julius marched from Rome at the head of some 10,000 to 12,000 men, including 3,000 to 4,000 heavily armed Swiss mercenaries and 26 very unhappy members of the College of Cardinals. While the immediate target of his anger was the rebellious cities of the Papal States—particularly Perugia and Bologna—a brief feint in the direction of the Florentine Republic was not out of the question.

By late November, with the pope consolidating his victories in conquered Bologna, Michelangelo realized he could hold out no longer, though even now he insisted on additional protections. "Michelangelo is so frightened," a relieved Soderini explained, "that, despite the pope's brief, it would be necessary for the *Reverendissimo* di Pavia [Cardinal Francesco Alidosi] to write a letter . . . and promise Michelangelo safety and freedom from bodily harm." After receiving the necessary guarantees, on November 28 Michelangelo set out on the fifty-mile journey to Bologna, accompanied by a priest and carrying in his saddlebag a letter from the Gonfaloniere begging the pope's forgiveness. "The bearer is the sculptor Michelangelo," it read in part,

> *sent to please and satisfy His Holiness, our Lord. We certify that he is a splendid young man, and in his profession unequaled in Italy, and perhaps in the whole world. We cannot recommend him too earnestly. His disposition is such that, if spoken to kindly and well treated, he will do everything. It is necessary to show him love and to favor him and then he will do works that will astonish all who see them.*

For the proud Michelangelo, submitting, even to a pope, was humiliating. "I was forced to go there," he recalled bitterly many years later, "with a rope around my neck, to ask his pardon."

Julius received Michelangelo coldly. As the repentant artist knelt before him in the great hall of the Palace of the Sixteen, the pope observed sourly that by meeting in Bologna he had been forced to travel the greater distance. "You might have come to us," he grumbled, "and [yet] you have waited for us to come to you."

What happened next reveals not only Julius's irascibility, but also a sur-

prising sympathy for the artistic temperament. Answering that "he had not erred maliciously but through indignation for he could not bear to be hunted away as he had been," Michelangelo begged the pope's pardon. When Julius did not respond immediately, the priest who had accompanied Michelangelo on his journey from Florence attempted to intercede on his behalf. "Your holiness," he began, "do not remember his fault, for he has erred through ignorance; these painters in things outside their art are all like this." Instead of mollifying the pope, however, the priest's clumsy intervention only managed to bring Julius's wrath down upon his head. "You abuse him," Julius thundered, "whilst we say nothing; you are the ignorant one, and he is not the culprit; take yourself off in an evil hour." With this, the luckless priest was driven from the room "with blows by the servants of the Pope," after which Michelangelo received his absolution.

Instead of picking up where he had left off on the tomb, however, Michelangelo was ordered by Cardinal Alidosi to cast a bronze statue of the seated pope, fourteen feet high, to be set up in front of Bologna's Basilica of San Petronio. The prospect of casting a giant clothed figure in bronze was about as unappealing a commission as Michelangelo could have conceived. He tried to excuse himself by explaining that he had little experience in the medium, but once it was clear that the pope had made up his mind, he applied himself with his usual diligence. To aid him in the difficult task he summoned two seasoned professionals from Florence: Lapo d'Antonio di Lapo, and Lodovico di Guglielmo Lotti, a bronze-caster who had apprenticed with the great Antonio Pollaiuolo.

At first the work went smoothly, not least because the pope had revived their former intimacy—no small thing for an artist as sensitive as Michelangelo to slights both real and imagined. "[O]n Friday afternoon at two o'clock Pope Julius came to the premises where I am working," Michelangelo reported to his brother Buonarroto, "and stayed to watch me at work for about half an hour; then he gave me his blessing and went away. He was evidently pleased with what I am doing." It may have been on this occasion that Michelangelo asked the pontiff some advice as to what he should place in the figure's right hand. The artist suggested a book, but Julius disagreed: "What! a book?" he asked incredulously. "[A] sword! As for me, I am no scholar."

Despite Julius's renewed affection, these were difficult days for Michelangelo. He disliked Bologna, finding the citizens hostile and the climate intolerable. "[S]ince I have been here it has only rained once and has been hotter than I ever believed it could be anywhere on earth," he grumbled to Buonarroto. "Wine here is dear, as it is with you, but as bad as can be, and everything else likewise, which makes for a miserable existence and I long to be quit of it." Adding to the discomfort of the weather was the squalor of lodgings that, even by his own less-than-exacting standards, were barely adequate to his needs. "I am living in a mean room," he said, "for which I only bought one bed and there are four of us sleeping in it. . . ."

He might have objected less to the close quarters were it not for the fact that his new roommates proved to be both incompetent and disrespectful, the two qualities Michelangelo hated most. "Lapo I threw out, because he's a good-for-nothing and wicked, who would not do as I asked," he told his brother. "Lodovico, however, is better and I would have kept him for another two months, but Lapo, in order not to be the only one blamed, convinced him that they both should go."

Adding to his troubles was the menacing mood of a city chafing under the papal yoke. "Everyone here is smothered in armor," Michelangelo informed his brother Giovansimone, a situation that placed him in a particularly uncomfortable position, since he was perhaps the most prominent client of a despised regime.

Still, Michelangelo toiled away. For over a year he remained in Bologna, doggedly carrying out his master's instructions. He was determined not to repeat past mistakes, and while he vented in letters to his family, he suppressed any hint of his old rebelliousness. Even when the first casting ended in disaster, he kept his cool, remarking laconically, "[L]et it suffice that the thing has turned out badly." After a second attempt fared only slightly better, Michelangelo shrugged that things "could have turned out better, or again much worse," sighing that it would take several months "to clean it up."

By then Michelangelo was desperate to leave. "To me it seems like a thousand years," he wrote to Buonarroto, "for such is the way in which I'm living here that if you knew what it's like you would be appalled." After tedious months spent filing off the blemishes and buffing the metal to a fine sheen,

the statue was finally lifted into place on the afternoon of February 21, 1508. From high on his perch in the city's main square, the brazen Julius glowered over the people he had conquered and then abandoned to the tender mercies of the ferocious cardinal Alidosi. Though Michelangelo's colossus was destroyed only a few years after its installation,* a contemporary penned a few verses that captures the menacing figure Michelangelo had conjured:

> *From whom do you flee, frightened traveler,*
> *As if the Furies or Gorgons*
> *Or the piercing Basilisk pursued you?*
> *Julius is not here, but only the image of Julius.*

Michelangelo was back in Florence by early March, relieved to be done with the onerous task and to have escaped the hostile city still in one piece. A few days after his return he wrote a friend to say he was finally enjoying some "peace and quiet." He was anticipating an extended stay in Florence, since later that month he signed a one-year lease on the house on the Borgo Pinti that had been set aside for him by the Opera del Duomo. But the pope apparently had other plans. Michelangelo had barely settled in when Julius summoned him once more to Rome, this time to take up the project first contemplated two years earlier—to paint the vault of the Sistine Ceiling.

II. HOLY OF HOLIES

Sitting at the northeast corner of the massive Basilica of St. Peter, the brick box of the Sistine Chapel is both unimpressive and forbidding. Built in 1483 by Julius's uncle, Sixtus IV, the chapel features thick walls, narrow windows, and bristling battlements that testify to the constant threat of violence that bedeviled the Renaissance papacy. Conceived as half place of worship, half

*It was torn down on December 30, 1511, following Bologna's successful rebellion against Julius. Adding insult to injury, part of the bronze was used to cast a cannon for Julius's enemy, Duke Alfonso d'Este. The cannon, christened by the duke with the ironic name *La Giulia,* was soon used to fire on papal troops.

fortress, the architect even furnished the building with slits from which defenders could pour boiling oil down on would-be attackers.

Despite its dour exterior, the chapel played a key role in the pomp and ceremony of the papal court, serving as both the pope's private place of worship and the site where, upon the death of the reigning pontiff, the cardinals met in the conclave to appoint his successor. In 1483, as Cardinal di San Pietro in Vincoli, Julius himself had presided over the chapel's consecration; two decades later it was the scene of his greatest triumph when his colleagues decided to crown him with the papal tiara. The vital role the chapel played in papal ritual is also hinted at by its rather odd proportions: measuring 134 feet long, 44 feet wide, 68 feet high, the Sistine Chapel has the precise dimensions given in the Bible for the Kodesh Kodeshim, the Holy of Holies in the Temple of Solomon.

Architecturally, the chapel's interior is almost as plain as its exterior, a simple rectangular shed topped with a shallow barrel vault. This severe layout is relieved by a series of arched windows that pierce the upper walls, providing light but also imparting a rhythmic articulation to the otherwise uninterrupted expanse of the ceiling.

The austerity of the three-dimensional layout, however, is deceptive since from its earliest days the walls were covered with frescoes painted by some of the greatest masters of the age. On one side are scenes from the life of Moses; on the opposite wall, scenes from the life of Christ—parallel narratives that together establish the Church's role as the vehicle of salvation. Among the masters summoned by Sixtus to decorate his private chapel were Perugino, Pinturicchio, Botticelli, Ghirlandaio, and Piero di Cosimo, the last three sent by Lorenzo the Magnificent as a peace offering at the conclusion of a two-year war between the Florentine Republic and the pope.

Only the ceiling retained something of the chapel's original austerity. Here, some 60 feet above the inlaid marble floor, was a 5,800-square-foot expanse of blue sky speckled with golden stars, the vault of heaven presiding serenely over teeming narratives below. But in 1504, and again in 1508, large cracks had appeared in the plaster, requiring patches that marred the beauty of the celestial realm. It was these unsightly intrusions that first suggested to Julius the idea of employing Michelangelo to provide a new decorative

scheme. Michelangelo himself later recalled the origins of his most famous fresco:

> *After I installed the figure on the façade of San Petronio and returned to Rome,*
> *Pope Julius still did not want me to carve the tomb, and assigned me instead to*
> *paint the vault of the Sistine, for which he agreed to pay me 3000 ducats. The*
> *initial scheme was to paint the twelve Apostles in the lunettes, while the rest*
> *was to be covered with the usual decorations. Then, having begun the work, it*
> *seemed to me it would turn out poorly, and I told the pope that depicting only*
> *the Apostles would seem a paltry thing. He asked me why: I told him: "Because*
> *they themselves were poor men." So he gave me a new commission, telling me*
> *that I should do what I wanted and that he would accommodate me, and that I*
> *should paint all the way down to the histories below.*

It is reasonable to question Michelangelo's version of events, particularly since it came in the context of the decades-long quarrel over the completion of the tomb, when he was anxious to shape the facts to bolster his case against Julius's heirs. Indeed, many scholars balk at the notion that a pope as opinionated as Julius would ever have permitted a lowly artist a free hand to paint whatever he liked, particularly in the chapel where he himself communed with the divine. But however improbable, the evidence supports Michelangelo's claim.* Several sketches survive that show variations on this original scheme. Together, they reveal an artist struggling with the limitations of his assignment and looking for a way to turn a thankless task into something worthy of his genius. It was typical of Michelangelo that even though he was dragged kicking and screaming to the project, once commit-

* Even though Michelangelo was responsible for the design, he no doubt sought the approval of the pope and/or his close advisors. This was his modus operandi when it came to designing Julius's tomb, and how he approached the equally complex task of designing the tombs for the Medici dukes. After a considerable back-and-forth between Michelangelo and Cardinal Giulio de' Medici's secretary, Domenico Buoninsegni, the latter writes: "Nevertheless, [the Cardinal] says you know better than he does, and he leaves it to you." (Quoted in de Tolnay, *Medici Tombs,* p. 34. For full quotation see chapter 5.) One can assume a similar dynamic in the case of the Sistine Ceiling.

ted, he dedicated himself heart and soul to making something that would astonish the world.

Whether Michelangelo himself developed the program for the ceiling or whether (as many scholars contend) he was merely following a program developed by a learned theologian profoundly impacts how we interpret the vast panorama that unfolds above our heads. According to the latter theory, the nine narrative panels, the enthroned prophets and sibyls, the dozens of nude figures sprawled in startling attitudes across the ceiling, as well as the lunettes depicting the ancestors of Christ and the four scenes in the corner spandrels, all form an elaborate intellectual puzzle that can be decoded only by those well versed in the arcana of sixteenth-century religious doctrine. In this scenario the Sistine Ceiling is a work of profound erudition and obscure symbolism, promoting an agenda that can have no resonance for contemporary viewers. Each departure from tradition—like the placement of the panel depicting the Sacrifice of Noah before the panel depicting the Flood or the conflating of the scenes depicting God's Creation—becomes a key to unlocking the hidden meaning of the whole.

But for all the impressive scholarship that has been marshaled in an effort to determine the Sistine Ceiling's elusive meanings and to unmask its secret author, the evidence strongly suggests that Michelangelo himself was almost entirely responsible for what we see, and that he developed the elaborate program organically in response to the demands—technical, conceptual, and esthetic—that confronted him when he discarded the pope's simplistic plan and opted for a more elaborate scheme. What we see is the product of Michelangelo's genius, not merely the skills of a consummate craftsman illustrating a theological text, but the passionate, unconventional vision of an artist who thought deeply about the miracle of Creation and developed his own unique language to confront life's most profound mysteries.

Michelangelo cherished his artistic independence too much to submit to the dictates of a bookish scholar. As he often reminded those who were inclined to look down on his profession, he was no simple-minded artisan churning out formulaic altarpieces but an artist of titanic ambition, a philosopher in marble, a rhapsodist in pigment, a conjurer of celestial visions and plumber of infernal depths. He embodied the transformation from

skilled artisan to man of letters that had been urged by Leon Battista Alberti at the beginning of the fifteenth century. "It would please me if the painter were as learned as possible in all the liberal arts," he wrote in his treatise *On Painting*: "For their own enjoyment artists should associate with poets and orators who have many embellishments in common with painters and who have a broad knowledge of many things." Michelangelo lived by this creed. For two years he had been in daily conversation with the greatest minds in Europe—Ficino, Pico, Poliziano, and Lorenzo the Magnificent himself, who had taken the awkward boy under his wings—and he always sought out men and women of learning. He certainly did not need some professor whispering in his ear to inspire him. The old division of labor between the patron who developed the iconography and the artist who skillfully arranged a predetermined set of figures and symbols was under assault by a new generation of artists. Men like Leonardo, Raphael, and, above all, Michelangelo, rewrote the rules, wresting control of the creative process from their masters. Even a man as opinionated as Pope Julius recognized that to get the most out of his protégé he had to step aside and allow him to follow the promptings of his own temperamental muse.

Once Michelangelo decided to replace the Twelve Apostles with a more ambitious scheme, the choice of subject matter was practically forced on him by the logic of the decorative program already in place. His narrative had to complete, or at least complement, the meaning of the scenes on the chapel walls chronicling the parallel lives of Moses and Christ that led logically and inexorably to the foundation of the Holy Church.* Following the three-part division of history proposed by St. Paul, Moses represented the

* The pivotal work is the famous scene by Perugino, *Christ Giving the Keys of the Church to St. Peter,* which illustrates the line from the Gospel of Matthew: "Thou art Peter, and upon this rock I shall build my church" (Matthew 16:18). This line provides the scriptural justification for papal authority. Peter was believed to be the first Bishop of Rome, and his successors considered themselves his heirs, entitled to claim the mantle of authority bestowed upon the first Apostle by Christ himself. A tradition held that the cardinal who occupied the cubicle beneath this fresco during the conclave had the best chance of being named pope. Though it did not always work out, Giuliano della Rovere

history of Man *sub lege* (under law), while Christ represented the history of Man *sub gratia* (under the dispensation of grace). Thus it was only natural that Michelangelo would choose as his subject the Book of Genesis, the history of man *ante lege,* that is, before Moses received the Law on Mount Sinai—a theme that had the added advantage of providing maximum narrative drama.

A far more challenging task was to develop a coherent scheme for a series of complex, uneven spaces, encompassing not only the vast expanse of the vault itself, but also numerous smaller fields. These smaller fields include lunettes (the half circles above the windows that, in turn, are interrupted by small openings), spandrels (the triangular spaces at the intersection of the arched windows and vertical supports), pendentives (the fan-shaped fields where the windows and the ceiling meet, and the four larger fields in the corners just below the vault), and all the awkward spaces in between. Generally underappreciated by art historians, the solution Michelangelo contrived to overcome this difficult problem was *the* essential creative breakthrough, providing him with an armature of unprecedented expressive power and conceptual richness.

Instead of minimizing or ignoring the natural divisions of the ceiling, Michelangelo chose to build on them. He organized the visual field like an editor organizing a difficult text, dividing it into various chapters and subchapters, each with its own heading and each assigned its proper place. The moldings and cornices of the actual chapel anchor an elaborate simulated architecture that, in turn, serves to articulate the hierarchical structure of the celestial realm. Unlike the actual architecture of the building, governed by the laws of physics—by the imperatives of stress and weight—this trompe-l'oeil architecture is governed by a purely metaphysical logic. At the base, supporting everything else, are the massive thrones of the prophets and sibyls; these ancient seers who foretell Christ's coming are the theological foundation upon which all else rests. Running along the pillared arms of these thrones

did occupy the lucky cubicle in the conclave of 1503. (See Chambers, "Papal Conclaves and Prophetic Mystery in the Sistine Chapel," p. 324.)

is a cornice topped by plinths that serve as platforms for athletic nudes who squirm on their perches like restless children. These are the famous *ignudi,* who act as intermediaries between the earthly and heavenly realms. Behind these plinths spring ten graceful arches that divide the ceiling into nine distinctive "bays," each of which contains a scene from Genesis chronicling the early history of the world: from Creation to the Fall of Man, and from the Fall to his first redemption in the Covenant between God and Noah.*

This basic scheme allowed for almost infinite elaboration. The lunettes and spandrels, for instance, occupy a distinct metaphysical zone; relatively low on the ceiling, near the feet of the prophets, they belong to the terrestrial realm. Surprisingly, Michelangelo has populated these panels with a motley crew representing the ancestors of Christ, human specimens who run the gamut from the noble to the grotesque. Michelangelo's irreverent treatment seems odd until one remembers that while Christ's spiritual nature derived from God, his *earthly* nature was inherited from flawed men and women.

We still haven't exhausted the full range of possibilities opened up by Michelangelo's imaginative architectural setting. The trompe l'oeil piers and arches are decorated by a class of motifs that constitute "the art within the art" of the ceiling—faux-marble statuettes and reliefs that enrich the main narrative, often playfully, sometimes ominously, but always adding new voices and textures to an already polyphonic choir. Among those providing a lighthearted counterpoint to their more heroic neighbors are pairs of marble cherubs; rendered as part of the architecture, these statuettes—illusions of illusions—testify to the reality of the other figures who balance precariously on the stony framework. Yet another race of beings, the so-called brazen nudes—demonic figures who lurk in the shadows like trolls beneath a bridge—are squeezed into the narrow triangular spaces between the arches

* The nine "openings" alternate between larger and smaller scenes. The four larger openings contain the great panoramic vistas of the ceiling, *The Deluge, The Temptation and Fall, The Creation of Adam,* and *The Creation of the Sun, Moon, and Planets.* The five bays containing the smaller panels have a pictorial richness all their own, since they include the medallions and the *ignudi* who support them. These bays are also flanked by the sibyls and prophets, while the other four are flanked by the pendentives depicting the ancestors of Christ.

that frame the windows and the prophets' thrones. They are the grim cousins of the cherubic infants, reminders of the varied menagerie that lurks in the unlit corners of God's Creation.

The "art within the art" also includes ten faux-bronze medallions that carry forward, as if in a distant echo, the main narrative of human history unfolding at the summit of the vault.* Add to these the four corner pendentives, each of which involves a symbolic rehearsal of the Passion of Christ, and the chapel (viewed as a unified program) embraces human history from the Creation to the Fall, to our final redemption through Jesus's sacrifice on the Cross.†

One of the peculiarities of Michelangelo's scheme is that there is no "right way" to see it: there is no single perspective, no privileged viewpoint, that allows us to make sense of the whole. This is most apparent when we come to the apex of the vault, where the nine scenes from Genesis are framed by rectangular openings in the fictive architecture like patches of sky glimpsed through a stonework trellis. Instead of pursuing an elaborate illusion in which the fictional architecture appears to open onto a vision of the celestial realm, Michelangelo renders these scenes so as to undermine any notion of a coherent space. Some of them—particularly the later scenes depicting God's Creation—make use of dramatic foreshortenings as though we were seeing the figures from far below, but most make no concession to our point of view. Panels like *The Deluge, The Temptation,* and *The Creation of Eve* lie on a plane perpendicular to the one we stand on, and bear no plausible relation to the foreshortened architecture that frames them. This demonstrates

* The subject of the medallions has been debated at length. Some believe they are meant to represent the Ten Commandments. A more plausible explanation is that they were drawn from illustrations to a popular illustrated Bible of the time, the *Biblia vulgare istoriata,* by Niccolò Malermi. Five of the scenes come from the Books of the Maccabees, chronicling the revolt of Judah Maccabee and his brothers against the ruling Seleucid Dynasty. In the Rome of Julius, this history would be seen as a reference to the pope's righteous struggle against the foreign occupiers.

† This sense that the Sistine Chapel contains the entire history of the world was given even greater relevance in 1535–41 when Michelangelo painted his *Last Judgment* on the altar wall. (See chapter 6.)

that Michelangelo was learning the tricks of the trade as he went along since, as Vasari pointed out, this painting *al di sotto in sù* (from below to on high) posed "a more formidable task than any other in painting." But this inconsistency was not merely a product of inexperience; it is built into a scheme that is superficially logical but utterly impossible. There is no correct vantage point from which the ceiling makes sense, no possibility of final resolution. Rather than diminishing the impact, however, this defiance of the basic laws of gravity heightens our sense that we are witnessing something miraculous, a reality beyond our reality that is both convincing and thoroughly disorienting. Ultimately, Michelangelo's visionary masterpiece aims for transcendence rather than mere plausibility. Filled with Escher-like conundrums, Michelangelo's ceiling provides us a glimpse of a truth "which passeth all understanding."

Michelangelo began work on the ceiling in the spring of 1508, marking the occasion with a laconic entry in his account book: "I record how today, the tenth of May in 1508, I Michelangelo, sculptor, received from His Holiness, our Lord Pope Julius II, 500 *duchati di camera,* which were given to me by *messer* Charlino, chamberlain, and *messer* Charlo degli Albizzi for the purpose of painting the ceiling of the chapel of Pope Sixtus,* which I shall begin working on today under the conditions and according to the agreements that appear in a document made by *Monsignore* Remolo di Pavia and signed by me."

This did not mean that he actually picked up his brushes at this date. There was an enormous amount of work to be done before he actually began to paint. Among countless other tasks, assistants had to be hired, scaffolding erected, and the old plaster removed. And at the same time as he was tending to these logistical matters, he had to grapple with the creative challenges

* Michelangelo had originally been offered 3,000 ducats to paint the Apostles; he was promised 6,000 ducats when the project expanded. How much he actually received is debatable, since funds for the ceiling were confused with funds for the Julius Tomb. Michelangelo engaged in a decades-long battle with Julius's heirs for the fees to which he felt entitled. (See *Letters,* I, apps. 9 and 11, for a full discussion of the issues.)

posed by the vast, awkward space, working out the overall scheme and the individual poses in hundreds of studies made from the live model.* For all his mercurial genius, Michelangelo was a consummate craftsman, heir to a centuries-long workshop tradition that valued perspiration over inspiration. Janus-like, he looked back to the artisan practices of his forebears, even as he looked to a new age in which artists were treated as temperamental demi-gods. He regarded himself as a visionary genius, but at the same time he was too respectful of his craft to assume that his brilliance would compensate for slipshod execution.

Despite the legend (promoted by Michelangelo himself) that he completed the ceiling almost single-handedly, he knew from his experience in Ghirlandaio's workshop that such a large-scale undertaking demanded a team of competent assistants. As a jingoistic Florentine, he naturally turned to his compatriots for help. He began by writing to his old friend Francesco Granacci, offering him the job as foreman of the crew. The loyal Granacci accepted and set about hiring a team of five experienced assistants who would travel with him to Rome.

Finding suitable candidates proved difficult, in part because Michelangelo's terms were rather stingy. "[W]hen they have come here and have come to an agreement," he wrote in his ledger, "the said twenty ducats received shall be paid on their account as salary, said salary from the day they left Florence to come here; and if they are not in agreement, they shall have half of said money for the expense and time of travel." Granacci complained to Michelangelo of his difficulties, but assured him that "in any case I will come, if I must, even if it's only Bastiano [da Sangallo] and me."

By the summer, Granacci had managed to cobble together a team of five painters, all of them more experienced in fresco than Michelangelo himself. Joining him for the trip to Rome were Giuliano Bugiardini and Jacopo di

*Of the almost 1,000 drawings he made for the ceiling, only about 70 survive. These include both rough sketches and more detailed studies. Among the most famous is a drawing of a young boy in red chalk that was the basis for the Libyan Sibyl, now in the collection of the Metropolitan Museum in New York. Even Michelangelo's female subjects were based on studies of the male nude. It is likely that he used various shop boys as models.

Sandro, a fellow graduate of Ghirlandaio's studio, Indaco (the elder), Agnolo di Donnino, and Aristotile da Sangallo.* The list is provided by Vasari, who goes on to say that Michelangelo fired them shortly after they arrived: "[S]eeing how their work was far from what he might have wished . . . he decided one morning to destroy all they had done. Then, shutting himself up in the chapel, he would not let them in. . . . Once it seemed no longer a joke to them, they took themselves off to Florence with their heads hung low. From then on Michelangelo arranged to complete the entire work by himself. . . ."

As was often the case, however, the truth was somewhat less dramatic. It is clear that Michelangelo never relied as much on his assistants as had been the practice in Ghirlandaio's studio, but he was also not the solitary genius he claimed to be. The hands of various helpers can be detected throughout the work, particularly in the early narratives and in minor elements like the faux-bronze medallions. But it would be accurate to say that he exercised a far greater degree of control over the entire process than was typical for such a massive project. The fact that he hired mediocrities, paying each of them a meager fee, suggests that he regarded them as underlings rather than true collaborators. Even Granacci, the most talented of the bunch, was more distinguished for his agreeable manner than for his originality and was entrusted with only minor tasks.

When it came to his materials, Michelangelo showed the same bias in favor of his native land. In May 1508 Michelangelo wrote a letter to Fra Iacopo at the Monastery of San Giusto alle Mura in Florence, informing him that he'd "been hired to design certain schemes, or rather to paint them," and requesting "a certain amount of fine blue pigment. . . ." His reliance on Florentines was not merely a sign of jingoism: Michelangelo's hometown had

* Michelangelo drove his assistants hard and there was a great deal of turnover. Jacopo di Sandro was one of the first to leave. Michelangelo warned his father to "turn a deaf ear" to his slanders, since "he has been complaining about me here, [and] I suppose he will also complain in Florence." (*Letters*, I, no. 45, p. 48.) Michelangelo was joined in the summer of 1508 by Giovanni Michi, and by the sculptor Pietro Urbano. In 1509, Granacci and Bugiardini left and were replaced by Giovanni Trignoli and Bernardino Zacchetti.

an unmatched tradition of fresco painting, and this particular monastery was famous throughout Europe for the quality of its pigments. Its reputation was such that in his contract for *The Adoration of the Magi,* Leonardo had insisted that all his colors be supplied by the conscientious brothers of San Giusto. Michelangelo was also determined to have the best, well aware that the beauty of his work—and its longevity—depended on the quality of the ingredients he used.

Even supplied with the best of ingredients and an experienced crew, however, Michelangelo was apprehensive. Carving in stone he felt supremely confident; when it came to fresco painting he was filled with doubt. *Buon fresco* (true fresco) was the most demanding form of painting, requiring vast expertise and painstaking preparation. "Of all the methods that painters employ," Vasari contends, "painting on the wall is the most masterly and beautiful, because it consists in doing in a single day that which, in the other methods, may be retouched day after day. . . ." In *buon fresco,* colors are applied to wet plaster to ensure a permanent chemical bond between pigment and surface, which means that an artist has to be familiar with the properties of his materials, plan ahead, and work with both speed and precision.* As Vasari concludes: "There is needed a hand that is dexterous, resolute and rapid, but most of all a sound and perfect judgment; because while the wall is wet the colors show up in one fashion, and afterwards when dry they are no longer the same."

Michelangelo already had some experience designing (if not executing) a large-scale fresco, but painting a vault some 60 feet off the floor posed unique challenges. When composing his scenes, he would have to compensate for the distortions created by the curved surface, and take into account the fact that the figures would be viewed from far below. Anxiety fed a paranoia that was never far from the surface, fueling his belief that

* In *buon fresco,* colors are applied to wet plaster, but less skilled craftsmen often touched up their works *a secco* (in dry). *A secco* applications are less durable and often flake off. Much of the controversy surrounding the restoration of the Sistine Ceiling in the 1980s revolved around whether Michelangelo used only the technique of *buon fresco* as Vasari claimed or whether he retouched it *a secco.* Most scholars agreed that any *a secco* elements were added by later restorers and could be safely removed.

he was being set up for failure by his rivals: "In this manner it seemed possible to Bramante and other rivals of Michelangelo to draw him away from sculpture," Vasari wrote, "in which they saw him to be perfect, and to plunge him into despair, they thinking that if they compelled him to paint, he would do work less worthy of praise, since he had no experience of colors in fresco. . . ." Faced with a task for which he felt so ill prepared, Michelangelo blamed others for his predicament, conveniently forgetting that he himself had lobbied for the more elaborate scheme.

Preparations continued throughout the spring and summer of 1508, prompting protests from Paride de Grassi, the pope's master of ceremonies, who complained to his master that the dust and noise made it impossible to hold services. Much to his annoyance, Julius sided with the artist and told him that the cardinals would simply have to live with the disruptions.

Michelangelo was ready to begin painting by early October. While his assistants hauled heavy bags of sand, lime, ash, and buckets of water to the base of the platform, he contemplated the vast, empty expanse before him. He had designed the scaffolding with care, making sure he allowed enough room between the planks and the vault to stand erect while he worked, but before long his back ached and his eyes became so inflamed he could barely read. He composed a rueful sonnet filled with bitter humor, listing his various ailments, accompanied by a sketch that shows him hard at work, back bent, neck twisted, as he dabs at the surface above his head:

> *I've already got myself a goiter from this hardship*
> *Such as the water gives the cats in Lombardy,*
> *Or maybe it's in some other place;*
> *My belly is pushed by force underneath my chin.*
> *My beard toward Heaven, I feel the back of my skull*
> *Upon my neck, I'm getting a harpy's breast;*
> *My brush, always dripping down above my face,*
> *Makes it a splendid floor.*
> *My loins have pushed into my tummy,*
> *And by counterweight, I make of my ass a horse's rump,*
> *And without eyes, move my steps in vain.*

Before me, my hide is stretching
and to fold itself behind, ties itself in a knot,
And I bend like a Syrian bow.
Therefore deceptive and strange
Issues the judgment that my mind produces,
Because one aims badly with a warped pea-shooter.
My dead picture
Defend henceforth, Giovanni, and my honor,
Because I am not in a good place, and I am not a painter.

Each morning an assistant would trowel on a new area of smooth, wet plaster to be painted that day, larger or smaller depending on the intricacy of the scene. (These sections, known as *giornate,* or days, can still be detected through close inspection of the surface.)* Another assistant would then transfer the corresponding section of the cartoon to the moist surface, either by tracing the lines with a stylus or by the more laborious method known as *spolvero* in which charcoal powder was sifted through tiny pin pricks in the master drawing. Once the outlines were fixed, Michelangelo laid the color on rapidly, applying his water-based pigments in shimmering, translucent veils with boar-bristle brushes before the plaster dried.

But for all his meticulous preparations, the project was nearly abandoned after only three months when the just-completed sections became badly discolored. Seeing all his hard work come to ruin, Michelangelo threw down his brushes in disgust and, seeking an audience with the pope, asked to be relieved. "I have already told your Holiness that this is not my art," he said: "all that I have done is spoiled; if you do not believe it send and see."

Fortunately for Michelangelo (and for history), the man Julius sent to inspect the damaged work was the knowledgeable and sympathetic Giuliano

* The scene of *The Flood*, one of the most intricate on the entire ceiling, took a total of twenty-nine *giornate* (not including the twelve Michelangelo destroyed after deeming them unsatisfactory). As Michelangelo gained in confidence, he covered larger sections in fewer days. *The Creation of Eve*, for example, required only three *giornate*, while *God Separating the Light from the Dark* needed only one.

da Sangallo. He quickly determined the source of the problem and suggested a simple remedy. Michelangelo's Florentine helpers, he explained, had failed to account for the damp of the Roman winter, mixing their plaster with too much water, a formula that promoted the growth of mold. Sangallo, having isolated the cause of the problem and provided them with a new formula, the pope "made [Michelangelo] proceed, and the excuse was unavailing."

Michelangelo's readiness to throw in the towel suggests that his heart was still not in the work. He was unhappy, plagued by insecurity, and nagged by the feeling that his true talents were being wasted. He led a spartan existence in the crowded house on the Piazza Rusticucci, neglecting his meals and—with the exception of his fellow toilers on the ceiling whose company he could hardly escape—shunning most human contact. His natural melancholy was exacerbated by the fact that, living only for his work, he had nothing to fall back on when faced with professional disappointments. He called his art a wife who has always given him tribulation, and his work his children. Setting out each dawn in the direction of the Chapel, he was forced to pick his way through ghostly canyons formed by the blocks hauled at such cost from Carrara hillsides, a constant reminder of the neglected tomb and his frustrated dreams. One sign that he longed to return to what he regarded as his true profession was that, even when dealing with official business for the ceiling, he signed his letters, "Your Michelangelo, sculptor in Rome."

In January he poured out his frustrations to his father: "I am still in a bind since it's been already a year since I've had as much as a *grosso* from this Pope, though I've not asked him for more since the work is not progressing in a way that it seems to me merits it. Such is the difficulty of the work and, again, it's not my profession. And so I waste time needlessly." Matters had not improved by the following summer when he groused: "Here, I am ill content and none too healthy and overworked, without help and without money. . . ."

But still he plowed ahead, afraid to defy the pope again and unwilling to give his rivals the satisfaction of witnessing his failure. And as he worked, he gained valuable experience, picking up speed and exhibiting greater boldness in execution. Self-doubt was replaced by self-confidence and his

conviction grew that in overcoming his greatest hurdle he would produce his greatest triumph. He was, as Vasari says, "determined to demonstrate in such a work that those who had painted there before him were destined to be vanquished by his labors, and also resolved to show to the modern craftsmen how to draw and paint."

Michelangelo and his team worked from east to west, that is, from the Chapel entrance toward the altar wall. Technical and stylistic analyses reveal that the central narrative scenes and the adjacent sibyls and prophets were painted simultaneously. Indeed, all show a similar evolution toward simpler, more monumental forms. The earlier scenes tend to be busy, crowded with figures too small to make much of an impact when seen from 60 feet below; these earlier panels are flanked by prophets who fit comfortably within their thrones. By the time Michelangelo reached the middle of the ceiling, he was conjuring a race of giants, while the adjacent prophets spill from thrones that can no longer accommodate their massive frames.

Michelangelo drove his assistants like galley slaves, goaded by an impatient master and by his own fierce ambition. Unfortunately, despite a monklike dedication to his work, Michelangelo could not shut out the rest of the world. He was employed by the most profligate patron on earth, but serving at Julius's court meant suffering the turbulence of life at the center of a whirlwind. Not only was he harried by unreasonable demands made on him by the pope—a man of "a vehement nature, and impatient of delay"—but he was harassed by the carping of the cardinals whose scarlet robes were ruined by the dust falling from the scaffold and by the preachers who complained their inspired phrases were drowned out by the incessant din.

Even more disturbing to his peace of mind was the cutthroat atmosphere fostered by Julius. Like Piero Soderini, the pope apparently believed the way to get the most out of his artists was to pit one against the other. Michelangelo's natural tendency was to regard colleagues as rivals and imagine conspiracies that never were, but Julius's fickle partiality served only to feed his paranoia. Late in 1508 the pope brought Raphael to Rome to help fresco his new apartments in the Belvedere. Not surprisingly, Michelangelo was infuriated by the appearance of yet another rival for the pope's attention. His sus-

picion of the newcomer was sharpened by the fact that it was Bramante who sponsored him, in order, Michelangelo assumed, to promote his compatriots at the expense of the Florentine contingent. The 100 ducats initially offered to the young artist reflects his junior status and the modesty of the commission, but Michelangelo still feared the emergence of an Umbrian cabal at the heart of the Vatican.

Michelangelo was acquainted with the handsome, good-natured youth from his initial visit to Florence in 1504. Since he dismissed Raphael as little more than a facile imitator of other people's work, it galled him when Julius and the wealthy cardinals of Rome loaded him with lucrative commissions, even though Michelangelo had no desire to take them for himself. To prevent Raphael and other mediocrities from snooping around and stealing his ideas, he kept the doors to the chapel locked and the scaffolding well draped with canvas. Unfortunately, this penchant for secrecy extended not only to his competitors but to Julius as well, leading to further misunderstandings. On more than one occasion when Julius demanded to see what he was paying for, Michelangelo refused him entry. This insubordination, combined with Julius's habitual impatience, contributed to renewed tensions. At one point relations between the two headstrong men deteriorated to such an extent that the pontiff threatened to have the artist tossed from the scaffolding.

Though Michelangelo managed to irritate the pope with his suspicious ways, he was apparently unable to prevent his rivals from spying on him. Raphael was only the biggest fish to slip through his net, aided by Bramante who, as the pope's *magister operae* (chief of works), had the keys to the chapel. To the impressionable young painter, even a brief opportunity to study the fresco by candlelight proved a revelation. "[T]he sight of it," Vasari recounts, "was the reason that Raffaello straightaway repainted, although he had already finished it, the Prophet Isaiah that is to be seen in S. Agostino at Rome, above the S. Anne by Andrea Sansovino; in which work, by means of what he had seen of Michelagnolo's painting, he made the manner immeasurably better and more grand, and gave it greater majesty. Wherefore Michelagnolo, on seeing afterwards the work of Raffaello, thought, as was the truth, that Bramante had done him that wrong on purpose in order to bring profit and fame to Raffaello."

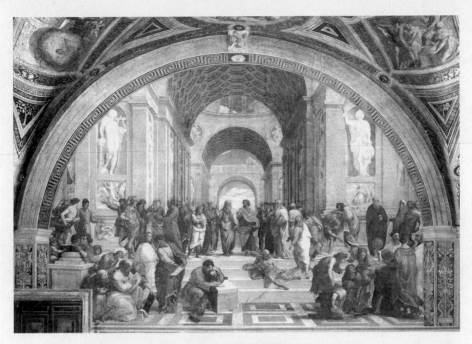

Raphael, *The School of Athens*, 1509–10. *Scala/Art Resource, NY*

To be fair, Raphael was more than the mindless hack Michelangelo believed him to be. He was an accomplished master in his own right who could learn from giants like Perugino, Leonardo, and even Michelangelo himself, and transform these lessons into something wholly original. He had come to Rome in 1508 as the junior partner of Sodoma, but in no time he had eclipsed the older artist. The frescoes he painted for the so-called Stanza della Segnatura in the pope's residence are among the greatest masterpieces of the High Renaissance, as accomplished as Michelangelo's and certainly more accessible.* Among the celebrated works he painted in this room, *The School of Athens* is the most perfect expression of Raphael's harmonious genius. Indeed, this magisterial work epitomizes the Renaissance ideal, the belief in the perfectibility of Man and the faith that reason will

*The title, given to the room in the seventeenth century, means the room of the signature, presumably because the pope signed important documents there. In Julius's time it more likely housed his private library.

always triumph over darkness. It is a view of the world that came naturally to him. "He was not obliged like so many other geniuses to give birth to works by suffering," Vasari noted. Instead, "he produced them as a fine tree produces fruit." In many ways *The School of Athens* is the antithesis of the Sistine Ceiling, tranquil where Michelangelo's masterpiece is agitated, a shrine dedicated to intellectual serenity rather than a barbaric temple of unfathomable mysteries.

In *The School of Athens,* Raphael has conjured a spacious dome and coffered vault—one that owes much to Bramante's designs for St. Peter's—beneath which the ancient philosophers congregate to ponder life's deepest questions. At the center is the idealist Plato pointing to the heavens, while his more pragmatic pupil Aristotle gestures to the earth; and, in the right-hand corner, surrounded by a flock of eager disciples, stands Euclid with his protractor, to whom Raphael has given the features of his friend Bramante. These great minds meet in harmonious congress in a space whose geometric perfection and sense of proportion, order, and balance seems to offer a reproach to the imploding architecture Michelangelo invented for the Sistine Ceiling.

There is one interloper in this idyll: the disheveled, brooding man in the foreground representing Heraclitus, "the weeping philosopher." Technical analysis demonstrates that Raphael added this figure after the fresco was already completed, probably after August 1510, when the first half of the Sistine Chapel was revealed to the world. There is little doubt that this bearded figure—slouched on the steps in a filthy worker's smock and knee-high boots, absorbed in his own thoughts—is a portrait of Michelangelo. It is a backhanded tribute to a man whose misanthropic nature earned him the epithet "the hangman" from the normally easygoing Umbrian, a tribute that is all the more poignant given that all Raphael received in return for his admiration was Michelangelo's contempt. Indeed, it is impossible to imagine Michelangelo returning the favor. His attitude toward Raphael, a paradoxical combination of envy and disdain, would never have allowed the younger artist a place in *his* painting.

III. TIME'S ARROW

Michelangelo completed the first half of the ceiling in July 1510.* In little more than twenty months of intense, agonizing, and ultimately triumphant labor, he and his assistants had covered over 2,000 square feet with sweeping panoramas and crowded vistas, with dozens of figures in striking poses, either nude or robed in dazzling colors, each a bravura display of anatomical precision and expressive gesture. Challenged by the cosmic story of Creation, Michelangelo developed a new artistic vocabulary, one that invested the monumental muscularity first achieved in the *David* with a new dynamism and emotional depth. Already in that heroic figure the lassitude of the *Bacchus* and the solemn reverie of the *Pietà* have been replaced by a taut expectancy. A latent violence registers as a faint tremor that courses through David's sleek limbs, but that potential is held in check by an almost Olympian self-possession. He is very much the master of himself and of the moment. The Lord's presence instills in him a quiet confidence that makes him all the more lethal.

But the Sistine Ceiling is a raging tempest in which God is no longer a comforting presence but a surging, disruptive power. Those who participate in or are witnesses to His Creation are tossed about by forces beyond their comprehension; they are whirling dervishes whose experience of the divine is manifested in convulsive movement. Agitated, undone—enlightened, agonized, or ecstatic—revelation courses through their bodies like an electric current.†

*In July 1510 he wrote to his brother Buonarroto: "Here I'm working as usual and will have finished my painting by the end of next week, that is to say, the part I began, and when I have uncovered it, I think I shall receive payment and will try to get leave to come home for a month." (*Letters*, I, no. 52, p. 54.) Unfortunately, Julius's military campaigns intervened and Michelangelo spent a frustrating year trying to extract the funds to begin the second half. The official unveiling of the first half did not occur until August 1511. Paride de Grassis marked the occasion with a laconic entry in his journal: Julius, he noted, attended the vespers services "either to see the new paintings, recently revealed in the chapel or because his devotions led him to." (Quoted in George Bull, *Michelangelo: A Biography*, p. 96.)

†During his stay in Bologna, Michelangelo had had another opportunity to study the reliefs of Jacopo della Quercia on the doors of San Petronio. The rugged muscularity of

The overall structure of the Sistine Ceiling is Talmudic: that is, it consists of a central scriptural text—in this case the story of Genesis—surrounded by commentary in the form of scenes and figures that echo, explicate, and elaborate its core meaning. Michelangelo renders God's Creation as a seismic event, and those who testify to its miraculous nature are shaken from their complacency, filled with both awe and dread. Even Isaiah, one of the calmer figures on the ceiling, betrays a profound discomfort. He has (literally) been disturbed, or at least interrupted. He looks up from the book he's been reading, the finger of his right hand holding his place as he turns toward the cherubic infant over his shoulder who whispers something in his ear and points with his thumb to what's taking place in the register above them. Isaiah's eyes are hooded, his lips parted, as if he's just awakened from a trance. Understanding comes slowly, rising in a vortex that begins at his feet and spirals upward until it reaches his troubled brow. To glimpse even a fragment of God's Truth is a disruptive experience, registered across the prophet's entire body even before his mind stirs to righteous anger.

Seated to his right is the Cumaean Sibyl, the priestess of Apollo who from deep inside her fetid cave, intoxicated by volcanic vapors, mumbles prophecies that foretell Christ's coming. Michelangelo depicts her once-powerful form ravaged by time, the necessary price of hard-won wisdom. Like Isaiah, she twists in her chair, but her *contraposto* involves a greater contortion as if her lower limbs and torso were being tugged in opposite directions. Unlike her neighbor, whose book has been put aside so he can listen more atten-

these figures continued to impress him. Another source for these more animated forms was the recently discovered *Laocoön,* a sculpture unearthed in a Roman vineyard in 1506. Michelangelo himself was present on that January morning, sent by Julius to confirm that it was indeed the masterpiece described in Pliny's *Natural History.* The statue depicts the horrifying death of the priest Laocoön and his two young sons, strangled by serpents sent by the god Apollo to punish him for his impiety. Far more violent than the *Apollo Belvedere,* the torqued, agonized forms offered a new expressive vocabulary. Two of the nudes accompanying *The Sacrifice of Noah,* for example, are taken almost directly from the *Laocoön,* but removed from their original context, their twisting poses express spiritual doubt or a religious epiphany, each of which disturbs the soul in some way.

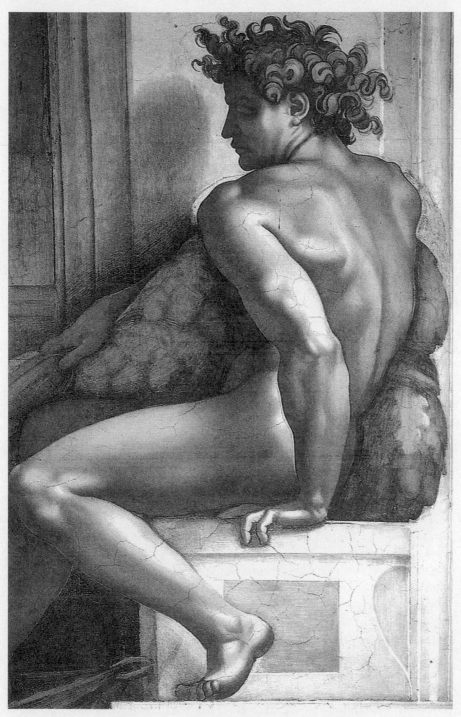

Michelangelo, *Ignudo,* Sistine Ceiling, c. 1510.

tively to the figure whispering in his ear, she hunches over a massive tome, mouthing the words written as if by fire upon the page.

She too is made uncomfortable by her inspiration, her gargantuan frame at war with itself. Even more agitated are the nude youths—the *ignudi*— perhaps because they are closer to the summit of the vault, realm of God's immanence and cauldron of Creation. None of them sits easily in his seat. Some are about to rise, others flail about wildly as if singed in the furnace blast of the divine.

Many have labeled these well-toned athletes angels, but they possess none of the attributes normally associated with celestial beings. Rather than reflecting the world of pure spirit they seem to belong unapologetically to the realm of the flesh, occupants of a lower order responding to the miraculous visions above with awe, fear, hilarity, or even outright incredulity—hardly appropriate behavior for a heavenly choir practiced in singing God's praises. Michelangelo actually borrowed many of the poses from ancient sculptures, which has encouraged some scholars to posit a Neoplatonic explanation in which the nudes are rebranded as pagan *genii*, embodiments of the intellect or rational soul.* But this label is just as unsatisfactory as that of "wingless angels"; these wanton youths are no more plausible as avatars of rationality than they are models of celestial calm.

*The Christian and Neoplatonic interpretations are complementary rather than contradictory. As manifestations of the soul and the intellect, these *genii* play a role similar to angels in the Christian faith. De Tolnay identifies five separate grades of *genii* in the Sistine Ceiling. In this scheme the *ignudi* are the *genii* of the rational soul; the small figures behind the prophets and sibyls represent the *genii* of natural intellect, and the *putti* below as the *genii* of bodily nature. No doubt there is something to this analysis, but such elaborate intellectual constructs go too far, I believe, in assuming that Michelangelo was an intellectual rather than an artist seeking forms that made intuitive sense. Benedetto Varchi, who delivered Michelangelo's funeral oration, demonstrates the ways in which pagan and Christian meanings were fused: "Every man is accompanied by his two *daimons*—and these two *daimons* are those which the ancients called *genii,* given to each man at his birth, and which we Christians call angels, two of which are given to every one of us. . . . And these two *daimons, genii,* or angels, can be understood as the two contrary souls that are in us; the spiritual which is immortal and celestial, and the sensual which is terrestrial." (Quoted in de Tolnay, *The Sistine Ceiling,* p. 48.)

It should come as no surprise that these strange creatures cannot be accommodated within a traditional iconographic scheme. Michelangelo often populates his tableaux with nude figures whose presence is at best ambiguous, if not actually incongruous. Their closest cousins are those naked boys haunting the landscape behind the Holy Family in the *Doni Tondo*. Here, perhaps, they are meant to stand for Man prior to Redemption, supremely beautiful but unenlightened, possessed of only a sensual nature. Male nudes also play a prominent role in Michelangelo's designs for Julius's tomb. Described as "slaves" or "captives," their precise symbolic function is not immediately apparent. The fact that Condivi described them as "the virtues [who] were the prisoners of Death," while Vasari interpreted them as "the provinces subjugated by th[e] Pontiff and rendered obedient to the Apostolic Church," reveals that even his contemporaries had to scramble to come up with plausible explanations.

Ultimately, attempts to wedge Michelangelo's idiosyncratic iconography into a neat theological box miss the point.* What matters is the *expressive* function of the nude body. Whatever philosophical or scriptural label we slap on them, the *ignudi* are there primarily to testify to the disorienting fury of God's procreative urge. Unlike the prophets and sibyls who experience this force in mediated form—through words inscribed in books and scrolls—the nudes are caught in the very eye of the storm. While the former are cerebral, embodying enlightenment, the latter are creatures of blind instinct. Reacting reflexively to the sacred drama unfolding above them, their eloquent bodies testify to miracles they only dimly comprehend.

The narrative panels whose potency is proclaimed so vividly by the *ignudi* consist of nine scenes taken from Genesis laid out like a comic strip along

* An incident that occurred while Michelangelo was working on the Medici tombs (see chapter 5) throws light on this subject, revealing how easily a mythological motif could be repurposed for use in a religious context. Originally, the lantern of the dome was to have been decorated with a fresco, the subject (significantly) to be chosen by the artist himself. Sebastiano del Piombo suggested perhaps a figure of Ganymede—the beautiful boy abducted by Zeus in the form of an eagle—joking that if he put a halo on him, everyone would interpret the scene as St. John of the Apocalypse ascending to heaven, a far more appropriate image for a Christian tomb.

the central spine of the ceiling. Beginning with the three stories of Noah and the Flood, Michelangelo proceeds backward in time. The next three panels are devoted to the story of Adam and Eve in the Garden, while the last three depict God's Creation before the arrival of humanity. In other words, the series begins in the inadequate present—the broken world that resulted from the Fall and that was only partially healed by the covenant following the catastrophe of the Flood—and proceeds toward greater and greater perfection. St. Augustine sums up this sorry history in a single memorable sentence: "And thus, from the bad use of free will, there originated the whole train of evil, which, with its concatenation of miseries, convoys the human race from its depraved origin, as from a corrupt root, on to the destruction of the second death, which has no end, those only excepted who are freed by the grace of God." By reversing time's arrow, Michelangelo reverses the biblical narrative and even entropy itself. Genesis is a story of decay, a chronicle of the breakdown of God's perfect universe through Man's disobedience, but in the natural flow of the chapel from entrance to altar, we move from a world degraded by the sinful creatures who populate it to one dominated by a transcendent, all-powerful Father.*

This reverse chronology is built into the structure of the chapel itself, which is divided by an ornate marble screen that separates the portion traditionally open to the laity from that reserved for the clergy. At the time Michelangelo painted the ceiling, the altar wall featured Perugino's fresco depicting the Assumption of the Virgin, an event symbolizing Mary's role as mediator between heaven and earth. The trajectory of Michelangelo's narrative reinforces the message embodied in the actual space, of a spiritual journey that culminates at the altar where, during the performance of Mass, the priest offers the sacrament of the Eucharist. It is through the performance of this sacred rite that the downward spiral of history set in motion by Man's disobedience is halted, restoring our shattered union with God through the reenactment of Jesus's death on the Cross.

Though Christ never appears on the ceiling, everything points to him and

* Unfortunately, the twenty-first-century visitor enters the chapel from the opposite end, undermining Michelangelo's intended narrative.

to his Church as the vehicle of our salvation. The ceiling takes as its point of departure the first book of the Old Testament, but its true subject is the "good news" of the Gospels that tells of our redemption through the Incarnation and Crucifixion. Indeed, the Gospels can be viewed as the story of Genesis told backward, just as Michelangelo presents it, as an ascent toward grace rather than a fall from it. Like other Christians of his time, Michelangelo was taught to view the Old Testament through the New, a methodology first elaborated by St. Augustine in the fifth century. "[W]e all hold confidently to the firm belief that these historical events and the narrative of them have always some foreshadowing of things to come," he declared, "and are always to be interpreted with reference to Christ and his Church, which is the prophecy from the beginning of the human race, and we now see the prophecy being fulfilled in all that happens. . . . Accordingly, the writer of these holy Scriptures (or rather the Spirit of God through his agency) is concerned with those events which not only constitute a narrative of past history but also give a prophecy of things to come."

Each scene from Genesis, then, not only recounts the story of Creation and the fall of Man, but reaffirms the promise of redemption. Thus *The Drunkenness of Noah,* the scene closest to the entrance, refers both to the wine of the Eucharist, symbol of Christ's sacrifice and, through the mocking by Noah's son Ham, recalls the mocking of Christ before his execution. The first three scenes taken together tell the story of the Flood and its aftermath, a crucial moment in the story of our salvation because it ends when God proclaims His first covenant with Man:

> God spoke to Noah and his sons, "See I establish my Covenant with you, and with your descendants after you; also with every living creature to be found with you, birds, cattle and every wild beast with you: everything that came out of the ark, everything that lives on the earth. I establish my Covenant with you: no thing of flesh shall be swept away again by the waters of the flood. There shall be no flood to destroy the earth again."

To a pious Christian of the sixteenth century, this image would have called to mind Jesus on the Cross, just as *The Birth of Eve* evoked the drama of the

Passion. In the story of Noah, the concluding covenant prefigures the ulti-mate contract binding God and Man through the incarnation and sacrifice of His Son, while the scene depicting Eve's emergence from Adam's rib re-calls the fatal wound Jesus received while on the Cross.

The ceiling is a dense fabric woven together from such metaphorical strands; it is as much allusion as illusion. The sibyls and the prophets, for instance, do double duty as emissaries from the pre-Christian world whose gift of foresight allows them to attest to the divinity of Jesus. Jonah, depicted in a critical spot above the altar, is a precursor of Christ because the three days he spent in the belly of the great fish anticipated the three days between the Crucifixion and the Resurrection, while Isaiah's words, like those of the Cumaean Sibyl, were interpreted by Christians as prophecies of Christ's suf-fering and death.

None of this meant that Michelangelo needed help from a trained theo-logian or that his intent was to pose elaborate riddles indecipherable to all but scholars. As a conventional Christian who was also exposed to the pro-gressive strains of humanist philosophy, he had long been steeped in such analogic thinking. While still a young man, he had been among the crowds spellbound by Savonarola's sermons. In one famous series, delivered in the autumn of 1494 when it seemed as if the marauding French army was about to engulf Florence, the fiery preacher compared current tribulations to God's cataclysmic Flood. "He preached in the church of Santa Reparata," wrote one of those in attendance, "and when, at the moment the King of France entered the city, he announced that the ark was closed, the whole assembly amid ter-ror and dismay and outcries went out into the streets, and wandered up and down, silent and half dead."

Echoes of Savonarola's apocalyptic harangues reverberated decades later in Michelangelo's retelling of the biblical story, but an impulse to look be-neath the surface for signs of God's providence was not confined to religious fundamentalists. Even as he attended sermons by Savonarola in the Cathe-dral, Michelangelo was being seduced by the mystical Neoplatonic flights of Ficino and Pico, who taught that the world apprehended by the senses was an illusion concealing a dimension of ideal form and pure intellect.

This dual education prepared Michelangelo for the task at hand, not

by providing him with a detailed road map but by allowing him to strike out boldly on his own path. His images are unforgettable because he was conceiving new forms and discovering new meanings, not just dutifully illustrating a predetermined text. He works by instinct and analogy, his independence of mind and inventive imagination opening up new expressive possibilities. When he combines the two scenes of the Temptation and the Expulsion—melding serpent and avenging angel so that they appear almost as a single hybrid creature—he is opening up new theological possibilities in the act of creating a striking image.* In the panel ostensibly showing the Separation of the Earth from the Water, he has relied so little on the text that scholars have had trouble identifying the scene. But few who see the image of the Almighty hovering above the waters can ever forget His titanic energy and Jove-like majesty. Michelangelo is an artist, not a pedant, a conjurer of sacred mysteries rather than a transcriber of received wisdom. He is a profound but unsystematic and unorthodox reader of Scripture, reveling in the unexpected, flirting with heresy, celebrating his own illicit passions and exploring his morbid pathologies.

The five bays completed by July 1510 include four of the prophets—Joel, Zechariah, Isaiah, and Ezekiel—accompanied by their three female counterparts—the Delphic, the Erythrean, and the Cumaean Sibyls—as well as twelve of the *ignudi* and assorted ancestors of Christ. The five scenes from Genesis include the three depicting Noah and the Flood, along with *The Creation of Eve* and *The Temptation and Expulsion from the Garden.*

Typically, as Michelangelo prepared to take down the scaffolding and reassemble it on the far side of the chapel, he tried to keep his colleagues and the general public from seeing what he was up to. But once again the pope refused to indulge his penchant for secrecy. Julius not only enjoyed

*It is surely no coincidence that, together, tree, serpent, and angel make the shape of a cross, reminding us of the connection between the Tree of Knowledge and the Tree of Life, whose timber was used for the Cross upon which Jesus died, according to mystical interpretations. As St. Ambrose put it, "death through the tree, life through the Cross." (Quoted in Dotson, I, p. 242.)

commissioning great works of art but craved the adulation that came with a reputation for munificence. "[H]e insisted on having it uncovered," Condivi recorded, "although it was still incomplete and had not received the finishing touches. Michael Angelo's fame, and the expectation they had of him, drew the whole of Rome to the chapel, where the Pope also went, even before the dust raised by taking down the scaffolding had settled."

The impact on the public mind of seeing the vault laid out for the first time can hardly be overstated, particularly for his fellow artists, who realized their work would be judged timid and old-fashioned by comparison. It was probably at this time that Raphael rushed back to add the figure of Heraclitus to *The School of Athens;* certainly, all his subsequent work shows a new vigor and muscularity inspired by this opportunity to study Michelangelo's fresco at length. But Michelangelo feared that Raphael was after something more than mere inspiration, claiming that, with the connivance of Bramante, he was trying to maneuver the pope into assigning him the second half of the ceiling. This farfetched notion, however, was just another paranoid fantasy on the part of an artist who, however much he hated the project, hated even more the prospect of someone else profiting from his labor.

Michelangelo himself was among those taking advantage of the opportunity to survey the ceiling from the chapel floor, rather than with his nose pressed up against the plaster. From 60 feet below, the earliest panels— particularly *The Flood* with its congested throng—were hard to decipher, and the adjacent nudes and prophets appeared insufficiently majestic. The opportunity to view the ceiling from a distance confirmed a trend, already visible in the scene of the *Temptation and the Expulsion,* toward greater simplicity and monumentality. If Michelangelo was indifferent to public acclaim and irritated that the pope encouraged his rivals to feast on the fruits of his talent, he had at least overcome the self-doubt that beset him when he began. He was now supremely confident in his own abilities, and the fact that he was covering wide swathes in a few short days was an encouraging sign for the future. If all went well, he would soon be done with the unpleasant task of painting the ceiling and could take up once more the abandoned tomb.

But Michelangelo's hopes for a speedy conclusion were soon dashed. A month after the unveiling, Julius launched another one of his bloody campaigns, this time to drive the French from Italian soil. Though they had helped him in his war against the Venetian Republic, Julius now viewed his former allies as a threat to his own independence. "[They] are trying to reduce me to nothing but their king's chaplain," he rumbled, announcing his intention to drive them back across the Alps. Louis responded in kind, sneering, "the Rovere are a peasant family. . . . Nothing but the stick at his back will keep this pope in order."

On August 17, 1510, Julius rode out of the city at the head of the papal army with the cry *"Fuori i barbari!"* (out with the Barbarians). Unlike the triumphant campaign of 1509 against the Venetians, however, this one began badly. Delayed in Bologna by illness and then by an unusually harsh winter, the papal forces were threatened with annihilation. But even at his lowest ebb, routed on the battlefield and debilitated by fever, Julius remained defiant, at one point strapping on his armor while muttering: "I'll see if I've balls as big as those of the King of France."

Meanwhile, Michelangelo fretted in Rome, unpaid and unemployed. He had been promised 1,000 ducats to build the new scaffolding but, he complained, the pope "has gone away and has left me no instructions, so that I find myself without any money and do not know what I ought to do," adding: "I do not want him to be angry if I were to leave, and to lose my due, but to remain is hard." Late in September, with still no word from Julius and no money from the treasurer, he set out for Bologna. It was the first of two journeys he would make to the city in a desperate bid to persuade the pontiff to make good on his promises.

On his second trip to see the pope, in December 1510, he stopped in Florence to visit with his family. As usual, the various members of the Buonarroti clan were seething with resentments and prey to delusional schemes, most of them based on the belief that Michelangelo would always bail them out. Even Lodovico apparently had no compunction helping himself to Michelangelo's money, withdrawing without his permission 100 ducats from his account in Florence.

But the family member who caused him the most grief was his brother

Giovansimone, his junior by four years, a feckless good-for-nothing who managed to precipitate a crisis in the already tumultuous Buonarroti household. When Michelangelo learned of the violent quarrel between Giovansimone and their father, he lashed out at his younger brother:

> *Giovan Simone . . . I have tried for many years, with kind words and deeds, to induce you to live well and to get along with your father and with the rest of us, and yet you go from bad to worse. I won't say that you're wicked, but you are acting in ways that please neither me nor the rest of your family. . . . For some time now, I have provided for your expenses and your house, for the love of God, believing that you were my brother as much as the others. Now I know you are not my brother, since if you were you would not threaten my father; in fact, you are a brute, and like a brute I'll treat you. You know that he who threatens his own father is said to forfeit his own life. But enough. I tell you that you've nothing in this world, and if I hear the least complaint of you, I will ride there and show you the error of your ways and teach you not to destroy the possessions and set fire to a house that you have not earned yourself. . . . If I am forced to come there, I will show you such things that you'll shed hot tears and you will know what little cause you have for your arrogance.*

He concluded his letter by reminding Giovansimone of all he'd done for him and his brothers:

> *[F]or twelve years I have been travelling all over Italy, enduring every humiliation, bearing every hardship, flaying my body in every endeavor, placing my life in a thousand perils, only to help my family. And now that I'm beginning to raise us up a little, you seem to want only to tear down in an hour all that I've built over so many years with so much suffering.*

Despite Giovansimone's appalling behavior and despite his resentment at being used by relatives who lived off the sweat of his brow, Michelangelo remained fiercely loyal to his family, in part because the honor of the Buonarroti name was crucial to his pride and sense of himself.

In fact, for all his protestations of poverty, Michelangelo had already suc-

ceeded in restoring luster to the faded Buonarroti name. No matter how often he claimed that the pope had shortchanged him, it was clear he was prospering. With the money he earned, he had begun to invest in properties in Florence and the surrounding countryside, establishing the Buonarroti among landed gentry to which he always felt they belonged.* It was during the years he was painting the Sistine Ceiling that he first announced his plan to set up three of his brothers in their own business. The project was finally realized in 1514 when he purchased a wool shop, which, while it never flourished, provided them with something Michelangelo valued more than money—social prestige. Even though Michelangelo helped them all, Buonarroto was the only one who managed to make a success of himself, eventually parlaying his desultory career as a businessman into a more-than-respectable career in government. In 1515, Buonarroto rose to the rank of prior, a far more exalted position than any enjoyed by his father during his career as a civil servant.

Meeting with Julius in Bologna, Michelangelo found the pope a changed man. Illness and a string of reversals at the hands of the French had left the once-fearsome pontiff gaunt and dispirited. But what he had lost in terms of belligerence he seemed to have made up for in gravitas. Over the course of his illness he had grown a beard, which now hung down over his sunken chest in white, wispy strands, swearing he would not shave until he had driven the barbarians from their midst. Now, approaching the end of life, he was no longer Il Papa Terribile but had come to resemble one of those Old Testament figures like Noah, Zechariah, or Ezekiel populating Michelangelo's fresco. It is this haunted, haggard face that Raphael captured in his

* He bought his first property, a small farm in Pozzolatico, for 600 ducats in 1505. In 1508 he bought three buildings in Florence itself, two on the Via Ghibellina and one on the Via Santa Maria, which is now the museum known as the Casa Buonarroti. In October 1511 he proposed spending an additional 1,400 ducats, and in May and June of 1512 he purchased two additional properties in Florence, the first near Santa Croce, the second in the parish of Santo Stefano. These were not the actions of someone on the verge of poverty. In 1515, Pope Leo X bestowed an additional honor on the family, naming them Conti Palatini, Counts Palatine, thus confirming Michelangelo's belief in his noble pedigree.

famous portrait, showing Julius as a man who, though old and careworn, still burned with inner fire.

Perhaps it was his newfound introspection or his understanding (driven home by recent defeats on the battlefield) that the art he commissioned was likely to prove his most enduring legacy, but Julius was receptive to Michelangelo's pleas, sending him on his way with promises that he would receive the necessary funds to complete the Chapel. When Michelangelo arrived back in Rome at the beginning of 1512 he found an additional 500 ducats in his bank account and a deed permitting him to live in the house on the Piazza Rusticucci rent-free.

IV. THE FORMLESS WASTE

With his money troubles behind him, at least for the moment, and his family enjoying a rare interlude of calm, Michelangelo could finally turn his attention to the neglected ceiling. He had been away for almost half a year. Over the months of idleness he had plenty of time to mull over what he'd already achieved and absorb the lessons of seeing the fresco for the first time as the public would, from the floor, craning his neck to gaze on figures high above his head. His style had begun to evolve even before the old scaffolding had come down, as if he realized instinctively that compositions based on a few large forms vigorously handled would be more effective than the busy compositions with which he'd begun. (The evolution toward more majestic forms may also have had a more prosaic origin: a realization that he could cover more square feet more quickly this way.) No doubt the experience of seeing the fresco from the pavement confirmed his judgment and pushed him further in the direction of simplicity and monumentality.

Perhaps the most important thing he gained from viewing the fresco from below was (literally) a fresh perspective. While he painted the earlier panels as if they were perpendicular to our space—that is, parallel to the ceiling and the floor—in the narrative panels painted during the second campaign, he frequently deployed the *di sotto in sù* perspective that Vasari claims was the most difficult art of the fresco painter. Even now, Michelangelo did not employ perspective consistently; he never attempted the crowd-pleasing il-

lusion that the ceiling has melted away and become open sky, but instead exploited selectively and strategically the expressive possibilities of daring points of view. The earlier panels seem firmly earthbound, but these later narratives propel us into space. All the usual signposts we use to orient ourselves vanish as we enter the seething cauldron of Creation, before there was ground to stand on or sun to light our way, before even time itself.

Michelangelo's newfound mastery of radical foreshortening is most evident in the two fan-shaped panels in the corner: *The Brazen Serpent* and *The Punishment of Haman,* which echo *David and Goliath* and *Judith and Holofernes* at the far end of the chapel. Each of these scenes is linked thematically, an episode of Jewish deliverance that foreshadows the redemption of humanity from sin in Jesus Christ. But it is only the two later panels that exploit the *di sotto in sù* viewpoint for maximum dramatic impact. Haman's suffering on the gibbet is heightened by showing his contorted body from below so that muscles, already stretched to the snapping point, appear to convulse in agonized clots. Even more shocking is *The Brazen Serpent,* where the telescoping perspective creates an effect of writhing limbs tumbling into our space as if from an overhead abattoir.

In the second half of the ceiling, Michelangelo displays an unprecedented emotional range. His figures are supercharged, Titans capable of scaling the highest summits and excavating the lowest depths. The scenes of Haman and the Brazen Serpent show Michelangelo in his darkest, most pessimistic mood, while *The Creation of Adam,* the first scene completed after he remounted the scaffolding in January 1511, shows him reveling in the glory of Man's limitless potential. One is reminded, as with the *David,* of Pico's view of Adam as a man "confined by no limits," who may choose "to descend among the lower forms of being" or "reborn out of the judgment of [his] own soul into the higher beings, which are divine." Here, for the first time in the ceiling, Michelangelo gives free rein to his delight in the human (specifically male) form. The languid body of Adam as he props himself up on his elbow is unabashedly sensuous, a celebration of Man's uncorrupted beauty at the beginning of the world. His pose echoes that of Noah in the scene of his drunken humiliation, setting up a contrast between the glory of Man's God-given beauty and the degradation of his fallen state. The aging Noah,

though "a man perfect in his generation," belongs to a corrupted world where flesh is associated not only with illicit pleasure but with suffering and pollution. Adam's beauty, by contrast, is unmarred. He is innocent of shame just as he is innocent of knowledge, a man perfect though also limited. Sprawled on the grass, he begins to stir to consciousness as he senses God's presence, reaching out longingly to the source of all life like a lover to his beloved.

This is not the first time Michelangelo has represented God in the ceiling. The Lord appears in the earlier panel, *The Creation of Eve,* as a grave, patriarchal figure with a long white beard.* The God of *The Creation of Adam* shares almost nothing with this unremarkable figure. Rather than standing on the ground, he hurtles through space, his billowing mantle shrouding a seraphic host that seems unhinged by a divine ecstasy. He thrusts His hand toward Adam's, His implacable will and certain purpose matched by Adam's yearning yet tentative reach. Their fingers approach but never touch, leaving a narrow gap crackling with invisible discharges across which the animating spark leaps.

Here, Michelangelo's originality, his willingness to depart from the text for the sake of greater dramatic impact, is on full display. The image he creates appears nowhere in Scripture. "God fashioned man of dust from the soil," the Bible tells us. "Then he breathed into his nostrils the breath of life, and thus man became a living being." But Michelangelo transforms this intimate act into something far more muscular. Never before in the history of art has the Lord of Hosts been conceived in such a manner. He is a transcendent being, completely corporeal (even his nipples are visible through his sheer, windswept robe) yet somehow also pure, unadulterated spirit.

* The reason this scene occupies the pivotal central panel, rather than the more obvious *Temptation and Expulsion,* can perhaps be explained by a passage from St. Augustine: "For at the beginning of the human race the woman was made of a rib taken from the side of the man while he slept; for it seemed fit that even then Christ and His Church should be foreshadowed in this event. For that sleep of the man was the death of Christ, whose side, as He hung lifeless upon the cross, was pierced with a spear, and there flowed from it blood and water, and these we know to be the sacraments by which the Church is 'built up.'" (*City of God,* xxii, 17, pp. 839–40.)

Michelangelo's conception owes more to ancient depictions of Jupiter than to the Judeo-Christian tradition, where God has always seemed too awesome to be rendered convincingly (despite the fact that Scripture states that Man was made in His image.) For the most part, artists preferred to depict Christ, God made flesh; when they attempted to depict God Himself, the result had usually been to diminish Him. Even an artist as gifted as Jacopo della Quercia came up short in this regard. His own version of *The Creation of Adam,* which may well have inspired Michelangelo's, shows God as a regal old man, not as a transcendent being, supreme ruler of the universe.

It is this transcendent being who dominates the remainder of the ceiling, an airborne Hercules who conjures light from dark and form from chaos. Much of the power of these final frames comes from Michelangelo's decision to raise the Almighty from the earth and send Him careening through the void. Unencumbered by the laws of gravity, He shows Himself superior to law itself. In *The Separation of the Earth from the Waters,* God is rendered remarkably foreshortened, so that he seems to rocket out of the picture and into our space. In *The Creation of the Sun, Moon, and Planets,* He appears twice, coming and going. We see Him once speeding toward us, fashioning the orb of the sun with a gesture of imperious command; and, in an even more daring image, flying away from us so that we see little more than the soles of His feet and His sacred buttocks. In the hands of a lesser artist, such an image would appear ridiculous, perhaps even blasphemous, but Michelangelo has endowed the Creator with such titanic energy and supreme authority that we barely notice the incongruity.

It speaks volumes about Michelangelo's self-confidence that he dared to tackle the most difficult, most unpaintable subject in all of art. Capturing God's ineffable grandeur poses such a daunting task that many religions have instituted an outright prohibition, and even Christian painters, for whom no such prohibition applies, remain leery, knowing how easy it is to be accused of hubris or, even worse, to appear ridiculous. For an artist of Michelangelo's ambition, however, the subject was compelling, perhaps even inevitable. Of course, even at his most egomaniacal, Michelangelo was too conventionally pious, and too aware of his failings, to invite a comparison, at least as

a man. But as an artist, he believed he tapped into something supernatural. He writes in one of his sonnets of "lovely art that, heaven sent, conquers nature herself." And in his *Dialogues with Michelangelo,* Francisco de Holanda quotes the great artist comparing the creator of the universe to a painter: "[G]ood painting is nothing else but a copy of the perfections of God and a reminder of His painting." It would be going too far to claim that, in painting God, Michelangelo was fashioning his own self-portrait, but in depicting the creator of the universe he, like Prometheus, was stealing some small ember of the divine fire for himself.

In these last few frames Michelangelo carries us on such a fast-paced, vertiginous journey that by the time we reach the panel *God Separating the Light from the Dark* our heads are spinning. The cyclonic energy generated by the creative act radiates outward in concentric circles, causing everyone and everything to sway like wind-lashed treetops in the wake of an approaching storm. Even the massive prophets and sibyls who occupy this torrid zone cannot resist the propulsive forces unleashed by Creation. The Libyan Sibyl executes an improbable seated pirouette, her back turned to us while her hips swivel forward as if the book she's been reading is a discus about to be launched into space. Across the ceiling from her is Jeremiah, "the weeping prophet," a dark and brooding figure whose angular features recall those of the artist himself. Most remarkable of all, however, is the figure of Jonah, the reluctant prophet, who occupies the crucial position right above the altar. He is the only figure with the courage (or temerity) to gaze at the vault above him, turning his face toward God and His Creation. The centrifugal forces that tug at the prophets—from Isaiah and the Cumaean Sibyl in the center to Daniel and the Libyan Sibyl near the altar—have become cyclonic. Jonah, his eyes wide with fright or the ecstasy of divine revelation, spins on his seat, his feet lifted from the ground as if he's about to be sucked by the vortex into the heavens. Like many of Michelangelo's most eloquent inventions, he interiorizes conflict. He is a man torn between two imperatives, gesturing earthward even as he gazes heavenward, a man struggling with God before finally succumbing to His will.

The last figures Michelangelo painted were the ancestors of Christ in the lunettes above the windows. Painted freehand, without the use of cartoons

to guide him, they demonstrate a supreme confidence gained after almost four years on the scaffolding. After the heroic host depicted above, these peculiar creatures come as a bit of a shock. On the vault itself, even the so-called brazen nudes possess a certain grandeur, but the ancestors are a gaggle of odd ducks. Some, like the pointy-bearded Booz, verge on caricature, as if Michelangelo was indulging in a rarely glimpsed satiric wit. These mismatched family groups with their household goods, their squirming infants, and workaday clothes, are deliberately mundane. They belong to our world, share our faults and our homely virtues. As the ancestors of Jesus in his earthbound aspect, they form the all-too-human link between our world and the celestial realm above. They derive from an ancient tradition in which humorous or grotesque characters were inserted at the margins of sacred tableaux, adding a touch of realism to scenes that might otherwise collapse under the weight of their own piety or dissolve into vaporous dreams. For Michelangelo they play a similar role, grounding the celestial drama above in daily life and confirming the profligate variety of Creation.

The frenetic pace of this last campaign left Michelangelo spent. "I work harder than any man who has ever lived," he wrote to Buonarroto in July, 1512, "and am in bad health and greatly exhausted." But a few months later he could finally see a light at the end of this very long tunnel, writing to his brother, "I expect to finish by the end of September," and making plans to return to Florence: "I shall be home before All Saints [November 1] in any case, if I do not die in the meantime. I'm being as quick as I can, because I long to be home."

The final months of work coincided with a happy turn in the pope's fortunes, relieving Michelangelo's anxiety that he'd be forced to abandon the ceiling with the end in sight. By the summer of 1512, Julius had snatched triumph from the jaws of almost certain disaster. On April 11, near Ravenna, forces of the Holy League fought the French and their allies in one of the bloodiest battles ever waged on Italian soil. Though the French held the field, they were, according to Guicciardini, "so weakened and dispirited . . . by the victory which they had won at such expenditure of blood, that they seemed more like the conquered than the conquerors." Most devastating was

the death of their brilliant commander, Gaston de Foix, a loss that sent the French armies "flying like mist in the wind."

Reading an account of the French retreat, Julius turned to Paride de Grassis, his Master of Ceremonies, and exulted: "We have won, [Paride], we have won!" * As word spread, the mood in Rome turned from despondency to jubilation. The pope, recently reviled as the author of their troubles, was now greeted as a liberator. Fireworks were set off from the Castel Sant' Angelo and bonfires kindled in the squares. Julius, confirming the destiny foretold when he chose his papal name, was hailed as a new Caesar. "Never was any emperor or victorious general so honored on his entry into Rome," wrote the Venetian envoy, "as the pope has been today."

In many ways, the Sistine Ceiling was a more powerful, and certainly more enduring, tribute both to papal authority and to the man who currently occupied the Throne of St. Peter than the bronze statue destroyed in Bologna. Not only was the entire program a magisterial affirmation of Christian doctrine—with a particular emphasis on the Church as the sole instrument of salvation—but Michelangelo had liberally garlanded the ceiling with acorns and oak-leaf clusters of the della Rovere family crest. For the most part, these bits of foliage sprout up around the various *ignudi;* these nudes, in turn, support the bronze medallions that depict stories from the Books of the Maccabees, linking the ancient tale of the Jews' struggle for religious liberty to Julius's own campaigns to drive the barbarians from the peninsula. Thus interwoven with lofty themes of Creation and Salvation are more prosaic reminders of earthly power.

It is not surprising that Michelangelo would allow blatant propaganda to intrude on his sacred narrative; his artistic courage was always more pronounced than the political or physical variety. In any case, his feelings for his patron were ambivalent. A sonnet of 1511 includes a not-so-subtle rebuke of his master (referred to slyly as an "arid tree"), but the feelings he expresses are those of a disappointed suitor rather than a principled opponent:

* His victory was secured with the help of 18,000 Swiss pikemen. In gratitude for their service, Julius named them "Protectors of the Liberty of the Church," and established the Swiss Guard as papal bodyguards, a role they maintain to this day.

You have succumbed to rumors
*and rewarded those who are the real villains.**
It is I who have been your faithful servant from days of old,
as close to you as rays are to the sun,
though you mourn not as my years slip by,
I please you less the more I slave.
Once, I hoped to rise through your ascent,
believing that the scale of justice and the sword of power
would triumph, not these idle chatterers.
But heaven is granted to he who seeks
no reward here on earth,
and leaves to others to harvest fruit from an arid tree.

If only, he implies, Julius did not listen to the slanders of his enemies, all would be well. He has no wish to condemn him; in fact, he craves his love and attention. If this poem reflects jealousy and hurt feelings, another poem from the same years rails bitterly at the corruption of the city Julius ruled, where "[c]halices [are] hammered into sword and helmet!/ Christ's blood sold, slopped in palmfuls." But unlike Savonarola, who made similar charges using much the same language, Michelangelo was not willing to risk his career or his life in pursuit of a losing cause.

Over the years many of his defenders, hoping to absolve him of the charge that he prostituted his art for personal gain, have detected various obscene gestures or hidden jokes at Julius's expense in the ceiling, but none of these scenarios is persuasive.[†] Michelangelo was tormented by the knowledge that his art was predicated on an unholy alliance between Mars and Mammon that could perhaps be embellished, but not redeemed, by the grandeur of his work.

On October 1, 1512, Michelangelo informed his father that he'd completed the ceiling. Though his mood is hardly ebullient, one can detect a

* Likely a reference to Bramante, or possibly Raphael.
† For instance, one of the putti standing over the shoulder of Zechariah is supposedly making the obscene "sign of the fig" in the direction of the della Rovere coat of arms.

certain relief concealed beneath all the usual gripes. "I finished painting the chapel," he reported to Lodovico: "the Pope is well satisfied, but nothing else goes as I anticipated. It is the fault of the times, which conspire against our art." The unveiling took place on October 31, 1512, the ninth anniversary of Julius's election. The pope's master of ceremonies, Paride de Grassis, notes with little excitement, "our chapel was opened, the painting being finished." Condivi's description suggests a rather more memorable occasion. "It was seen with great satisfaction by the Pope (who had that very day visited the chapel)," he wrote, "and all Rome crowded to admire it." He follows with a description of an incident that, while possibly apocryphal, is nonetheless revealing:

> [The ceiling] lacked the retouches *a secco* of ultramarine and of gold in certain places, which would have made it appear more rich. Julius, his fervor having abated, wished that Michel Angelo should supply them; but he considering the business it would be to reerect the scaffolding, replied that there was nothing important wanting. "It should be touched with gold," replied the Pope. Michael Angelo said to him familiarly, as he had a way of doing with His Holiness: "I do not see that men wear gold." The Pope again said: "It will seem poor." "Those who are painted here were poor also," Michel Angelo replied.

Here, in a sense, is Michelangelo's own answer to the conundrum posed by serving lords whose wealth and power were built on morally questionable foundations. While the pope himself can only perceive externals, the artist traffics in deeper truths. He is an adept of an exalted form of alchemy that turns gold into spiritual capital.

V

The Dead

The night was mine, the dark time; fate had sworn
from my look at birth, in cradle, that's my due.

—Michelangelo, sonnet

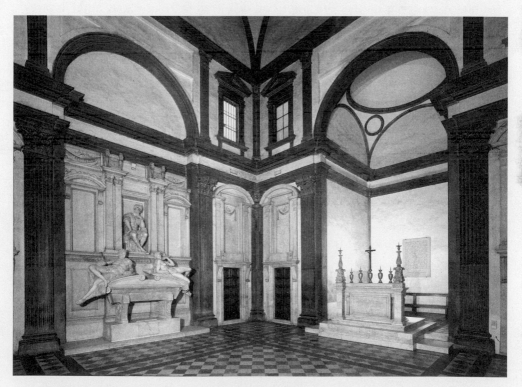

Michelangelo, *Medici Tombs*, New Sacristy, San Lorenzo, 1520–34. *Scala/Art Resource, NY*

I. RETURN OF THE MEDICI

Ten days after officiating at the unveiling of the Sistine Ceiling, Julius took to his bed with a high fever. The sixty-nine-year-old pontiff no longer possessed those reserves of vital energy that so often in the past had allowed him to rally after the doctors had given up hope. Even before the pope's final descent, the Venetian ambassador reported that "negotiations are already beginning for the choice of his successor." Julius lingered for another two months before breathing his last on the night of February 21, 1513.

Julius's death came at the height of his popularity. The once-intimidating Papa Terribile was now universally admired, even beloved. Paride de Grassis marveled: "I have lived forty years in this city, but never yet have I seen such a vast throng at the funeral of any former Pope. . . . Many even to whom the death of Julius might have been supposed welcome for various reasons burst into tears, declaring that this Pope had delivered them and Italy and Christendom from the yoke of French barbarians."

Michelangelo left no record of how he felt at the pope's passing, but he was certainly distressed by the news. Theirs had been a complicated relationship, marked by frequent quarrels, but also by mutual respect. The artist recognized in the pope a kindred spirit, a man whose egotism provided the perfect vehicle through which to carry out his own grandiose schemes. Though he often tried to slip off the rope he claimed the pope had placed around his neck, even he had to admit that the pontiff's stubborn refusal to allow him to pursue his own course had coaxed from him perhaps his greatest work.

For any artist, the loss of a patron, even one as mercurial and overbearing as Julius, generally meant a period of uncertainty as he was forced to find new projects and new sources of funding. In this instance, however, the disruption was minimized by the fact that Julius had tied up Michelangelo's services beyond the grave. The pope had set aside 10,000 ducats in his will to complete the long-neglected tomb, and on May 6, 1513, Michelangelo signed a contract with his heirs—Cardinal Santiquattro (Lorenzo Pucci) and Cardinal Aginensis (Grossi della Rovere)—for a redesigned monument to be erected not beneath the dome of the new St. Peter's as originally

envisioned but in the Sistine Chapel. Though the new plan called for a wall monument rather than the free-standing structure contemplated eight years earlier, it matched the original project in terms of size and in the richness of the sculptural program. (The contract still called for Michelangelo to create at least forty sculptures for the monument; the choice of the Sistine Chapel was logical, since Julius's uncle, Pope Sixtus IV, was already buried there.) To facilitate his work on the project, Julius and his heirs considerately provided Michelangelo with a new house, located across the Tiber, near Trajan's Column.

Michelangelo's new accommodations in the Macel de' Corvi (the Alley of the Ravens), though not an elegant palace of the kind Raphael was currently building himself on the Via Giulia, was a distinct improvement over the dirty, crowded studio on the Piazza Rusticucci. A document from 1516 describes it as "[a] house of several stories, with reception rooms, bedrooms, grounds, a vegetable garden, wells and other buildings." Spacious but austere, with high ceilings and a grand staircase, it more than met Michelangelo's simple needs. Behind the house was a large yard where chickens scrabbled among the marble blocks. Here his servants grew beans, peas, and lettuce to supplement his frugal diet. The property also contained a few outbuildings that were soon converted into bedrooms for the various servants and assistants who made up Michelangelo's household.

Even with these improvements, life at the Michelangelo residence was far from luxurious. When he asked his father to find him a new *garzone* (boy) in Florence, he advised Lodovico to seek out "the son of poor but honest people, who is used to roughing it and would be prepared to come here to serve me and do all the things connected with the house, such as the shopping and running errands when necessary. . . ." In return for this menial labor, Michelangelo promised that "in his spare time [he] would be able to learn. If you find anyone," he concludes with a typical dig at the local population, "let me know, because here only rascals are to be found."

When on March 11, 1513, the new pope was announced, Michelangelo's prospects for glory in the Roman capital seemed assured. Michelangelo had known the man who now took the title Leo X for over two decades, since those happy years when they were both teenagers in the Palazzo Medici. For

the latest occupant of St. Peter's throne was none other than Giovanni de' Medici, Lorenzo's bookish and pleasure-loving second son. Most assumed that this personal connection would allow the artist unprecedented access to the man who controlled the purse strings, a particularly enticing prospect since at the youthful age of thirty-seven—eight months younger than Michelangelo himself—the cultivated Leo seemed poised to usher in an age of unprecedented splendor.

If Leo shared Julius's taste for art, he differed from his predecessor in almost every other respect. Julius's tumultuous reign had ended triumphantly, but the cardinals were exhausted from nearly a decade of conflagration. The ambassador of the Holy Roman emperor described the new pontiff as "a lamb rather than . . . a fierce lion . . . a promoter of peace rather than of war," while his Swiss counterpart opined: "It was the best choice which could have been made, for Giovanni de' Medici inclines to peace, and is as gentle and temperate as Julius II was violent and harsh."

Where Julius was a man of volcanic temper and restless ambition, the plump, indolent Leo seemed content to enjoy the trappings of office while harboring no greater aspiration for the Church than that it should supply him and his family with wealth and prestige. Upon his election he reportedly said to his brother: "As God has seen fit to grant us the papacy, let us enjoy it." His goodwill toward Michelangelo in particular appeared to be confirmed when, instead of scaling back the opulent projects of his predecessor as most popes were inclined to do in order to spend more lavishly on themselves, Leo increased the funds devoted to Julius's tomb by 6,500 ducats.

But despite a superficial cordiality, Michelangelo's relations with the new pontiff were strained. Indeed, even before Cardinal Giovanni's elevation, there were signs of tension between the two former housemates. It is possible that Leo's ambivalence stemmed from the time Michelangelo lived under the Medici roof, provoked by jealousy as the intruder vied for his father's attention. If Giovanni harbored any resentment toward Michelangelo from these early days, his feelings could not have been improved by the artist's eagerness to serve the regime that had been responsible for his family's expulsion. With Leo pope and the Medici once more in the ascendant, questions of loyalty and betrayal had come to the fore.

Leo's elevation had been preceded by a sudden upswing in the fortunes of the Medici family, one that would prove awkward for those Florentines, like Michelangelo himself, who had worked for the previous regime. Though Florence had fielded only a token force during the Battle of Ravenna, the City of the Baptist emerged as the biggest loser in that bloody melee. It had been the long-standing policy of the Soderini regime to back the French in their contest with the pope, even going so far as to sponsor (albeit reluctantly) the council of the schismatic bishops King Louis convened in Pisa. Their halfhearted efforts, however, only managed to earn them the scorn of their French allies while simultaneously stoking Julius's rage. When the French were forced to abandon the Italian peninsula, Florence was left to face the pope's retribution alone.

Among the immediate beneficiaries of the new Italian order were Giovanni and Giuliano de' Medici, who for the last decade and a half had been scheming to return to their native land.* Dipping into the fabled Medici wealth, Cardinal Giovanni hired a mercenary army under the Spanish captain Ramón de Cordona and, with the pope's blessing, set out to reconquer his native city. Laying siege to Prato, a town twelve miles north of Florence that served as their principal defensive bastion, on August 29, 1512, Spanish cannons managed to open a narrow breach in the walls. The inexperienced defenders panicked, abandoning the civilians to the tender mercies of ill-disciplined and ill-fed troops.† The sack that followed was appalling, stinging the conscience of civilized Europeans. Even the cynical Machiavelli called the massacre at Prato "a pitiable spectacle of calamity." Cardinal de' Medici was less troubled, remarking blandly that "although it has given me

* At the time Michelangelo accepted the commission to sculpt the *David,* the government's most implacable enemy had been Lorenzo's oldest son, Piero. His death in 1503 had left Giovanni head of the family. Though more cautious and certainly more intelligent than his older brother, the cardinal was equally committed to restoring the Medici to Florence.

† This was the citizen militia, created by Niccolò Machiavelli, that had paraded so proudly across the Piazza della Signoria in February 1505. (See chapter 3.) The militia was a key part of the Second Chancellor's policy to make Florence less dependent on foreign mercenaries.

pain, [it] will at least have the good effect of serving as an example and a terror to the [Florentines.]"

Horrified by the destruction of their neighbor, Florence surrendered to Cordona and his Medici backers. Over the course of the next few months, the Medici brothers reasserted control over the city of their birth, dismissing the former leaders—including both Soderini, who fled to Rome, and Machiavelli, who was briefly imprisoned and tortured—and replacing them with trusted henchmen. The hard work of purging and rebuilding had barely begun when Cardinal Giovanni learned of Julius's death. Leaving the government of Florence in Giuliano's hands, he hurried back to the Vatican in time to participate in the conclave from which he would eventually emerge triumphant.

Despite the fact that he was in the midst of the final, furious campaign to complete the Sistine Ceiling, Michelangelo's thoughts turned to his family during these troubled days. Describing what had happened to his native city as an "evil plight," he urged his father and brothers "to withdraw to some place where you would be safe, abandoning your possessions and everything else, since a man's life is of more value by far than his possessions." As always, abstract political considerations took a backseat to more prosaic concerns. What would count more with the new pope, happy memories of the years they spent together in Il Magnifico's palazzo, or the fact that he had been a valued client of the regime that expelled his family?

Even before Giovanni's election, Michelangelo was desperate to proclaim his loyalty to the new bosses of Florence. "[T]here are rumors going about that I've spoken against the Medici," he wrote to his father in October of 1512:

I have never spoken out against them on any matter, except for that which was discussed by everyone, that is what happened in Prato, about which the very stones would have cried out had they been able. Afterwards, many other things were said here that I simply repeated. "If it's true that they behaved this way then they behaved badly." Not that I believed that they had, and let us pray to God they did not. A month earlier, someone with whom I was friends spoke very ill of them, but I said that it was wrong to speak like that and that he

should no longer address me thus. So I want Buonarroto to see if he can quietly
discover who said that I had slandered the Medici . . . and if it came from
someone who claims to be my friend, I can guard myself against him.

The letter is typical of Michelangelo: disingenuous, timid, and self-serving. It is almost certain that, despite his protestations, he *had* spoken ill of the Medici, as had many among the Florentine expatriates in Rome. But Michelangelo was never one to stand on principle if a principled stance would compromise his physical safety or interfere with his art.

In fact, Michelangelo did have cause to worry. Leo's attitude toward Michelangelo was complicated, colored not only by their past history but by their incompatible temperaments. No doubt Leo made a certain allowance for the foibles of men of genius, as Julius had before him, but he clearly found Raphael more to his taste, generally favoring the Umbrian over the Florentine in awarding lucrative contracts. While Leo kept Raphael's large workshop humming with new commissions, he held Michelangelo at arm's length, content to see that he was gainfully employed on Julius's tomb but offering little in the way of new work. Indeed, Leo seems to have regarded the companion of his youth with a mixture of admiration and dread. On the one hand, he acknowledged their past association, and even claimed to have fond memories of their time in the Palazzo Medici. "I know the high regard the Pope has for you," recorded the painter Sebastiano del Piombo. "When he speaks of you it is almost with tears in his eyes, because as he told me, you two were raised together, and he shows that he knows you well and loves you." But, despite their former intimacy, or perhaps because of it, Leo remained wary. His conflicted feelings are captured in a letter to Michelangelo from Sebastiano, written shortly after Raphael's death, when Sebastiano was hoping to take over the commission to paint the Vatican apartments. Telling the pope that with Michelangelo's guidance he would rise to the task, Leo replied: "I do not doubt this, as you have all learned from him." Sebastiano continued:

And, between you and me, His Holiness told me: "Look at Raphael's works, how
as soon as he saw those of Michelangelo he abandoned the style he'd learned

from Perugino and tried as much as he could to follow those of Michelangelo.
But he is terrible, as you see. It is impossible to work with him." I responded
to His Holiness that your terribilità *harms no one, and that you seem terrible*
because of your passion for the great work you've undertaken. . . .

This reference to Michelangelo's *terribilità* offers a tantalizing glimpse into
the ways in which the artist's difficult personality fed into the mythology of
his genius. Michelangelo's foul temper is turned into a virtue by his friend,
held up as a sign of his dedication to his art. Nothing shows the transforma-
tion of the artisan into the artist more clearly than this. "[Y]ou frighten ev-
eryone, even popes," Leo marveled, as if he didn't know whether to laugh or
cry. Who would put up with divalike displays from a mere craftsman? Insub-
ordination, an unwillingness to follow rules laid down by others, is the hall-
mark of an original mind, and originality, rather than technical proficiency,
the mark of a true artist. In fact, an artist of Michelangelo's stature has by
now escaped almost completely his master's control. He is like some wild
and magnificent beast who can be managed but never tamed. While some
patrons continued to act like the tyrants of old, many preferred to coddle the
fragile psyches of their most valuable servants.

Fortunately for Leo, he could still purchase genius on the cheap, at least
in terms of the cost to his peace of mind. Raphael was every bit as accom-
plished as Michelangelo and, if not quite as imaginative, he came without all
the baggage toted around by the mercurial Florentine. Leo took full advan-
tage of the genial painter, employing him to decorate his apartments and,
on Bramante's death in 1514, appointing him *magister operae* in charge of
rebuilding St. Peter's.

For Michelangelo, Leo's preference for Raphael actually offered much-
needed breathing room. He had his hands full with the tomb and, despite
his jealousy of the younger man, had little desire to compete with him on his
own turf. Still, he was reluctant to cede the field entirely. Stung by popular
opinion in Rome "[that] judged that in the whole field of painting Raffaello
was, if not more excellent than Michelagnolo, at least his equal," he fought
back through devious means. "[H]e took [del Piombo] under his protec-
tion," Vasari related, "thinking that, if he were to assist Sebastiano in design,

he would be able by this means, without working himself, to confound those who held such an opinion, remaining under cover of a third person as judge to decide which of them was the best."

In Sebastiano del Piombo, Michelangelo had found the ideal champion to carry out his proxy war. Not only did he possess the skill to meet the Umbrian master on the field of battle, but with his pugnacious personality he was eager to mix it up. A former pupil of the great Giorgione, Sebastiano had a Venetian's love of color and feel for the subtleties of light and atmosphere, but he lacked the strong foundation of drawing (*disegno*) that was the hallmark of the Florentine tradition. With Michelangelo making up this deficit by supplying him with cartoons, Sebastiano's other gifts would allow him to challenge, and perhaps even best, Raphael at his own game.*

Sebastiano took to the task with relish. If possible, he loathed Raphael more than Michelangelo himself, accusing him (on scant evidence) of "steal[ing] at least three ducats daily from the pope out of the workmen's wages and out of gildings" in his role as the pope's *magister operae*. On another occasion the Venetian urged Michelangelo to "[c]arry out your vendettas and mine in one fell swoop," superfluous advice to someone who clung as tightly as he did to his grudges.

For all Raphael's affability, the rivalry was not entirely one-sided; a fierce ambition burned beneath the bland façade. Lodovico Dolce, in his *Dialogue on Painting (The Aretino),* describes how Raphael met this tag-team challenge. "I remember that when Sebastiano was being pushed by Michelangelo into competition with Raphael," he wrote, putting words in the mouth of the

*Among the paintings for which Michelangelo supplied the basic designs were a *Pietà* for the Basilica of S. Francesco in Viterbo, a *Flagellation* for S. Pietro in Montorio in Rome, and a *Raising of Lazarus* painted for Cardinal Giulio de' Medici. This last altarpiece was made in direct competition with Raphael's *Transfiguration*. Michelangelo, who at the time was in Florence, was kept abreast of the situation by his friend Sellaio: "[T]hree days ago I wrote you how Sebastiano has undertaken to paint that panel [of Lazarus]. . . . Now it seems to me that Raphael is turning the world upside down to see that he doesn't do it, so as to avoid comparisons. Sebastiano remains suspicious of him . . . [but] he has the spirit that will do it in a way that he will remain in the field of combat." (Goffen, 247.) In the end, while Sebastiano's painting was considered very fine, Raphael's was an undisputed masterpiece.

famed playwright who was the principal speaker in his dialogue, "Raphael used to say to me, 'Oh, how delighted I am, *Messer* Pietro, that Michelangelo helps this new rival, making drawings for him with his own hand; because from the repute that his pictures do not stand up to the *paragone* with mine, Michelangelo will see quite clearly that I do not conquer Sebastiano (because there would be little praise to me to defeat one who does not know how to draw) but Michelangelo himself, who (and rightly) is held to be the Idea of *disegno.*"

While Raphael continued his unbroken string of triumphs—the paintings of the Stanza dell' Incendio in the pope's Belvedere apartments, the magnificent *Galatea* for Agostino Chigi, the pope's banker, and, perhaps most galling of all for Michelangelo, ten cartoons for tapestries to be hung in the Sistine Chapel, just below his own fresco—Michelangelo struggled to make headway on the tomb for Pope Julius. While painting the ceiling he had thought of nothing else but returning to this project, but now that he could devote himself wholeheartedly to his "true profession," progress was not what he (or his patrons) might have hoped for.

Part of the problem was his relentless perfectionism. At one point, when faced with a choice between assigning portions of the tomb to other masters or being hauled before a judge for breach of contract, he still had to be talked into the sensible course of action by Sebastiano. "All the world will know that what is done from now on will not have been by your hand," the Venetian reassured him, "and you will bear no responsibility for it, come what may, as you are too well known, and you are resplendent like the sun. Neither honor nor glory can be taken from you; just consider who you are, and think that no one is making war on you except yourself." Hiding the bitter pill of criticism ("no one is making war on you except yourself") beneath a dollop of flattery ("you are resplendent like the sun"), Sebastiano ultimately persuaded Michelangelo to yield to the inevitable, but he had difficulty relinquishing any meaningful control. Michelangelo consistently bit off more than he could chew and then failed to delegate even menial tasks to subordinates.

For long periods between 1515 and 1521, Michelangelo was in Carrara and the quarries of Pietrasanta supervising the excavation of marble for the various projects he had undertaken. Pietrasanta, in particular, cost him

valuable time as months were consumed building a road to facilitate the transport of stone from the still-undeveloped site. "[T]he *scarpellini* from here have no understanding of marble," he grumbled, "and as soon as they saw their lack of success, they went with God. . . . For this reason I had to stay there from time to time, to set them to work, and to show them the lines of the marbles and what things to avoid, which marbles are the poor ones, and even how to quarry, because in things of this kind I am skilled."

Even with this hands-on approach, however, disaster could not always be averted. In 1514 he accepted a commission to carve a statue of *The Risen Christ* for the church of Santa Maria Sopra Minerva in Rome. After working for many months, Michelangelo discovered a dark vein running right across Jesus's face, forcing him to discard the flawed work and begin anew.*

From the "vexations, annoyances, and travails" of these years, Michelangelo did manage to produce at least three splendid works: the two "slaves"† now in the Louvre, and the magnificent *Moses* that now forms the centerpiece of the greatly reduced version of Julius's tomb that was eventually installed in San Pietro in Vincoli. In the two slaves, Michelangelo continues his exploration of the expressive possibilities of the nude male body. The *Rebellious Slave* displays the exaggerated *contraposto* that Michelangelo deployed so effectively to reveal inner conflict. His arms bound behind his back, his shoulders hunched, he is a universal symbol of Man at odds with the world. The so-called *Dying Slave* (he actually appears to be swooning rather than dying, either through sheer exhaustion or in the aftermath of sexual ecstasy) recalls both the *Bacchus* and the dead Christ from the St. Peter's *Pietà*,

* It is this second version that is now on display in the church, so named because it stood on the site of an ancient temple to the goddess Minerva. Though hailed by his contemporaries as a masterpiece, *The Risen Christ* is now probably the least appreciated of Michelangelo's sculptures. To modern eyes it appears insipid, with none of the tension or grandeur normally associated with his work. Harried as always, Michelangelo permitted his assistant Pietro Urbano to finish the sculpture, but then he bungled it so badly that Michelangelo was forced to correct his work.

† These two works and the series of unfinished sculptures now in the Accademia in Florence are variously called slaves or captives, demonstrating their iconographic ambiguity. Whatever title one assigns to them, their bondage is clearly meant to be seen as a metaphysical condition.

figures embodying voluptuous passivity or the loss of spiritual vigor that occurs when we yield to our carnal nature. It is impossible to determine exactly what symbolic function Michelangelo intended by placing these nude figures on a papal tomb. Like the *ignudi* of the Sistine Ceiling, they may well enshrine in a very general sense the Neoplatonic conception of the soul trapped in its fleshy prison, but, as in that earlier case, we shouldn't push the analogy too far. Their message is clear enough, and need not be subjected to an overdetermined scholarly autopsy.

The *Moses* is the one certifiable masterpiece from these frustrating years, and one of the few sculptures Michelangelo brought to a high degree of finish. Indeed, *Moses* is so powerful that he overwhelms the tomb of which he is a part.* Julius's cenotaph is a sad remnant of the grand monument originally planned, but the *Moses* remains a commanding presence in the church. So great is the charisma of this Old Testament prophet that, according to Vasari, even the skeptical Jews of Rome were moved every Sabbath to make a pilgrimage to the church "like flocks of starlings, to visit and adore that statue; for they will be adoring a thing not human but divine."

It is doubtful whether a large number of Roman Jews actually overcame their abhorrence for graven images to bend their knees before this powerful effigy, but Moses' immense spiritual authority makes the story compelling, if not plausible. No one has ever managed to convey such restless dynamism and smoldering power in a seated figure. Moses is a close cousin to the prophets and sibyls from the Sistine Ceiling, a man, as they are, possessed by the unsettling spirit of the Lord. His left leg drawn back, his torso thrust slightly forward as if he is about to rise, his pose most closely resembles that of Joel. But while bald Joel, intently studying the scroll he's unwinding, has the scholar's slightly musty air, Moses possesses all the pent-up energy of a racer at the starting block. Repeating a trick he deployed so effectively in the *David,* Michelangelo shows the figure riveted by something outside our field

* Michelangelo originally intended the *Moses* to be paired with a statue of St. Paul. This plan, like so many others, was scrapped in favor of the current arrangement, in which he is flanked by statues of Rachel and Leah, symbols of faith and charity or, conversely, the contemplative and active life.

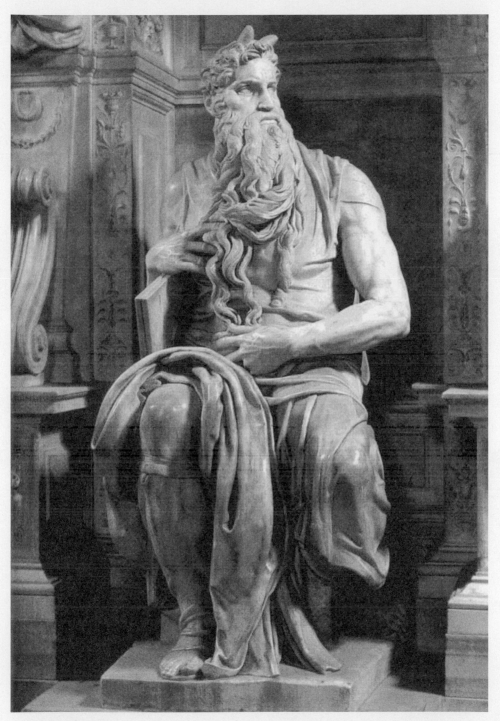

Michelangelo, *Moses,* Julius Tomb, San Pietro in Vincoli, 1513–16. *Scala/Art Resource, NY*

of vision. In each case, that which activates the pose and gives meaning to the figure—an approaching threat or the immanence of the Lord—is only implied. We cannot perceive it directly, but can still measure its awesome power through the figure before us who registers the invisible presence with every fiber of his being.

Unlike David—and more in keeping with the figures of the Sistine Ceiling—Moses experiences God as a kind of psychic disruption. He is not the poised young hero but someone staggered by the enormity of what he is witnessing. His eyes blaze. Distractedly, he tugs at the strands of his cascading beard with one hand while clutching his stomach with the other as if his epiphany manifests itself as physical pain. Powerful as he is, he is not in control of the situation. The awe that grips him has bypassed sense, bypassed reason itself; he is filled with a divine madness.

Perhaps no other work captures Michelangelo's famous *terribilità* as well as the *Moses*. Over the course of his long career, the sweetness of the *Pietà* and the self-possession of the *David* seem like aberrations, islands of calm in an otherwise tempestuous ocean. *Moses* may not be Michelangelo's greatest achievement, but it is perhaps his most characteristic, an expression of his conviction that the universe is governed by forces beyond our comprehension and beyond our capacity to control. While Pico celebrates Man's power to shape his destiny, Michelangelo views life as a constant struggle with those forces, both good and evil, that mock our puny efforts to master them. In each case, Man is cast as the hero of his own narrative, but for Michelangelo the story has no happy ending, not least of all because each one of us is divided against himself. At his sunniest he never achieved the harmonious balance that characterizes masterpieces like Raphael's *School of Athens* and that bespeak a bland confidence that reason will ultimately triumph. Michelangelo is capable of expressing joy, even ecstasy, but almost never serenity. In his quieter moments, Michelangelo strikes an elegiac tone; when he activates his figures, they seethe and rumble, tremble in the throes of divine inspiration or lock themselves in a futile struggle against Fate. Even David, for all his cool, is a man of violence, a warrior against the forces of darkness that besiege the citadel of light.

The four larger-than-life statues Michelangelo carved between 1513 and

1516 represent a more than respectable output, particularly given the high quality of the work and the fact that so much of his time was spent in the quarries as foreman for a crew of stonecutters. But since the revised contract for Julius's tomb called for more than forty statues to be completed within a seven-year period, the pace was clearly insufficient. It was obvious that even to come close to meeting the deadline would require a large team of qualified sculptors, but Michelangelo was still incapable of delegating anything but the most pedestrian tasks.

He was already far behind schedule when a sudden change in the political landscape threw the fate of the entire project into confusion. Leo had begun his reign on the best of terms with Julius's heirs, demonstrating his benevolence by increasing the funds allotted to his predecessor's tomb. But by 1516 relations with the della Rovere clan had taken a dramatic turn for the worse. Outraged by Francesco Maria della Rovere's refusal to provide him the military assistance he'd requested, Leo excommunicated the duke and replaced him as lord of Urbino with his own nephew Lorenzo.

It was in this context that yet another contract was drawn up between Michelangelo and Julius's heirs. Tacitly acknowledging the family's diminished position, this third iteration called for a drastically downsized monument.* The new contract states that it was the della Rovere themselves who requested the changes, but it is clear that the decision to settle for less was forced upon them not only by the sudden loss of the pope's favor but also by Michelangelo's failure to deliver what he'd promised.

Even before the breach with Duke Francesco, Pope Leo had begun to wonder whether Michelangelo's genius might not be put to better use. Like all Renaissance popes, he was concerned with his legacy as a munificent patron of the arts, and commissioning nothing from the greatest master of the age would leave a gaping hole in his résumé. In a letter dated June 16, 1515, Michelangelo told his brother Buonarroto: "I must make a great effort here

* Signed in July 1516, the contract called for twenty-two sculptures instead of the forty originally envisioned. At the same time, Michelangelo was allowed nine years to complete the work, an acknowledgment that the original seven-year deadline had been unrealistic.

this summer to finish the work [on the tomb] as soon as possible, because afterwards I anticipate having to enter the service of the pope."

II. SAN LORENZO

The offhand remark of Michelangelo to his brother signals another momentous shift in Michelangelo's career, a career that moved back and forth between the geographic poles of Florence and Rome, and that was spent in the service of one or the other of the great patrons of Italy. For the next decade and a half, the city of his birth rather than the gaudy, rowdy capital of the Church will be the focus of his efforts, and the Medici rather than the della Rovere will demand his loyalty and claim the fruits of his labor.

The solution to the problem of how best to employ Michelangelo's unique talents occurred to Leo sometime after visiting his native city late in the fall of 1515. This homecoming was not only a personal triumph for a man who'd spent most of his adult life in exile, but an opportunity to reassert Medici authority over the city that had once rejected him. Welcoming him back, Leo's compatriots put on a spectacular show, though it was less a spontaneous outpouring of enthusiasm for the first native-born pope than it was a carefully choreographed production of the Medici propaganda machine. The city Pope Leo entered on November 30, 1515, was anxious to demonstrate its loyalty and to banish the signs of a decades-long decline. Buonarroto provided his brother with a vivid description of the celebration:

> [H]is entrance was greeted with a great show of devotion, a great clamor of
> people shouting "Palle," * so loud that the world seemed to spin round. . . .
> Before the pope came his escort of guards, and then his grooms who were
> carrying him under a rich canopy of brocade borne by cardinals, and about his
> throne came the Signoria. There was no respite even once for three days from
> the sounds of bells and firing. There was also a beautiful show of triumphal
> arches, with a good ten of them in several places and of an obelisk at the end of
> the bridge of Santa Trinità. . . . As these were festivities, the poor in turn have

* The *palle* were the red balls on the Medici crest.

Raphael, *Pope Leo X with Cardinals Giulio de' Medici (Clement VII) and Luigi de' Rossi*, c. 1518.

Scala/Ministero per i Beni e le Attività culturali/Art Resource, NY

received alms and a great deal of money was being thrown all the time from the
door of the Hall of the Pope.

Another observer was appalled at the excess, estimating that over 2,000 men
were employed for more than a month at a cost of 70,000 florins, "all for
things of no duration," though he consoled himself with the thought that
"the money that was scattered in this way added to the earning of the poor
workmen."

One of the most important stops on this sentimental journey was the
Church of San Lorenzo. Located just behind their palace on the Via Larga,
this ancient shrine was the focus of Medici piety and patronage. The cur-
rent building had been commissioned from Brunelleschi in 1419 by Leo's
great-great-grandfather, Giovanni de' Bicci, founder of the branch of the
family that had dominated Florentine politics for most of the past hundred
years. It was here that Leo's ancestors were buried, beginning with Giovanni
himself, along with his wife, Piccarda, in the Old Sacristy, and their son
Cosimo, *pater patriae* (father of his country), interred in a crypt beneath the
transept. Also buried at San Lorenzo were the pope's own father, Lorenzo
Il Magnifico, and Lorenzo's younger brother, Giuliano, assassinated in 1478
during the Pazzi Conspiracy. Their bodies were currently held in the Old
Sacristy, but only until a new chapel could be built to receive their remains
on a permanent basis.

For Leo, lavishing patronage on the family shrine was a sign that, as in
the time of Cosimo and his own father, the people of Florence could expect
to enjoy the fruits of Medici largesse. "Pope Leo X," writes Vasari, "being no
less splendid than Julius in mind and spirit, had a desire to leave in his native
city . . . in memory of himself and of a divine craftsman who was his fellow
citizen, such marvels as only a mighty Prince like himself could undertake."
The most obvious place to start was with San Lorenzo's shabby façade, an
unadorned expanse of rough-hewn sandstone at odds with the elegance of
the interior. Shortly after paying his respects to his forebears, Leo decided to
organize a competition for a new façade on this important public square that
would proclaim the Medici's indispensable role in the religious and civic life
of the city.

Among those submitting designs for the prestigious commission were Michelangelo's old ally Giuliano da Sangallo, his brother Antonio, Baccio d'Agnolo (the architect in charge of overseeing the ongoing work on the Duomo), Jacopo Sansovino (a protégé of Bramante), and Raphael of Urbino. Raphael's presence on this list is not as surprising as it might at first appear. Even though Raphael was known primarily as a painter, Leo had appointed him *magister operae* after Bramante's death. In the Renaissance, architecture was not yet monopolized by professionals. (Both Brunelleschi and Bramante were artists before rising to fame as architects.) As would prove to be the case with Michelangelo himself, the skills Raphael acquired as an artist—skills that fell under the general heading of *disegno* (design) and that all had their origin in the foundational discipline of drawing—qualified him in the minds of his contemporaries to construct even large-scale buildings.

Whatever his qualifications, the mere mention of Raphael's name in con-nection with this plum commission—in Michelangelo's own backyard, no less!—seemed calculated to goad the proud Florentine into action. Michel-angelo insisted that he never sought the commission, which would have been a clear violation of the agreement he had just signed with Julius's heirs, but agreed only reluctantly to participate at the insistence of the pope. Ac-cording to Vasari and Condivi, both of whom repeated what Michelangelo told them, he had to be dragged "weeping" to the project. "Michael Angelo," wrote Condivi, "made all the resistance that he could, saying that he was bound to Cardinal Santi Quattro and to Aginensis, and could not fail them. But the Pope, who was determined in this matter, replied: 'Leave me to deal with them.' So he sent for both of them and made them release Michael An-gelo, much to the sorrow of both himself and the Cardinals. . . ."

Michelangelo implied much the same thing in a letter of 1520 when, vent-ing his frustrations after the project had been canceled, he laid responsibility squarely at the feet of the pope: "When, in fifteen hundred and sixteen, I was in Carrara pursuing my own affairs, that is procuring marble to transport to Rome for the Tomb of Pope Julius, Pope Leo sent for me regarding the façade of San Lorenzo that he wished to build in Florence. . . . I left Carrara and proceeded to Rome, where I executed a design for the said work. . . ."

The evidence, however, paints a somewhat less flattering picture. Though

no single document proves Michelangelo sought the commission for the façade, it appears that he was at the very least a willing coconspirator.* For one thing, Michelangelo's passion for Julius's tomb seems to have cooled. In August 1516—that is, only one month after signing the new contract—his friend Sellaio wrote him a letter urging him to redouble his efforts "in order to give lie to those who say you have gone off and will never bring it to conclusion." The explanation for Michelangelo's apathy is simple: while the reduced version of the tomb no doubt relieved some of the stress, it also sapped his enthusiasm. He'd reneged on his commitments in Florence to take on a project that would be a "mirror to all Italy," but in its newly reconfigured form the tomb would be only a shadow of his dreams.

On October 7, 1516, Pope Leo announced that the commission had been awarded jointly to Michelangelo and Baccio d'Agnolo, an architect with years of experience as *capomaestro* in charge of work on the Duomo and the Palazzo della Signoria. This arrangement apparently did not satisfy Michelangelo, since on November 3 Domenico Buoninsegni—the papal treasurer—wrote a letter to reassure Michelangelo that he would have to carve only the principal figures, the rest being executed by others based on his models. But Buoninsegni seems to have misunderstood the cause of Michelangelo's anger. He was not upset, as the treasurer seemed to think, because the proposal placed excessive demands on him, but because he was expected to collaborate with someone he regarded with contempt. Given Michelangelo's inexperience as a builder, having a seasoned architect on hand seemed a reasonable precaution, but what seemed sensible to his patron appeared to the artist to demonstrate how little faith they placed in his abilities. Michelangelo evidently threatened to quit the project over the issue, since on November 21 Domenico Buoninsegni wrote in exasperation: "Now, from your last

* A letter from the papal treasurer dated October 1516 urges Michelangelo and his partner to set up a secret meeting with the pope to forestall the commission going to a rival. That rival, though unnamed, was almost certainly Raphael, whose cause was championed by Cardinal Bibbiena. (See *Carteggio,* I, 204–5, no. clxii.)

letter, I see that you've changed your mind, saying that you no longer wish to come [to Rome]. And considering what you have said before, I see so many alterations that if I don't go crazy it will be a wonder. . . . I am determined now not to involve myself in these matters, since I don't know what I have to gain except shame and criticism."

It was precisely because he dreaded this kind of confrontation that Pope Leo had taken so long to hire Michelangelo in the first place. Fortunately, the nearly two hundred miles between Rome and Florence provided a useful buffer. Leo further insulated himself by leaving the detailed management of the project in the hands of both his treasurer, Buoninsegni, and his cousin, Cardinal Giulio de' Medici.

Cardinal Giulio, the illegitimate son of Il Magnifico's brother, had been raised in the Medici palace after his father was killed in the Pazzi Conspiracy of 1478, and so, like the pope himself, had known Michelangelo from the days of his youth. An intelligent, cultivated man, he was more tactful than his cousin, understanding that a kind word or a small courtesy could go a long way toward soothing the artist's easily bruised ego. "The cardinal doesn't put faith in anyone or believe anyone who speaks ill of you," Sellaio reassured him, "even if there are a number of them, and great men, and he makes jokes of them. But it is necessary that you make liars of them. . . . And comfort yourself and be cheerful, to complete this work and serve such a man who wishes you well as a brother." Michelangelo, for his part, appreciated his kindness, declaring "I'm always ready to risk life and limb, if need be, for the Cardinal de' Medici."

No doubt Michelangelo would have objected to collaborating with anyone on the project, but he felt a particular disdain for Baccio. He accused the architect of consorting with undesirables, a charge against which Baccio defended himself by telling Michelangelo's brother "that he never thought of becoming encumbered with Raphael of Urbino, and that he was his mortal enemy." This admission, however, was not enough to mollify Michelangelo, whose antipathy was professional as well as personal. Despite (or perhaps because of) Baccio's vastly greater experience as a builder, Michelangelo openly criticized his partner's work, describing the gallery he had designed

for the base of Brunelleschi's famous dome on the Cathedral as "a cage for crickets" and making "such a clamor that the work was stopped." *

In the end, Michelangelo reluctantly agreed to work with Baccio, but only if it was understood that the architect was to be regarded merely as the junior partner. Even when these conditions were met—conditions which must have been humiliating for the older man—Michelangelo continued to carp. "I came to Florence to see the model that Baccio finished," Michelangelo wrote to Buoninsegni in March, 1517,

> *and it was as I expected . . . a childish thing. I am leaving tomorrow and returning to Ferrara and have arranged with la Grassa [a stone mason from Settignano] to make the clay model according to the design, and to send it to you. He tells me he will make one that's suitable. I do not know how it will turn out. I believe, in the end, I will have to do it myself. . . . I cannot do otherwise.*

This last statement—"I will have to do it myself . . . I cannot do otherwise"— sums up Michelangelo's approach to every project he was involved with. The flip side of his faith in his own powers was his assumption that no one else was up to the job. His insistence on controlling every aspect of his work was a source of his greatness, but it often led to disappointment when the magnificent visions he conjured surpassed the ability of any one man to bring them to fruition.

Despite this less-than-auspicious beginning, the pope and the cardinal agreed to proceed on Michelangelo's terms. The contract laid out a schedule based more in hope than on reason, stipulating he was to complete the façade in eight years, for a total cost of 40,000 ducats. In May all seemed to be on track. "I am eager to tackle this work of the façade of San Lorenzo, whether it be the architecture or the sculpture, so that it becomes a mirror for all of Italy," Michelangelo wrote Buoninsegni, evidently warming to the task. To which Buoninsegni replied with equal enthusiasm: "As to your say-

* Visitors to Florence today can still see the partially completed gallery running along the southern facet of the dome. Michelangelo proposed an alternate design, but it was never built.

ing how eager you are for this undertaking, they [the pope and the cardinal] are well pleased."

But like Julius's tomb, this project soon ran into trouble. Michelangelo had taken a typically audacious approach, "not accept[ing] anyone beyond himself as his guide or superior in the architecture of such a work." But, Vasari continues in one of his rare criticisms of his idol, "this refusal of assistance was the reason that neither he nor any other executed the work, and that those masters returned in despair to their customary pursuits."

In December, Michelangelo traveled to Rome to present his model to Leo and Cardinal Giulio. What Michelangelo had in mind was a work of enormous ambition and startling originality, an elaborate architectural screen providing a home for more than twenty statues, including six over life-size seated figures in bronze above the main door, and seven low-relief marbles. Seamlessly integrating architectural and sculptural elements, the façade expanded on ideas already present in Julius's tomb. In many ways it was a throwback to the age of the great Gothic cathedrals, when sculpture formed an integral part of the architecture but, in contrast to those earlier masterpieces, Michelangelo's statues would not be absorbed within the fabric of the building—stiff, columnar figures that conformed to the geometry of the structure—but rather fully independent forms stressing the organic integrity and expressive range of the human body.

Domenico Buoninsegni reported happily that "the Pope and the Monsignore [Giulio] viewed the model and they expressed themselves as well pleased and satisfied. . . . I heard no criticism, except that it was said that the difficulties have multiplied to an extent that you will never finish it in your lifetime, which in truth is but a slight criticism." Of course, this was more than a slight criticism; Michelangelo's Medici patrons had put their finger on the crux of the problem, though, typically, they failed to act on their insight.

Matters were not helped by Michelangelo's habit of alienating those who could have shared the burden of creating the dozens of statues he had in mind. One of those he managed to offend was an old friend, the sculptor Jacopo Sansovino, who believed Michelangelo had talked the pope out of giving him the job of modeling the relief panels. "Not having been able to speak with you before your departure, I am letting you know what I think

of you," he wrote Michelangelo. "[Y]ou measure everyone using your own yardstick, and it matters nothing to you whether there are contracts or trust, and every hour you say yes or no as it suits you or works to your benefit. . . . I did not yet realize that you never do well by anyone, and that, beginning with me, to expect otherwise would be to expect that water would not drown you."

Given the atmosphere of mutual recrimination, the project was probably doomed from the start. Decades later, yet another rival of Michelangelo ascribed the failure entirely to Michelangelo's difficult personality. "[T]he reason [Michelangelo] never supplied any of those statues [for the façade]," wrote Baccio Bandinelli, "was only because he never wanted help from anyone, so as not to set up any masters. . . ."

But it is unfair to pin the failure solely on the artist. Mismanagement and political meddling from Rome were as much to blame for the fiasco as Michelangelo's inability to work with others. An already daunting task was made infinitely more difficult when Leo ordered him to obtain most of the marble for the façade from the quarries of Pietrasanta, rather than Carrara, where he had developed a good working relationship with the local artisans.* Unlike Carrara, Pietrasanta lacked the basic infrastructure and trained workforce needed to get the marble out of the mountains and down to the barges, where they could be transported to Florence. "I have undertaken to rouse the dead," he grumbled, "if I want to subdue these mountains and bring art to this place." But Pietrasanta had the great virtue, as far as Pope Leo was concerned, of being located in Florentine territory; in demanding

* It is unclear what role Michelangelo played in this ill-advised decision. The evidence suggests that he was initially opposed, but then accepted the situation—particularly after his relations with the stoneworkers of Carrara soured. He later said of the workers of Carrara that "as they had not fulfilled the contracts and previous orders for the marbles for the said work [on S. Lorenzo], and as the Carrerese were bent upon balking me, I went to have the said marbles quarried at Seravezza, a mountain near Pietra Santa in Florentine territory." (*Letters*, I, no. 144, March 1520, 129–30.) In the end, after endless delays and disruption, Michelangelo was forced to return to Carrara, which ultimately supplied most of his raw material.

that Michelangelo shift to the new site, he was acting like a politician look-
ing out for his constituents. Unfortunately, Florence's gain was Carrara's loss,
and the marquis, Alberico Malaspina, chose to treat Michelangelo's actions
as a personal betrayal, fomenting such discontent among the longshoremen
that they refused to load the blocks onto the boats.* "The barges I hired at
Pisa never arrived," Michelangelo groaned. "I think I've been cheated, and so
it is with all my affairs. I curse a thousand times the day I left Carrara. This
has been the ruin of me."

One result of the San Lorenzo commission was that after years of empty
promises to his father, Michelangelo was finally able to return home. By
1515 he was already spending considerable time in Carrara, and paying fre-
quent visits to his family in nearby Florence. In the early months of 1517 he
planted his roots once more in native soil. He even made arrangements to
have the blocks for Julius's tomb shipped to Florence and distributed to the
three workshops that had been placed at his disposal.

Much as he loved his native land, however, returning home was a mixed
blessing, since the tenderness he felt for his family was inversely propor-
tional to their proximity. A constant source of irritation was the way ducats
disappeared from his bank accounts as his father helped himself liberally to
his son's earnings and his brothers dreamt up new schemes for getting rich
without doing any real work. In 1514, Michelangelo finally lent Buonarroto
1,000 ducats to purchase the woolen shop they had been discussing for years,
but even this generosity came with a reproach for "Your Ingratitude" and a
demand that he repay him "in money or in kind" within ten years.† Relations

* The quarrel was not resolved until October 1518, when Leo personally intervened,
sending a papal brief to the marquis ordering him to cooperate with Michelangelo.
Declaring his own innocence in the matter, Malaspina blamed everything on the artist,
declaring "he always wants to fight with everyone and create difficulties." (Quoted in
Hirst, *Michelangelo: The Achievement of Fame*, 322, n. 105.)
† Michelangelo's comments were occasioned by Buonarroto's complaint that he'd had to
advance some of his own money to pay the wages of a stoneworker named Michele. As
Michelangelo pointed out, the money Buonarroto claimed was his originally came from

between Michelangelo and his father were particularly tense as the two men eyed each other warily across the dinner table. The inevitable explosion came in the fall of 1521 when Lodovico, protesting a perceived insult, ostentatiously stormed out of the house and went to live in exile on his farm in Settignano. Instead of confronting Michelangelo directly, Lodovico decided to slander him in the streets and squares of Florence. Since Michelangelo was now a famous man, the public was more than happy to enjoy even this faint whiff of scandal. "Dearest father," Michelangelo wrote in evident distress,

> *I was amazed at your behavior the other day, when I did not find you at home, and now, hearing that you complain of me and say that I threw you out, I'm even more surprised; for I'm certain that, from the day I was born until now, I never wished to do anything, neither small nor big, that was to your disadvantage, and always, every burden that I bore I bore for the love of you. And since I've returned to Florence from Rome, you know that I've always cared for you, and said that all I had was yours. . . . Don't you see how bad you've made me look, saying that I've thrown you out? Now I've had it up to here, what with my other worries and every other thing! All of which I've done for love of you. See how you repay me! So have it your way. I'll try to pretend I've tossed you and that I've always treated you shamefully, and so just as if it were true I'll ask your forgiveness. Act as if you're pardoning your son who has always wished you every ill in this world. And so, again, I ask you to pardon me, like the wretch I am, and not to spread gossip about me as if I had thrown you out, because it matters to me more than you could know. I am, after all, still your son!*

There is something poignant about Michelangelo's continual, but ultimately futile, struggle to earn Lodovico's approval. "I have never exerted myself but for him," he told his brother, knowing how little his efforts were

his brother. (See *Letters,* I, no. 92, July 30, 1513, 87–88.) As for repaying the loan, Michelangelo had reason to be concerned. A year earlier, a friend had advised him against lending the money, expressing doubts about both his brothers' business sense and about market conditions.

appreciated, "in order to help him in his need, as long as he lives." Loyalty bound father and son, but expressions of affection were less common than bitter quarrels that pointed to unresolved tensions. Even in a society where sons were expected to treat their fathers with reverence, Lodovico's sense of entitlement seems excessive. On rare occasions his father's ingratitude would provoke an angry outburst, but for the most part Michelangelo showed him a deference he did little to merit. In fact, Michelangelo's constant carping over the deficiencies of his colleagues, his jealousy, his accusations that they were incompetent, disloyal, or ungrateful, are reminiscent of the charges his father often threw in his face, as if he was compelled to reproduce the most unpleasant aspects of the paternal hearth in the workplace.

What held the Buonarroti clan together was the belief that their fates were intertwined. The behavior of any one of them affected all, each triumph redounding to their credit and each scandal besmirching their collective name. Michelangelo's brothers basked in his reflected glory, while he did his best to make sure they did not sink so low as to bring him shame. Both he and his father were united by a mutual interest in promoting the Buonarroti name, but pushed apart by a stiff-necked pride. Both were cast from the same mold, touchy and quick to take offense. It was not a formula calculated to promote familial bliss.

Tensions in the Buonarroti household were exacerbated by Michelangelo's professional disappointments. In March 1520 work on the façade of San Lorenzo was suddenly suspended. Dismayed by this unexpected news, Michelangelo wrote a long and bitter letter to an unknown correspondent in which he enumerated the many sacrifices he had made for the sake of the pope and pointed out how little he'd received in return: "I am not charging for the wooden model I made, which I sent to Rome; I'm not charging for the three years I've wasted on this project; I am not charging for the fact that I've been ruined on account of San Lorenzo; I am not charging for the great insult of having me brought here to take charge of the façade and then having it taken from me—and I still do not know why."

The reasons for the cancellation have never been fully explained. Vasari suggests it was the fault of a Roman cabal led by Domenico Buoninsegni,

who turned on Michelangelo when he would not participate in a scheme to divert papal funds into his own pocket. "Michelangelo refused," Vasari claimed, "not consenting that his genius should be employed in defrauding the Pope, and Domenico conceived such hatred against him that he went about ever afterwards opposing his undertakings, in order to annoy and humiliate him, but this he did covertly. He thus contrived to have the façade discontinued. . . ."

While peculation was endemic in the Vatican bureaucracy and it is clear that Michelangelo and Buoninsegni had some sort of falling out, the story is too similar to the one used to explain Bramante's antipathy to be entirely convincing.* In fact, the termination of the project probably had more to do with the precarious state of papal finances and frustration over the slow pace of progress. Leo was currently involved in various costly military campaigns and heavily invested in the ongoing program to rebuild St. Peter's. Like Julius, he promoted the sale of indulgences across Europe to help offset his huge expenditures, but these were never enough to balance the books. In addition, a large-scale project to pave the floor of the Duomo in Florence demanded huge quantities of marble. Given the difficulties with the quarry at Pietrasanta, there was probably not enough stone to go around.

In any case, the façade was not actually abandoned, merely postponed. Cardinal Giulio had decided to put it on hold so he could concentrate his attention and his resources on another enterprise, one that now seemed more urgent than the costly and troublesome façade. In March 1516, Giuliano de'

*The two had begun as friends. When Michelangelo left for Florence, Buoninsegni took the artist's place as a member of a Florentine expatriate dining club to which he belonged, and when the artist purchased some fabric for his own use, he asked Buoninsegni to handle the transaction for him. Whatever caused the rift, it appears to have been bitter and permanent. A few years later the two were still at loggerheads. Giovan Francesco Fattucci, a chaplain of the Duomo and Michelangelo's representative in Rome, wrote in 1525: "Domenico Buoninsegni and Bernardo Niccolini are the ones who are prolonging the work and delaying the marbles in order to provoke you." (*Letters*, I, app. 14, p. 271.)

Medici—Pope Leo's brother and the youngest son of Lorenzo Il Magnifico—died, probably from the effects of syphilis; three years later he was joined by his nephew, Lorenzo, Duke of Urbino, at the age of twenty-seven. Neither man lived up to the high standards set by his illustrious forebears, but their early deaths were a severe blow to the family's dynastic ambitions, since this meant that the two surviving male descendants of Cosimo, *pater patriae,* were both clerics—Pope Leo and Cardinal Giulio—prohibited from passing down their titles to legitimate heirs.*

Even before these twin disasters, plans were under way to build a new sacristy at the northwest corner of San Lorenzo to complement the old, where the Medici patriarch Giovanni de' Bicci was entombed with his wife and grandsons. This second mortuary chapel was intended to provide the final resting place for Lorenzo and Giuliano, fathers of Pope Leo and Cardinal Giulio respectively; the unexpected deaths of the two dukes merely increased the urgency of bringing this project to a speedy conclusion.

From the beginning Michelangelo was the obvious choice to take charge of the important commission. Construction began almost immediately after work on the façade was suspended, but Michelangelo, sulking in his tent like Achilles, held out until November. For eight months while stonemasons put up the exterior walls, the cardinal used his considerable persuasive powers on the artist, knowing that sooner or later he'd be forced to relent. No matter how upset he was over the capriciousness of his masters, Michelangelo was now entirely dependent on the Medici for the fulfillment of his own ambitions.

*There was an eight-year-old boy, Alessandro, rumored to be Lorenzo's illegitimate son. For a time there was talk of Giulio leaving the Church to start a family, but he was too important an advisor to his cousin to seriously consider this option. Lorenzo had a daughter, Catherine, who would go on to marry Henry II, king of France, thus merging the blood of Florentine bankers with Gallic royalty. The Medici who in the next generation would rule Florence as dukes were descended from Cosimo's brother, the same branch of the family to which Michelangelo's patron, Lorenzo di Pierfrancesco, belonged.

Brunelleschi, Basilica of San Lorenzo, early fifteenth century.

III. TEMPLE OF MELANCHOLY

The decision by the Medici to suspend work on the façade of San Lorenzo and devote their energies to constructing the family tomb was partly dictated by circumstance, but it also marks an important shift in their relationship to the people of Florence. Though San Lorenzo held a special place in the hearts of the Medici family, it was also an important religious center for the entire Florentine community. When they committed themselves to refurbishing the public face of the church, the Medici were also demonstrating a commitment to their compatriots, following the age-old practice of promoting private interests through civic patronage. Of course, a prominent family was expected to patronize public projects *and* private spaces; each was a legitimate way to express patriotism and fulfill one's pious duty. After all, in endowing a second chapel at San Lorenzo, the Medici were only doing in more spectacular fashion what the Pazzi had already done at Santa Croce, the Tornabuoni at Santa Maria Novella, and the Sassetti at Santa Trinità.

But for the family that exerted an unprecedented control over the institutions of religious and political life, it signaled shifting priorities. By devoting their resources to a private mortuary chapel, the Medici made it clear to the people of Florence that they no longer felt the need to woo them with lavish displays. They were turning inward, contemplating their relations with the Almighty rather than engaging with their fellow citizens. In the icy grandeur of the New Sacristy we can feel the lifeblood of the ancient republic ebbing away. It is telling that the two figures whose untimely deaths spurred the building of the mausoleum were the first of the Medici to claim the exalted title of duke.* Another member of the family was currently pope, while his cousin was not only one of the most prominent members of the Sacred College but also the Archbishop of Florence. The civic virtues Michelangelo himself proclaimed so stirringly in the *David* have retreated or disappeared

* Giuliano received the title Duke of Nemours from the French king after marrying Filiberta, daughter of the Duke of Savoy. Lorenzo was invested with the title Duke of Urbino by Pope Leo. Significantly, neither title gave them any claim to rule in Florence itself, which was still nominally a republic.

altogether: the locus of meaning has moved from the public square to the intimate family chapel; the struggle for liberty in the here and now has been abandoned as idealized figures now fix their stony gaze on eternity; the fighter lays down his arms to reinvent himself as a saint or a philosopher.

For more than a decade and a half Michelangelo struggled to complete the tomb, persevering through war and plague—not to mention more mundane difficulties caused by bad weather and incompetent assistants—trying to reconcile the conflicting demands of his patrons and to tame the unbridled fertility of his imagination. Over the course of this often-frustrating saga, he transformed not only his own craft but the trajectory of Renaissance art as a whole. Forms and expressions that were only latent in the Sistine Ceiling, dissonant notes barely audible beneath the trumpet blasts, now begin to assert themselves, stepping out from the shadows and blinking in the cold sepulchral light.

The Medici Chapel, or New Sacristy, chronicles the passing of one age and the emergence of another. Beneath its graceful cupola the optimistic spirit that characterized the Renaissance congeals, replaced by a mood of anxiety; faith in reason is replaced by expressions of doubt; civic values decay into morbid introspection. In the eccentricities of his architecture and in the odd distortions Michelangelo imposed on his figures, one can detect the emergence of a new expressive language, one that usually goes under the rather elastic term of *Mannerism*.* In the New Sacristy the motifs of classicism are

* The term Mannerism was coined only in the nineteenth century, though contemporaries—including Vasari—often used the term *maniera* to indicate an artist's sense of style or manner. Significantly, sixteenth-century writers did acknowledge a period of decadence that set in following the great achievements of Leonardo, Raphael, and Michelangelo. The younger generation's debt to Michelangelo was recognized, but many (including Vasari) deplored the lengths to which painters like Pontormo, Rosso Fiorentino, and Parmigianino carried tendencies already present in the late work of the master. The term Mannerism, now often dismissed as a doomed effort to slap a simplistic label on divergent artistic tendencies, sought to ascribe positive values to art once dismissed as strange or misguided. See, for example, Vasari's criticism of Pontormo's "bizarre and fantastic brain [that] was never content with anything." (*Lives*, II, 359.)

shuffled, yielding quirky new combinations, while the human form, home to a restless spirit yearning for something that mere flesh cannot encompass, is stretched Gumby-like past all plausibility. The search for balance, the supreme confidence in Man's ability to master his environment, is rejected in favor of forms that exhibit insufficiency; the heroism of a doomed struggle against fate is preferred to the harmonious resolution of conflict.

Neither Michelangelo nor his patrons were fully aware of the profound historical and psychological shift memorialized in the Medici tombs at San Lorenzo. Like any great artist, Michelangelo was not only responding to demands of the specific commission but channeling the prevailing mood, giving voice to inarticulate murmurings and form to that which was still inchoate. The tombs Michelangelo provided are every bit as regal as his patrons could have wished, but in their almost neurotic introversion they unwittingly commemorate not only the death of men but of an ideal. As ancient republican institutions grew more feeble—even the outward forms had atrophied to a point where they seemed only to mock past triumphs—the artist registered these changes deep within his soul. A Florentine patriot, he now answered to men determined to stamp out the last vestiges of the city's ancient liberties. The fact that he was not explicitly partisan made it easier to serve many different masters, but even Michelangelo could sense the loss of the communal vitality that had sustained the republic for centuries. By the time he returned to Florence in 1517, real power had already passed to Rome, where an autocrat reigned in gilded splendor and gave only a passing thought for what transpired in the city of his birth. The shrine Michelangelo built for the great man's relatives recalls the splendor of the imperial capital, but only as a hollow echo; it is a monument to death, to absence, a temple of introspective melancholy.

The elegiac nature of the commission touched a chord in a man who felt the cumulative effects of overwork and disappointment. In a letter written in 1517, when he was still only forty-two, Michelangelo already described himself as "an old man." A few years later he grumbled: "I have a great task to perform, but I am old and unfit; because if I work one day I have to rest four." Melancholy always came naturally to him, but it grew more pronounced as

the confidence of youth receded and the darker demons that haunted the recesses of his consciousness began to assert themselves. He struggled with bouts of despondency and found solace in human contact. "Yesterday evening," Michelangelo recounted to Sebastiano in Rome, "our friend Captain Cuio and several other gentlemen kindly invited me to go and have supper with them, which gave me the greatest pleasure, as I emerged a little from my depression, or rather from my obsession."

He found other means, as well, to shake off depression. In middle age he took up his pen as often as his hammers and chisels, discovering in poetry a personal outlet he was not permitted in works commissioned by powerful lords with their own agendas. Here he strikes a more intimate, more confessional tone. In his youth Michelangelo gave the impression of a man on the make who was simply too busy to allow personal entanglements to slow him down. Even then he was almost certainly not living a life of monkish celibacy, but there is no indication of deep personal attachments. But now new notes are sounded in his correspondence and his verses. He reaches out to his fellow man not only socially but by baring his soul on the page.

Expressions of spiritual anguish increase; he is acutely aware of his own sinfulness:

> I live on death, and do believe,
> live happily on misery;
> he who lives and knows not anguish and death
> is destined for the flames,
> just as I am by passion consumed.

Like the tomb of Pope Julius and so many other projects Michelangelo began, the Medici Tombs (or the New Sacristy) were never finished and, in their present form, cannot be considered the definitive realization of his vision. But even in their fragmentary state they represent his most successful attempt to unite the arts of sculpture and architecture within a single, unified system of meaning.

In one medium he was an unsurpassed master, in the other a relative

novice, but his approach to both—and to the difficult problem of integrating the two—proved characteristically audacious.* Throughout Michelangelo's career, bold innovation was often the result of struggling against preexisting limitations, as if his creative fires were stoked by the challenge of overcoming intractable problems. The badly worked block from which he conjured *David* and the awkward spaces of the Sistine Ceiling elicited some of his most inspired solutions. The same tensions helped spur the creative solutions deployed in the New Sacristy.

The innovative architecture Michelangelo developed for the New Sacristy emerged naturally in the process of developing the overall sculptural program for the tombs. His original proposal to Cardinal Giulio was for a freestanding, centralized tomb in which each of the four sides would commemorate one of the Medici deceased. But after Giulio voiced his concern that such a structure would dwarf the rest of the chapel, Michelangelo abandoned this conception in favor of more traditional wall tombs. Ultimately, he settled on a scheme for a double tomb to house the remains of the two so-called Magnifici (Lorenzo and Giuliano, fathers to Popes Leo and Clement) and single tombs for each of the two dukes (or captains). The fourth wall was to be reserved for the altar, a vital if often overlooked element in a chapel whose principal function was to perform Masses for the dead.

From the outset Michelangelo's options were severely circumscribed by the need to follow the basic layout of Brunelleschi's Old Sacristy on the far side of the nave, a masterpiece of early Renaissance architecture against which Michelangelo's efforts would be judged. As always, however, Michelangelo refused to be bound by strict rules, viewing the fifteenth-century model as a point of departure rather than a destination. He would pay trib-

* In 1514, Pope Leo had given him a minor commission to design the façade of a small chapel in the Castel Sant'Angelo in Rome, and around 1516, while he was working on the façade of San Lorenzo, he designed a small gallery on the interior. Around the same time, he received another minor commission for some ground-floor windows on the Palazzo Medici.

ute to the original—and to the Florentine architectural tradition of which it was a founding monument—but then ring changes on that basic theme, giving rise to novel forms and providing his successors a heady example of an artist unafraid to attack sacred cows and violate taboos.

Michelangelo's reverence for the masters of the past was sincere, particularly for the giants of the Florentine tradition whose heir he believed himself to be. In architecture his admiration for Brunelleschi was unbounded, as it was in painting for Masaccio and in sculpture for Donatello. Later in life when asked if he would attempt to distinguish the lantern of the dome he was designing for the Basilica of St. Peter's from the one designed by Brunelleschi, he reportedly answered, "Different it can be made with ease, but better, no." While he was envious of his contemporaries—above all Leonardo and Raphael—the dead did not arouse his jealousy.

The ground plan of the New Sacristy conforms almost exactly to that of Brunelleschi's on the north side of the nave. It consists of a cubic space almost 40 feet in each dimension, surmounted by a hemispherical dome, and extended on one side by a rectangular altar. In many of the details too, Michelangelo has followed Brunelleschi's lead. The interior is a study in contrasts, employing a traditional Florentine building technique in which the structural supports are carved from a dark gray sandstone known as *pietra serena* that stand out in bold relief against white stucco walls. This rhythmic give-and-take imparts an austere grace and self-evident structural logic to the whole, a system that had been perfected a century earlier by Brunelleschi himself. Michelangelo even employs the same classical order, based on fluted Corinthian pilasters, to convey a mood of stately measure, of harmonious proportion, of mathematical clarity.

But from these simple ingredients Michelangelo has concocted a strange brew. Vasari (who went on to supervise the completion of the Medici Chapel after Michelangelo's death) only hints at the radical transformation his predecessor wrought when he declares that he followed Brunelleschi "but with another manner of ornamentation . . . in a more varied and original manner than any other master at any time, whether ancient or modern. . . ." To modern eyes, Michelangelo's departures from the classical orders appear minor. After all, the New Sacristy features those same pillars, pilasters, pediments,

capitals, and architraves that have been a staple of Western architecture since before the building of the Parthenon, or at least since the Romans reinterpreted them in light of their own needs; even the decorative motifs—acanthus-leaf capitals, funerary urns and wreaths carved in low relief, grotesque masks and skulls symbolizing death—would have been familiar to someone strolling through an ancient cemetery and studying the grave steles or making offerings at a temple to a pagan god. But Michelangelo deploys these forms with unprecedented freedom. He has evidently delved into the writings of the Roman theorist Vitruvius, whose *Ten Books on Architecture* were read as gospel by Renaissance builders; he draws as well on his own knowledge gleaned from firsthand study of ancient monuments. But he studies the ancient authority not with the devotion of an acolyte but with the subversive intent of a heretic, "wherefore," Vasari says, "the craftsmen owe him an infinite and everlasting obligation, he having broken the bonds and chains by reason of which they had always followed a beaten path in the execution of their works."

The radical nature of Michelangelo's undertaking was such that half a century later Vasari still frets that he set a bad precedent in excusing those with more imagination than good sense to create "new fantasies . . . which have more of the grotesque than of reason or rule in their ornamentation." In flouting decorum (to employ one of Vitruvius's favorite terms) Michelangelo was defying contemporary practice. While his contemporaries measured their success by how skillfully they quoted precedent, Michelangelo, as he showed when he "antiqued" his own Cupid, regarded the cult of the ancients as absurd. He respected their achievement but was not cowed by their reputation. He dismissed impatiently the notion that sculptures carved thousands of years ago could not be surpassed and that ancient buildings provided a vocabulary of forms to be treated as holy text, departure from which was akin to sacrilege. Looked at another way, Michelangelo's approach represents a return to origins, a rediscovery of essences that over the centuries had been obscured by a thick crust of rules and precedents—a deference to authority the authorities themselves never had.

Like many of Michelangelo's most powerful works, the Medici Chapel is an essay in dynamic contrasts, of incommensurate forms and unresolved

tensions. Building a shrine to feudal and ecclesiastical power in the heart of republican Florence, he has given concrete form to the contradictions inherent in the commission. Contrasting textures and vocabularies capture the unease of a transitional moment: Florentine simplicity reproaches Roman opulence; Republican virtue forms an uneasy partnership with autocratic excess.

The structural skeleton of the New Sacristy—the pilasters and architraves carved from dark *pietra serena*—pays homage to and elaborates on Brunelleschi's forms. These more traditional elements recall a simpler age, the age of Giovanni de' Bicci and Cosimo, when even a Medici was compelled to observe the forms, if not the substance, of republican government. Even here, however, Michelangelo departs from his model, adding a third story that attenuates the sturdy proportions of the older building to form a structure at once lighter and more ethereal.* The pendentives that support the dome don't spring, as they do in Brunelleschi's chapel, directly from the architrave that runs just above our heads, but are separated from the earthbound realm by an intervening clerestory, creating an affect of spiritual uplift but also a sense of the vast distance between our world and the heavens above. This ascent replicates the apotheosis of the family whose glory is celebrated here. From their role as simple citizens, first among equals, the Medici have now become the vicars of Christ on earth, a promotion codified in an architecture that, soaring heavenward, has left the rest of us behind.

Where Brunelleschi provides a logical balance between horizontal and vertical elements, Michelangelo emphasizes the vertical axis through a singularly imaginative device. In the lunettes just below the dome, Michelangelo has replaced Brunelleschi's round oculi with tall windows that brush against the base of the cupola. To increase the soaring effect, Michelangelo has made the windows trapezoidal, wider on the bottom and narrowing as they rise, increasing the illusion of loft through forced perspective.

* In this departure from Brunelleschi, he may have been inspired by the Sacristy of the Church of Santo Spirito, designed in 1489 by his old friend Giuliano da Sangallo, which also includes a third story.

Exploiting optical distortions for expressive effect, Michelangelo stands the practice of architecture—that most practical of art forms—on its head. In his buildings, the manipulation of space can no longer be considered an abstract problem in static measurement, but must take into account a body moving through that space and experiencing it in four dimensions. This experiential quality is even more pronounced in the vestibule to the Laurentian Library—which he designed only a few years later and that was located only a few hundred feet from the New Sacristy—where the stairs cascade in rippling flows, as if they do not simply exist but embody a process of *becoming*.

While Brunelleschi's buildings are based on a simple set of proportions rigorously multiplied, Michelangelo's play off our faulty perceptions. They also defy our expectations. Reassuring solidity is eschewed in favor of forms that seem to war with themselves, like the reclining sculptures on the sarcophagi whose limbs are locked in equally self-defeating poses. Space is not fixed, but contingent; form is not planar but organic; rigid geometry yields to something more plastic, more expressive.

Michelangelo gives free rein to his inventive imagination on the lowest of the three tiers, where the Medici dukes rest in their elaborate sarcophagi and where their effigies preside in frozen splendor. Here, Michelangelo has introduced an alien element into the austere fabric, a marble architecture of unprecedented richness that mediates between the Euclidean geometry of the walls and the biomorphic forms of the sculptures themselves. Rather than simply placing his figures within a self-sufficient architectural setting, Michelangelo sets up a dialogue between the figures and the structures that enclose them, imbuing normally rigid forms with a vitality of their own. Those decorative eccentricities that both inspired and terrified Vasari are really hybrid forms, the rigid geometry of the built environment infused with the dynamic pulse of a living organism.

The radical nature of Michelangelo's approach is less apparent to contemporary audiences, but to cultured men and women of the Renaissance his subversion of the classical orders was nothing short of blasphemy. His liberal approach is apparent in the eight doors located at the chapel's corners. By extending the decorative moldings along the threshold (which might

prove a tripping hazard were the doors actually used), Michelangelo elevates form over function, transforming a practical into a pictorial element.* Each of these false entrances, in turn, is surmounted by an ornate tabernacle, a mysteriously blank stone window adorned with a single garland. Too heavy for the doors below them, they are supported on brackets whose delicacy merely draws attention to their inadequacy to perform the task at hand. These largely empty shrines are treated with an imaginative freedom that subverts, even parodies, the very notion of functionality. Surmounted by pediments that appear fractured and gouged out as if shattered by tectonic forces, they register stress, squeezed into corners too narrow to comfortably accommodate them. All is in flux, each post incapable of fulfilling its supporting role, each lintel decomposing under unsustainable pressure. There is an organic push/pull to the architectonic forms that turns walls into the diaphragm of a living, breathing creature.

Where a traditional craftsman would confine the more delicate elements to the upper portions, Michelangelo often reverses the expected order of things so that fragile brackets and slender columns seem to hold up immense piles of stone, creating a vertiginous sense of dislocation similar to that imparted by the multiple perspectives of the Sistine Ceiling. As an architect, Michelangelo retains those qualities that make him such a powerful artist, endowing forms with a sense of movement that seems to reflect inner turmoil or metaphysical distress. Indeed, Michelangelo treats architecture as not only a frame for his figurative sculpture but as sculpture itself, as form that is both malleable and emotionally fraught. In place of Brunelleschi's implacable logic, Michelangelo gives us an architecture of emotion; in place of clarity, he revels in ambiguity.

Michelangelo plays a kind of conceptual peekaboo throughout the chapel in which he cuts against the grain of our expectations. His fascination with

* One of the doors actually serves as the entrance to the chapel, and two open onto small sacristies near the choir. The other five are merely decorative. While another artist faced with this arrangement would likely have made all the doors—real and false—appear usable, Michelangelo has treated them all as merely decorative.

visual paradox extends to sculptural elements that are deliberately unre-
solved, strained, or even contradictory. Perhaps the most obvious example
involves the strange costumes he has chosen for the two dukes. Despite
the fact that both wear ornate cuirasses, their chest muscles and the fleshy
creases of their bellies are clearly delineated as if their armor were nothing
more than a sheer, skin-tight fabric. Such garments have no historical or
practical justification, but they reinforce that disquieting sense that we have
entered a realm where the laws that govern everyday life no longer apply.
Like the false doors and broken pediments, the ducal armor exists as pure
symbol, stripped of any functional role, as if to highlight the fact that these
two men are warriors in name only, their battles more metaphysical than
real.

Michelangelo's work on the Medici Chapel coincided with a traumatic pe-
riod in Florentine and Italian history and an unhappy decade and a half in
the artist's own life. Many of the dislocations and much of the anxiety of that
tumultuous age are enshrined in this disquieting masterpiece. The rich mar-
ble veneer of the lower story already memorializes this political upheaval as
the clan of merchant-bankers sought to reinvent itself in light of its newly
exalted status. Recalling the pompous architecture of Imperial Rome—albeit
in idiosyncratic fashion—Michelangelo's hybrid forms reminded his compa-
triots that the Medici were no longer simply citizens, first among equals, but
belong to the ages.

 Medici hegemony, however, was built on fragile foundations. In De-
cember 1521, Pope Leo died suddenly at the age of forty-seven, and in the
subsequent conclave the cardinals, instead of doing what was expected of
them and elevating his cousin, chose the dour Dutchman Adriaan Florensz,
Bishop of Cortona, who ascended to the papal office as Hadrian VI. (Giulio's
failure in the conclave was due to the interference of the French king, who
feared the Medici cardinal was too close to Emperor Charles V.) With Leo's
death, Medici dominance of Florence no longer seemed assured, and the
projects they financed in large part through Church revenues were thrown
into confusion. Through Cardinal Giulio—who had been de facto ruler of

Florence since before Duke Lorenzo's death in 1519—they still operated the machinery of local government, but without the prestige and the resources of the papacy behind them, the Medici and their allies were more vulnerable to a republican challenge. In June 1522, a group of young intellectuals meeting in the gardens known as the Orti Oricellari—most of them friends of Machiavelli, inspired by the old civil servant's writings—were discovered plotting the assassination of the cardinal and the overthrow of the Medici regime. Though quickly suppressed, the failed conspiracy and its brutal aftermath cast a pall over the city. For Michelangelo, sympathetic to the radicals but a servant of the establishment, the internal contradictions inevitably colored the mood of his work.

More pedestrian issues also interfered with Michelangelo's progress, including the usual difficulties finding men to work the quarries of Pietrasanta and Carrara who met his exacting standards. Management of a project on this scale demanded organizational skill, and despite his preference for solitary work, Michelangelo had become the boss of a large crew of skilled and unskilled laborers. In 1525, while he was continuing to work on the New Sacristy and had begun the Laurentian Library, he was supervising a payroll of more than 100 craftsmen at San Lorenzo alone. In addition to common laborers, he oversaw a team of gifted artisans, including Francesco da Sangallo (son of his old friend Giuliano) and Silvio Corsini. It was these men who actually carved most of the decorative elements—from drawings by Michelangelo—a sign that the unremitting pressure of work was forcing him to relinquish some measure of control. But even now he had a tendency to micromanage every detail. While he was away in the quarries, work ground to a halt in Florence as the *scarpellini* were instructed not to do anything without his explicit instructions. In truth, this was probably a wise precaution since Michelangelo's designs were so unorthodox that any attempt to execute them in his absence was bound to cause confusion.

The death of Pope Leo was not an immediate disaster for Michelangelo. For years he had been dealing chiefly with Cardinal Giulio, who remained as committed as the pope to raising monuments to the family's greatness. If financing was somewhat harder to come by, at least the cardinal's attention was not divided between Florence and Rome. Since he was no longer serving

as the pope's principal advisor, Giulio had more time to devote to securing his family's position in his native land—an important part of which centered around the various projects underway at San Lorenzo.

But now that Michelangelo had lost the protection of his most powerful patron, the della Rovere heirs—who for a decade had been watching with impotent rage while Michelangelo took on ever more work for the Medici— were emboldened, demanding that he fulfill the terms of the contract for Pope Julius's tomb. In April 1523, Julius's nephew Francesco della Rovere, newly restored to his Duchy of Urbino, made a pilgrimage to Rome to pay tribute to the new pontiff. Among the matters he particularly wished to take up with Hadrian was the status of his uncle's tomb, neglected for years by an artist who had taken tens of thousands of his ducats and produced little in return. Faced with financial ruin and a concerted attack on his honor, Michelangelo wrote a desperate letter to Ser Giovanni Francesco Fattucci, a chaplain of the Cathedral of Florence who was acting as Michelangelo's representative in Rome:

> Now you know that in Rome the Pope has been informed about his Tomb of Julius and that a motu proprio [decree] has been drawn up for him to sign, in order that proceedings may be taken against me for the return of the amount I received on account for the said work, and for the indemnity due; and you know that the Pope said that this should be done "If Michelangelo is unwilling to execute the Tomb." It is therefore essential for me to do it, if I don't want to incur the loss, which you see is decreed. And if, as you tell me, the Cardinal de' Medici now once again wishes me to execute the Tombs at San Lorenzo, you see that I cannot do so, unless he releases me from this affair in Rome. And if he releases me, I promise to work for him without any return for the rest of my life. It is not that I do not wish to execute the said Tomb, which I'm doing willingly, that I ask to be released, but in order to serve him. But if he does not wish to release me, but wants something by my hand for the said Tombs, I'll do my best, while I'm working on the Tomb of Julius, to find time to execute something to please him.

Michelangelo's habit of promising more than he could possibly deliver, of refusing no commission that came his way—either because it came from

a friend, or it posed a particular artistic challenge or would increase his fame—in short, of juggling more balls than he could keep in the air, had finally caught up with him. A few years earlier, facing a similar backlog of unfulfilled commissions, he had written despairingly: "I'm dying of anguish and seem to have become an impostor against my own will." In the case of Julius's tomb, the suffering brought about by pangs of conscience might well be compounded by the humiliation of being dragged before a judge on charges of fraud.

Cardinal Giulio still hoped to keep Michelangelo busy at San Lorenzo, but in his current reduced position he could do little to protect the artist from the resurgent della Rovere. Michelangelo initially rejected a generous monthly salary of 50 ducats from the cardinal, since he could not devote himself to the Medici until he got the della Rovere off his back. He informed the cardinal that he would work for him

> with this proviso, that the taunts to which I see I am being subjected, cease, because they very much upset me and have prevented me from doing the work I want to do for several months now. For one cannot work at one thing with the hands and at another with the head. . . . I haven't drawn my salary for a year now, and I'm struggling against poverty. I have to face most of the worries alone, and there are so many of them that they keep me more occupied than my work, since I cannot employ anyone to act for me, as I haven't the means.

Of course, one should not accept Michelangelo's chronicle of woe at face value. He had every motive to paint the worst possible picture of his circumstances, and his notions of poverty, as we have seen, would have puzzled most of his fellow citizens, who were forced to get by on much less. But his distress was very real, caused more by the toll it was taking on his tattered reputation than on his bank account. Trying to get out from under his debt to the della Rovere, he contemplated selling some property in Florence. He also called in the loan for the woolen shop from his father and brothers, precipitating yet another of those crises that threatened to tear the family apart. After Lodovico made the outrageous charge that his son was trying to cheat him, Michelangelo wrote a letter dripping with sarcasm:

*If my life is an annoyance to you, you've found the remedy and will soon secure
the key to that treasure that you say I have; and you will thrive, because all
Florence knows how you were a fine rich man and how I always robbed you
and deserve to be punished. You will be praised to the skies! Shout it from
the rooftops and call me whatever you like, but do not write to me any more,
because you prevent me from working and I still need to make up what you've
had from me for the last twenty-five years. I wish I didn't have to say this, but I
can't hold back.*

IV. AGE OF ANXIETY

The quarrel with his father increased Michelangelo's sense of isolation; all
the world seemed to have turned against him, and he was left feeling ex-
hausted and dispirited. Ultimately, he was willing to pay a steep price to buy
back his honor. Prodded by the cardinal, he finally agreed to accept an al-
lowance, but only if it was reduced to a paltry 15 ducats per month, a stipend
Fattucci described as "shameful." Two years later, in April 1525, he declared
himself ready to admit his fault if only this would get his creditors off his
back. "They can't sue me if I admit that I've done wrong," he pointed out.

*I'll act as if I've been taken to court and lost and must give them satisfaction.
And this I'll do, if I can. But if the Pope wishes to help me in this matter—
which would give me great pleasure, seeing that, either from old age or
infirmity I will never finish the Julius's tomb—he, in his role as middleman, can
say that he wishes me to restore what I've received for completing it, so that I
can be free of this burden, and the relatives of the said Pope, having obtained
restitution, can give the job to whomever they choose and have it made as
they wish.*

Even as he cast about for a way to satisfy both the cardinal and the heirs of
Pope Julius, he continued to work sporadically on the tomb in his Florentine
studio. It was during these unhappy years that he began the four magnificent
Captives now in the Accademia Gallery in Florence. Though he finished
none of them, they are among the most powerful in Michelangelo's entire

oeuvre. Only partially released from the surrounding matrix of stone, each seems to struggle against his fate, engaged in a Manichaean contest of pure spirit against corrupt matter. For Neoplatonists like Pico della Mirandola, the body is the prison of the soul, released only in death. "Through the first death, which is only a detachment of the soul from the body . . . the lover may see the beloved celestial Venus," Pico declares, "but if he would possess her more closely . . . he must die the second death by which he is completely severed from the body. . . ." In his own writings, Michelangelo often expresses a similar idea, at one point transcribing Petrarch's famous line "Death is the end of a dark prison." The sculptor, probing the inarticulate mass with his chisel, finding form within formlessness, replicates the kiss of death, a stripping down to bare essentials that releases the soul from its fleshy cage.

More than any artist in history, Michelangelo left behind an impressive body of half-completed works, many of which are masterpieces in their own right. In fact, a list of his unfinished works would be far longer than a list of paintings and sculptures fully executed. But even works like the New Sacristy or the captives meant for Julius's tomb—fragments of a larger whole that by no stretch of the imagination can be said to reflect Michelangelo's initial conception—remain compelling, not despite their half-realized state but largely because of it. To modern audiences in particular, the rough-hewn *Captives* are more poignant than the polished *Pietà*, their manifest imperfection providing a glimpse into the artist's soul that is closed off by the gleaming finish of the earlier work.

It is not only modern audiences who find something to admire in Michelangelo's unfinished work. In his funeral oration for the artist, Benedetto Varchi declared that the artist's genius was such that his roughed-out sculptures surpassed the finished works of lesser masters. The fact that so many of his uncompleted works are still with us is a testament to how avidly they were collected in his own day, preserved in the years following his death as mementos of the great man's life. Treated like holy relics, these fragments participated in the cult growing up around the artist. As Michelangelo came to be revered as a kind of secular saint, his work was valued not in proportion to the skill exhibited, but by how intimately it was associated

with his person. *A sua mano* (by his own hand) was a phrase frequently inserted into contracts of the time to ensure that the master actually carried out the work in question, but in the case of Michelangelo this standard clause became a kind of fetish as collectors sought anything, no matter how trivial, that bore the sign of the artist's touch. Where before, sketches used in the process of working out a composition were discarded as worthless, Michelangelo's were treasured as art in their own right.* In fact, these unfinished artworks were perhaps even more precious than those he actually completed, like a cloth stained with a martyr's blood.

Michelangelo's fortunes brightened in September 1523 with the death of Pope Hadrian. Not only had the pope been personally hostile to Michelangelo, he seemed to have had little use for art in general. A pious and ascetic man, he tried to rein in the excesses of his predecessors and launch the kind of reforms that might have risen to the challenge posed by Martin Luther and his followers. Unfortunately, his stinginess made him unpopular with the people of Rome, who depended on vast papal expenditures to provide them with both jobs and entertainment. His death was celebrated by Romans, who inscribed on the door of his personal physician, whose efforts on behalf of his patient were so ineffectual, the mock tribute: "To the Liberator of the Fatherland, the Senate and the Roman Pope."

The conclave that followed proved even more than usually contentious. Cardinal Giulio de' Medici was the preferred candidate of Emperor Charles V, which automatically made him anathema to the French contingent. Charles, the Holy Roman emperor, was the most powerful monarch in Europe, ruler of a domain that extended from Spain in the south to Flanders and Germany in the north. With voyages of exploration and settlement heading out from the ports of Spain and Portugal, he could claim large chunks of the New World as well as the old, making his the first truly global empire.

* Michelangelo was less than thrilled with this market for his castoffs. While in Florence, he ordered Sellaio (much to the latter's dismay) to burn all the cartoons for the Sistine Ceiling to prevent them from getting into the hands of collectors.

Cardinal de' Medici's elevation was opposed by the only European monarch who could approach the emperor in terms of wealth and military might: the French king, Francis I. Unfortunately, Francis had not abandoned his ancestral claims to large parts of the Italian peninsula, while Charles, despite the fact that he had troubles of his own—including the religious revolt incited by Martin Luther that was already spreading to much of north and central Europe—was not inclined to give the French a free hand in Italy. And so the two great continental powers prepared to resume the ruinous generational conflict that had brought untold suffering to the people of Italy and no commensurate benefit to the contestants who had spilled so much blood for so little gain.

Given the sharp divisions within the Sacred College, it is not surprising that it took more than fifty days for the conclave to name Hadrian's successor, ultimately awarding to Cardinal Giulio the title he had anticipated on the death of his cousin two years earlier. Though Giulio, who took the name Pope Clement VII, had been promoted by the Spanish contingent, once in office he was forced to steer a narrow course between the two great powers, pledging his loyalty to whichever one seemed less likely to swallow up the Papal States at any given moment. This proved a difficult and ever-shifting calculation, which necessarily meant that his policy pleased no one. On February 24, 1525, French and imperial forces clashed at Pavia in northern Italy. Not only were the French forces crushed, but Francis himself was taken prisoner. To many observers, it seemed as if the decades-long struggle for European supremacy was finally at an end.

But nothing in that unhappy land was ever settled, since, as had happened after the effortless triumph of French king Charles VIII in 1494, the success of one side immediately galvanized every other party to resist the victors. Leading the fight to overturn the verdict of Pavia (though surreptitiously, since he was still officially allied with the emperor) was Pope Clement, who tried to repeat the success of Julius in driving out the "barbarians." But Clement had none of Julius's martial temperament. He hoped to prosper through cleverness rather than force of will, signing and breaking treaties with an alacrity that earned him a reputation for deviousness. "[A]lthough he had a most capable intelligence and marvelous knowledge of world af-

fairs," wrote Francesco Guicciardini, who served him for many years, "yet he lacked the corresponding resolution and execution. For he was impeded not only by his timidity of spirit . . . but also by a certain innate irresolution and perplexity." The Venetian ambassador summed him up with a brief, cutting analysis: "He talks well but he decides badly."

For Michelangelo the new pope's faults were not immediately apparent or particularly relevant. What mattered to him was that after two difficult years he had an ally back on the throne of St. Peter. Now he could rededicate himself to his work secure in the knowledge that he had the full support of the wealthiest and most powerful patron in Christendom. Clement had already demonstrated that he was a sensitive master, far more appreciative of his genius and tolerant of his prickly personality than Leo had been. Michelangelo greeted the news of his elevation with a sigh of relief. "You will have heard that Medici is made Pope," he wrote to his assistant Topolino in Carrara, "at which it seems to me all will rejoice; and I believe that here, with regard to art, much will be accomplished."

In the short run, at least, Michelangelo's optimism proved well founded. Crucially, Clement was prepared to intervene with the della Rovere heirs, urging them to moderate their demands in order to free Michelangelo for what he considered the more important work on the Sacristy and the Laurentian Library. Clement's offer to put Michelangelo on salary demonstrates his sensitivity to the artist's needs, ensuring much-needed financial security and peace of mind after an extended period in which he'd enjoyed neither. In Clement, Michelangelo had the most congenial patron since the days of his youth, when the current pope's uncle had given him a room in his palace and place of honor at his table.

Even with such a tactful master, however, Michelangelo bridled at any hint of interference. "If Your Holiness wishes me to accomplish anything," he pleaded with the new pope in January 1524, "I beg you not to have authorities set over me in my own trade, but to have faith in me and give me a free hand. Your Holiness will see what I shall accomplish and the account I shall give of myself." For the most part, Clement gave Michelangelo the room he needed, trusting sufficiently in his genius to take a hands-off ap-

proach. The artist, responding favorably to his gentle guidance, kept his master apprised of his intentions. Between Michelangelo and Clement there were none of those titanic clashes of will that marked even his most fruitful collaborations with Julius, or the chilly reserve that characterized his relations with Pope Leo.

We can follow the evolution of this collaboration in a series of letters exchanged between Michelangelo, the (then) cardinal, and Giulio's agent, Domenico Buoninsegni, during the planning stage of the Medici tombs. Perhaps surprisingly, even the most basic issues—such as how many tombs the chapel was to contain and who, exactly, was expected to occupy the various sarcophagi—were not determined in advance, but worked out in letters between Giulio in Rome and the artist in Florence. A number of sketches by Michelangelo survive showing him trying out various formulations that he then ran by his patron. Giulio's responses indicate a sensitive and well-informed critic, probing for the weak points in the design while ultimately deferring to the artist's judgment.

From the beginning Michelangelo conceived of the architecture and sculpture as elements of an integrated system. His figures are not simply framed by the structural elements in the traditional manner. Instead, the two together form the bones and sinews of a living organism, responding to the same stresses, animated by a single will. Michelangelo, in effect, has turned his initial conception of a freestanding tomb inside out, so that the sculptural plasticity of the centralized monument is now transferred to the four walls of the chapel. In the process, the normally planar forms of the built environment have taken on the expressive physicality of Michelangelo's sculpture, characterized by cavities and tumescences, stresses and fractures.

For all its stunning originality, the Sacristy as it exists today feels oddly unbalanced. The most glaring absence is the missing double tomb Michelangelo planned for the wall opposite the altar. Instead of the elaborate figure-draped sarcophagi, surmounted by effigies of the deceased—these, in turn, to be integrated into an ornate architectural environment of niches and tabernacles—we are left with three isolated sculptures plunked down on a plain rectangular box against a bare wall. The three statues depict the two Medici patron saints, Cosmas and Damian—these executed by Fra Giovanni

Montorsoli and Raffaello da Montelupo, each working from drawings by the master—and an unfinished Madonna and Child, largely by Michelangelo's own hand. The two saints are workmanlike but uninspired, while the Virgin and Child seem forlorn in their barren surroundings.

No doubt the unsettling effect would have decreased had these figures been integrated into the tomb as intended, but the sense of emotional isolation, even alienation, seems to inhere in the figure of the Virgin herself. Indeed, from his very first treatment of this subject in the *Virgin of the Stairs,* Michelangelo's Madonnas are characterized by emotional distance. The version in the Medici tombs, in which the infant twists his body to reach for his mother's breast, shows Michelangelo's usual mastery of anatomical form, but the mother's estrangement from her child is particularly disturbing, as if her sorrow at his eventual death prevents her from responding to or even acknowledging the squirming infant in her lap.

The negative impact of this insufficient figure is exaggerated, since she is intended to be the focal point of the chapel. All eyes (or at least those of the two commanding figures of the captains, as well as the paired saints to either side) turn to her. This makes sense since the Chapel is dedicated to the Virgin, invoked during Mass on behalf of the dead, but all this attention gives the whole chapel a weirdly off-kilter feel. Like one of those broken pediments Michelangelo employs to such expressive effect in both the tabernacles and on the sarcophagi, the Medici tomb projects weakness where we expect the greatest strength. We come to the Mother of God seeking solace but leave empty-handed.

Perhaps it is only an accident of history, but this emotional void at the heart of the chapel seems strangely apt. A monument to the dead, the New Sacristy is an extended essay in absence. Blank doors, empty niches and tabernacles, blind windows all abound as if we are Alice in Wonderland stranded in an unfamiliar place, not knowing how we got here and having no obvious means of egress. That which is *not* present overwhelms that which is. It is a room as mysterious and unknowable as death itself.

This same deracinated mood prevails when we turn to the tombs of the two dukes. Though far more faithful to Michelangelo's conception than the double tomb of the Magnifici, these, too, are only partially realized. In each,

the deceased is represented as a figure seated within a rectangular niche, dressed in armor to signal his earthly role as a commander of the papal armies. The armor deliberately evokes the pompous militarism of imperial Rome, though, characteristically, Michelangelo offers his own eccentric variations on the ancient model. The empty niches on either side were originally meant to contain nude allegorical figures, though, as with the *ignudi* on the Sistine Ceiling, their exact symbolic function is unknown.

It is often said that Michelangelo conceived of his sculptures as confined within the block.* Unlike statues made by his successors—younger contemporaries like Giambologna and Cellini, and the great Baroque sculptor Bernini—his figures don't appear to reach into the space around them, but instead to reinforce the cubic integrity of the column from which they emerged. Much of their dynamic tension comes from the feeling of critical mass, of roiling energies building up under extreme pressure. Each seems to struggle against limits; none is truly freed from the constricting matrix out of which it was born.

In the Medici Chapel, however, Michelangelo goes further than any artist before him in integrating the figure into the surrounding space. Viewed in isolation, each sculpture is self-contained. But, crucially, none of these figures can be understood without reference to the other residents of the shrine; each responds to his neighbors, either as synchronous or opposing elements in a linked pair. Both Giuliano and Lorenzo gaze at the Madonna on the far wall, while she averts her eyes, apparently troubled by the role she will be asked to play in the divine mystery of her son's sacrifice.

The two captains themselves form a complementary pair, representing alternate paths to approaching the sacred. Giuliano responds with a kind of quickening, a divinely inspired arousal. He seems to have just awakened from a dream. He turns toward the Virgin and Child like David (to whom he bears more than a passing resemblance) responding to the giant's ominous

* An apocryphal story claims that Michelangelo defined a good sculpture as one that could be rolled down a hill without breaking. (See Panofsky, "The Neoplatonic Movement and Michelangelo," *Studies in Iconology*, 172.)

tread. His heavy arms suggest a recent slumber, but his face is alert, atremble with the immanence of the divine.

While Giuliano is outwardly directed, his nephew turns in on himself, brooding on the sacred tableau before him. He is slumped in his chair, his face lost in shadow beneath the projecting brim of his helmet. While Giuliano is stirred from his trance by the vision of the Virgin and her child, the more introspective Lorenzo meditates on the nature of his own soul.* In his left hand Giuliano holds two coins as if making an offering, his generosity a reproach to Lorenzo, who hoards his gold in the money box he keeps on his knee.

On the lids of the sarcophagi, Michelangelo has replaced the traditional effigy of the deceased with pairs of allegorical figures that, collectively, embody the ceaseless flow of time: on the tomb of Giuliano, Michelangelo has carved both *Night* and *Day*; on the tomb of Lorenzo, *Dawn* and *Dusk*. Like the complementary figures of the two captains, these figures are conceived as contrasting pairs. Duality is raised to the status of a universal principle: male cleaves to female; light is separated from dark; life is inevitably followed by death.

The organizing principle of paired opposites extends to the poses themselves. As *Night* (female) twists one way, her companion *Day* (male) twists the other, like separated strands of DNA that together contain the essence of life. The poses of *Dawn* and *Dusk* more closely mirror each other, but the subtle departures from symmetry—*Dawn*'s far arm is bent, while *Dusk*'s is held straight; her left foot is tucked behind her knee, while his is locked painfully in front; her limbs are heavy with sleep, while his are tightly clenched; she possesses the sinuous grace of youth, while he exhibits the ravages of hoary age—offer a set of themes and variations carried out on progressively smaller scales.

A straightforward explanation of Michelangelo's allegorical scheme is provided by Condivi, who sums it up as "Time, that consumes all things."

* This figure soon came to be known as *Il Penseroso*, the thoughtful one. Rodin's *Thinker* is largely a reinterpretation of Michelangelo's famous statue.

Exploring an idea he first touched on in the Sistine Ceiling, Michelangelo treats time as an oscillation of opposites, beginning "In the Beginning" when God set history in motion by dividing the light from the dark. Or, as he puts it in a sonnet from the 1530s:

> *He who made me, and out of nothing,*
> *time not existing until someone's there,*
> *dividing one into two, the sun on high,*
> *the moon far closer.*

As we are born into time, so will time destroy us. Mortality is the price we pay for participating in Creation, the progression of our lives measured by the circling of the heavenly bodies.

Michelangelo provided a rare commentary on his own work in a poem he wrote at the same time he was carving his statues:

> *Day and Night speak, and here is what they say—We have*
> *with our quick steps guided to his death Duke Giuliano,*
> *and it is only right that he should wreak vengeance on us.*
> *His vengeance is this: that having died himself, in death*
> *he has taken the light with him, and with his closed eyes, no longer shining*
> *here on earth, he has shut ours.*
> *Had he lived, what would he have made of us?*

Here, following Condivi's formulation, we have the image of time as the thief, the devourer, a traditional theme for a funerary monument. Day gives way to night, light to dark in steady alternation, a ravening heartbeat, that parcels out our dwindling years.

But this is not the final word. "Cease in a moment both time and hours," Michelangelo wrote in a sonnet of 1533, "both day and sun in its ancient path. . . ." Death conquers Time; Life will ultimately triumph over Death. Christ's sacrifice stops the wheel's rotation, ensuring that our souls outlast our corruptible bodies and we enter the realm of eternity. The artist too performs a kind of sacrament, conferring immortality on those he depicts, long

after flesh has turned to dust. He becomes an adept of spiritual mysteries, mediator between this world and the next.

Like an Egyptian priest preparing the pharaoh's body to sail forever in the barque of the Sun, Michelangelo, in preparing Lorenzo and Giuliano for eternity, has been forced to discard much gross matter along the way. Much that was peculiar to them in life, all that is corruptible, particular, distinctive—all that does not conform to the ideal—is tossed aside in favor of abstract universals. This process was noted by contemporaries who were acquainted with the two dukes and complained that the statues bore no resemblance to their earthly counterparts. Responding to the criticism, Michelangelo explained that he "did not model either Duke Lorenzo or Lord Giuliano as nature had made them, but gave to them a grandeur, proportion, a decorum, grace, and splendor that seemed to him would elicit greater praise, saying that a thousand years hence no one would know that they appeared different, so that people would gaze upon their images in admiration and be awestruck."

But who were future generations supposed to shower with praise? The two captains, admittedly mediocre men who had accomplished little in their brief lives, or the artist who gave them such a spectacular send-off? It is characteristic that even as he carved the figures, Michelangelo was already thinking in terms of millennia—that is, of his own immortality rather than that of the two Medici dukes, who were destined to be forgotten shortly after they were interred. Indeed, the New Sacristy is a deeply autobiographical work, the first of his masterpieces that truly seems to embody his own melancholy spirit. The darkness that was always present now comes to the surface, drawn forth by the nature of the commission and by the troubled times through which he was living.*

* He develops this theme in a poetic exchange with Gian Battista Strozzi. Strozzi wrote:

> *The Night you see so sweetly sunk in sleep*
> *was quarried by an angel from this stone:*
> *To say she sleeps is just to say she lives.*
> *Disturb her, if you don't believe, and speak . . .*

Indeed, the years during which he worked on the Medici tombs were marked by political turmoil and personal disappointment. For all his fame, he was oppressed by a sense of failure as he saw his various endeavors fall short of his dreams. A perfectionist, he was rarely pleased with what had been accomplished, dwelling instead on what might have been. His constant carping alienated even those who shared his goals. Battista Figiovanni, Prior of San Lorenzo, described him with more than a hint of sarcasm as "the unique Michelangelo Simoni with whom Job would have lost patience after a day."

For Michelangelo the constant quarreling took its toll. "[N]o one has ever had dealings with me, I mean workmen, for whom I have not wholeheartedly done my best," Michelangelo told his friend Piero Gondi in 1524. "Yet because they say they find me in some way strange and obsessed, which harms no one but myself, they presume to speak ill of me and to abuse me; which is the reward of all honest men."

Not only did he feel ill used by his colleagues, but betrayed by his own body, which was no longer capable of withstanding the demands he made on it. He frequently complained of being old and tired, but he rarely wallowed in paralyzing despondency, at least not for long. Like many with a melancholy disposition, Michelangelo embraced his condition, using it to fuel his creativity:

> *The night was mine, the dark time; fate had sworn*
> *from my look at birth, in cradle, that's my due.*
> *And like the one who'll plagiarize his nature,*
> *soul growing glummer with night's darkening gloom,*
> *I grieve for my dismal days, so little worth.*

To which Michelangelo had the figure reply:

> *Sleep's dear to me, but dearer my stone being*
> *while injury and shame go on and on.*
> *It is my luck neither to hear or see.*
> *And so do not disturb me. Oh, speak low.* [Quoted in Hughes, p. 200.]

Better to be dead, he seems to say, than to face the corruption of the world around him.

Michelangelo, *Pietà*, 1498–99.

Michelangelo, *David*, 1501–4. *Nicolo Orsi Battaglini/Art Resource, NY*

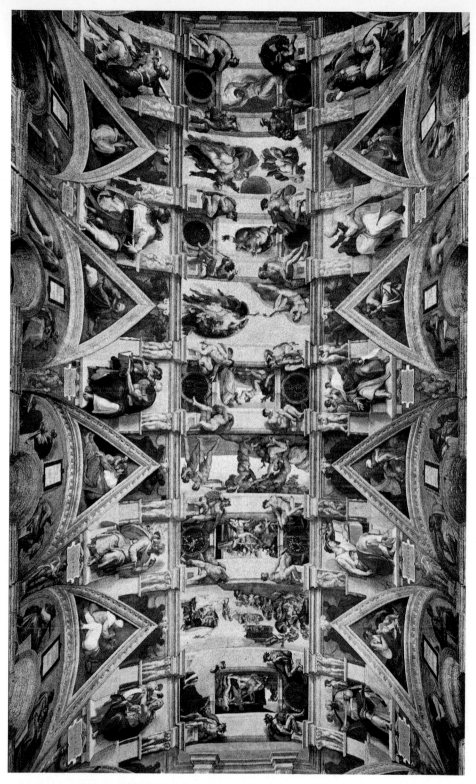

Michelangelo, Sistine Ceiling, 1508–12. *Erich Lessing/Art Resource, NY*

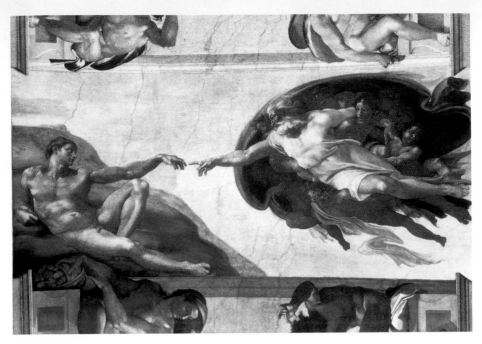

Michelangelo, *Creation of Adam*, Sistine Ceiling, 1508–12. *Erich Lessing/Art Resource, NY*

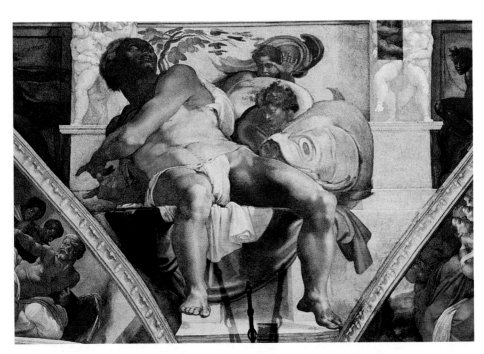

Michelangelo, *Jonah*, Sistine Ceiling, 1508–12. *Erich Lessing/Art Resource, NY*

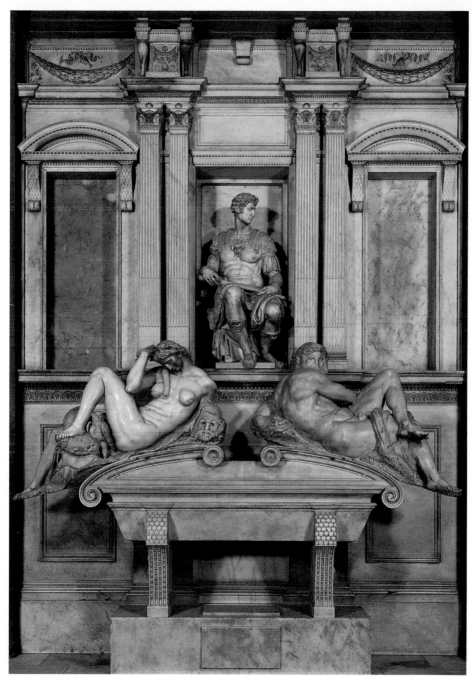

Michelangelo, *Tomb of Giuliano de' Medici*, Medici Tombs
(New Sacristy), San Lorenzo, 1520–34. *Scala/Art Resource, NY*

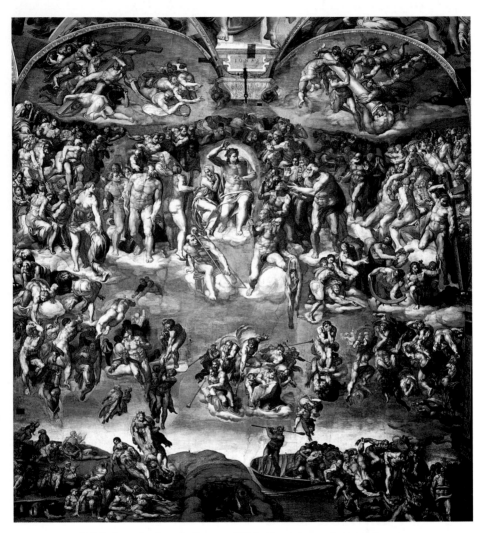

Michelangelo, *Last Judgment*, 1536–41. © *Ultreya / Takashi Okamura*

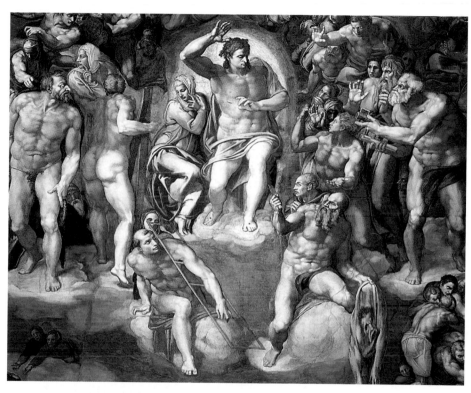

Michelangelo, *Last Judgment*, Central Portion with Christ and
St. Bartholomew, 1536–41. © *Ultreya / Takashi Okamura*

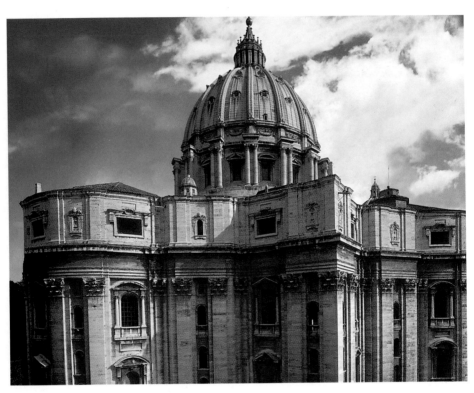

Michelangelo, St. Peter's Basilica, Dome and Hemicycles, 1547–64. *Scala/Art Resource, NY*

If life is torment, then death offers release. "O night, though black, the sweetest time," he writes in a sonnet of the 1530s,

> *to peace converting all our toil . . .*
> *O shadow of death, that closeth*
> *every anguish of the soul, all pain of heart,*
> *for every ill a blessed remedy.*

As his own outlook on life grew increasingly glum, death seemed to offer release. In the shrine to the Medici dead, Michelangelo offers his fellow travelers on this dismal journey a final consolation: Time, devourer of our mortal flesh, source of corruption, can win only a temporary victory; sloughing off "this mortal coil," our souls will rise, pure and free, wrapped in the chill embrace of eternity.

V. SACK AND SIEGE

Michelangelo was not the only one to greet the election of Pope Clement with a sigh of relief. Giulio de' Medici was a capable man, less self-indulgent than his cousin, and more attuned to the sensibilities of the Italian people than his dour predecessor. Taking the reins of the Florentine Republic after the death of Lorenzo in 1520, he had demonstrated far greater tact than his arrogant nephew. "[H]e abstained from pleasures and was assiduous in his duties," wrote Guicciardini, "so that there was no one who did not expect from him the greatest and most extraordinary achievements." But the optimism that accompanied his elevation quickly dissipated. The diplomatic skills that won him the respect of his compatriots failed him on the larger stage of European geopolitics. Caught between Holy Roman Emperor Charles V and King Francis of France, Clement behaved erratically, throwing himself into the arms of one suitor or the other with a promiscuity that earned him the contempt of both. Treaties were signed one day only to be torn up the next; diplomacy was reduced to duplicity. One observer summed up Clement's tenure this way: "A papacy made up of greetings, consider-

ations and speeches, of more, of then, of but, of yes, of perhaps, of yet, of many words without meaning."

Though Michelangelo was too wrapped up in his own concerns to dwell on the deteriorating political situation, the storm brewing was so massive that he was inevitably caught up in its fury. In October 1525, Michelangelo indicated that "the four figures are not yet finished, and there's still much to do," adding that "the four Rivers* are not yet started because there are no marbles. . . ." Eight months later he was able to report substantial progress: "I'm working as hard as I can, and within fifteen days I'll begin the other captain [Giuliano]; then, the only important things left will be the four rivers." But by December of 1526, work on the chapel and the adjacent library had stalled. "[T]he times are unfavorable to this art of mine," he grumbled, and wondered aloud "whether I have any further expectation of my salary."

This disruption was part of a much larger crisis engulfing the papacy and, indeed, the whole of Europe. In March 1526 the emperor and the king of France signed the Treaty of Madrid, by the terms of which King Francis was released from captivity in return for an agreement that he would renounce his claims in Italy. Machiavelli, for one, saw this as a recipe for disaster. "There will be war in Italy, and soon," the former Second Chancellor concluded gloomily, proving himself as able a prophet as he was a political philosopher.

Clement, fishing in troubled waters, soon persuaded King Francis to renege on his commitments, pointing out they had been made under duress. Then, in concert with Florence, Milan, and Venice, the two men formed the League of Cognac for the purpose of driving the imperial forces from Italian soil. Unfortunately, this motley alliance proved no match for Charles's army, which included among their number many German *landsknechte*, formida-

*The four figures were likely the four symbolic "times of day" for the lids of the sarcophagi. The meaning of the pagan river deities has never been fully sorted out, though it is likely that Michelangelo intended some kind of fusion of Christian and Neoplatonic ideas. They were likely meant to represent the four rivers of Hades mentioned by Dante in *The Inferno*—Acheron, Styx, Phlegethon, and Cocytus—and intended as symbols of the soul's journey through the afterlife. These rivers were also associated by the Neoplatonist Cristoforo Landino with "all those evils which spring from a single source: matter." (Quoted in Panofsky, *Studies in Iconology,* p. 204.)

ble fighters whose martial ardor was increased by the fact that many of them were followers of Martin Luther and filled with a visceral hatred for the man they regarded as the Antichrist in Rome.

In the spring of 1527 the tragedy played out in slow motion as an imperial army numbering over 30,000 men under the Duke of Bourbon snaked southward, lunging in the direction of Florence before heading for the papal capital. The forces of the League followed behind, nipping at their heels but doing little to impede their progress. On May 5, the imperial army arrived before the gates of Rome. After the Duke of Bourbon was killed by a sniper's bullet (the artist Benvenuto Cellini rather improbably claimed credit for the fatal shot himself), Spanish and German divisions assaulted the walls of the city, breaching them the next day. The sack that followed was one of the worst atrocities ever visited upon a European city. "Many were suspended hours by the arms," wrote one eyewitness to the mayhem unleashed upon the populace by vengeful soldiers:

> many were cruelly bound by the genitals; many were suspended by their feet high above the road or over the river, while their tormentors threatened to cut the cord. Some were half buried in cellars, others were nailed up in casks or villainously beaten and wounded; not a few were branded all over their persons with red-hot irons. Some were tortured by extreme thirst; others by insupportable noise and many were cruelly tortured by having their teeth brutally drawn. Others again were forced to eat their own ears, or nose, or their roasted testicles, and yet more were subjected to strange, unheard of martyrdoms that move me too much even to think of, much less describe.

The fact that the murder, rape, and pillage were carried out by fellow Christians rather than by infidel Turks shocked the conscience of all Europe. Even cynical old Machiavelli, following in the camp of the army of the League of Cognac, was shocked by what he called the "dreadful news from Rome," while the usually phlegmatic Guicciardini described 1527 as the year "full of atrocities and events unheard of for many centuries: overthrow of government, wickedness of princes, most frightful sacks of cities, great famines, a most terrible plague . . . everything full of death, flight and rapine."

Nowhere were the shock waves felt more strongly than in Florence, since Clement was not only the leader of the Holy Church but the de facto lord of the city. Day-to-day management had been left to his deputy, Cardinal Passerini—who in turn served as regent for two Medici nonentities, Ippolito and Alessandro de' Medici*—but with the pope now a virtual prisoner in his fortress, the Castel Sant'Angelo, the regime had lost the main pillar of its support. Once more the ancient cry of *"Popolo e libertà!"* was heard in the streets of Florence as the emboldened citizens stormed the government palace, driving Passerini and his two wards into exile.

For many Florentines, the proclamation of the new republic promised a return to the glory days when sensible burghers led the city and everyone marveled that a small town on the Arno could produce so many men of genius. But while his compatriots celebrated, Michelangelo found himself in an awkward position. His own convictions were republican, but he was willing to serve any master as long as he was allowed to pursue his art in peace.

Fortunately for Michelangelo, the new leaders did not hold his apostasy against him, but the collapse of Medici power still meant that the various projects at San Lorenzo—for which he had sacrificed so much and to which he had devoted a decade of his life—had not only lost their principal sponsor but their rationale. Hostility to Michelangelo's former patrons and to the symbols of Medici power only increased when Clement and Charles V signed the Treaty of Barcelona, uniting emperor and pope in the common goal of suppressing the upstart Florentine Republic. (In return, the pope agreed to deny Henry VIII a divorce from his current wife, Catherine of Aragon—who happened to be Charles's aunt—which he wanted so he could marry Ann Boleyn.)

Far from ostracizing Michelangelo, the new regime was eager to make use of him. In August 1527, he was offered a job as clerk to the *Cinque del Contado,* the department overseeing affairs in the countryside. Though he refused this rather menial post, the government soon provided him with a task more in keeping with his talents, commissioning a monumental *Hercules*

* Ippolito, only sixteen at the time, was the illegitimate son of Giuliano, while Alessandro, a year older, was said to be the illegitimate son of Lorenzo. Some believed he was actually the illegitimate son of Pope Clement himself.

to stand alongside the *David* at the entrance to the government palace as a symbol of fortitude in the face of adversity.*

In fact, the commission had been decades in the making. Shortly after the completion of the *David,* Piero Soderini had proposed a companion piece and had even purchased on behalf of the Signoria a large marble column for the project. Little was heard of the *Hercules* during the years Michelangelo spent in Rome, but at some point—and much to his chagrin—Clement awarded the commission to Baccio Bandinelli, a mediocre but prolific sculptor, no doubt in the sensible belief that Michelangelo already had his hands full with his work at San Lorenzo. According to Vasari, it was Domenico Buoninsegni who "persuaded the Pope to give the marble for the statue to Baccio . . . saying that these two great men would stimulate each other by competition. . . . Baccio boasted that he would surpass Michelangelo's *David,* while Buoninsegni declared that Michelangelo wanted everything for himself."

The competition for the prestigious monument was fueled not only by the usual personal animosities but by a subtle political subtext. Even before the revolution of 1527, the people of Florence took up Michelangelo's cause. "We had then in Florence the greatest master of the age, and the people wanted him to work on [*Hercules*], because he had made the *Gigante,*" one citizen recalled. "But because [Michelangelo] was working on the Medici tombs, Pope Clement VII gave it to another Florentine sculptor, so that his own tomb would not be harmed." While many remembered fondly the role Michelangelo had played during the last republic, Bandinelli, in addition to being a second-rate sculptor, was regarded as little more than a Medici stooge. When a barge carrying Bandinelli's column overturned in the Arno, one wit declared that this was "because it was deprived of the *virtù* of Michelangelo, knowing it was to be mangled by the hands of Baccio, desperate over such an evil fate, it threw itself into the river."

Now that the Medici were once again public enemies, Michelangelo was the logical choice to take up the symbolically important work. But as Michel-

* From the end of the thirteenth century, Hercules had been on the official seal of Florence, with the inscription "The club of Hercules subdues the depravity of Florence." (de Tolnay, *Medici Tombs,* 98.)

angelo had recently admitted, the times were unfavorable to his art. With a desperate fight for independence looming, Michelangelo's practical expertise would prove more valuable to the state than his artistic skills. The project for *Hercules* was set aside, to be taken up only after the crisis had passed. Demonstrating once again the versatility of the Renaissance artist—and following in the footsteps of Brunelleschi and Leonardo—Michelangelo now turned his talents to military engineering. In April 1529 he was put in charge of the city's defenses as *governatore generale* of the Tuscan fortifications. His recent work at San Lorenzo provided him with valuable experience handling large teams of men, which he put to good use directing the even larger crews rebuilding the bastions on the high ground near the Church of San Miniato. As always, he threw himself into the work with gusto, constructing redoubts of an innovative design capable of withstanding the artillery that would soon be launched against them by the combined forces of pope and emperor.

As papal forces under the Prince of Orange closed in on the city, the situation inside the walls grew increasingly desperate. Supplies of food and water were choked off by the advancing army, making the populace susceptible to the plague that ravaged the city in repeated waves. Michelangelo's favorite brother, Buonarroto, was struck down by the disease during a virulent outbreak in the summer of 1528, leaving the family more dependent than ever on its one productive member. Now, in addition to growing demands made on him by the beleaguered government, Michelangelo was responsible for securing the future of his brother's children, including his twenty-year-old nephew Lionardo, upon whom the fortunes of the next generation of Buonarroti now rested.*

The pressures, both public and private, seemed to be too much for him, since at the very moment his people and his family needed him most, Michelangelo experienced one of those baffling crises of nerve that had afflicted him in the past. Fearing yet another plot on his life, on September 21, 1529,

* Buonarroto was the only brother to marry. He had four children by his wife, Bartolomea, including Francesca (1517–37), Lionardo (1519–99), Cassandra (dates unknown), and Simone (1521–30). Michelangelo's extensive correspondence with Lionardo provides our best insights into the artist's personal life during his final decades, including his obsessive interest in safeguarding the honor of the Buonarroti name.

he and two companions fled the city and headed north to Venice. Even while enjoying the protection of the Most Serene Republic and its sheltering lagoon, Michelangelo did not feel secure, going so far as to request safe passage to France, where he could live out his days as a client of His Most Catholic Majesty. Nine days after his precipitous flight, the government of Florence declared Michelangelo a rebel, threatening him with arrest and loss of property. In response, Michelangelo offered an account of his actions marked by defensiveness and evasions:

> *I left without telling any of my friends, and in great disorder. . . . but it was not out of fear or an unwillingness to see the war through to the end. . . . On Tuesday morning, someone came through the gate of San Niccolò where I was at work on the bastions, and whispered in my ear that I shouldn't stay any longer because I was risking my life. Then he came back and dined at my home, and he provided me with a horse, and he did not leave my side until I had departed Florence, letting me know this was for my own good.*

Condivi tells a slightly different story, claiming that Michelangelo abandoned the city after learning that Malatesta Baglioni, the commander of Florentine defenses, was planning to betray the city to their enemies. When he brought his concerns before the Signoria, they "reproached him with being a timid man and too suspicious [so that] when Michelangelo perceived how little his word was considered, and how the ruin of the city was certain, by the authority he had, he caused one of the gates to be opened and went out with two of his people."

A more plausible explanation is given by an acquaintance, one Giovanbattista Busini, who cited numerous disagreements between Michelangelo and the Gonfaloniere, Niccolò Capponi, over his plans to fortify the strategic hill of San Miniato. "Each time, on his return," Busini recalled, "[Michelangelo] found the hill dismantled, whereupon he complained, feeling this a blot on his reputation and an insult to his magistracy." Fear no doubt contributed to Michelangelo's dereliction of duty, but just as critical was his wounded pride.

While Michelangelo's first instinct was less than heroic, in the end he played an honorable role in his city's doomed struggle. After numerous pleas

from friends who assured him that all would be forgiven should he return, Michelangelo had a change of heart. Setting out for Florence early in November, he arrived home two weeks later.

The city to which he returned was in desperate straits. By now Florence was completely invested by imperial forces intent on starving the city into submission. Near the end, the daily death toll climbed to nearly 200 from hunger and disease. While the rich made do with short rations, the poor resorted to hunting rats for meat. As reality grew ever grimmer, citizens turned to the supernatural for deliverance. Visions of flying angels bearing flaming swords appeared overhead, recalling an earlier time when a fire-and-brimstone preacher had whipped the populace into a religious frenzy. Guicciardini, in the camp of the besieging army, wrote that his compatriots defended their walls "for seven months when one would not have expected them to resist even seven days," noting that "[t]his obstinacy sprang largely from their faith in the prophecy of Fra Girolamo [Savonarola] of Ferrara, that they could not perish."

But faith proved no match for cannon and steel. On August 10, 1530, a week after the death of Florence's only capable commander, Francesco Ferrucci, the city surrendered to the inevitable. Though the public terms offered by Clement were mild—demanding only the payment of an 80,000-ducat fine and the return of Medici rule—the pope secretly encouraged those who had suffered under the republican regime to take their revenge. Thus began a reign of terror, led in part by the historian Francesco Guicciardini, who spoke for his fellow aristocrats when he declared, "we have as our enemy an entire people." Six leaders of the previous government were beheaded, many others imprisoned or forced into exile, while those who remained had to endure "tortures and persecutions."

Throughout his life Michelangelo had managed to escape the consequences of his flexible loyalties, but this time promised to be different. Pope Clement's strongman in Florence, Bartolomeo [Baccio] Valori, was determined to punish those who had played any role in the previous regime. And while Michelangelo could not be considered a political leader, he was perhaps the most famous man to lend his prestige to the anti-Medici cause. The artist's normal timidity served him well in this instance. Alerted that

a contract had been put out on his life, Michelangelo fled to the house of Giovan Battista Figiovanni, the former Prior of San Lorenzo. Despite his earlier criticism of the artist's difficult personality, Figiovanni put himself at considerable risk in order to shield him from the vengeance of the new regime. "[T]he pope having won the peace, Michelangelo came to me," Figiovanni later recalled. "The commissar Bartolomeo Valori sought to have him killed by Alessandro Corsini, henchman of the pope, for the many offenses directed at the house of the Medici. I saved him from death and saved his belongings: he told me a thousand times of his regrets."

Though Valori and Corsini* viewed Michelangelo as a traitor, Clement was inclined to forgive and forget. When he was informed that the artist had gone into hiding, he sent word back to Florence that Michelangelo was not to be molested. Clement was not a vindictive man. The harsh measures imposed on the rebellious city were meant to discourage future disloyalty, but he knew the artist posed no threat. "Michelangelo is wrong," the pope declared. "I never did him harm." In fact, rather than reprimand him for his disloyalty, Clement urged him to resume his work on the abandoned projects at San Lorenzo.

With his safety now assured, Michelangelo came out of hiding, but despite his relief that the worst was over, he remained anxious and depressed. Returning to the studio after a long absence, he was confronted with a daunting prospect. Crowding the sheds of his various properties were barely begun and half-finished works, not only a half dozen or more statues for the New Sacristy, but an almost equal number of *Captives* intended for Julius's tomb, scattered sheets bearing the designs for the Laurentian Library, as well as clay models for the Hercules (soon to be reassigned to Bandinelli).

Once more Michelangelo picked up his chisels and his pens, but work did not provide him the usual relief from his cares. The dreams of former years had turned to ash, while the city of his youth, its once vital spirit crushed by the cold hand of tyranny, had become a glum, gray place, seething with

*According to an anonymous chronicle of the time, the *Anonimo Magliabecchiano*, Corsini bore a particular grudge against Michelangelo because one of the cadavers he had dissected while he was working on the *Battle of Cascina* turned out to have been a relative of Corsini.

resentment and mutual recrimination. Protected from bodily harm by Pope Clement, Michelangelo was tolerated only grudgingly by the new regime, which was busy stamping out the last vestiges of Florentine liberty. In the spring of 1532, law caught up with reality when Alessandro de' Medici was named "duke of the Florentine Republic." Not only was Florence now officially the hereditary property of the Medici family, but they themselves were little more than vassals of the emperor, dependent on foreign lances to cow the populace into obedience.

Michelangelo plodded away on the statues for the New Sacristy, but his heart was no longer in it. More than a decade had passed since he had originally conceived the chapel's innovative forms, but the world had changed too much—and he with it—to revive that initial spark. His attitude was not helped by the fact that the young Duke Alessandro de' Medici seems to have conceived a deep hatred for him.* "Michael Angelo lived in great fear, because he was greatly disliked by the Duke," Condivi recalled, "a young man, as everyone knows, very fierce and vindictive. There is no doubt that, if it had not been for fear of the Pope, he would have had him put away long ago."

Propelled by fear and by his sense of obligation to the pope, Michelangelo drove himself to the point of nervous exhaustion. "[H]e works much, eats little and badly, and sleeps less," reported Giovan Battista Mini, uncle of his assistant, "and for a month now he has been made an invalid by catarrh, headaches and dizziness." On more than one occasion his health deteriorated to such an extent that his family feared he would not survive. Clement was so concerned that he issued a bull threatening Michelangelo with excommunication should he work on any other project but the family tomb. Despite this exhausting pace, an agent for the Marquis of Mantua (hoping to get a work for his master from Michelangelo's hand) insisted "that there are many who believe that he will not finish it all in his lifetime."

It is clear that by this time Michelangelo's ties to his native city were fraying. During the years he had lived in Rome working for Pope Julius, he had

* One source of his anger was Michelangelo's refusal to help design the fortress near the western walls of the city. This fortress, now called the Fortezza da Basso, was intended to ensure the permanent submission of the city to Medici rule.

felt like an outsider. His friends were largely Florentine expatriates, and he still belonged heart and soul to the city on the Arno. But after more than a dozen frustrating years in his hometown, his patriotism had worn thin. Florence was no longer a vibrant, independent city, but a cultural backwater and political colony. The once-proud merchants who had erected splendid monuments to honor family and country were either exiled, disenfranchised, or had been reduced to flunkies at the ducal court.

Michelangelo never made a conscious decision to abandon the Medici tombs. He simply lost interest, as he often did when a project dragged on too long or the artistic challenges had been overcome. Throughout the chapel we can see the signs of his flagging commitment, even in the most nearly completed elements—the tombs of Lorenzo and Giuliano—where crucial pieces are missing. The niches flanking the captains are empty, while the allegorical figures Michelangelo placed on the lids of the two sarcophagi appear to be sliding off their perches, dangling uncomfortably over the void. The four statues of river gods that Michelangelo had planned to carve would have sat to either side of the sarcophagi and provided much needed visual support to the figures above, but these never got beyond the stage of full-scale models.

The somber palette of the Sacristy—a Whistlerian tone poem in grays and shades of white—is also somewhat misleading. Originally, the coffered dome was decorated with paintings by Giovanni da Udine, which Vasari later whitewashed. Of the frescoes Michelangelo planned for the walls, we know even less, though a couple of quick sketches survive from this period, one depicting the Brazen Serpent, the other the Resurrection, which may originally have been intended for the chapel.

But for all its imperfections, the New Sacristy remains a compelling space, a unique blend of sculptural and architectural elements. Disquieting, deracinated, and deliquescent, it bears the scars and registers the dislocations of the difficult times in which it was created, chronicling both the death throes of the republic and the difficult birth of a new era. It is no coincidence that the two dukes laid to rest in Michelangelo's splendid tombs are the very men to whom Machiavelli dedicated *The Prince,* the notorious "handbook of tyrants" that marks the beginning of the modern age. Like that revolutionary text, the New Sacristy is the product of an age of anxiety, one that not only

marked the death of the medieval commune and the rise of nation-states proclaiming the divine right of kings, but that witnessed the most profound challenge to the moral authority of the Holy Church in its fifteen-hundred-year history. While Pope Leo was erecting monuments to his family's magnificence, an Augustinian monk was inciting a rebellion against the authority of Rome that would soon tear the continent apart.

Disillusioned and increasingly isolated at home, Michelangelo now spent as much time in Rome as he did in Florence, struggling to bring the unhappy saga of Julius's tomb to a close. Despite frequent attempts by the della Rovere to have him evicted, he had managed to hold on to his house in the Macel de' Corvi, which was tended in his absence by his loyal friend Sellaio and where work on the tomb continued even in his absence.

One last bond would have to be severed before Michelangelo turned his back completely on his native land. He had relocated to Florence in 1517 in order to carry out the commission for the façade of San Lorenzo, but also to be near his father. For good or ill, their lives were profoundly entangled as each dedicated himself in his own way to upholding the honor of the Buonarroti name. In the summer of 1531, Lodovico died at the age of eighty-seven. Coming soon after the death of Buonarroto, his passing was yet another blow at a time when Michelangelo had little else in his life to look forward to. "Already burdened with a heavy heart," he began a poem from this time,

> *I still thought I'd relieve the weight of woe*
> *through tears and sobbing, or at least in part.*
> *But fate, abounding, filled to overflow*
> *grief's source and stream, now welling unconfined*
> *with another death—no worse pain here below!*
> *That death your own, dear father. Now in mind*
> *two deaths, their claims distinct . . .*
> *fraternal, filial, separate though entwined.*

Oppressed by his losses, Michelangelo was growing increasingly disengaged from his projects at San Lorenzo, working only fitfully and delegating much of

the execution to various assistants. In the end, even the pope appeared to lose, if not interest, at least focus. Clement had never been one to pursue a goal with single-minded purpose, and with numerous statues still only half completed and many others not even begun, his imagination was fired by a new project. In September 1533, while en route to Marseilles (where he was to bless the marriage of his great-niece Catherine to Henry, younger son of Francis of France), he invited Michelangelo to meet him in the village of San Miniato al Tedesco. There, Sebastiano del Piombo informed him, Clement would propose "something that [you] would never dream of."

Michelangelo was certainly tempted by the prospect of a grand new undertaking, one untainted by compromises and marred by painful memories, but his decision to leave Florence and move back to Rome was inspired as much by personal as by professional considerations. During a recent stay in the southern capital, the fifty-seven-year-old artist had met someone and fallen in love. Now the Eternal City seemed ripe with promise, while his native land appeared ever more drab. "I see that I am yours," he wrote to the object of his affection, ". . . and drawn by the lure of your beauty I reach you, as a fish on the hook is pulled in by the line."

Increasingly alienated at home, Michelangelo felt the tug of a new life awaiting him in Rome. In September 1534, he informed a Florentine friend, "I am leaving tomorrow morning and going to Pescia and then to Rome. . . . I shall not return here any more." Making his way toward the Porta San Piero Gattolino on a late-summer morning, Michelangelo gazed on the streets and squares of Florence for the last time. Throughout the remainder of his long life he would continue to call himself a Florentine, but the love he felt for this once-vibrant city had faded, replaced at least for the moment by a fiercer passion that quickened his pulse and made him look to the future with a mix of hope and dread.

As he set out onto the road for Rome, Michelangelo bade farewell to his native land with few regrets. There was nothing to hold him there any longer; at journey's end he thought he saw the faint light of a new dawn. Or, as he himself put it in a poem written to his new love:

Heaven's only where you are; else, total dark.

Michelangelo, *Last Judgment*, 1536–41. © *Ultreya / Takashi Okamura*

VI

The End of Time

[C]ertain persons had informed him that Pope Paul IV was minded to make him alter the façade of the chapel where the Last Judgment is, because, he said, those figures showed their nakedness too shamelessly. When, therefore, the mind of the Pope was made known to Michelangelo, he answered: "Tell the Pope that it is no great affair, and that it can be altered with ease. Let him put the world right, and every picture will be put right in a moment."

—Vasari, *Lives*

I. BELOVED

The object of Michelangelo's newfound passion was a twenty-three-year-old Roman nobleman named Tommaso de' Cavalieri, a man of striking good looks, great charm, and impeccable manners. The two had met in the spring or summer of 1532, during one of the artist's extended stays in Rome. Michelangelo's attraction to the young man was immediate and intense, eliciting a torrent of breathless letters and poetry that more closely resembled a schoolboy crush than the mature reflections of a fifty-seven-year-old man. Forced to return to Florence to continue his work at San Lorenzo, Michelangelo was despondent: "[I]f I yearn day and night without intermission to

be in Rome, it is only in order to return again to life, which I cannot enjoy without [my] soul." Anguished by the miles that separated them, he poured out his heart to the man who seemed to him not only a vessel of beauty but a paragon of virtue:

> I realize that I could no sooner forget your name than the food on which I live; indeed, I could more easily forget food, which unhappily nourishes only the body, than your name, which nourishes both body and soul, filling each with such sweetness that I experience neither melancholy nor fear of death, as long as you are in my mind.

Generations of biographers—beginning with Condivi himself—have turned a blind eye to Michelangelo's obvious infatuation, denying that his letters conveyed anything more than an abstract, philosophical passion.* In the Renaissance, friendship between men was often couched in terms that strike modern readers as excessive. This was a world where women were largely confined to the home, the convent, or the whorehouse, and it is not surprising that men's emotional as well as intellectual life tended to revolve around members of their own sex. Attachments could be intense without being erotic, and it was not regarded as improper to express affection in the most effusive terms. Neoplatonic philosophy, fashionable in the circles in which Michelangelo traveled, also encouraged confessions of love, since love was viewed as the universal force uniting all to all and whose most profound manifestation was the soul's desire to reunite with God. "Thus, loving loyally," Michelangelo concludes one sonnet, "I rise to God, and make death sweet by thee."

But it's clear that Michelangelo's feelings for Cavalieri went beyond mere friendship, that he was smitten by the handsome nobleman. The let-

* Michelangelo's admirers went to great lengths to protect his reputation from the whiff of scandal. His great-nephew, also named Michelangelo, "corrected" many of the poems and letters, reversing the sex of the recipient, causing scholars to posit a more respectable, but totally implausible, love affair between the artist and the Marchesa of Pescara, Vittoria Colonna.

ter quoted above exists in three drafts, a clear indication that he struggled to find exactly the right words with which to convey the contents of an overflowing heart. When writing to his colleague Sebastiano del Piombo, he had thoughts only for the handsome nobleman, begging the painter to "commend me to him innumerable times, and when you write to me tell me something of him so that I can keep him always before me, since if he were to fade from my memory I think I would quickly die."

The conventions of the day permitted Michelangelo to give his true feelings a respectable gloss. Erotic passion could be passed off as something innocent or idealistic, a strategy so effective that it deceived generations of admirers who refused to accept that their hero was sexually attracted to men. Michelangelo himself took refuge in the fiction that his feelings for Cavalieri were above reproach, chiding the gossips who mistook his blameless admiration for lust:

> *In your handsome face I see, my lord,*
> *that of which in this life I cannot clearly speak.*
> *The soul, still cloaked in flesh,*
> *is lifted heavenward towards God.*
> *And if the foolish, vulgar crowd*
> *tars others with the sins they themselves commit,*
> *it matters not. I cherish*
> *a love, a faith, a desire, pure and true.*

Whatever the "foolish, vulgar crowd" might say, he insisted that he was attracted only to the purity of Cavalieri's soul. Conveniently enough, that purity manifested itself in a handsome face, since physical beauty was regarded as an outward sign of inner grace, the first step in an ascent from matter to spirit that led ultimately to God, as in this madrigal from the 1530s:

> *My eyes are drawn to every lovely thing,*
> *my soul to its salvation*
> *rising heavenward,*
> *with no destination but beauty in its flight.*

From stars on high
rains down a splendid light,
infusing us with desire
that on earth goes by the name of love.
No better guide the ardent heart
that loves and longs, than a comely face
in whose eyes we see reflected heaven's grace.

Michelangelo's protestations were as much an attempt to deceive himself as to deceive others. As a good Christian, he knew lust was sinful (particularly outside the bounds of holy matrimony); as a good Platonist, carnal desire was hardly any better, representing an unforgivable descent into the world of gross matter. But however hard he tried to convince himself he was motivated only by the purest thoughts, he was tormented by the knowledge that he fell short of this chilly ideal. Alongside poems trumpeting the glories of his newfound love are others seething with the anxiety of a troubled conscience. "Wild desire is not love—it kills the soul," he wrote, as if from personal experience. Simultaneously lifted up and cast down by his illicit passion, he despaired of his own salvation.

Cavalieri was flattered by the great man's attentions, but he doesn't seem to have fully reciprocated Michelangelo's feelings. He was fond of the artist and awed by his genius, but his letters are reverent rather than romantic. "I do not deem myself worthy that a man of your eminence should deign to write to me," he replied to Michelangelo's confession of love. "I think, nay rather, I am certain that the cause of the affection you bear me is this—that being a man supreme in art yourself—or rather the epitome of art itself—you are constrained to love those who are the followers and lovers of art, among whom, according to my capacity, I yield to few. I promise you truly that the love I bear you in exchange is equal or perhaps greater than I ever bore any man, neither have I ever desired any friendship more than I do yours. And if not in other things, at least in this I possess excellent judgment. . . ." Rather than respond to the artist's erotic overtures, Cavalieri deliberately misconstrues the nature of his feelings in order to place them on a more cerebral plane.

Michelangelo, for his part, seems to have accepted the terms of their relationship as Cavalieri defined them, though he remained jealous and obsessed, pestering mutual friends until they reassured him of Cavalieri's continued devotion. "[A]s far as I can see he has no less affection for you than you have for him," his agent in Rome, Bartolommeo Angiolini, responded to one such query. On another occasion Angiolini insisted: "Your Messer Tommaso is very grateful in the recognition that he has been so favored by God as to have acquired such a friendship with a man as endowed as you are. . . ."

What brought them together in the first place was Cavalieri's interest in art. Like many a young gentleman, Cavalieri hoped to round out his education by learning to draw, a skill that, as Castiglione observed in *The Courtier,* "may appear mechanical and hardly suitable to a gentleman" but is, in fact, "a worthy and beneficial art." The depth of Michelangelo's infatuation can be gauged by the fact that when he sent Cavalieri a number of elaborate and finely wrought works on paper, his normal self-confidence deserted him. "[I] should confess myself disgraced before heaven and earth," he wrote, "if from your letter I had not seen and believed that your lordship would willingly accept some of my drawings. . . . And if you really esteem my works in your heart as you profess to do in your letter, I shall count that work much more fortunate than excellent, should I happen, as I desire, to execute one that might please you."

The drawings Michelangelo created for Cavalieri, like the poems he wrote during these years, conceal an erotic flirtation beneath a high-minded Platonic discourse. They include *The Rape of Ganymede, The Punishment of Tityus,* and a strange work known as the *Bacchanal of Children.* The story of Ganymede, a beautiful youth abducted by Jupiter in the form of an eagle, has obvious homoerotic overtones, but the myth was also given a more cerebral interpretation by philosophers who reimagined the gods' misdeeds as intellectual allegories. According to Cristoforo Landino, a leading Florentine Neoplatonist, Jupiter's lust was (like Michelangelo's) not carnal but intellectual: "Ganymede, then, would signify the *mens humana,* beloved by Jupiter, that is: the Supreme Being. His companions would stand for the other faculties of the soul . . . the vegetal and sensorial." Likewise, the story of Tityus,

whose liver was gnawed by a giant vulture to punish an attempted rape, was generally viewed as a cautionary tale about the dangers of succumbing to carnal desire. More peculiar is the red-chalk drawing known as the *Bacchanal of Children,* an orgiastic scene of mischievous *putti* that may also serve as an allegory of the flesh unconstrained by reason.

Executed in black or red chalk on paper, the pieces Michelangelo made for Cavalieri are "presentation" drawings, not studies or sketches for other works but highly finished works of art in their own right.* That even ephemeral works from great masters like Raphael or Michelangelo were now avidly sought by collectors is one more sign of the growing cult of the artist. In fact, the greater intimacy of the drawing meant that in some ways it was more highly prized than the grand public work, since it was closer to the source of inspiration and bore the traces of the master's hand. Such was the market for authentic creations that even preparatory sketches—once discarded after they had served their purpose—were now coveted by connoisseurs.

Ironically, the same impulse that made a fetish of anything touched by the master's hand also encouraged the proliferation of reproductions that were far removed from the original. Printmakers like Marcantonio Raimondi could now earn a comfortable living making engravings of works by stars like Raphael and Michelangelo. The wide dissemination of these reproductions meant that artists who might otherwise have no opportunity to study the originals could fall under the spell of the great masters. Even biographers were aided by the new technology. Instead of providing a detailed description of *The Last Judgment,* for instance, Condivi contents himself with the remark: "The composition is careful and well thought out, but lengthy to describe: perhaps it is unnecessary, as so many engravings and such a variety of drawings of it have been dispersed everywhere." Like the mass media in modern times, engravings by Raimondi and a host of lesser practitioners promoted a cult of celebrity through endless repetition.

* Other works included in this portfolio are various versions of the *Fall of Phaeton,* and two other mythological scenes whose meaning has yet to be fully explained—*Archers Shooting at a Herm* and *The Dream of Human Life*—as well as a picture of Cleopatra being bitten by the asp.

• • •

Michelangelo's residence in Rome was made tolerable by the happy prospect of being near Cavalieri, but in most other ways the move seemed inauspicious. Rome had still not recovered from the horrific sack seven years earlier; much of the city lay in ruins, its artistic riches plundered and the survivors still reeling from the months of rape and murder inflicted by imperial forces. The scars from that *annus horribilis* were both physical and emotional. They were visible to even the casual visitor in gutted churches and desolate neighborhoods, but also more subtly inscribed on the traumatized faces of the survivors, where a gloomy fatalism had replaced the rambunctious swagger of old. For Michelangelo, the city held its own ghosts. As he was preparing to return, Bartolommeo Angiolini informed him that his house on the Macel de' Corvi, though it had survived intact, was down to bare walls, the garden rank and overgrown. Hoping to make the prospect seem less gloomy, Angiolini promised to buy some new furniture, adding that "the hens and master cock are in fine feather, and the cats complain greatly over your absence."

Most of all, the uncompleted tomb of Pope Julius continued to haunt him, as the della Rovere pressured him to abide by the terms of the latest contract. "I desire to be rid of this obligation more than to live," Michelangelo cried out in despair.

Adding to his uncertainty, it appeared that the new commission Clement had promised him was little more than the fevered dream of a dying man. By the time Michelangelo arrived in Rome on September 23, 1534, the pope was at death's door, prematurely aged by the disasters of his reign. The people of Rome blamed his vacillating and ineffectual policies for the catastrophe, and his constant double-dealing meant that he was trusted by neither the emperor nor the king of France. Within forty-eight hours of Michelangelo's arrival, Pope Clement was dead, depriving the artist of his most powerful sponsor and exposing him to retribution from the della Rovere heirs.

Once again, however, Michelangelo was fortunate in the selection of the new pope. As it turned out, Clement's successor was another friend of his youth—Cardinal Alessandro Farnese, scion of a powerful Roman family who had spent his formative years as a guest at the Palazzo Medici. There, under Il Magnifico's patronage, he had enjoyed the company of the leading

Titian, *Pope Paul III*, c. 1545. *Gianni Dagli Orti/The Art Archive at Art Resource, NY*

philosophers and poets of the day, along with that of a young Florentine sculptor notable for his brooding intensity and rough manners.

Paul III, as Alessandro Farnese was now known, had most of the faults and some of the virtues of the typical Renaissance pope. He owed his rapid ascent less to personal merit than to the fact that his sister, the beautiful Giulia, was the favored mistress of Pope Alexander VI, and during his decades as a prince of the Church, Alessandro seemed determined to live up to the low standards set by his patron. Like the Borgia pope, he openly acknowledged his many children, appointing his sons to the College of Cardinals and generally treating the Church as an instrument for promoting the fortunes of the Farnese family. On the plus side, he was an intelligent and cultured man who believed that part of his responsibility as pope was to promote the fortunes of the ancient capital.

Like Clement—but unlike their fellow housemate in the Palazzo Medici, Giovanni (Pope Leo)—Paul's appreciation for Michelangelo's genius was more than enough to overcome any qualms the pope might have about dealing with the artist's prickly personality. In fact, the problem was not that the new pope failed to appreciate Michelangelo sufficiently, but that he was so eager to monopolize his services that the artist was unable to meet his other obligations. "In the year 1533 [sic] came the death of Pope Clement," Vasari recounts,

whereupon the work of the library and sacristy in Florence, which had remained unfinished in spite of all the efforts made to finish it, was stopped. Then, at length, Michelangelo thought to be truly free and able to give his attention to finishing the tomb of Julius II. But Paul III, not long after his election, had him summoned to his presence, and, besides paying him compliments and making him offers, requested him to enter his service and remain near his person. Michelangelo refused, saying that he was not able to do it, being bound by contract to the Duke of Urbino until the tomb of Julius should be finished. The Pope flew into a rage and said: "I have had this desire for thirty years, and now that I am Pope do you think I shall not satisfy it? I shall tear up the contract, for I am determined to have you serve me, come what may."

According to Vasari, Michelangelo was so upset by the pope's reaction that he fled Rome in order to continue working on the tomb in peace. But that seems to be another invention of Michelangelo, who always blamed other people for his failure to deliver on his promises. The truth is, he had made too many compromises and suffered too many indignities for the project to hold his interest any longer. Julius's heirs had not only harassed him mercilessly, but had accused him of taking their ducats under false pretenses and lending out his income at interest. "[T]hose who have robbed me of my youth, my honor, and my possessions, call me a thief!" he raged. And, in truth, the charges were unfair. In his own mind, and in his own way, Michelangelo was entirely scrupulous: "Painting and sculpture, hard work and fair dealing have been my ruin and things go continually from bad to worse. It would have been better had I been put to making matches in my youth, than to be in such a fret!"

The charge that he was a swindler hurt him deeply and made him ever more determined to get out from under the burden. By informing Paul that he would have to put his dreams on hold until the demands of the della Rovere had been met, Michelangelo provoked the pope into taking dramatic action. On September 1, 1535, Paul III issued a *motu proprio* (personal decree) naming Michelangelo "supreme architect, sculptor and painter of our Apostolic Palace . . . and a member of our household with each and all the favors, prerogatives, honors, duties and preferences that are enjoyed and can be or are accustomed to be enjoyed by all our familiars."

Although the final (much reduced) contract for Julius's tomb wasn't signed until almost a decade later, Paul's intervention temporarily relieved the pressure from a project that, he claimed, had consumed the whole of his youth.* In return for his services, the pope agreed to pay Michelangelo

*In the end, Michelangelo carved only three statues for Julius's tomb, the magnificent *Moses* and *Rachel* and *Leah*. By now he was so sick of the project that he was willing to relinquish control, assigning three additional figures to Raffaello da Montelupo. His assistant Francesco Urbino and Giovanni de' Marchesi carved many of the architectural elements. The tomb as it exists today in San Pietro in Vincoli reflects little of Michelangelo's original conception, though the *Moses* alone makes it worth a visit. The della Rovere seemed to recognize that the monument they had worked so hard to create was insufficient, since they ultimately decided to leave Julius's remains in the Sistine Chapel.

an annual salary of 1,200 scudi,* a sum more than adequate to ward off any financial worries that might distract the artist from the great plans the pope had in store for him.

As long as Michelangelo served him and no one else, Paul was an indulgent master, forgiving his eccentricities and allowing him a free hand in executing commissions as he thought best. Michelangelo, in turn, showed his appreciation by token gifts of pears and Trebbiano wine. The warmth and informality of their relationship is recorded by Francisco de Holanda, a young painter who had been sent to Rome by the king of Portugal to improve his craft. "Sometimes," Michelangelo told his young colleague, "I may tell you, my important duties have given me so much license that when, as I am talking to the Pope, I put this old felt hat nonchalantly on my head, and talk to him very frankly, but even for that he does not kill me; on the contrary, he has given me a livelihood."

Though Pope Paul was an indulgent master, Michelangelo resented anyone hovering over him while he worked. "[E]ven his Holiness annoys and wearies me," he confessed to Holanda, "when at times he talks to me and asks me somewhat roughly why do I not come to see him, for I believe that I serve him better in not going when he asks me, little needing me, when I wish to work for him in my house; and I tell him that, as Michel Angelo, I serve him more thus than by standing before him all day, as others do."

Paul insisted on his prerogatives in important matters, but he was shrewd enough to know how far a small act of kindness could go in setting Michelangelo's suspicious mind at ease. Shortly after his accession, he made a pilgrimage to the artist's house on the Macel de' Corvi, accompanied by an entourage of ten cardinals. In a city where the coin of papal favor was a currency more valuable than gold, such a public display of favor went a long way toward restoring the credit he'd lost over Julius's tomb.

The first item on the pope's agenda was to complete the great project

* The scudo was a new coin minted by the papacy that replaced, and was roughly equal in value to, the gold ducat. Half of the salary was supposed to come from the receipts from a ferry over the Po at Piacenza, but Michelangelo had great difficulty collecting what had been promised from the local lord.

Clement had proposed to Michelangelo two years earlier during their meeting in San Miniato al Tedesco. As originally conceived by Clement, the plan was to paint two frescoes for the Sistine Chapel: on the entrance wall to the east, *The Fall of the Rebellious Angels,* and on the western wall, where the altar stood, a *Resurrection.* Exactly how and why the plan evolved remains obscure, but, as often seemed to happen with Clement, he apparently reversed course in midstream, proposing instead a single monumental fresco for the altar wall on a theme whose cosmic scope made it a fitting companion to the story of Creation overhead. At some point in the months before his death, he instructed Michelangelo to paint perhaps the most difficult scene in all religious art: a vast end-of-times panorama, showing the ultimate fate of the universe whose birth the artist had rendered so powerfully two decades earlier.

There is no proof that Michelangelo was the first to propose the new subject, but it is so thoroughly in keeping with his approach—reflecting both his vaunting ambition and his taste for tragic grandeur—that it seems likely he was involved in the decision. His natural inclination was to expand the scope of any commission, as in the case of the Sistine Ceiling, where he replaced the Twelve Apostles proposed by Julius with the epic story of Creation, or the *David,* which seemed to demand a site more prominent than the one originally assigned. Substituting the somber *Last Judgment* for the hopeful *Resurrection* sent a clear signal that the princes of the Church were attuned to the mood of a people still traumatized by the horrors they'd endured. Unflinching in its savagery, Michelangelo's apocalyptic masterpiece gave grim comfort by assuring the victims that in the end justice would be done. His vision is dark—anything less would have struck a false note—but those who contemplated the terrifying spectacle he conjured had the satisfaction of knowing that however out of joint the world appeared, all would be set right at the end of times.

II. ANGELS WITH LOUD TRUMPETS

In April 1535 the serenity of the Sistine Chapel was disturbed once again by the tramp of clogs, the clang of hammers, and the whine of saws, as work-

ers began erecting the scaffolding on the western wall. A short time later the plasterers arrived, sending up thick clouds of dust that caught in the throat and settled on the silk vestments of the dignitaries assembled for the daily Mass.

The pope assigned the task of preparing the wall to Michelangelo's long-time ally Sebastiano del Piombo. For the past decade he had enjoyed a comfortable if not particularly productive career, supplementing his income from commissions by serving as keeper of the seal for the pope.* Though to all appearances relations between Michelangelo and the Venetian-born painter had remained civil, they no longer worked hand in glove as they had in the days when the competition with Raphael had drawn them together to defeat a common enemy.

The truth is that their relationship had been born of expedience rather than any deep sympathy, a fact that became apparent immediately following Raphael's sudden death at the age of thirty-seven. To Sebastiano in particular, this seemed less like a tragedy than an opportunity. Hoping to profit from Michelangelo's influence in the Vatican, he dashed a letter off to his friend in Florence: "I'll briefly fill you in on the situation regarding the painting of the pope's chambers," he wrote. "Raphael's boys are boasting greatly, and propose to do them in oils. I beg you to remember me and to recommend me to the most reverend monsignor, and recall that I have acquitted myself well on similar projects, and I wish to tackle this one, since I will cause you no embarrassment, as I have not up till now." Michelangelo obliged his old ally, but the facetious tone of the letter he sent to the pope's advisor, Cardinal Bernardo Dovizi, seemed intended as much to pierce Sebastiano's pretensions as to secure his appointment. "Monsignor, I come to your Most Reverend Lordship not as a friend or servant, since I merit neither title, but as one who is low, poor, and foolish, to ask that Bastiano the Venetian be appointed, since Raphael is dead, some part of the work in the palace. But if it seems such a favor would be wasted on one such as I, it seems to me that in serving

* It is this position as *piombatore*—from the Italian word for "lead," from which the seals were made—that gave Sebastiano Luciani the name by which he is generally remembered.

fools there is still some pleasure, just as on occasion, for a change of pace, one might try onions for one who is used to mushrooms." When Sebastiano presented the letter, the cardinal merely laughed at him, calling it "a great joke" and informing him that the job had already been assigned to Raphael's former apprentices. Sebastiano grumbled that for the next week the letter made the rounds of the Vatican and "is almost the only topic of conversation and makes everyone laugh."

Over the following decade a superficial cordiality masked a growing estrangement, culminating in a final misunderstanding that turned former friends into bitter enemies. While Michelangelo worked on the cartoons, Sebastiano and his crew set to work preparing the altar wall, laying down a slick surface suitable for painting in oils rather than the rough coat of *arriccio* (plaster) needed for fresco. It's impossible to believe that the Venetian was unaware of the Florentine's long-standing aversion to oil painting. It's also impossible to believe that Michelangelo had no idea what was going on in the Chapel in his absence. His failure to raise an objection at the beginning seems like classic passive-aggressive behavior. Only after Sebastiano had completed the task and removed the scaffolding did Michelangelo make his feelings known, but once he got going, he made up for lost time. Saying that oil painting was only "for lazy people and women," Michelangelo demanded the whole wall be removed.

Having humiliated his former comrade, Michelangelo took over the preparations himself, fretting over every detail as was his wont. First, he demolished Sebastiano's work. Then, working with a mason named Maestro Giovanni Fachino, he rebuilt the wall using thin bricks specially made for the purpose. The wall's most unusual feature is that it slopes inward as it rises, so that the top projects eleven inches over the bottom. Vasari claims that this was done to ensure that dirt and smoke from the candles on the altar would not collect on the surface of the fresco but, as Michelangelo was surely aware, the unusual construction would actually have the opposite effect.* It seems instead that Michelangelo, always sensitive to the

* In 1547 the pope created a new position of guardian and cleaner of the frescoes of the Sistine and Pauline chapels, "to clean well and keep clean the pictures of the vault from

optical and psychological impact of a given form, wanted to increase the dramatic impact of his monumental fresco by inducing in the viewer the sensation of being enveloped by looming armies of the damned and legions of the blessed. Like the top-heavy architectural forms of the New Sacristy, the canted wall of *The Last Judgment* encourages a vague feeling of disquiet as the elect assemble overhead in teetering, vertiginous cohorts, while the damned plunge precipitously to their doom.

Preparing the Sistine Chapel to receive his latest masterpiece involved a certain amount of creative destruction. From a liturgical point of view, the altar wall contained the most important image in the chapel: Perugino's *Assumption of the Virgin,* the sacred event to which the shrine was dedicated. Above this iconic image were two more paintings by Raphael's master, one depicting the birth of Jesus and the other the discovery of Moses among the bulrushes, the starting point for each of the narrative series along the room's main axis. Michelangelo may have taken a grim satisfaction in destroying three important works by an artist with whom he had quarreled in the past. Many years earlier, Vasari recounts, the older Perugino had been jealous of the upstart Florentine, "and seeing the greatness of his own name . . . being obscured, he was ever seeking to wound his fellow-workers with biting words. For this reason, besides certain insults aimed at him by the craftsmen, he had only himself to blame when Michelangelo told him in public that he was a clumsy fool in his art. But Pietro being unable to swallow such an affront, they both appeared before the Tribunal of Eight, where Pietro came off with little honor."

But if Michelangelo had few regrets about demolishing the work of Raphael's teacher, at least he was an equal-opportunity vandal. Above Perugino's panels, to either side of the magnificent *Jonah,* were two lunettes by Michelangelo himself depicting the ancestors of Christ. These too were slated for destruction to make way for the new composition. In fact, an early

dust and other defilements and to preserve them from smoke of the lights which ascend in both chapels during the performance of the divine offices." (See George Bull, *Michelangelo: A Biography,* 339.) The first man to hold the position was Michelangelo's assistant Urbino.

sketch indicates that Michelangelo had originally intended to retain Perugino's *Assumption,* but he quickly rejected this compromise as unworkable. In the end, he was determined to eliminate anything that would disturb the unity of the image he had in mind.

Michelangelo began painting in April or May of 1536, beginning at the top right-hand corner and working his way down the wall in alternating bands. Despite the great physical labor involved in covering the immense surface, Michelangelo did almost all the work himself, aided only by his trusted assistant Urbino, who prepared the *intonaco* (smooth plaster), ground his colors, and tried his hand at a few of the minor figures.

Francesco d'Amadore, known as Urbino, had been with Michelangelo since about 1530, when Antonio Mini left his service to seek fame and fortune in France. While Michelangelo's relations with his peers were almost always marred by jealousy, he was often kind to those who served under him, as long as they were thoroughly devoted and demonstrated at least a minimal competence. When Mini departed for France, Michelangelo gave him a number of valuable drawings as well as the painting of *Leda and the Swan* (originally commissioned by the Duke of Ferrara), which Mini sold to earn enough to live on while he got on his feet, an example of the kind of generosity Michelangelo was capable of when he didn't feel threatened.*

Taking a job with the workaholic Michelangelo was not for the timid. He drove himself hard, and his employees were expected to show the same zeal and indifference to creature comforts as he did. Fortunately, Urbino, who was about eighteen when he entered the great man's service, was devoted to his master, and Michelangelo repaid his loyalty in kind, urging the pope to provide him with a comfortable salary and nursing him when he was ill. The strength of Michelangelo's attachment is shown by the fact that he remained at Urbino's bedside during what proved to be his final illness in 1555. His death was a severe blow to the artist, who had come to rely on him. "I must tell you," Michelangelo wrote to his nephew,

* Like most of Michelangelo's disciples, however, Mini was more loyal than able. His attempt to set up as an independent master was an abject failure, and he died only a few years after leaving for France.

that last night, the third day of December at 9 o'clock, Francesco, called Urbino, passed from this life to my intense grief, leaving me so stricken and troubled that it would have been more easeful to die with him, because of the love I bore him, which he merited no less; for he was a fine man, full of loyalty and devotion; so that owing to his death I now seem to be lifeless myself and can find no peace.

Even after his death Michelangelo continued to repay Urbino for his years of service by providing handsomely for his widow, Cornelia, and their two children.

Nor was Urbino the only one to benefit from Michelangelo's benevolence. He was unfailingly generous toward the poor, constantly reminding his nephew Lionardo to donate a portion of the money he sent him to various charitable organizations in his native Florence. "As to the almsgiving," Michelangelo reminded him, "it seems to me that you're too lax. If you do not give of my money for the soul of your father, still less will you give of your own." Significantly, one of his greatest concerns was to provide dowries for the daughters of destitute noblemen who would otherwise be unable to marry someone of their own class—a form of charity that speaks to his own fears of downward social mobility.

Michelangelo's sympathy for the humble was heartfelt and, as already noted, he often seemed most comfortable in the company of lowly workers. After his father's death Michelangelo worried over the fate of Lodovico's longtime housekeeper and was deeply distressed when he got word of her passing: "The news of Mona Margherita's death has been a great grief to me," he wrote to Lionardo, "more so than if she had been my sister—for she was a good woman; and because she grew old in our service and because my father commended her to my care, God is my witness that I intended before long to make some provision for her." This warmth stands in marked contrast to his stormy relations with colleagues or those higher up on the social scale. While he claimed to belong to society's elite, it was among the rude *scarpellini* and household servants that he felt most comfortable and that his human kindness could find an outlet.

Though *The Last Judgment* was to prove his most controversial work,

its execution proceeded without the squabbles and crises that so often undermined his major commissions. During the casting of the bronze statue of Julius in Bologna and while painting the Sistine Ceiling, Michelangelo employed a small team of assistants. In each case rapid turnover and public spats revealed tensions in the workplace. Even less satisfactory were conditions at San Lorenzo and the quarries where he supervised large crews whose unreliability forced him to waste valuable time and energy. He much preferred to work alone, where nothing distracted him from his single-minded purpose, or with a single dedicated servant who understood his needs and never questioned his decisions. Despite the demanding nature of this latest project, the arrangement proved efficient. Urbino could be counted on to carry out his master's wishes without complaint, providing another set of hands while subordinating his will and artistic personality to his master.

Also contributing to the efficiency of the operation was the fact that Michelangelo was able to purchase whatever materials he needed through the papal treasury. This was particularly important because the huge expanse of blue sky demanded large quantities of ultramarine, a costly pigment made from pulverized lapis lazuli. While working for Pope Julius, Michelangelo often had to pay out of pocket and then beg for reimbursement from the treasurer, but now Jacopo Meleghino, Commissioner of Papal Works, supplied him with everything he needed.

Once the altar wall had been remade to Michelangelo's specifications, he and Urbino worked rapidly from cartoons prepared by the master in his studio. Many of the secondary figures reflect the freedom achieved in the final stages of the ceiling, where he captured the essentials of a pose in a few vigorous sweeps of the loaded brush. Even more than in that earlier work, he seems compelled to show the human form in every possible (and many an impossible) attitude and from every point of view. Radical foreshortenings and telescoping perspectives show how much he had learned from painting the ceiling, and while many contemporaries regarded these contortions as artificial, they serve an important expressive function, conveying the disorienting effect of the Apocalypse when all familiar landmarks will be swept away and even the laws of physics no longer apply.

Michelangelo worked on the fresco for five years, but only 449 *giornate* were required to cover almost 2,000 square feet with more than 400 figures—a remarkable pace maintained by an artist now in his sixties. The one major interruption came near the end of the campaign, in the summer of 1541, when Michelangelo hurt his leg falling from the scaffolding. Despite the severity of the injury, he refused medical care and might well have died had his friend the physician Maestro Baccio Rontini not forced his way into Michelangelo's house, where he discovered the artist "in a desperate state." Refusing to leave his bedside until he was cured, Rontini nursed him back to health. The impact of the accident on the finished product can be observed in some of the figures in the lower left-hand portion of the fresco, where the diminished quality of the drawing betrays the hand of the loyal but mediocre Urbino.

If the pigments he employed in painting *The Last Judgment* were expensive, he required fewer of them than he had when painting the ceiling. The stripped-down palette Michelangelo now employed distinguishes it from his prior work in the chapel and reflects the dualism inherent in the theme. At the End of Time complexity collapses and the universe is reduced to either/or, saved or damned; there is little nuance, no in-between. The Sistine Ceiling chronicles a woeful tale of decline, but one that is filled with scenic incident and moments of incandescent triumph. *The Last Judgment,* by contrast, is reductive, distilling all human history into a single critical moment. Michelangelo builds the fresco around a dominant contrast between cold blue sky and the warm reddish-brown flesh tone of the figures. Gone are those pastel hues—lavender, turquoise, mint, and pale yellow—that had imparted a shimmering delicacy to the cosmic drama of the ceiling.* The mood is now starker, more somber; the limpid morning light of Creation has been replaced by harsh sunset hues, as the unforgiving shafts of a dying sun cause naked flesh to stand out in bold relief against a deepening firmament.

* Many of the brighter notes we see in *The Last Judgment* are found in the garments—for instance, the lime green of St. Catherine's robe—added by later artists to cover up the scandalous nudity.

In fact, Michelangelo's reductive approach to painting *The Last Judg-ment* precisely reverses the expansive one he had deployed in painting the ceiling. Changes in organization, scale, and mood all signal rupture rather than continuity with that earlier campaign. There is no use, he seems to say, pretending that nothing has happened in the two and a half decades that have intervened between then and now. Both he and his audience have been chastened by experience, seared by the suffering they have witnessed. God's Creation feels more like a curse than a blessing, and we await the Final Days with a mix of dread and expectation.

For all its raw emotional power, the Sistine Ceiling is didactic, a discursive narrative laid out in multiple chapters, each commented upon by encircling images that tease out hidden meanings. Confronted with the awkward, com-partmentalized layout of the vault, Michelangelo made a virtue of necessity, adding his own trompe l'oeil architecture that provided a visual and con-ceptual framework to tame the explosiveness of God's fecund imagination. Faced with a similarly fragmented field on the altar wall, Michelangelo went in the opposite direction, eliminating anything that would interrupt the singularity of his vision. While the story of Creation unfolds in time, like a growing organism sprouting multiple narrative tendrils, *The Last Judgment* is a study in compression. Everything is stripped down to bare essentials, which to Michelangelo is nothing more or less than the human form in all its variety and tragic nobility.

Instead of inhabiting a built environment, the souls in *The Last Judgment are* the architecture. "He opened out the way to facility in this art in its prin-cipal province," Vasari wrote of the fresco, "which is the human body, and, attend[ed] to this single object. . . ." In Francesco de Holanda's *Dialogues,* Michelangelo makes a similar point. "Excellent painting imitates the works of God," he says, "and the noblest painting imitates his noblest work, the human figure. . . ." In the end, Man becomes not merely the measure of all things, as the Greek philosopher Protagoras claimed; he is (almost literally) the *only* thing, supporting the vault of heaven—and bearing the entire bur-den of meaning—on his strong back.

Not only is *The Last Judgment* painfully compressed, it seems full to burst-ing, as if about to spill out into our space. In the ceiling, multiple layers stand

between us and the site of God's immanence; in *The Last Judgment,* all barriers disappear. Even the decorative frame—a traditional Renaissance device that creates the illusion that we are looking through a window onto a three-dimensional space beyond—has been eliminated in order to provide the viewer with an experience as unmediated as possible. On the right edge of the scene, Dismas, the good thief of the Crucifixion, appears to rest his cross on one of the actual cornices that run along the walls of the chapel, heightening the illusion that the space of the painting is continuous with ours. Nothing stands between us and Christ's righteous anger. The earlier cataclysm of the Flood pales in comparison to the ultimate catastrophe of the Apocalypse; no lawyerly covenant will save us. Even the ground beneath our feet dissolves as we are caught up in the storm. We can no longer find our proper place in space or time, since both have ceased to exist, and, torn between hope and fear, we face the Supreme Judge naked and alone, deprived of our works, stripped of our adornments, tumbling helplessly in the void.

Belief in an end time when all wrongs would be righted, the virtuous rewarded, and the wicked punished, is central to Christian eschatology. References to such a decisive moment are scattered throughout the Bible, including this passage from the Gospel of Matthew that provided theologians with much of their material and artists with much of their imagery:

> [T]he sun will be darkened, the moon will lose its brightness, the stars will fall from the sky and the powers of heaven will be shaken. And then the sign of the Son of Man will appear in heaven; then too all the peoples of the earth will beat their breasts; and they will see the Son of Man coming on the clouds of heaven with power and great glory. And he will send his angels with a loud trumpet to gather his chosen from the four winds, from one end of heaven to the other.

In Byzantine churches, a mosaic of the Last Judgment often lined the interior of the dome; in Romanesque and Gothic basilicas the scene was often carved on the tympanum above the door, located, appropriately enough, at the western entrance, in the direction of the setting sun. Wherever it was

situated, it served as a reminder to the faithful that history unfolded according to a divine plan and that each would have to answer for his sins.

Despite the rich dramatic possibilities, medieval interpretations tended to be highly schematic, parceling out the blessed and the damned in neat little rows, each assigned a specific place in the hierarchy according to merit. There was no attempt to portray the Last Judgment as an event taking place at a particular moment in time, much less that it was a calamitous rupture in the fabric of Creation. Instead, the Last Judgment presented a diagram of a well-ordered universe in which everything had its proper place in God's eternal scheme.

One of the best examples of this approach—and one with which Michelangelo was intimately familiar—is the thirteenth-century mosaic on the interior of the dome of Florence's Baptistery. Here Christ sits enthroned in a circular mandorla, a distant figure of Buddha-like serenity. To either side are angelic choirs, along with the Twelve Apostles (the so-called Deësis group that mediates between the earthly and heavenly realms), a host of martyrs, and various degrees of the elect. The damned are confined to the lower right (Christ's left), their bodies restored just in time for them to endure an eternity of abuse at the hands of their demonic captors, including a giant horned Satan who feeds these unfortunates into his gaping maw. Except for a single angel tooting his horn, there is nothing to indicate that we are witnessing a cataclysmic event. Indeed, everything about the mosaic, from the gleaming gold background to the static poses to the orderly arrangement of saints and sinners, indicates that this is a representation of the universe as it is, as it was, as it will always be, not a moment of crisis.

These earlier versions tend to be not only static but strictly hierarchical. Frozen in time, they are also rigidly stratified, perpetuating in the hereafter social distinctions that were already present in the world and that were the hallmark of a well-governed kingdom; each had a role to play and everyone knew his place. Christ is nothing if not meticulous, assaying the various degrees of virtue or vice with scientific precision. Hell tends to be more democratic and far messier than heaven, with sinners jumbled about higgledy-piggledy, as if righteousness were tied to order and sin to chaos.

In the early years of the fourteenth century, the painter Giotto reimagined

the didactic symbolism of sacred painting in terms of events taking place in actual space and unfolding in real time. His protagonists do not simply present themselves to the viewers as ideal, unchanging forms; they embrace, they quarrel, they react to one another like real men and women, performing the sacred drama like actors on a stage. But even this revolutionary artist was unable to break free from convention when it came to depicting the End of Time. His *Last Judgment* in the Scrovegni Chapel in Padua displays most of the medieval formulas, including a stratification that grows ever more rigid as we ascend toward the heavenly realms.

Taking Giotto as their point of departure, however, Renaissance artists reconceived the Last Judgment as an event unfolding in time rather than as a static pictograph encoding the eternal structure of the universe. Luca Signorelli's magnificent frescoes in the Cathedral of Orvieto are the most accomplished Renaissance treatment before Michelangelo tackled the subject, but even he lays out the narrative piecemeal, deploying multiple panels, each telling a part of a multivalent narrative, much as Michelangelo had told the story of Creation on the Sistine Ceiling.* Thus the saved and the damned are depicted on separate walls, while the resurrection of the dead occupies a third—all of which tends to dissipate dramatic impact. Fear and hope occupy separate zones; the lost and the saved are segregated populations, each indifferent to the other's fate.

In fact, the Last Judgment as a subject had faded in popularity in the fifteenth and early sixteenth centuries. The Renaissance Church found life on earth too pleasant to be enamored of Apocalyptic visions, and artists who excelled at making sacred dramas come alive before the astonished eyes of the viewer were on less sure ground when tackling the End of Time. The theme was too vast, too distant from everyday experience, to be captured in the more realistic idiom of the day. Perhaps the most imaginative attempt at

* Michelangelo knew the frescoes well, and even incorporated a few of Signorelli's figures in his own composition, particularly in the lower right where the damned are being dragged away by various demons. Vasari notes Michelangelo's debt to his predecessor: "I do not marvel that the works of Luca were ever very highly extolled by Michelangelo, nor that in certain parts of his divine Judgment . . . he should have availed himself in some measure of the inventions of Luca. . . ." (*Lives*, I, 612.)

translating the supernatural event into the language of the Renaissance came in a surprising medium and from a surprising source—a small medallion cast by Michelangelo's old teacher from Lorenzo's sculpture garden, Bertoldo di Giovanni. Michelangelo may well have had this modest image in the back of his mind when it came time to formulate his own, more monumental version, since his Christ bears a more-than-passing resemblance to the athletic, striding figure Bertoldo conjured in bronze.

But nothing that came before can prepare us for the thunderous impact of Michelangelo's fresco. Covering a wall 66 feet high and half as wide, it owes its power as much to temporal compression as spatial expansion. Michelangelo does not arrange his composition in orderly tiers or distribute the action among various panels. Instead, he crams everything into a single unforgettable image, a vast whirlpool in space as clamorous and startling as the trumpet blast that awakens the dead.

III. THE FLAYED MAN

Michelangelo's *Last Judgment* is the most prominent monument to the tumultuous age that replaced the complacent optimism of the High Renaissance; it registers the dislocations that came about as universal but lightly held beliefs were challenged by sectarians driven by narrow dogmatism. Just as the Medici tombs enshrined the disquiet that accompanied the destruction of the old republic, *The Last Judgment* registered the even more disruptive religious upheaval that followed in the wake of Luther's revolt.

As old certainties were challenged by both sides in the religious wars, the medieval version of the Last Judgment as an orderly judicial proceeding seemed inadequate. In Michelangelo's conception, the End of Time is cataclysmic and chaotic. The saved and the damned, the heavenly choirs and the demonic hosts, no longer inhabit separate realms but are all caught up in the same irresistible maelstrom. Michelangelo presents us with a metaphysical battleground where the fate of many is still uncertain. All decorum is lost as souls struggle like victims of a shipwreck clawing desperately for a place in the lifeboats. Some are pulled down by demons who grab any body part that presents itself, including, in one particularly vivid image, a man who is con-

veyed to the infernal regions by his testicles. But even the ascent to heaven
involves backbreaking labor as the saved are hoisted up by angels whose
muscles bulge with the strain. One individual is pulled in both directions at
once, from below by a serpent who coils around his ankles, from above by an
angel who reaches under his armpits in a desperate attempt to win one more
soul for the celestial realm.

Michelangelo does not present a model of a perfected universe but one
that is still reeling. At some point, no doubt, the universe will settle down as
each finds his or her proper place within God's scheme, but not yet. Michel-
angelo's heaven is every bit as frenetic as the hell conceived by earlier artists,
filled with murmuring, disoriented crowds. The elect embrace, as if con-
gratulating each other on their close escape, but no one is secure. Many seem
surprised to be here, uncertain of their status, or perhaps they are distraught
about those they left behind. Even the saints appear to be gripped by fear,
while the damned have yet to plumb the full depths of their despair.

Near the center of this human vortex is Jesus Christ, who strides forward
with certain purpose, no longer the impassive magistrate but a powerful fig-
ure who sets the whirlwind in motion, damning with one hand while raising
up the elect with the other.* His Herculean physique—so different from the
serene, disembodied souls of the medieval imagination—is commensurate
with the enormity of the task. In Michelangelo's interpretation, dispens-
ing justice is not simply a matter of assigning each man and woman to the
proper sphere, but rather a violent intervention in a world resistant to God's
will. Christ is as nimble and menacing as a boxer in the ring, a metaphysical
warrior every bit as belligerent as the God who unleashed the Flood.

Jesus Christ is not only the pivotal figure around which the universe
seems to turn but also the most unexpected. Abandoning centuries of prec-
edent, Michelangelo depicts him as a young beardless man who bears an un-
canny resemblance to the *Apollo Belvedere* (a statue he knew well since it was
part of the Vatican collection). The analogy is not as farfetched as it might

* Michelangelo defies tradition by having Christ damn with his right hand while sav-
ing with his left, which also gestures to the wound on his side, indicating the sacrifice
through which mankind was redeemed.

appear. In the early days of Christianity, artists faced with giving visual form to their creed fell back on familiar precedents borrowed from their pagan counterparts. Depicting Jesus in the guise of the pagan sun god was particularly apt, since Christ in the Gospels is often compared to the sun and his teachings to the rays that illuminate the world. In returning to this ancient formula, Michelangelo plumbed the roots of his faith to recover an image of the Savior not exhausted by overuse.

Michelangelo strengthens this connection by surrounding Jesus in an aureole of light, the only sign of his supernatural power.* Despite the superficial resemblance, however, Michelangelo's Christ is more Zeus than Apollo. He is an angry god of storms, hurler of thunderbolts. Michelangelo has transformed Apollo's effortless grace into a pose of awesome power; his dainty step becomes a propulsive stride. The bland expression of the pagan deity becomes the stern frown of an imperious lord, filled with righteous anger at those who have spurned the grace they've been offered.

Compared to his superhuman vigor, Mary appears remarkably ineffectual. Seated at the side of Jesus, a delicate flower wilting in the volcanic heat radiated by her companion, the two form one of those mismatched, uncomprehending pairs so common in Michelangelo's treatment of the Virgin and her Son. Originally, Michelangelo had contemplated a very different composition. Early studies for *The Last Judgment* show Mary actively intervening on behalf of the condemned, her arms outstretched in a gesture of supplication. In the final version she no longer plays her traditional role of intercessor pleading like an attorney on behalf of her client. Instead, she turns away, bowing her head, unable to watch the unfolding horror but apparently resigned to the harsh verdict her Son pronounces. By changing the pose of this one figure, Michelangelo has tipped the scales: mercy no longer

* More farfetched are theories linking Michelangelo's paintings with the new heliocentric theory of the solar system, which, while it had not yet been published, was beginning to be discussed in learned circles, including on one occasion in the Vatican itself. (See especially Shrimplin-Evangelidis, "Sun-Symbolism and Cosmology in Michelangelo's *Last Judgment*," *Sixteenth Century Journal*, vol. 21, no. 4 [Winter 1990]: 607–44.) There is little reason to suppose Michelangelo would have been particularly interested in such questions or what they might have contributed to his theological message.

tempers justice, and forgiveness retreats in the face of divine rage. Below her, the angels hold up two books, one inscribed with the names of the saved, the other with the names of the damned. It is a sign of the times, and of Michelangelo's own state of mind, that the book of the damned is a far heftier tome.

Mary's transformation from impassioned advocate to passive mourner suggests Michelangelo's pessimism about his own prospects for salvation. "So accustomed am I to sin, that heaven has denied me the grace that falls in every place," he confesses. Michelangelo shows us what awaits a man who closes his heart to God in the despairing figure who covers his face in his hands, just above the image of Charon herding the damned to the infernal regions by beating them with his oar. Doubled over in pain, he is a tragic icon every bit as searing as the protagonist of Munch's *Scream*.

This haunting figure seems to stand for all those of weak or wavering faith, among whom Michelangelo must have included himself. His own faith, though sincere, was uneasy and plagued by guilt. In both image and word he expresses his longing for communion with the divine, but this desire is constantly thwarted by feelings of moral inadequacy, just as the joy he took in the beauty of the human body was marred by his belief that the flesh was a prison from which the soul yearned to escape. He evokes the depth of his torment in one of the fresco's most memorable images: the flayed skin of St. Bartholomew to which he has imparted his own distinctive features. The shapeless, sagging form offers a parody of old age, an unsparing self-portrait he repeats in verse a few years later when he describes himself as "the pulp in fruit compacted by its peel" and chronicles in gory detail the repulsive sights and smells of his decrepit body.

But this grotesque image is not merely a confession of self-loathing. Michelangelo had often used the metaphor of a discarded pelt to signal the soul's release from the degradation of carnal existence. He returns to the image in a sonnet for Cavalieri, where it now takes on erotic overtones:

> *How I wish, my lord, that I could clothe*
> *thy living form in my flayed skin,*
> *like a snake who sheds his scales upon a rock*
> *and, dying, ascends to higher life.*

In each case, the flayed skin represents a kind of rebirth, either spiritual or sexual, embracing the Neoplatonic conception of the soul that, impelled by love, must discard its mortal ballast before it can begin its ascent toward God.*

In the context of the Last Judgment, however, the idea that the spirit becomes whole only after it leaves the body behind runs into serious theological difficulties. Though philosophers like Marsilio Ficino tried to conceal the contradiction, the Platonic insistence that our physical form is perishable while only the immaterial soul endures, flies in the face of Christian teaching that we will be resurrected in our (perfected) bodies. "I believe that my Redeemer lives," proclaims the Office for the Dead, "and that on the Last Day I shall rise from the earth, *and in my flesh* I shall see God, my Savior." At the End of Time, each of us will be joined to the body he or she will inhabit throughout eternity, a ghoulish process that Michelangelo has portrayed in the bottom left-hand corner of his fresco.

By including this grotesque self-portrait, Michelangelo may wish to signal his rejection of the sterile intellectualism of his Neoplatonic past in favor of an emotionally charged faith. This interpretation is reinforced by the fact that he depicts the blessed not as ethereal phantoms but as figures whose robust physicality mocks the discarded husk he's become. Stretched like taffy between two metaphysical poles, his fate is still undecided. He places himself (physically at least) among the elect, but he is unique among them in not inhabiting his resurrected body. He has cast off his bodily form but has yet to win the kingdom of heaven. Seduced by beauty but racked by guilt, yearning for God's presence in his life but aware of his own unworthiness, proud of his achievement but convinced that worldly ambition is a sin, Michelangelo presents himself as a mass of contradictions that not even the Lord Himself can sort out.

In his *Dialogues,* Francisco de Holanda paints a picture of Michelangelo's life in these years that seems at odds with the darker, more conflicted story

* In *The Phaedo,* Socrates says: "If we're ever going to know anything purely, we must get rid of the body, and must view the objects themselves with the soul by itself. . . ."

that emerges from his own art and writings. Of course, it would be a mistake to take everything Holanda says at face value, since his intent was to portray an Ideal rather than to offer a biography of a particular man, but his depiction at least has the virtue of being based on firsthand knowledge. Set in the Convent of San Silvestro, near Michelangelo's home in Macel de' Corvi, the *Dialogues* chronicle a series of conversations between Holanda, Michelangelo, and a couple of Michelangelo's highborn friends, Vittoria Colonna—the Marchesa of Pescara—and a Sienese nobleman named Messer Lattanzio Tolomei.

The artist that Holanda presents to us is not the irascible, antisocial terror so often caricatured by his contemporaries, but an urbane man about town: a bit temperamental perhaps, but courteous, kind, and thoughtful. Busy with his projects for the pope, the great man still takes time out to meet with friends, often stopping by the gardens of the convent, where he attends pious lectures and discusses weighty matters of philosophy and artistic theory. Not only is Michelangelo thoroughly at ease in this aristocratic company, but he is accepted as a social equal, a gentleman who also happens to be a genius.

The polished character Holanda presents is not entirely fictional, though his portrayal certainly contains an element of wishful thinking. Michelangelo had indeed mellowed over the years. With nothing left to prove, he no longer pursued his art with the single-minded fury of old or lashed out indiscriminately against rivals he feared were stealing his best ideas. In 1537, the year before Holanda himself arrived in the city, Michelangelo was named a citizen of Rome, a high honor for a foreigner and a mark of the universal esteem he now enjoyed. His famed *terribilità* was less in evidence as he transformed himself into the grand old man of Italian art.

But this is clearly an airbrushed portrait that softens his harsh edges and dresses his shabby figure in clothes more suitable to the refined circles in which he now traveled. While Holanda acknowledges his hero's foibles, he insists that his eccentricities do not disqualify him from polite company. In fact, they are signs of his refined and sensitive nature. At one point Michelangelo addresses the issue head-on. "I wish to make a complaint against many persons," he declares,

on my own behalf and on behalf of painters of my temperament. . . . There
are many persons who maintain a thousand lies, and one is that painters are
eccentric and that their conversation is intolerable and harsh; they are only
human all the while, and thus fools and unreasonable persons consider them
fantastic and fanciful, allowing them with much difficulty the conditions nec-
essary to a painter. . . . painters are not in any way unsociable through pride,
but either because they find few pursuits equal to painting, or in order not to
corrupt themselves with useless conversation of idle people, and debase the
intellect from the lofty imaginations in which they are always absorbed.

To Vasari, Michelangelo expressed the same idea in blunter terms: "[I]t is
necessary that [he] who wishes to attend to studies of art flee company."

In presenting his more courtly version of the artist, Holanda completes
the task begun by Alberti a century earlier, removing the painter or sculptor
from the ranks of the lowly artisan and placing him among the respectable
citizens who work with their minds rather than their hands. Holanda wishes
to extol Michelangelo as a rare creature, absolved to some extent from con-
ventional expectations, while simultaneously dropping the names of his
wellborn friends in an effort to confirm his high status. This is not quite the
Romantic myth of the alienated genius brooding alone in his garret, but a
halfway point where the artist and society maintain an uneasy alliance, each
conferring upon the other a kind of legitimacy. Negotiating this delicate bal-
ance, Holanda stands the age-old prejudice against the uncouth painter or
dust-caked sculptor on its head, transforming the vice of social awkwardness
into the virtue of authenticity.

In Holanda's account, those who accuse Michelangelo of boorishness
mistake superficial manners for genuine feeling, which is the true mark of
a noble soul. In fact, as Michelangelo himself claims in another contempo-
rary dialogue—this one written by his friend Donato Giannotti—he shuns
small talk not out of an indifference to his fellow man but from an ardent
heart that is too full to traffic in meaningless encounters. "Whenever I see
someone who may have talent," he tells Giannotti, "I am bound to fall in love
with him, and I fall prey to him in such a manner that I am no longer my
own: I am all his. So if I were to have dinner with you, as you are all so well

endowed with talent and kindness, beyond that each one of you three has already robbed me of something, each one of those dining with me would take a part of me."

Reading Giannotti and Holanda allows us to watch as the legend overtakes the man. Their sanitized portrait of the sensitive but ultimately respectable citizen, cultivated and at ease in the most refined company, presented an acceptable alternative to the popular image of a misanthrope at war with everyone, including himself. The reality of his life in Rome during his final decades lay somewhere in between these two extremes. Though he continued to be consumed by work, Michelangelo was no longer living in squalid isolation. His letters and poems reveal an inner life far more tortured than the bland portrait Holanda presents, but they also provide ample evidence of a loyal circle of well-connected friends who looked after him and with whom he felt comfortable enough to share his most intimate thoughts.

Fame facilitated Michelangelo's entrée into Rome's elite, and financial security eased his daily stress. Having been born into poverty—and compounding this mistake by entering a profession that was still regarded as beneath the dignity of a gentleman—he had finally achieved a status that satisfied his own easily wounded pride. Even so, Michelangelo was always more comfortable among the rude *scarpellini* than in elegant salons. He himself provides a rather glum picture of his life in a letter of 1547, though this too should be taken with a grain of salt, since it was written as a defense against accusations that he was consorting with Florentine exiles plotting against the Medici regime. "[A]ll Rome knows what sort of life I lead, since I am always alone," he wrote pathetically. "I go out little and speak to no one, Florentines least of all. . . ."

The truth was that, like many men of genius, he was still too wrapped up in his art to make a congenial dining companion. He lacked that *sprezzatura*—the effortless grace—which Baldassare Castiglione in *The Book of the Courtier* praises as the mark of a true gentleman and that everyone admired in the author's good friend Raphael. Michelangelo's intensity was the opposite of aristocratic nonchalance. If he attracted a few devoted friends, it was due to the admiration his genius inspired rather than to social graces he never mastered.

• • •

For Michelangelo, fame proved to be a mixed blessing. While the greatest lords of Europe now usually treated him with the deference to which he felt entitled, he could not possibly keep up with their increasingly desperate pleas for some work, no matter how slight, from his hands. With the death of Leonardo in 1519 and Raphael a year later, his status as Europe's greatest living artist was secure.* Popes, dukes, and kings all vied for his services, to such an extent that he was forced to master the art of polite refusal, excusing himself with one great lord by citing his obligations to another. Demand was so great that even the king of France found himself thwarted. In 1546, Francis wrote to the artist expressing his "great desire" to have something from him, "praying you, if you have some excellent works already made at his arrival, to give them to [Francesco Primaticcio], with his paying you well. . . . And moreover, . . . that he cast copies of the *Risen Christ* and of the *Pietà*, so that I can decorate one of my many chapels with them, as things about which I have been assured are among the most exquisite and excellent of your art." But by now Michelangelo had become adept at hiding the sting of rejection beneath a bouquet of flattering words. "Sacred Majesty," he replied,

> I know not which is the greater, the favor or the wonder that Your Majesty
> should deign write to a man like me, and still further to request of him
> examples of his work, which are in no way worthy of Your Majesty's name. But
> such as they are, be it known to Your Majesty that for a long time I have desired
> to serve You, but have been unable to do so, because even in Italy I have not
> had sufficient opportunities to devote myself to my art. Now I am an old man
> and shall be engaged for some months on work for Pope [Paul]. But if, on its
> completion, a little of life remains to me, I will endeavor to put into effect the
> desire which, as I have said, I have had for a long time, that is to say to execute
> for Your Majesty a work in marble, in bronze and in painting.

* Even those who preferred Titian as a painter had to admit that Michelangelo's achievements as a sculptor and architect elevated the Florentine over his Venetian rival.

His fame guaranteed that not only his art but his private life were subject to sometimes uncomfortable scrutiny. The dangers of this higher profile are well illustrated by his rocky relations with the waspish Pietro Aretino, "the scourge of princes," who always had his finger to the wind and was eager to interject himself into any situation that would either earn him a profit or at least make him the center of attention. Before *The Last Judgment* was half complete, the writer was already hoping to capitalize on the attention it was receiving. "Now who would not be terrified to apply his brush to so awesome a subject?" he inquired of Michelangelo in September 1537:

> *I see an Antichrist in the midst of the rabble, with an appearance only conceivable by you. I see terror on the faces of all the living, I see the signs of the impending extinction of the sun, the moon and the stars. . . . I see Nature standing there to one side, full of terror, shrunken and barren in the decrepitude of old age. I see Time, withered and trembling. . . . Then I see the guardians of the infernal pit, who are dreadful to behold and who to the glory of the martyrs and the saints are taunting all the Caesars and Alexanders, who may have conquered the world but did not therefore conquer themselves. . . . I see the lights of Paradise and the furnaces of the abyss which pierce the shadows cast on the vault of the empyrean. . . .*

In his younger days Michelangelo might well have answered such a pompous, self-serving missive with a curt dismissal, but now he responded with a lighter touch:

> *Magnificent Messer Pietro, my lord and brother—The receipt of your letter has caused me at once both pleasure and regret. I was exceedingly pleased because it came from you, who are uniquely gifted among men, and yet I was also very regretful, because, having completed a large part of the composition, I cannot put your conception in hand, which is so perfect that, if the Day of Judgment were passed and you had seen it in person, your words could not have described it better.*
>
> *Now as to your writing about me, I not only say in reply that I should*

welcome it, but I entreat you to do so, since kings and emperors deem it the
highest honor to be mentioned by your pen. In the meantime, should I have
anything that might be to your taste, I offer it to you with all my heart.

In conclusion, do not, for the sake of seeing the painting I am doing, break
your resolve not to come to Rome, because that would be too much.

The gentle irony Michelangelo employs here, so different from the cutting tone he often used with his rivals, may reflect a genuine admiration. More likely, it stemmed from an understandable reluctance to offend someone whose sharp pen was usually deployed to wound those who crossed him.

In the end, Michelangelo's best efforts were not enough to keep the mercurial writer on his side. Aretino's about-face came in April 1544, after the artist politely refused his request for some drawings. "But why, O Lord," Aretino wrote plaintively, "do you not repay my constant devotion, I who revere your celestial quality, with a relic of one of those papers that will cost you so little? You can be certain that I would appreciate two scratches of carbon on a piece of paper more than all the cups and chains that this prince has ever bestowed upon me."

Like a rejected suitor, Aretino now turned on the man he had so recently labeled "celestial," assailing him at his weakest point when he speculated publicly that such gifts were reserved for "certain Gerards and Thomases"—a reference to Gherardo Perini and Tommaso de' Cavalieri, men who, the gossips assumed, shared Michelangelo's bed as well as his affections.

To be fair, Aretino's change of heart was not based solely on personal pique. Always quick to seize the moment, he knew he could salvage his own unsavory reputation by damaging the artist's. If the poet transformed himself in an instant from one of Michelangelo's most ardent admirers into his fiercest critic, it was less a matter of petty spite than opportunism. Aretino was quicker than Michelangelo to sense the winds of change that were sweeping across Europe, and while the artist was unable or unwilling to bend, the writer was only too happy to hoist his sails and ride the breeze.

IV. SPIRITUALI

By the time Aretino launched his attack, it took no great courage to take on the famous artist. Michelangelo's latest masterpiece, so highly anticipated before the fact, had been met with howls of protest when it was finally unveiled in October of 1541, and Aretino was merely adding his voice to an already mighty chorus.

The Last Judgment was presented to the public at a particularly fraught moment, when men and women on either side of the growing religious divide were primed to examine every text and representation for subtle theological messages, anxious to seize any weapon to attack their opponents and fearful of discovering any chink in their own armor. As a papal commission in the most sacred shrine in Christendom, the fresco was destined to attract particular scrutiny. Michelangelo's idiosyncratic approach to Scripture, which in quieter times might have provoked little comment, not only aroused the ire of Church officials, who suspected him of flirting with schismatic beliefs, but derision from critics of that same Church, who pointed to his latest work as evidence of an institution that had lost its moral compass.

Indeed, signs of trouble began even before the painting was finished. At some point—probably in 1539 or 1540, after upper portions of the fresco had been completed but before Michelangelo had populated the nether regions with the armies of the damned—Pope Paul visited the chapel accompanied by his master of ceremonies, Biagio da Cesena. While the pope was pleased with what he saw, the man tasked with maintaining decorum in the Vatican was shocked by the pervasive nudity. Not surprisingly, Michelangelo bridled at the suggestion he make any changes, dismissing Biagio as a hack with no understanding of art. Then, as a warning to philistines everywhere, he proceeded to paint the features of the prudish master of ceremonies onto Minos, the demon with ass's ears and a snake's tail who stands guard at the gates of hell.* When Biagio saw the unflattering portrait, he demanded the

* Michelangelo derives his image from Dante's famous description in *Inferno* V: "There stands Minos, horrible, snarling, examines their offenses at the entrance, judges and dispatches them according as he girds himself; I mean that when the ill-born soul comes

pope intervene on his behalf and instruct the artist to remove the offending image. But Paul, demonstrating once again his loyalty to the artist, merely joked that had Biagio been placed in purgatory, he might have been able to do something, but that since he had been placed in hell, he was unable to oblige.

Assembled dignitaries and a few select citizens of Rome got their first glimpse of Michelangelo's monumental fresco on All Saints Eve, 1541, twenty-nine years to the day since the ceiling was first unveiled to almost universal acclaim. Upon seeing the completed work for the first time, the pope was said to have fallen to his knees, exclaiming, "Lord, do not charge me with my sins when you come on the day of Judgment."

Others, however, were sharply critical. Many agreed with Biagio da Cesena that there was something unseemly about the display of so much naked flesh in a holy place, apparently forgetting the nudes that for decades had been frolicking above their heads with no sign of God's disapproval. Even Michelangelo's allies feared they were in danger of being drowned out by his detractors. "The work is of such beauty," wrote Nino Sernini, agent for Cardinal Ercole Gonzaga, who had asked him to procure a copy of the work, "that your excellency can imagine that there is no lack of those who condemn it. The very reverend Theatines [reactionary defenders of the faith] are the first to say that the nudes do not belong in such a place . . . although even in this [Michelangelo] has shown great consideration, for hardly ten figures of so great a number are seen as immodest. Others say he has made Christ beardless and too young, and that he does not have the appropriate majesty, and so there is no lack of talk." Typical of these critics was the anti-Lutheran preacher Fra Ambrogio Caterino, who simply dubbed the work "shameful."

These were the opening salvos in a campaign that would grow increasingly assertive over the years, ultimately leading to charges of impiety and

before him it confesses all, and that discerner of sins sees what is the place for it in Hell and encircles himself with his tail as many times as the grades he will have them sent down. Always before him is a crowd of them; they go each in turn to the judgment; they speak and hear and then are hurled below."

even heresy on the part of the artist. Had *The Last Judgment* been completed two or three decades earlier, it would have struck many as unconventional, perhaps even radical. No doubt it would have sparked conversation among the cognoscenti, who would have debated the artistic innovations Michelangelo had introduced, and perhaps even carping from the more conservative elements who generally disapproved of artists reinterpreting the sacred text in light of their own concerns. After all, that's how the public responded to the Sistine Ceiling, which was equally unconventional in its approach to Scripture.

But the outrage provoked by *The Last Judgment* was unprecedented. Michelangelo had set out in 1536 to paint a Renaissance masterpiece; emerging from the Chapel five years later, he found himself blinking in the dawn of a new age. The easygoing tolerance and worldly sophistication that had prevailed during the reigns of Julius II and Leo X had been replaced by a suspicion of anything that smacked of freethinking and a puritanical discomfort with the human body. As long as the Church had exclusive custody of the keys to the kingdom of heaven, its leaders took a relaxed stance toward artists' representations of sacred narratives, but once their monopoly was challenged by Luther and his followers, they demanded of the artists they conscripted the unquestioning obedience of soldiers engaged in a holy war.

The age of the Platonic Academy, in short, had become the age of the Inquisition. To make matters worse, *The Last Judgment* was unveiled only months after an attempted reconciliation between Protestants and Catholics in the imperial city of Regensburg had collapsed, devolving into mutual recrimination. Each side in the theological debate now closed ranks, more determined than ever to hew to strict interpretations of sacred text and to vilify anyone who deviated from the party line.* The very next year, Pope Paul established the Roman branch of the Inquisition (modeled on its notorious

* As early as 1536, Pope Paul had called for a general council to respond to the crisis precipitated by Luther and his followers to meet in the northern Italian city of Mantua. Delayed until 1547, largely due to disagreements between the emperor and the king of France, this became the famous Council of Trent, which set the stage for the Counter-Reformation and a resurgent Catholic Church.

Spanish predecessor) in order to define more sharply the tenets of the faith and root out anything that departed from it. Heading up the new body was Cardinal Caraffa, a man who once declared: "Even if my own father were a heretic, I would gather the wood to burn him." With men like Cardinal Caraffa in the ascendant, Michelangelo's highly individualistic approach to matters of faith was no longer acceptable.

Defenders of the faith like Cardinal Caraffa had cause for alarm. Michelangelo was not simply a passive witness to the momentous debates shaking the foundations of belief or the innocent victim of a new puritanism. Though he was never one to indulge in theological hairsplitting, he was deeply engaged in the great religious debates of the day, disturbed by the crisis consuming the Church but also intoxicated by the new spirituality transforming the inner lives of men and women on both sides of the divide. While superficially orthodox, his *Last Judgment* breathes the spirit of reform, embodying a yearning for a new relationship with God, one unmediated by priests, that eschews the safety of empty ritual in favor of an intense and unsettling embrace of the divine.

Michelangelo's conflicted response to the crisis mirrors the confusion of many in a time of profound dislocation. Consumed by guilt over his carnal urges and fierce ambition, he constantly strived to perfect his sinful nature. But for many years he had been alienated from conventional forms of religious observance. As a child of Florence, he'd felt the winds of reform blowing long before Luther's Ninety-Five Theses sounded like a thunderclap across Europe. And while he did not fully succumb to the blandishments of the fire-and-brimstone Savonarola, he was clearly attracted to his message of repentance. In the end, what prevented Michelangelo from joining the Piagnoni like his older brother Lionardo was not a lack of religious fervor but the preacher's disdain for the profession he practiced and that to him was as vital a source of spiritual sustenance as the sacraments.

Like many cultured men of his day, Michelangelo found himself tugged in opposite directions, seduced by the sensual, humanist strain within Renaissance culture, but also longing for a more personal relationship with God. When he first returned to Rome in 1534—during the period his passion for Cavalieri burned hottest—Michelangelo poured out his heart in a series of

drawings that were at once frankly sensual and pagan in their subject matter. Not surprisingly, as his passion for Cavalieri cooled and as his work on *The Last Judgment* began to dominate his thoughts, he set out once more on a spiritual journey from which he was sometimes distracted but never really abandoned.

His return to faith was nurtured by his friendship with the Marchesa of Pescara. Michelangelo probably first met Vittoria Colonna in the spring of 1536, while she was a resident at the Convent of San Silvestro. Vittoria was the daughter of one of the most exalted clans in Italy, the mighty Colonna of Rome, renowned for producing princes of the Church and mercenary generals in almost equal number. Following the death in 1525 of her husband, Francesco d'Ávalos, Marchese of Pescara, Vittoria had dedicated herself to a life of quiet contemplation, retiring to the convent, where she spent her days writing pious verses and studying with many of the foremost religious thinkers of the day.

By the time Michelangelo met her, the forty-six-year-old Vittoria was a beloved figure, renowned for her intelligence and revered for her goodness. Holanda describes her with only slight exaggeration as "one of the most illustrious and famous ladies in Italy and in all Europe . . . chaste yet beautiful, a Latin scholar, well-informed and with all the other parts of virtue and fairness to be praised in woman." Though fifteen years Michelangelo's junior, the great lady became something of a mother figure to a man who had few females to look up to in his life, a mentor and spiritual guide whose gentle nature exerted a calming influence on the often volcanic artist.

Like many sincere Catholics, the marchesa clung to the faith into which she was born while at the same time she was drawn to the Protestants' call for a more direct experience of God; she revered the Holy Church, but could not turn a blind eye to the corruption of a priesthood more interested in promoting its worldly status than saving souls. Neither she nor her spiritual mentors wished to break from the Church. Rather, they hoped that by adopting the simple faith of the Apostles they could save it from a collapse induced by internal rot.

Even before the catastrophic sack of Rome, Pope Hadrian acknowledged that the Church must accept some of the blame for the current fracturing

of Christendom. "God has permitted this persecution," he proclaimed, "because of the sins of mankind, especially of priests and prelates. . . . For our part, we pledge ourselves, that the Curia, perhaps the source of all evil, shall be wholly renovated." The disasters that plagued the reign of his successor only served to confirm this gloomy verdict. In 1536, Paul made common cause with the reformers when he instituted the Consilium de Emendanda Ecclesia (The Council on the Reform of the Church), naming as its head the devout Cardinal Gasparo Contarini.

But true reform was not simply a matter of rooting out corruption; a change of heart as well as of form was necessary before the Church would be able to meet its foes on the field of battle. In Italy, progressive Catholics like Contarini were known as the Spirituali. Many of them—including the Capuchin monk Fra Bernardino Ochino; Cardinal Reginald Pole,* cousin of King Henry VIII of England; and Pole's most famous disciple, Vittoria Colonna—were followers of the Spanish mystic Juan de Valdés. Like Luther himself, Valdés believed that grace was freely bestowed by God and could not be purchased through indulgences or even good works.

Luther's doctrine *sola fide,* justification by faith alone, challenged the Church by eliminating the elaborate machinery that allowed men and women to secure a place in heaven simply by purchasing indulgences or submitting to sacraments administered by a priest. In time, Luther's doctrine of justification by faith alone came to be viewed as a mortal threat to an institution that claimed to have received from Christ himself the "keys to the kingdom of heaven," but in these early days one could at least flirt with the dangerous belief while remaining a true son or daughter of the Church. *Del Beneficio di Gesù Crocifisso* (On the Blessings of Jesus Crucified)—written by a follower of Valdés, Fra Benedetto da Mantova—spread the doctrine of justification to the Catholic world, proclaiming: "The justice of Christ is sufficient to make us the Children of Grace, without any good works on our part. . . ."

Still, Vittoria and her fellow Spirituali had to walk a fine line, maintaining

* Condivi testifies to Michelangelo's intimacy with Cardinal Pole, "rare for his learning and singular goodness." (Condivi, 161.)

outward obedience to the Church while seeking a more direct experience of the divine.* As Cardinal Pole put it, she should "believe that she could only be saved by faith, but . . . act as if she could only be saved by works." Before attitudes hardened in the wake of the Council of Trent (1545–63), it seemed possible that the reformers and the papacy would find common ground.† Indeed, many had welcomed the election of the current pope, believing he shared their basic goals: "You have taken the name of Paul," they wrote. "We hope that you will imitate his charity. He was chosen as an instrument to carry the name of Christ long since forgotten among the heathen and by us the clergy, to heal our sickness, to unite Christ's sheep again in one fold, and to avert from our heads the wrath and already threatening vengeance of God."

Michelangelo was introduced to the doctrines of the Spirituali through his friendship with the marchesa. As he had done during the period of his infatuation with Cavalieri, Michelangelo memorialized his intimacy in both verse and image. While his desire for Cavalieri had wrung from him passionate sonnets and drawings filled with erotically charged pagan imagery, his relationship with the noble Vittoria elicited only pious expressions. Despite the best attempts of biographers (including Condivi) to manufacture a romantic interest between the artist and the chaste noblewoman, there was never the least hint of a sexual attraction. There is no doubt that Michelangelo cared for her deeply and that she returned his feelings, but nothing suggests anything more than an affection between two people united by mutual admiration.

Their friendship was sealed early on by an exchange of gifts. "Before taking possession, Signora," Michelangelo wrote upon receiving from her some

* As early as 1542, Fra Bernardino Ochino was forced to flee to Calvinist Geneva to avoid being hauled up in front of the Inquisition on charges of heresy, and in 1549, the *Beneficio* was placed on the Church's *Index of Prohibited Books*.
† The Council of Trent ultimately declared: "If anyone says that man's free will, moved and stimulated by God, cannot cooperate at all by giving its assent to God when he stimulates and calls him . . . and that he cannot dissent, if he so wills, but like an inanimate creature is utterly inert and passive, let him be anathema." (Quoted in George Bull, *Michelangelo: A Biography,* p. 329.)

Michelangelo, *Crucifixion*, c. 1536. © *The Trustees of the British Museum/Art Resource, NY*

religious verses, "of the things which Your Ladyship has several times wished to give me, I wanted, in order to receive them as little unworthily as possible, to execute something for you by my own hand. Then I came to realize that the grace of God cannot be bought, and that to keep you waiting is a grievous sin." In return for her gift, he made for the marchesa three exquisite drawings, including a Pietà and a magnificent image of the Crucifixion rendered in black chalk. "Unique Master Michelangelo and my most particular friend," Vittoria wrote after she had a chance to examine them, "I have received your letter and seen the *Crucifix* which has certainly been crucified in my memory."

The immediacy and raw emotion of these drawings reveals Michelangelo's deep engagement with Spirituali beliefs. Meant for private devotion, these images reflect a longing for an intimate experience of God. "Through the cross, through blood and sweat," Colonna wrote in one of her canzoni, "with a spirit ever more burning for trial, and not/ with idle wishes and sluggish deeds should man/ serve his true Lord." As she knelt beside Michelangelo's moving images, what need had she of priests and their rituals?

For Michelangelo, the Spirituali emphasis on a personal engagement with Christ confirmed his experience of God's presence in his life. He was skeptical of priests and the institution of the Church, certain that, for better or worse, he alone was responsible for his fate. The phrase he used in his letter to Vittoria—"I came to realize that the grace of God cannot be bought"—is an allusion to the belief in justification by faith that he had absorbed during their conversations at the Convent of San Silvestro, a sly tribute to his guide in matters of the soul. A more explicit reference to these ideas comes in a sonnet from the 1530s:

> *O flesh, O blood, O holy wood that caused Your agony,*
> *My sins are justified through You,*
> *the sin in which I'm born, my father too.*
> *You are the highest good; Your boundless mercy*
> *lifts me from the mire,*
> *so close to death, from God so far.*

It is easy to discern Vittoria's influence in the intimate drawings he made for her private devotion, but the doctrines of Valdés, Pole, and the rest of the Spirituali also shaped Michelangelo's conception of *The Last Judgment*. The massive fresco was the first work to grapple with the radical metaphysics in which the burden of salvation is lifted from the Church and placed instead on the individual conscience. Before the Protestants and the Catholic reformers revealed that grace could not be bought, the path to heaven had been well marked; it was even supplied with toll booths that allowed the faithful to proceed onward and upward after the payment of a nominal fee. The clergy served as both toll collectors and traffic cops, and the rites they administered constituted rules of the road that all could follow.

Michelangelo has done away with this neat, well-regulated scheme. All is chaos. Each of us must find his or her own way, groping in the darkness to an unseen destination. In his version of the world to come, the old hierarchies have been demolished, just as they were disintegrating here on earth. Salvation can no longer be assured by human institutions; certainty has given way to doubt, rigidity to a dynamism at once exhilarating and frightening. The new theology provided a religious experience that was more intense but also disorienting, as each of us stumbles along obscure paths, clinging to hope but full of dread. If the medieval conception of the Last Judgment served to reinforce the existing social order—with the Church in the crucial role as the mediator between heaven and earth—Michelangelo's reflects the anxiety of an age in which the traditional institutions had been discredited but the new theology was still in flux.

Traditionalists responded to the fresco with varying degrees of discomfort as they sensed a subversive message they could not quite define. To Michelangelo's contemporaries, one of the most striking features of the painting—a source of inspiration to some, confusion to many others—is the absence of the usual attributes by which an artist provides a who's-who of the heavenly realm. A few of the saints to Christ's left are identifiable by the traditional instruments of their martyrdom—St. Catherine with her wheel; St. Lawrence with his griddle; St. Bartholomew with the knife and flayed skin—but the hosts of Heaven are remarkable for their ambiguity or complete anonymity. Even Condivi and Vasari could not agree whether the figure immediately

to Christ's right dressed in animal skins is Adam or St. John the Baptist, while the figure bearing the Cross is either St. Philip or Dismas. And while St. Peter is immediately recognizable through the keys he holds, his counterpart St. Paul has never been positively identified. One critic complained that, unlike earlier painters who showed "sacred images modest and devout, with those signs that have been given by the ancients for the privilege of sainthood," Michelangelo and those who followed him painted "acrobats and actors rather than those who stand in contemplation . . . [and] have so lowered that holy usage with this new invention, that they could hardly paint figures more immodest in bathhouses or taverns."

Not only does Michelangelo's celestial realm lack signposts that would allow us to orient ourselves, it confronts head-on the unpredictability of grace. Instead of being greeted by neat ranks of well-labeled saints that explain our place in the celestial bureaucracy, we are thrown in with the clamorous mob, a confusing jumble of "acrobats and actors," many of them nude or half nude so that to many observers they looked less like the elect than like participants in an orgy. Another critic complained of those souls who embrace each other just to the right of St. Peter: "Is it not ridiculous to represent among the multitude of blessed souls in heaven, some tenderly kissing each other, when they ought to be intent, with their minds fixed in contemplation of the Divinity, and of the future sentence."

Michelangelo's tumultuous masterpiece offered an Apocalypse that spoke to the uncertainties of the new age, one in which the saints' role as intercessors between this life and the next has been undermined. Even Mary, traditional symbol of the Mother Church, no longer has the power to intervene on our behalf. And if these holy men and women cannot save us, how much less can we depend on those normal social markers that distinguish us here on earth. The clothes that separate the priest from his flock and the rich man from his servant have been discarded. In the end, each of us must face the ultimate test naked and alone.

Painting both saints and sinners in the nude, then, was not a gratuitous pagan intrusion into a Christian subject but an essential part of Michelangelo's message, an affirmation that we are all equal in the sight of the Lord. But such subtle theological reasoning offered an inadequate defense in the

face of increasingly vituperative attacks by Protestants, as well as many within the fold, who accused the Church of commissioning art that was both decadent and idolatrous. Following the lead of the pope's master of ceremonies, it was easier simply to denounce Michelangelo's fresco as indecent.

The most articulate, if the least scrupulous, critic was Pietro Aretino, a surprising role for a man who, only a few years earlier, was threatened with arrest after he provided verses to accompany a series of obscene engravings by Giulio Romano.

Now Aretino joined the hypocrites he so eloquently skewered when they pointed out his own transgressions. In an open letter to Michelangelo he professed his outrage at the sight of so much naked flesh, excusing the apparent inconsistency on the flimsy grounds that he at least kept his pornography separate from his faith. Willfully ignoring the deep philosophical significance Michelangelo attached to the naked body, he played to the crowd:

> [A]s a baptized Christian, I am shamed by the license, so unlawful to soul and intellect, you have taken in expressing those ideas and that goal to which all aspects of our truest faith aspires. So then—that Michelangelo of stupendous fame, that Michelangelo notable for his prudence, that Michelangelo whose demeanor all admire has chosen to display to the people a religious impiety only matched by the perfection of its painting. Is it possible that you, who since you are divine do not deign to consort with men, have done this in the most majestic temple of God? Above the chief altar of Jesus? In the greatest chapel of the world where grand cardinals of the church, reverend priests, and the Vicar of Christ himself confess? . . . And yet is a Christian, who because he rates art higher than faith, holds it as right royal a spectacle to observe no decency among martyrs and virgins as to show someone being seized by his genitals: a brothel would avert its eyes in order not to see such things. What you have done would better suit a voluptuous bath-house than the supreme chapel! It would be less heinous if you had no belief, rather than being a believer yourself, to sap belief in others.

Despite the heavy-handed sarcasm and the blatant dishonesty of the letter, Aretino makes at least one crucial point. His accusation that Michel-

angelo "rates art higher than faith" exposes his greatest transgression in the eyes of his critics: his insistence that the true artist must emancipate himself from the tyranny of vulgar princes and narrow-minded clerics. For more than four decades he had struggled to redefine what it meant to be an artist, replacing the traditional view of the craftsman who worked on commission with that of the shaman who tapped into a hidden source of spiritual power. But in the heated atmosphere of the Counter-Reformation such freethinking was unacceptable. Cardinal Gabriele Paleotti set down what was to be expected of artists from now on in his *Discorso Intorno alle Imagini Sacre e Profane* (Discourse on Sacred and Profane Images), largely in response to the scandal provoked by Michelangelo's infamous fresco:

> Some subjects by their nature are not known or are not clearly narrated in Scripture, in which case it seems to many that this allows them a wide field for representing them according to their own imagination. Such is the case in depicting the terrifying Last Judgment and the person of Lucifer, the damned souls, the celestial glory, or the highest heaven and the thrones of the blessed. In such things many inventions are made up merely from the artist's head, without being supported by or based upon any doctrine of the Holy Fathers or of others approved by the Holy Church. . . . We know that some painters at times excuse themselves, saying these novelties have an allegorical meaning. . . . We say, since it is the duty of the painter to represent things naturally as they are shown to mortal eyes, he must not go beyond his limits, but rather leave to the theologians and the holy doctors the expansion of them to other higher or more hidden meanings. Otherwise everything would be confused and things would pass tumultuously from the natural state to that of grace or glory.

The function of art, according to men like Cardinal Paleotti, was to speak plain truths to plain people, to instruct them in the basic tenets of their faith rather than confuse them with elaborate allegories. One like-minded critic complained that "if ten people contemplated [these paintings], they would make ten comments, and not one would correspond to the others."

The problem was not simply that artists like Michelangelo refused to take

instruction. Like the heretics, they placed themselves outside the authority of the Holy Church, obeying only their own idiosyncratic muse. Such independence of thought was the hallmark of the Protestants, who similarly rejected any guide but their own individual conscience. At least one critic drew an explicit link between Michelangelo's eccentric iconography and the errors of the northern schismatics. In 1549, when a copy of Michelangelo's *Pietà* was installed in Florence, an appalled citizen complained: "In the same month they unveiled in Sto. Spirito a Pietà, which was sent by a Florentine to the said church, and they say that it derives from that inventor of obscenities, Michelangelo Buonarroto, who is concerned only with art, not with piety. All the modern painters and sculptors, pursuing Lutheran whims, now paint and carve nothing for our holy churches but figures that undermine faith and devotion." It is unlikely that Luther and his iconoclast sympathizers would have discovered much to their liking in *The Last Judgment*, but in the eyes of conservative Catholics, Michelangelo's deeply personal approach to religious iconography was dangerous, perhaps even heretical.

V. THE BREECHES MAKER

As long as Paul III lived, Michelangelo could withstand the worst abuse his critics could launch in his direction, secure in the knowledge that his powerful patron would protect him. Ignoring the uproar over *The Last Judgment*, Paul demonstrated his continued devotion by asking him to paint the walls of his private chapel. *The Conversion of Saul* (c. 1542–45) and *The Crucifixion of St. Peter* (c. 1546–50) are the last two paintings from the hand of the elderly master, but they show no diminution in technical skill or boldness of conception. As always, Michelangelo develops the narrative almost exclusively in terms of the human body, stripping away every extraneous element in order to focus attention on the decisive moment. In each, Michelangelo demonstrates his unique ability to render psychic states and spiritual truths simply by the motion of bodies in space.

In *The Conversion of Saul*, Christ's sudden appearance in the sky is explosive, scattering everyone in the vicinity as effectively as a bomb blast. "Suddenly, while he was traveling to Damascus and just before he reached the

Michelangelo, *The Conversion of Saul*, 1542–45. *Scala/Art Resource, NY*

city," reads the relevant passage in *Acts,* "there came a light from heaven all around him. He fell to the ground, and then he heard a voice saying, 'Saul, Saul, why are you persecuting me?' . . . The men traveling with Saul stood there speechless, for though they heard the voice they could see no one. Saul got up from the ground, but even with his eyes wide open he could see nothing at all. . . ." For an artist, the image of a man struck blind by the searing light of truth is particularly compelling, and Michelangelo invests the scene with dramatic intensity, as if he identified with the holy man's predicament. This self-identification is emphasized by the fact that Michelangelo has once again departed from the biblical text to depict the saint as an old man with a flattened nose and a forked gray beard, much like the one that he himself wore. The stricken holy man is another of those covert self-portraits he so commonly inserts into his work. Like the warrior Saul, transformed by his vision into the Apostle Paul, Michelangelo has left behind the world of mere appearance in order to grapple with those eternal truths not available to sense alone.

Normally *The Conversion of Saul* would be paired with the scene of St. Peter receiving the keys to the Church from Christ, and there is some indication that this was the scheme Michelangelo initially contemplated. But he ultimately decided against this traditional coupling, presenting instead the more violent *Crucifixion of Peter.* Not only does this make for a far more dramatic contrast, but it seems in keeping with the militant spirit of the age. At a time when the Church was under siege, the complacent figure who would normally be shown receiving the keys from Jesus seemed a far less effective standard-bearer than the combative martyr for his faith that Michelangelo conjures. In the process he solves brilliantly the major compositional difficulty of depicting this upside-down crucifixion, showing the soldiers straining to raise the cross while an agonized Peter twists his head around to fix us in his accusatory stare.

Neither fresco generated anything like the controversy that greeted *The Last Judgment.* In part, this was because they were located in a much less prominent setting and were never as widely known. Engravings by Marcantonio Raimondi and a host of others disseminated images of *The Last Judgment* far and wide, while the Pauline frescoes were to be enjoyed only

by the pope and his immediate staff, sophisticated men who would not easily be confused by Michelangelo's eccentricities. Perhaps, too, the artist had learned his lesson. Though he still refused to be bound by the strictures of narrow-minded clerics, this time he made sure not to offend their delicate sensibilities. In marked contrast to *The Last Judgment,* all the figures in the *Conversion of Saul* and the *Crucifixion of Peter* are modestly clothed.

Pope Paul himself did not live to see the completion of the final works he had commissioned from his favorite artist. He died on November 10, 1549, with the artist standing vigil at his bedside. For Michelangelo, the loss was both personal and professional. "In reply to your last letter," he wrote to his nephew, "it is true that the death of the Pope has been a great sorrow to me and a loss no less, because I received many benefits from His Holiness and hoped to receive still more. But it has pleased God that it should be thus and we must be resigned. He died a beautiful death and was conscious to the last."

While the pope's death was a severe blow to Michelangelo, his compatriots greeted his passing with less than universal mourning. Upon ascending the throne fifteen years earlier, Paul had carried with him the hopes of the reformers. At first he lived up to expectations, steering ably between the French and imperial factions and demonstrating his commitment to reuniting the Christian flock. Under his aegis, the General Council that assembled in the imperial city of Trent in 1547 pushed for reconciliation with the schismatic Lutherans but, like much else in his reign, a promising beginning was squandered as the pope got bogged down in petty quarrels. Like many of his predecessors, Paul was a notorious nepotist bent on furthering the interests of his children and grandchildren at the expense of the Church. For his oldest son, Pier Luigi, he carved out the Duchy of Parma from papal lands, a move that alienated the Emperor Charles since the newly created duke maintained his hold on power with the aid of French troops. Following Pier Luigi's assassination at the hands of imperial thugs, Paul took his revenge by removing the Council from the German-controlled city of Trent to Bologna in the Papal States, all but guaranteeing a permanent rift in Europe, since the Protestants were unwilling to attend any sessions held in the heart of the enemy camp.

Despite these missteps, Paul's generally tolerant attitude toward religious dissent might yet have paid dividends. He approved the founding of the Jesuits—soon to grow into the militant arm of the Counter-Reformation Church—and established the Roman Inquisition, but his reign was characterized by moderation. "In principle," said Cardinal Girolamo Seripando, referring to the notorious institution, "this tribunal was moderate and merciful, true to the nature of Paul III . . . later, however . . . especially because of the hardness of Caraffa, this tribunal acquired a renown such that it was said nowhere on earth were so awful and horrible verdicts pronounced."

Michelangelo was among the beneficiaries of Paul's easygoing attitude, as the pope rebuffed the critics of *The Last Judgment* by heaping more honors on his aged shoulders. Once Paul passed from the scene, however, the forces of reaction gained ground. Tolerance gave way to fanaticism, pleas for reconciliation to calls for holy war. Though Michelangelo himself was never threatened with the torture that awaited those with less prestige, his work did not enjoy the same protections. Aretino was among those calling for the destruction of *The Last Judgment*, urging the pope to emulate Gregory the Great by "removing from Rome all the prideful statues of idols, rather than hinder the good in their devotion to the humble images of the saints."

The likelihood that Michelangelo's masterpiece might be destroyed increased in 1555 with the accession of Cardinal Caraffa as Pope Paul IV. The most prominent of the hardliners and the man responsible for the Roman Inquisition's brutal reputation, the new pope took a dim view of any work of art that did not set out official Church doctrine in clear terms that even the unlettered might understand. He was particularly offended by the monumental work on the altar wall of his own chapel that seemed to embody the lax, lascivious approach he deplored, saying, "it was not right that in St. Peter's there should be such a wicked exhibition of nakedness and buffooneries."

Despite old age and ill health, Michelangelo reacted to this latest attempt to censor him with his usual pugnaciousness. "[C]ertain persons had informed him that Pope Paul IV was minded to make him alter the façade of the chapel where the Last Judgment is," Vasari recalled, "because, he said, those figures showed their nakedness too shamelessly. When, therefore, the

mind of the Pope was made known to Michelangelo, he answered: 'Tell the Pope that it is no great affair, and that it can be altered with ease. Let him put the world right, and every picture will be put right in a moment.'"

Though Michelangelo refused to be cowed by the puritanical ideology now being pushed by the Vatican, he was unable to protect the integrity of his work from overzealous censors. In 1563, the hard-liners at the revived Council of Trent prevailed, setting out strict new rules for works of art and purging anything deemed to smack of pagan idolatry or obscenity. The following year they singled out the most notorious example, insisting that the most offensive parts of *The Last Judgment* be covered up. Fortunately, the man hired to do the job was a friend and ally of Michelangelo, Daniele da Volterra, who tried to minimize the damage he was charged with inflicting. Beginning in 1565, Daniele began adding loincloths and robes to many of the most prominent figures, a thankless task for which he was ridiculed with the nickname *Il Braghetone* (the Breeches Maker).

By the time Daniele finally began his work, Michelangelo was one year in the grave and thus spared the indignity of watching his masterpiece bowdlerized and the disappointment of seeing the values for which he had fought so hard all his life in retreat. The idea that art was merely an instrument to promote the prevailing ideology had triumphed, if only temporarily, over the notion that art should serve only its own imperatives. Time and again throughout history we have watched as this battle is waged anew, as periods of liberality are followed by retrenchment, as those in power label those who fail to hew to the party line as subversives. We see it in our own age when totalitarian regimes draft writers and painters into the cause of the state, and in somewhat milder form when government officials seek to cut off funding for any work they label indecent. To all who value the independence of the artistic conscience, Michelangelo's *Last Judgment* stands as a monument to freedom.

By the time of his confrontation with Pope Paul IV, Michelangelo had already put down his brushes for good. *The Crucifixion of Peter*, completed in 1550, was his final work in a medium he had never really embraced but in which he created some of his greatest masterpieces. "[H]e used to tell me,"

Vasari said, "the[se paintings] cost him much fatigue, for the reason that painting, and particularly working in fresco, is no art for men who have passed a certain age." His career as a painter had lasted more than sixty years, from the moment he first entered Ghirlandaio's studio, grinding pigments and performing other menial tasks. Though he later claimed to have learned nothing from this master, it is no coincidence that the greatest fresco painter of his generation had learned his trade with the most prolific practitioner of the previous era.

Michelangelo retired from the field with few regrets. "It is not my art," he would often declare, and his dismissive treatment of his first master suggests his antipathy to the medium upon which at least half his reputation as the world's greatest artist rested. But it was not only his career as a painter that was over. Michelangelo was now seventy-five, far exceeding the average life span of Renaissance men and women. Over these years he had outlived nine popes, having worked closely with five of them. And while his mind was as sharp as ever, his energy was flagging. "I am old, as you know," he wrote to his nephew Lionardo in 1549, "and so each hour might be my last." In addition to an overall loss of vigor, he was afflicted with kidney stones and had difficulty urinating. He continued to carve in stone, but only for his own pleasure, refusing any public commissions, offers of which continued to come in from the great lords of Europe.

He was ever more preoccupied with thoughts of death, second-guessing his chosen path and agonizing over his own salvation. As he prepared to meet his Maker, the pride he once took in worldly success has been exposed as vain illusion. "I've reached the end of my life's journey," he wrote in one of his final poems,

> in a fragile boat swept along on stormy seas
> to the port where all debark. I bear
> a log of every deed, both foul and fair.
> So long I've clung to fantasies,
> made of my art an idol and a king.
> But now I've come to know my error,
> sad emptiness of Man's desire.

Glad thoughts of love, what good are they
when my death approaches twice?
Of one I'm certain, the other looms.
My soul, no longer soothed to sculpt or paint,
now turns to that love divine
whose arms, stretched out upon the Cross,
open wide for my embrace.

But despite physical exhaustion and bouts of melancholy, Michelangelo still burned with creative fire. As an artist, he reminded a correspondent, he worked with his mind and not his hands, so that despite his diminished physical power, he still had much to contribute. Indeed, there was one project to which he could lend his talent, one that demanded little from the hands but more than any one mind could possibly deliver: the greatest building project of the age and one of the most ambitious of all time. It was a project that was to consume the remainder of his years, and one that satisfied both his earthly ambition and nourished the deepest longings of his soul.

VII

Basilica

[I]f the pains I endure profit not my soul, I am wasting my time and my work.

—Michelangelo

Michelangelo, St. Peter's, Dome and Hemicycles, 1547–64. *Scala/Art Resource, NY*

I. NOTHING GREATER, MORE SPLENDID, MORE ADMIRABLE

On a blustery April morning in 1506, Pope Julius II led a festive procession across the rubble-strewn square behind St. Peter's to a freshly excavated trench at the southwest corner of the ancient basilica. While the common folk trudged behind, choking on the dust stirred up by marching heralds and the hooves of the caparisoned horses ridden by the thirty-five cardinals and other assorted dignitaries, the pope sailed serenely above it all, borne aloft on the shoulders of the Swiss Guard in the ceremonial *sedia gestatoria* (portable throne). But anyone who assumed that the white-haired pontiff was too dainty to soil his gold brocades had not reckoned with his impatient spirit. A man who at the age of sixty-three still insisted on leading his troops into battle was unlikely to let others do all the work, particularly when the occasion being marked was one that would establish him as the greatest builder since the age of the Caesars.

As soon as the parade reached its destination, Julius leapt from his chair and plunged into the crowd. Then, as trumpets blared and the citizens of Rome roared their approval, he grabbed hold of the wooden ladder and clambered down—accompanied by two unhappy cardinals and a pair of *scarpellini*—disappearing into what his master of ceremonies described rather alarmingly as a "chasm in the earth." The ceremony almost ended in disaster when the spectators, hoping to get a better look, surged too close to the rim, sending an avalanche of dirt and small rocks down upon the sacred head. "[A]s there was much anxiety felt lest the ground should give way," Paride de Grassis noted, "the Pope called out to those above not to come too near the edge." Once the crowd had retreated to a safe distance, an urn was lowered into the pit, over which was laid the marble slab that would serve as the cornerstone of the new church. Inside the urn were twelve gilded medals (symbolizing the twelve apostles), each bearing on one side an image of the proposed edifice and on the other the features of the pope. The commemorative coins set forth in bronze the mixed motives that characterized most of Julius's undertakings—a fierce devotion to the

greater glory of the Church that was often indistinguishable from sheer egotism.

One resident of Rome not in attendance that morning was the sculptor Michelangelo Buonarroti. Only the day before, he had fled the city with Julius's minions in hot pursuit, intending to put as much distance between himself and the ceremony as possible. As self-centered as his master, he seemed to regard the event as a personal affront, as if the greatest building project in the history of the Church had been undertaken with no other purpose than to humiliate him. Over the past few months he had watched with growing dismay as Julius huddled in his apartments with the unctuous Bramante, poring over the plans for the new basilica. Julius was now so engrossed with this latest project that he no longer stopped by Michelangelo's studio to discuss plans for his tomb. A few hours before his flight, the pope's servants had rudely escorted the artist from the papal audience chamber, confirming Michelangelo's suspicion that he no longer enjoyed his master's confidence. Hurt by Julius's indifference and outraged by his rival's scheming, he packed his bags, hired a horse, and galloped off to Florence.

This was not the first time (and it would not be the last) that Michelangelo had allowed his paranoia to get the better of him, but for all his exaggerated sense of grievance, he was not wrong in concluding that Bramante's building had eclipsed his own less spectacular project. Julius's interest in the tomb had clearly waned, perhaps because he understood that lavishing treasure on a monument to himself would open him up to the charge of excessive vanity, while rebuilding the shrine at the heart of Christendom would secure his reputation as a leader who put the glory of the Holy Church before his own.

Before long, 2,500 men were swarming over the site, tearing down the old walls and laying the foundations for the new. An ambassador to the Holy See marveled at Julius's new obsession, reporting, "His Holiness shows every happiness and frequently goes to the building of St. Peter's demonstrating that he doesn't have any greater concern than finishing the building."

Ironically, it had been Michelangelo himself who had provided the initial impetus for Julius's grand folly, something he acknowledged when he boasted, "It's all happening because of me." His earliest biographers confirmed his version of events, Condivi declaring simply that "Michael Angelo

was the cause that it came into the mind of the Pope to rebuild the rest of the church [of St. Peter's] on a finer and more magnificent scale."

Despite Michelangelo's conviction that everything (for good or ill) revolved around him, there was nothing petty or vindictive in Julius's decision to replace the old church at the heart of the Vatican with a new, more magnificent edifice. The original building had become something of an embarrassment as well as a danger to the thousands of pilgrims who each year flocked to the shrine—not to mention the princes of the Church who were forced to attend Mass beneath sagging timbers and canted walls.

Even without the imperative to house Michelangelo's massive tomb, it was clear that something had to be done with the dilapidated structure. Begun by the Emperor Constantine in 326 C.E., the church marked the spot where Peter—Prince of the Apostles and first pope—was buried. But over the centuries the sacred shrine had been neglected, particularly during the decades of the so-called Babylonian Captivity (1309–78) when the popes had fled the violent, tumble-down city and taken up residence in Avignon.

When the popes returned to Rome in the early years of the fifteenth century, they embarked on an ambitious program of urban renewal. While most preferred the more glamorous task of erecting splendid new buildings, they also turned their attention to the restoration of structures too steeped in sacred history to be carelessly swept aside. Inspecting the crumbling fabric of St. Peter's at the request of Pope Nicholas V (1447–55), Leon Battista Alberti reported: "[T]he continual force of the wind has already displaced the wall more than six feet from the vertical. I have no doubt that eventually some gentle pressure or slight movement will make it collapse." This dire assessment prompted the first major intervention in more than a thousand years when Pope Nicholas commissioned the Florentine architect Bernardo Rossellino to shore up and enlarge the existing structure. In 1506, Rossellino's vast, unfinished tribune still stood at the western edge of the old basilica, a weed-covered monument to uncertain finances and even-less-certain leadership. It would take a pope of bold vision, unafraid to take on the traditionalists within the ranks of the Sacred College, one willing to step on a few toes and skewer a few sacred cows, before significant progress could be made.

Julius II was just such a man. When it became clear that the funerary ensemble Michelangelo had designed could not be accommodated within St. Peter's as it was currently configured, Pope Julius asked Bramante and Giuliano da Sangallo to propose a solution. While Sangallo suggested the simple expedient of adding a chapel to the existing structure, Bramante—with a far better understanding of his master's nature—captured the pope's imagination with a dazzling prospect. What better way to rival the Caesars of old than to replace the first church of Christendom with a splendid new edifice, one that would proclaim the triumph of the faith while simultaneously ensuring the undying glory of the man who first conceived it?

This last goal seemed assured even when the new structure consisted of little more than a few massive arches looming over a desolate patch of ground. In his funeral oration for Julius, Egidio da Viterbo proclaimed: ". . . all people are persuaded, on the basis of the visible pile of foundations already laid, that whatever will happen in the city of Rome and among whatever great works there come to be, this will forever be the greatest of them. Nothing in Italy and indeed nothing in the universal orb of nations will ever be more sublime, or in cost more magnificent, or in excellence greater, more splendid, more admirable."

Not everyone shared Egidio's enthusiasm. Cardinals worried about the expense, and many protested at the wanton destruction of a church founded by the first Christian emperor. As Paride de Grassis noted in his journal: "The name il Ruinante [the master of ruins] has been added to the vocabulary to describe Architect Bramante." A contemporary satire depicts Bramante arriving at the gates of heaven, where he is confronted by St. Peter, who asks the architect: "Why did you destroy my temple in Rome which, by its very antiquity, called even the least down to God? You are the rascal to whom we owe this evil deed."

The debate over what to do with the ancient basilica was symptomatic of the fissures and contradictions that plagued the Renaissance Church. On the one hand, Old St. Peter's was among the most venerated monuments in all Christendom. It was one of the last remaining links in Rome to the first Christian emperor—Constantine himself had shown his commitment to the faith by filling the first twelve bags with dirt dug from the foundation—a

visible sign of the unbroken chain of authority extending from the Apostle Peter to the man currently seated on his throne. "You are Peter and on this rock I will build my Church," Jesus told his first disciple. "And the gates of the underworld can never hold out against it. I will give you the keys of the kingdom of heaven; whatever you loose on earth shall be considered loosed in heaven."

But despite Jesus's focus on the kingdom of heaven, Julius, like most of his recent predecessors, was more comfortable in the role of a worldly prince than of a leader of the Christian flock, more attuned to the language of wealth and power than to the inscrutable mysteries of the spirit. In *this* world, outward display counted for more than virtue. It seemed intolerable to him that while the institution Peter founded grew in wealth and power, the actual building that marked his grave was crumbling away. The truth is that both the building and the larger institution were equally unsound, but while Julius was keenly aware of the structural deficiencies of the basilica, he was blind to the pervasive spiritual rot that threatened the fabric of the Church itself. In the end, by shoring up the one, Julius undermined the other. It was an irony not lost on Cardinal Pallavicino, who saw the folly of Julius's great undertaking: "This material edifice had destroyed a great part of his spiritual building. To procure the prodigious millions required by a construction so enormous, recourse was had to means which gave the first occasion to the Lutheran heresy, and inflicted upon the Church, in the end, the loss of many millions of souls."

But in 1506 the larger threat was still invisible, at least to someone of Julius's temperament. The instability of the existing building served as a handy excuse for what might otherwise be deemed a sacrilegious act, but a more important consideration for the pope was that Old St. Peter's did not fit in with his conception of the Church he led or his grandiose plans for his capital. The most sacred shrine in Christendom, the physical embodiment of the pope's claim to be Jesus's representative on earth, must be something more than a dilapidated structure of brick and timber, no matter how venerable. Not only was Constantine's church shabby, but it violated those canons of beauty and decorum set down by Vitruvius and revived by the humanists in recent decades. Ironically, the ancient building violated the standards

established by the ancients themselves, testifying to the now embarrassing fact that Christianity had begun as a humble religion and had been adopted as the official creed of the state only during the last decadent years of the Roman Empire. Old St. Peter's was a degraded product of a dying age, and while some might regard these charming flaws as evidence of Christianity's modest origins, Julius preferred a magnificent structure that would overawe the faithful with a vision of the Church Triumphant.

Donato Bramante was the perfect candidate to implement Pope Julius's vision. Not only was he supremely self-confident, but he had mastered the forms and techniques of the Roman builders. While most of his colleagues derived their understanding of ancient architecture from books—particularly from Vitruvius—in the years before he entered Julius's household Bramante had wandered about the city sketching the monuments, taking measurements, and excavating the foundations, uncovering the secrets of the engineers who had raised up soaring vaults and massive walls that, millennia later, continued to strike awe into those who pastured their sheep among the ruins. But despite his archeological investigations, Bramante was no slavish imitator. Rather than superficially aping the style of the ancients, he hoped to achieve a comparable sense of space while adapting classical forms to meet the requirements of a new age.

Bramante was not the first architect to take his inspiration from the ruins that still poked out from the fields and olive groves like the bones of long-dead beasts. Almost a hundred years before Bramante arrived in the Eternal City, Brunelleschi, accompanied by the sculptor Donatello, had sketched among the ruins. Returning to his native Florence, he initiated the first wave of Renaissance architecture by investing his buildings with the same structural clarity and mathematical logic he discovered in the ancient monuments. Using classical columns of impeccable Vitruvian pedigree and the characteristic semicircular arch, Brunelleschi swept away centuries of Gothic clutter, creating structures marked by pleasing regularity and sober dignity.

Brunelleschi's architecture, however, remains planar—based on flat walls, elegantly articulated, and linear colonnades. Interior space, while logically organized in modules based on simple ratios, is essentially inert, a void partitioned by, but not actively engaging with, the structural elements. Bra-

mante discovered that the secret to Roman architecture was the dynamic manipulation of mass and space. Inspired primarily by the Pantheon, with its hemispherical dome, and the ruined Basilica of Maxentius, with its three imposing vaults, Bramante tried to replicate that sculptural sense of mass and void that gave these ancient buildings their dramatic power.

When Pope Julius pitted Giuliano da Sangallo against Bramante to design a new St. Peter's, he was setting up a confrontation between a conservative architect who would carry on the tradition established by Brunelleschi with one who dared to challenge the ancient Romans on their own turf. The contest was over before it began. While Sangallo followed his friend Michelangelo to Florence to nurse his wounded pride, Bramante set about conjuring an edifice that would astound the world.

The building that Bramante ultimately proposed and that won the enthusiastic backing of Pope Julius, was a triumph of Renaissance idealism, a structure whose philosophical perfection was matched only by its impracticality. Perhaps such an outcome was to be expected; the rarefied air that philosophers breathe can prove too thin for mere mortals. Departing from the basic blueprint that had guided sacred architecture for millennia (at least in the West), Bramante conceived of the new St. Peter's in the form of a Greek cross, with four equal arms replacing the longitudinal axis of the traditional basilica. The basilican form, with its central aisle and two or more side aisles usually separated by a row of columns, originated in Roman administrative buildings, where such spaces served as a center of civic life. Adapted by the early Christians to house large numbers of worshipers, the form—often supplemented by a transept that gave the church its symbolically significant cruciform shape—was ideally suited to the celebration of the Mass, allowing the congregants to focus their attention on the altar where the priest performed the sacred rites.

But if the basilican form was hallowed by tradition and recommended by its suitability to the Latin rite, it did not sit well with humanists whose taste was governed by more abstract considerations. Alberti expressed his bias in favor of the centralized plan, particularly when it came to sacred architecture which, in order to "encourage piety" must first "delight the mind." Like all good humanists, Alberti believed that such delight was provoked when

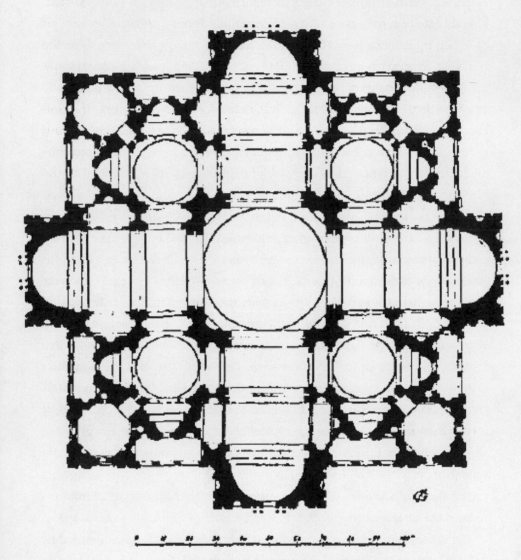

Bramante's Plan for St. Peter's, c. 1503.

the mind encountered forms that obeyed the laws of pure reason, which, expressed in architectural form, would replicate the most perfect forms found in nature. "It is obvious from all that is fashioned, produced or created under her influence, that Nature delights primarily in the circle," Alberti insisted. "Need I mention the earth, the stars, the animals, their nests, and so on, all of which she has made circular? We notice that Nature also delights in the hexagon. For bees, hornets, and insects of every kind have learned to build the cells of their hives entirely out of hexagons."

For Alberti—following a tradition that dates back to Plato himself—God expressed Himself in the world in terms of pure geometry. "For without order," Alberti says in *On the Art of Building,* "there can be nothing commodious, graceful, or noble." The planets, for instance, which belonged to the higher celestial realm, must travel in perfect circles—a prejudice that caused endless headaches for astronomers who had to devise elaborate mathematical schemes to bring observation into conformity with theory. Symmetry was an attribute of the divine, the sign that Mind underlay the apparent chaos of the universe. And just as early-twentieth-century architects were convinced that rational planning—usually taking the form of large housing projects laid out in simple grids—was the solution to urban ills, Renaissance artists believed in the healing power of mathematical forms. A famous fresco in Urbino (home to not only Bramante but also Perugino and Raphael) captures the Renaissance ideal of a city whose ordered geometry was both an expression of pure reason and an antidote to the haphazard layouts that turned most medieval cities into warrens of dark, unsanitary alleyways.

Vitruvius gave this faith in symmetry anthropocentric slant:

The design of a temple depends on symmetry, the principles of which must be most carefully observed by the architect. . . . Without symmetry and proportion there can be no principles in the design of any temple; that is, if there is no precise relation between its members, as in the case of those of a well shaped man. . . . And just as the human body yields a circular outline, so too a square figure may be found in it. For if we measure the distance from the soles of the feet to the top of the head, and then apply that measure to the outstretched arms, the breadth will be found to be the same height, as in the

case of plane surfaces which are perfectly square. . . . Therefore, since nature
has designed the human body so that its members are duly proportioned to
the frame as a whole, it appears that the ancients had good reason for their
rule, that in perfect buildings the different members must be in exactly sym-
metrical relations to the whole general scheme. Hence, while transmitting to
us the proper arrangements for buildings of all kinds, they were particularly
careful to do so in the case of temples of the gods, buildings in which merits
and faults usually last forever.

Leonardo created the most famous visual representation of this idea in his
Vitruvian Man, showing how a well-proportioned (male) body could be
inscribed within a circle and a square, these geometric forms being the most
perfect since they exhibit the greatest degree of symmetry. Though Leonardo
never actually built anything himself, he sketched out many designs for
churches in his notebooks. Perhaps because these were works on paper and
did not have to accommodate actual worshipers, each is based on the circle,
the square, or one of the regular polygons; pure geometry was privileged
over practicality.

Despite its uncanny resemblance to Leonardo's drawings, Bramante's
design for the most important building in Christendom was not simply
borrowed from the great man's sketchbook. The idea that a centralized plan
based on the circle, the square, or the hexagon was an emblem of God's plan
for the world was ubiquitous in the Renaissance. One can see similar domed
structures in paintings like Perugino's *Delivery of the Keys to St. Peter* in the
Sistine Chapel and in the *Marriage of the Virgin* by his pupil Raphael. *The
School of Athens* is the culmination of this ideal. In Raphael's grand concep-
tion, the greatest thinkers in history probe the deepest questions beneath
a spacious dome that echoes Bramante's church rising a few blocks to the
south.

The design Bramante submitted and Julius accepted was for a massive,
centrally planned structure based on a Greek cross with four equal arms
surmounted by an immense, hemispherical dome, all inscribed within the
symmetrical form of the cube. His goal, according to Paride de Grassis, was

to "raise the dome of the Pantheon on the Basilica of Maxentius." The fact that such a design would eliminate the axial focus crucial for the celebration of the Latin Mass was less important than the symbolic unity of a design that would stress God's perfection by replicating it in marble and mortar. It is impossible to determine Bramante's precise design from the surviving drawings. Perhaps the most faithful rendering of Bramante's conception comes from a commemorative medal struck at the time that shows the massive domed structure flanked by towers, which bears an uncanny resemblance to the famous Hagia Sophia in Constantinople.

Driven by Julius's impatience, Bramante worked rapidly, raising the four massive central piers that would support the dome before his death in 1514. By that time, Julius was also dead, his place at the head of the Church taken by the profligate Leo X. Despite Julius's penchant for waging war, he—with the assistance of his banker, Agostino Chigi—had kept a tight rein on finances. In February 1507, Julius appealed to the crowned heads of Europe to help defray the costs: "The New Basilica, which is to take the place of one teeming with venerable memories, will embody the future greatness of the present and the future. In proportions and splendor we believe it will surpass all other Churches of the Universe." But the great lords of Europe were apparently less enthralled with the project than he was, and soon the resourceful Chigi was forced to come up with more creative expedients.

The scheme he invented to raise the necessary funds involved an offer to remit the sins of the faithful in return for a cash contribution, transactions known as indulgences. Even the worldly Julius apparently had some qualms about resorting to such a blatantly corrupt practice. He turned to it only on a small scale at the end of his life. Leo had no such scruples. Under his reign, the sale of indulgences reached massive proportions, particularly in Germany, where Archbishop Albert of Brandenburg struck a deal in which he and the papacy shared in the profits from the wholesale trafficking in human souls. It was this practice to which Martin Luther vehemently objected. His disgust would expand into a wholesale denunciation of the Church and ignite the Protestant Reformation.

The *liber mandatorum*, an account of the annual costs associated with the building of St. Peter's, reveals that while on average Julius spent about

16,500 ducats a year on the building, in 1514, the first full year of his reign, Leo spent 60,000. Among the various criticisms leveled by Luther at the papacy and nailed to the door of All Saints Church in Wittenberg, many dealt implicitly or explicitly with the unholy bargain the pope had struck to build his church. "Christians should be taught that, if the pope knew the exactions of the indulgence-preachers, he would rather the church of St. Peter were reduced to ashes rather than be built with the skin, flesh, and bones of the sheep," reads the fiftieth proposition; while the eighty-second reads, "Meanwhile [the pope] redeems innumerable souls for money, a most perishable thing, with which to build St. Peter's church, a very minor purpose."

Far from being the crowning glory of Julius's reign, the vast construction project he initiated was quickly becoming a symbol of corruption. Not only was it responsible for driving huge numbers from the faith, but without Julius's steady management, it threatened to bankrupt the Church. "Everything is for sale," complained one critic, "temples, priests, altars . . . prayers to heaven, and God." Upon Leo's sudden death in 1521, one anonymous wit concluded that the notoriously gluttonous pope had "eaten up three Pontificates: the treasury of Julius II, the revenues of his own Pontificate, and those of his successor."

Reacting to the excesses of Leo's reign, the cardinals elected the Dutchman Adriaan Florensz as Hadrian VI, but during his brief time in office the Roman populace found his austerity far harder to bear than his predecessor's profligacy, which at least provided jobs and entertainment to the citizens. Hadrian's successor, Clement VII, hoping to carry his cousin Leo's work forward (but in a more responsible manner), established in December of 1523 a board known as the Fabbrica di San Pietro to manage the finances and oversee the construction of the project.* But like most of the things Clement put his hand to, a sound idea was undermined by poor execution. Work that had largely stalled for decades came to a complete halt with the disastrous sack of 1527. Even after the imperial troops departed, the pope seemed distracted by

* La Fabbrica still exists and continues to be responsible for the upkeep of the great basilica.

events in his native Florence, first with the rebellion and afterward with the various building projects at San Lorenzo.

Not all the blame for these lost decades can be laid at the feet of the popes who, after all, had more to worry about than attending to the building of a single church, no matter how symbolically important. Bramante's death in 1514 deprived the project of its presiding genius, and the appointment of his protégé Raphael as his successor, while greatly enriching the painter, did little to move the project forward. "What task can be nobler than the construction of St. Peter's?" Raphael asked his uncle Simone Ciarla. "This is certainly the first church in the world, and the greatest building that man has ever yet seen; the cost will amount to a million in gold. The Pope has ordered a payment of 60,000 ducats for the works. He thinks of nothing else. . . ."

Like his mentor, Raphael was not averse to doing well by doing good, making such profitable use of Leo's generosity that he was able to build himself a lavish palace in a fashionable neighborhood. "[H]e lived," noted Vasari, "not like a painter, but like a prince." After his own untimely death in 1520, Raphael was succeeded as chief architect by his assistant Baldassare Peruzzi, followed shortly by another of Bramante's protégés, Antonio da Sangallo, the nephew of Michelangelo's old friend Giuliano. But it was not until after the accession of Paul III in 1534 that the neglected project received a fresh impetus, as the pope tried to project confidence following the devastating sack and in the face of the assault on his legitimacy by the Protestant north. By that time, the great piers and central vaults raised by Bramante were overgrown with weeds, a fitting symbol of warped priorities and wasted opportunities.

A renewed push was encouraged not only by ideological imperatives but by the fact that papal finances had been put on a sound footing as gold and silver from the Spanish empire in the New World made up for revenue lost in the breakaway territories of northern Europe. While Michelangelo shut himself away in the Sistine Chapel grappling with the mysteries of the Final Days, Sangallo began tinkering with Bramante's original design, building a scale model in wood so elaborate that it took seven years to complete at the exorbitant cost of 4,000 ducats.

Even before Sangallo took the reins, the original centralized plan had

been modified by Peruzzi and Raphael to accommodate the liturgical re-
quirements of the Latin Mass. Sangallo's revision retained the piers and
vaulting raised by Bramante, but encrusting his design in so many columns,
towers, and secondary domes that the monumental elegance of the original
design was swallowed up in a wedding cake profusion of decorative ele-
ments. Inside, the cavernous spaces conjured by Bramante were subjected to
the same kind of elaboration, with multiple ambulatories separated from the
nave by colonnades. All in all, Sangallo's conception was more massive and
less impressive than Bramante's original.

What Sangallo lacked in artistic vision he made up for in technical
skill. Unlike most sixteenth-century architects who began as painters and
draughtsmen, Sangallo had absorbed the practical aspects of the profession
as an apprentice in Bramante's bustling firm. He had also learned the fine art
of skimming from the top to pad his own accounts, this despite the fact that
he had won the job in large part by promising to reverse the corruption that
was already rife within the system. "Acting more out of pity and respect for
God and St. Peter and respect and the desire to be useful to Your Holiness,
than to myself," he told Leo, "this is to inform you how the money being
spent with little respect for or use to God and Your Holiness is like throwing
money away. . . ."

Under Sangallo's leadership, however, the project became even more
bloated. Friends and relatives dominated the Fabbrica and grew wealthy sub-
contracting for the labor and materials. While the physical structure grew
only slowly, the number of those profiting from the greatest works project in
Europe grew exponentially, so that by 1546, the year of the architect's death,
la setta sangallesca (the Sangallo faction) was an entrenched constituency in
the papal bureaucracy.

But at least the building had begun to move forward after decades of
neglect. A new sense of purpose was injected into the project by a pope de-
termined to leave his mark on the city he had grown up in, and work crews
once again swarmed the area behind the half-dismantled old basilica.

II. FOR THE PROFIT OF MY SOUL

With the death of the sixty-two-year-old Sangallo—the sixth architect to head up the project since Bramante's death if one includes cameo appearances by Giuliano da Sangallo and Fra Giovanni Giocondo—it was clear to Pope Paul III that there was only one man with the stature to carry this crucial work forward. No patron since Lorenzo de' Medici had maintained such a sympathetic and productive relationship with the temperamental Florentine; the current pope not only admired Michelangelo's work but knew how to get the most out of him. He had defied the critics of his *Last Judgment*, proclaiming it a work of artistic genius and unimpeachable orthodoxy, and had demonstrated his confidence by assigning the artist to paint the walls of his private chapel.

When approached by Paul to carry on the work at St. Peter's, Michelangelo, as was his habit, played hard to get. It was not his art, he told him, and besides he was too old and tired to take on such a massive undertaking. Worst of all, *la setta sangallesca* had its tentacles in every aspect of the operation and would resent an outsider coming in and telling them how to run things. Michelangelo was never a team player, particularly when he could not select the team himself.

In the years that followed, Michelangelo made sure everyone knew that he had taken up the burden with the greatest reluctance. "*Messer* Giorgio my friend," he wrote Vasari in 1557, "I call God as my witness that it was against my will and only through the great pressure exerted by Pope Pagolo that I was put in charge of rebuilding St. Peter's ten years ago. . . ." But as always, it's best to be skeptical whenever Michelangelo tries to play the martyr. To hear him tell it, he hardly ever lobbied for a commission but had to be dragged kicking and screaming, relenting in the end out of a sense of obligation.

In this case his reluctance was understandable. He was already over seventy and had been in poor health for a long time. Decades of hard work and an indifference to both hygiene and bodily comfort had taken their toll. In addition to persistent problems urinating, twice in recent years he had come down with a life-threatening fever. Both times he appeared to be so close to death that his friend Luigi del Riccio had him carried to his own house,

where Michelangelo could be attended daily by del Riccio's personal physi-
cian. But though Michelangelo was no longer vigorous, he still burned with
ambition. *Operaius* (builder) for St. Peter's was the most prestigious and
high-profile position to which an artist could aspire, and shepherding the
immense building project to a successful conclusion would be the crown-
ing achievement of a glorious career. Not only would it satisfy his hunger
for worldly fame, but it would serve as a fitting tribute to his God. As he
approached the end of his long life, this second consideration loomed ever
larger in his mind.

Michelangelo's protest that architecture was not his art, like the similar
statements he made about painting, was disingenuous. He was already an
experienced builder, having designed a façade for San Lorenzo in Florence,
as well as the Medici tombs. While in Rome, he continued to supervise from
afar the ongoing work on the Laurentian Library, the most daring of his ar-
chitectural designs to date. Here, his expressive, idiosyncratic reconfiguring
of classical Vitruvian forms was on full display. The famous entrance hall in
particular captures his taste for visual puns that (were it not for his lugubri-
ous personality) might even be called playful. Columns, instead of project-
ing in front of walls, sit behind them in recessed panels, while the wall itself
protrudes, in effect serving as the visual support relinquished by the pillars.

Strangest of all are the stairs that flow from the reading room to the vesti-
bule below in rolling cascades. Given the novelty of the design, it's unfortu-
nate that Michelangelo was not on site to supervise the work. He explained
his ideas to Vasari, who was overseeing the project in Florence, though his
description is more poetic than precise. "I recall a certain staircase, as it were
in a dream," he told him, providing a rough accompanying sketch, "but I do
not think it is exactly what I thought of then, because it is a clumsy affair, as
I recall it. . . . I'm writing nonsense, but I know very well that you and *Messer*
Bartolomeo will make something of it."

The pope himself must have been particularly unimpressed with Michel-
angelo's demurral, since at the same time he was protesting his incompetence
he was hard at work redesigning—at Paul's request and through the good of-
fices of Tommaso de' Cavalieri—the piazza at the top of the Capitoline Hill
that housed Rome's civil government. The exact chronology of this master-

Michelangelo, Laurentian Library, 1524–34. *Scala/Art Resource, NY*

piece of urban planning has never been satisfactorily established, and much of the actual building took place after Michelangelo's death, but work was almost certainly under way in 1538 when the famous equestrian statue of Marcus Aurelius was brought there to serve as a centerpiece to the renovated square.

In ancient times the Capitoline Hill was the site of the Temple to Jupiter, a symbol of Roman pride regarded by millions of imperial subjects as the very center of the universe. Like much of the city, the Capitoline had fallen into ruins during the Middle Ages. Though technically the seat of the Roman government, the buildings were dilapidated and the square itself a barren, muddy expanse.* As late as 1536, when Emperor Charles V paid a state visit to Rome, the parade had been forced to detour around the hill to avoid the embarrassment of presenting such a sorry spectacle to the great man.

It was with the memory of this unhappy occasion fresh in his mind that Pope Paul decided to refashion the ancient center of Rome into a showpiece worthy of its glorious past, hiring his favorite artist to do the honors. The design Michelangelo drew up is one of the most influential pieces of urban planning ever devised, imitated in countless variations, from the elegant *places* of Paris to New York's Lincoln Center. As was almost always the case in Michelangelo's building projects, in the Campidoglio, as the piazza is known, he was not starting from scratch but had to work with preexisting structures and within an awkward space. Providing the Palazzo del Senatore with a new grand staircase gave a new axial focus to the piazza and refacing the Palazzo dei Conservatori turned an undistinguished medieval building into a show-piece of elegant Renaissance form. Michelangelo also designed a second pal-ace, the Palazzo Nuovo, to face the Palazzo dei Conservatori across the square, imparting a symmetry and sense of order that recalls those ideal cities that Re-naissance artists had for the most part been able to conjure only in paintings. A spacious ramp leading up to the piazza bestows a ceremonial, processional quality in keeping with the symbolic importance of the space.

* Part of the reason for the neglect was the fact that Rome's civil officers had very little real power. The last vestiges of communal independence had long been stamped out by the popes, who wielded the real authority in the city.

Michelangelo, Campidoglio (Capitol), begun 1538.

Thus far, the improvements Michelangelo made to the Capitoline Hill can be viewed as a particularly elegant variation on a traditional Renaissance theme: imposing geometric order on a space marked by randomness and confusion. But Michelangelo defies our expectations in large ways and small. He is as obsessed as most of his contemporaries with geometric form, but rather than laying out his plaza in terms of the circle and the square, he has built it around the oval and the trapezoid. The patterned pavement that frames the statue of Marcus Aurelius is an elongated ellipse of radiating lines, while the piazza as a whole widens from front to back, creating a forced perspective like the one he employed to such great effect in the windows in the Medici tombs. Though wildly unconventional, these innovations are not simply eccentric. Rather, they convey a feeling of movement, of shifting vistas as we process through the space, drawing us ever onward to the grand staircase at the far end of the square. As always for Michelangelo, form is not an end in itself, but something expressive of the body in motion and the mind in flux.

Bowing to the inevitable, Michelangelo graciously agreed to take over the building of St. Peter's on January 1, 1547, refusing his salary to indicate that he was shouldering this burden not for profit but for the love of God.* Not coincidentally, this grand gesture also served to distinguish him from his predecessor, who had turned La Fabbrica di San Pietro into a lucrative family business. When reporting on his progress to friends and colleagues, Michelangelo rarely failed to mention how much it cost him in terms of his peace of mind and how little he earned for his pains. "I was forced to undertake the work on the fabric of St. Peter's and for about eight years I have served not only for nothing," he explained to Vasari, who had been tasked

*To some extent, his refusal of a salary was an accounting technicality. He was handsomely compensated as Paul's *magister operae*. Later that same year he was awarded the proceeds from a ferry on the River Po. When the Duke of Parma refused to part with this revenue stream, his ambassador to Rome wrote: "Our Lord [the pope] spoke at length saying that if ever he had need of [Michelangelo] he had need of him now, in particular for the building of St. Peter's and of his Palace here, since Sangallo is dead. . . ." (See *Letters*, II, app. 33, 267–68.)

by his master Grand Duke Cosimo de' Medici to persuade Florence's most famous son to return home, "but at great cost and trouble to myself. But now that the work is advanced, that there is money to spend on it, and that I am almost ready to vault the dome, it would be the ruin of said fabric if I were to depart; it would disgrace me utterly throughout Christendom and would lay a grievous sin upon my soul." Given the metaphysical stakes involved, Michelangelo could hardly be faulted if he countered the duke's kind invitation with a polite refusal.

From the beginning Michelangelo was determined to put his stamp on the project, though he was constrained to some extent by what had already been accomplished by his predecessors. This was not necessarily a drawback, since much of his best work came when his fertile imagination was unleashed upon a particularly knotty problem. Above all, Bramante's long shadow loomed over the busy work site. Though he had been in his grave for more than thirty years, his basic conception and the work he actually managed to complete before his death determined many of the building's basic parameters. Four immense masonry piers 90 feet high, 30 feet in diameter, and 232 feet around established the dimensions of the central vault as well as the height of the nave and transept, each of which soared to 150 feet at their loftiest. Sangallo had modified Bramante's plan, providing much-needed reinforcement to the supports but also detracting from the clarity of the original by flanking the central space with columned ambulatories. His model also called for additional domes and spires as well as an extension of the nave to the east, turning Bramante's centralized Greek cross into a traditional basilica with a longitudinal axis.

Michelangelo did not hide his disdain for his predecessor or his cronies.* During the initial meeting in which he inspected the working model, "all the Sangallo faction . . . came forward and said how glad they were that the

* Michelangelo also clashed with the Sangalleschi over the design of the Palazzo Farnese, the opulent palace that Pope Paul III had commissioned. Begun by Sangallo, it was completed by Michelangelo, who again altered his predecessor's plan. Among other things, the Sangalleschi complained of the cornice he designed, which they claimed violated Vitruvian decorum by being far too heavy.

work had been given to him and that the model was a meadow that would always afford inexhaustible pasture." Michelangelo responded to this olive branch with sarcasm, agreeing with them only to the extent that "it would serve for sheep and oxen who know nothing of art." His contempt for the Sangalleschi was so strong that he reconciled with Bramante's ghost, apparently having decided that his former enemy was a genius after all. "Messer Bartolomeo, dear friend," he wrote to Bartolomeo Ferratini shortly after accepting the position of *capomaestro*,

> *One cannot deny that Bramante was as skilled in architecture as anyone since the time of the ancients. He it was who laid down the first plan of St. Peter's, not full of confusion, but clear, simple, luminous and detached* [from encumbrances] *in such a way that it in no wise impinged upon the palace. It was held to be a beautiful design, and manifestly still is, so that anyone who has departed from Bramante's arrangement, as Sangallo has done, has departed from the true course; and that this is so can be seen by anyone who looks at his model with unprejudiced eyes.*
>
> *He* [Sangallo], *with that outer ambulatory of his, in the first place takes away all the light from Bramante's plan; and not only this, but does so when it has no light of its own, and so many dark lurking places above and below that they afford ample opportunity for innumerable rascalities, so that at night, when the said church closes, it would need twenty-five men to seek out those who remained hidden inside, whom it would be a job to find.*

It is characteristic that Michelangelo would admit Bramante's virtues only after death had removed him as a rival; praising the beauty of the original plan also provided him with a handy cudgel with which to beat the Sangalleschi. But Michelangelo did not simply praise Bramante in order to damn Sangallo. With his sensitivity to the dramatic potential of mass and space, he understood that Bramante's soaring vaults had been elaborated to death by Sangallo's fussy intervention. Though even larger than Bramante's model, Sangallo's version is oddly diminished, as Michelangelo pointed out, by "numerous projections and angles," so that "his style had much more of the German than of the good antique or modern manner." His reference to

"many dark lurking places" that encourage "innumerable rascalities" sounds ludicrous until one remembers the faith Renaissance humanists placed in the healing power of geometry. If clear, uncluttered spaces mirrored the mind of God, then small, dark spaces might well attract the Devil.

Michelangelo's appointment as *operaius* disrupted the clubby, corrupt corporation that had run things for so many years. He sacked many of those closest to his predecessor, while thoroughly reorganizing the procurement process through which many enriched themselves at the Vatican's expense. But old habits were hard to break, particularly when they proved so profitable. A year after taking the reins, Michelangelo wrote a letter to the overseers of La Fabbrica scolding them for falling into old patterns:

> *Whoever takes delivery of materials necessary to the fabric but of inferior quality, which I have forbidden, does nothing but treat as friends those whom I have treated as enemies. This, I think, would be a new confederacy. Promises, gratuities and presents corrupt justice. I therefore pray you, with that authority I have from the Pope, henceforward not to take delivery of anything that is not suitable, even if it comes from Heaven, so that I may not appear to be what I am not—partial.*

Unstated, but nonetheless implied, is the moral superiority he gained by refusing a salary, though he cedes some of the high ground when he labels those he disagrees with "enemies," demanding of anyone who would serve him not only obedience but slavish devotion.

The first order of business was to knock down Sangallo's ambulatories, which had destroyed the clarity of Bramante's design. Then Michelangelo reinforced the central piers to allow them to carry the lofty dome he contemplated, modeled on Brunelleschi's famous cupola for the Cathedral of Florence. So far, however, the impressive crown he had conceived, and even the overall plan, were still only inside his head. Unlike Sangallo, who provided a detailed model of the proposed work, Michelangelo preferred to keep his assistants in the dark, supplementing rough sketches with detailed instructions on a strict "need to know" basis. As always, his preference for secrecy amounted to an obsession, as if even at this point in his career the thing he

dreaded most was the possibility that someone would steal his ideas. This was particularly self-defeating, since his other principal concern was to bring the work to a point that, even after his death, no one would be able to alter it.

Despite carping from the Sangalleschi, the pope had complete confidence in his *operaius*. On October 11, 1549, knowing he was nearing the end of his life, Paul issued a decree, putting in writing the authority Michelangelo had enjoyed in practice, officially naming him master of the basilica:

Forasmuch as our beloved son, Michael Angelo Buonarroti, a Florentine citizen, a member of our household, and our regular dining-companion, has remade and designed in a better shape, a model or plan of the fabric of the Basilica of the Prince of Apostles in Rome, which had been produced by other skilled architects, and has done the same to the building itself or its plan without accepting the reward or fee which we have repeatedly offered to him, but has done so because of the unfeigned affection and single-minded devotion which he has for that church;

And, moreover, trusting in the good faith, experience and earnest care of Michael Angelo himself, but above all trusting in God, we appoint and commission him the prefect, overseer and architect of the building and fabric of the aforementioned Basilica on behalf of ourselves and of the Apostolic See for as long as he shall live. And we grant him full, free and complete permission and authority to change, re-fashion, enlarge and contract the model and plan and the construction of the building as shall seem best to him; to choose and commission all and several helpers and prefects and other men needed to work in that said building, and to arrange their due and customary wages and fees; and to release, dismiss and withdraw at will those same men, and others chosen previously, and his deputies; and to provide others as it shall seem best to him to do. . . .

With this decree, Michelangelo's triumph over his enemies was complete, though perhaps only temporary. The eighty-two-year-old pontiff was increasingly frail, worn down by the strain of fending off the twin

behemoths of the French king and the Holy Roman emperor and by personal misfortunes, including the assassination of his oldest son, Pier Luigi, in 1547.

Paul's death, which came less than a month after he issued the decree, was potentially disastrous. Michelangelo had known Farnese since he was a boy, and as long as he lived he knew he would enjoy the protection and patronage of the great lord. His successor, elected after a contentious conclave lasting three months, was a relative unknown, the sixty-three-year-old Roman Cardinal Giovanni Maria Ciocchi del Monte, who took the name Julius III. Julius was a compromise candidate agreed upon after the pro-French and pro–imperial factions in the College fought to a standstill. Michelangelo did not have a close personal relationship with the new pope and, given the ongoing hostility of La Fabbrica, he had every reason to worry that his new boss would fall under the sway of his enemies.

Initially, the new pope appeared determined to at least be more even-handed in his dealings with the Fabbrica di San Pietro than his predecessor, who had taken Michelangelo's side in every quarrel. In a letter of February 1550 the artist fretted that Julius believed he was too old to carry out his duties. His suspicions only grew when he was summoned to a hearing in the Vatican organized for the express purpose of allowing the Sangallo faction a forum where they could air their many grievances. Michelangelo listened sullenly while his enemies attacked him. Offending not only against good manners but against good taste, they claimed, Michelangelo had reversed Sangallo's decision to build a traditional basilica and instead "was constructing a Temple in the image of the sun's rays"—that is, one featuring the centralized, radial plan contemplated by Bramante.

Chief among his critics was Cardinal Cervini, the official responsible for disbursing funds, who now rose to complain that he was kept in the dark about exactly what it was he was paying for. Michelangelo had remained silent through most of the hearing, but at this latest attack he rose to defend himself. Turning to the Cardinal, Michelangelo delivered a stinging rebuke. "I am not obliged, nor do I intend to be obliged, to say either to your Highness or to any other person what I am bound or desirous to do," he rumbled.

"Your office is to obtain the money and to guard it from thieves, and the charge of the design for the building you must leave to me."

Antagonizing the powerful cardinal could have been disastrous, particularly since Julius had yet to show where his sympathies lay. Forcing the issue, Michelangelo then addressed himself to the pope, playing the one card he had—the threat that if he was not given carte blanche to do as he pleased, he would simply walk away. "Holy Father, You see my reward; if the pains I endure profit not my soul, I am losing both time and labor."

Once again Michelangelo's ploy paid off. Much to his relief, and much to the chagrin of La Fabbrica, Julius decided to stand by his *operaius*. Placing his hands on the artist's shoulders, he replied: "Doubt not that you are gaining good reward both for soul and body." Adding substance to this gesture, he soon announced that he was renewing Pope Paul's decree giving Michelangelo complete control of the project. Once again an artist of genius had defied a powerful elite and emerged victorious. While there were plenty of cardinals to go around, someone of Michelangelo's talents was unique. When forced to choose, this pope, at least, had the good sense to take the side of the indispensable man.

III. BOUND BY NO RULES

Of all Michelangelo's major works, St. Peter's is the only one in which his contribution is not immediately obvious. Usually, his contribution is instantly recognizable, stamped by the force of his outsized personality. Even in the more cerebral form of architecture, where individuality is harder to assert, his designs are marked by an idiosyncratic, almost neurotic approach, as if he is incapable of making any form that is not expressive of some inner turmoil. But St. Peter's is a child with many fathers, not so much a collaborative effort as a product of a protracted custody battle in which each parent pulled his offspring in a different direction. More than a century and a half elapsed from Bramante's excavation of the foundations in 1506 to Bernini's completion of the magnificent piazza in 1667. Over this span almost a dozen master architects contributed their ideas and their labor to the project, as well as thousands of artisans and workers upon whose backbreaking labor

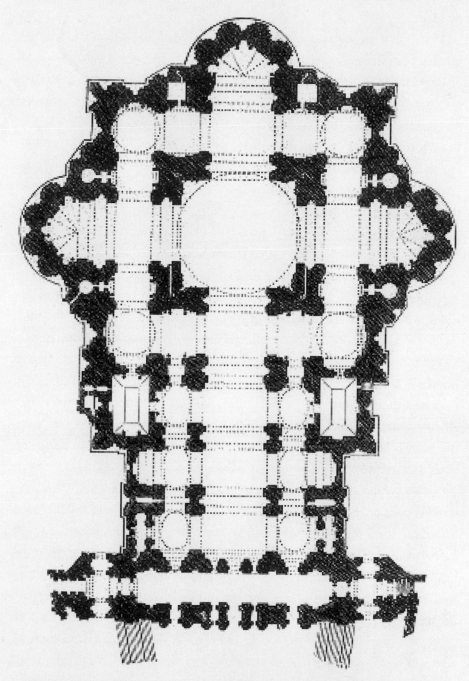

Michelangelo's plan for St. Peter's, c. 1546, extended by Carlo Maderno, c. 1602.

the flawed magnificence of Christendom's most famous monument depended.

The church we see today does not belong to Michelangelo any more than it belongs to Bramante, or Maderno, who provided it with a palatial façade, or Bernini, who turned a Renaissance masterpiece into a theater of Baroque bombast. Michelangelo's imprint is subtle but pervasive. He swept away the unnecessary clutter that Sangallo added, restoring the original grandeur of Bramante's conception but reinterpreting it through his own peculiar genius. He reduced the building's size but increased its power, melding disparate parts into a coherent whole, at once more nuanced and engaging than anything in the original design.

The best vantage from which to study Michelangelo's contribution is from the Vatican Gardens to the west of the basilica, where the dome seems to spring from the undulating wall like a leonine head proudly raised on massive shoulders. From here one can appreciate how he modified Bramante's plans to conform to his own conception of architectural form. While Michelangelo appreciated Bramante's masterful handling of mass and void, he was less concerned with abstract geometry than with organic unity and expressive potential. In the Medici tombs and the Laurentian Library, vertical members do not simply support their loads but bow and flex in response to stresses like Atlas straining to hold aloft the vault of heaven. In painting and sculpture, the human body was always his point of reference, and when Michelangelo turned to architecture, engineering was reinterpreted as a muscular contest of thrust and resistance. In a letter to an unknown cardinal, he paraphrases the famous passage in Vitruvius where he claims that the symmetry demanded of architectural forms derives from the symmetry of the human body. "It is therefore indisputable that the limbs of architecture are derived from the limbs of man," he insists. But then Michelangelo gives the passage a distinctive slant, saying that "[n]o-one who has not been or is not a good master of the human figure, particularly of anatomy, can comprehend this."

On the one hand, Michelangelo is engaged in a little self-promotion, attempting to persuade someone who may have been skeptical of his qualifications that his training made him the perfect man for the job. But he was doing more than this: Michelangelo's approach to anatomy, unlike

Vitruvius's—and also unlike that of Leonardo, the only contemporary to rival his profound knowledge of the human body*—is functional, not based on abstract mathematical proportions but on the dynamism of a body in motion. Inscribing the body inside various geometrical patterns works when that body is conceived as a static form, but what happens when that figure crouches, twists, or recoils in horror? Then, rigid formulas must give way to a different kind of understanding.

Michelangelo's approach to building follows from this insight. Weight, mass, tension, stress—these are not simply problems to be solved by the engineer but the very soul of the building. This is not exactly the modernist creed that form must follow function. Indeed, Michelangelo often makes a mockery of these fundamental laws of physics, as when he places the columns of the Laurentian Library vestibule in recessed niches or leaves the brackets of the Medici tombs hanging in midair. But unlike most architects, whose esthetic demands a static sense of order, of logical coherence, Michelangelo treats the building as a dynamic system, as each part responds to the forces working upon it. Exertion and exhaustion, rather than serenity and balance, are the hallmarks of his architecture.

In the case of St. Peter's, this quality can be most clearly seen in the so-called hemicycles, the walls and pilasters that weave around the rear of the building like a Chinese dragon and that support the soaring mass of the dome above. Compared to Bramante's perfect circles, squares, and crosses, Michelangelo's undulating wall feels like something living, an effect achieved, in part, by defying Vitruvian norms and turning the secondary piers at oblique angles so that one form flows into another. These quirky shapes are the equivalent of the lozenge he introduced into the pavement of the Campidoglio that gives the impression that the ground is being squeezed by the converging buildings to either side. The whole western half of the

*This is not an entirely fair characterization of Leonardo's approach. In many ways he was more scientific than Michelangelo. He had a deep interest in circulation and embryonic development, which held no interest for Michelangelo. But for Leonardo, such concerns were largely separate from his artistic ones. When it came to studying the human body for the purposes of art, he tended to follow Vitruvius's fascination for abstract mathematical proportions.

church appears to throb and swell in response to the burden of carrying the immense dome above, as if, like the millions of pilgrims making the rounds of the holy sites, the stones themselves wish to show their devotion to the Lord through the strength of their effort.

Also uncanonical are the giant Corinthian pilasters that rise from the ground to the architrave (the horizontal band that runs below the attic) and that knit together the multiple stories of the exterior wall into coherent units. Though based on ancient precedents, such "colossal" orders—which he also deployed in the buildings of the Campidoglio—can be found nowhere in Vitruvius. It was one of those creative adaptations to novel situations that offended those for whom the ancient texts were gospel.* In another break with convention, Michelangelo superimposes these pilasters so that they overlap and bunch together at each turn, like a bundle of sticks gathered in the hand, softening the angles and reinforcing the impression that we are looking at a natural rather than a man-made form. The bays articulated by these grouped pilasters are not uniform, but instead alternate in a pattern of wide-narrow-wide, creating a rhythmic movement that encourages us to move in sympathetic response. This accordionlike effect of compression and release is echoed in the architrave, where the parallel bands bunch together as if squeezed by the weight of the dome above. Ironically for a sculptor who famously despised the technique of modeling, Michelangelo treats his building materials as if they were as malleable as soft clay. Of course, the pilasters and other architectural elements are cut from hard stone—the warm, pale travertine so often favored by Roman builders—but they seem to respond to the undulant flow of the wall, dispersing or clumping together as it snakes along the ground.

Michelangelo's most visible contribution to the exterior is the soaring dome on its high drum that still dominates the Roman cityscape, a beacon to the armies of the devout—and to the hordes of tourists—who can use it to orient themselves without the need of a map. Even here, however, an uncertain

* Alberti and Raphael had both deployed the colossal order before Michelangelo, but no one used it with such skill and to such dramatic effect.

journey leads from conception to realization. While the drum was completed by 1564, the dome was not raised until 1590, when Giacomo della Porta finished the job in a remarkable two-year campaign.

Most scholars assume that the vertical contour we see today is not the one Michelangelo intended but is the invention of della Porta freely interpreting his predecessor's design. Making the dome steeper allowed for greater visibility as the church was extended to the east to form a traditional Latin cross, and relieved some of the lateral stress that would have been exerted by the hemispherical cupola originally contemplated. But in fact, sketches from Michelangelo's workshop show the artist playing around with alternate profiles, trying out different combinations of drum, cupola, and lantern. Unlike Sangallo, who worked out every detail in advance, Michelangelo liked to keep his options open, making modifications as he experienced the building rising up around him. If della Porta's dome does not follow Michelangelo's final conception, it certainly replicates ideas he had contemplated at an earlier stage of development.

Even if we grant that the steeper profile is della Porta's invention, in almost every other way the magnificent dome is essentially Michelangelo's. Bramante had proposed a low, stepped cupola of concrete inspired by the Pantheon, while Sangallo reconceived it as a tiered structure with stacked colonnades that would carry the fussy ornamentation of the lower stories into the sky. Not surprisingly, Michelangelo rejected Sangallo's solution. But he also rejected Bramante's, sensing that the immense bulk of the church demanded a more dramatic focal point.

In reimagining Bramante's cupola, Michelangelo naturally turned for inspiration to the famous dome erected by Brunelleschi more than a hundred years earlier in his hometown of Florence. Shortly after his appointment as *operaius,* he wrote to his nephew Lionardo: "I want you to get, through Messer Giovan Francesco, the height of the cupola of Santa Maria del Fiore from where the lantern begins to the ground, and then the over-all height of the lantern, and send it to me. Also send me in the letter the measured length of a third of a Florentine *braccio* [about two feet]."

Like Brunelleschi's dome, Michelangelo's cupola is a ribbed vault made from mutually reinforcing shells. As built, St. Peter's dome has three shells

beginning (from the inside out) with the skin that forms the hemispherical interior and ending with the more conical vault that creates its distinctive profile.* But while Michelangelo clearly looked to Brunelleschi for inspiration and structural guidance, he knew he could improve on the original. During his years in Florence he had been consulted by a commission tasked with completing the still-unfinished drum of the Cathedral. Not only did Michelangelo criticize Baccio d'Agnolo's design for a gallery as "a cricket cage," but he tried to work out his own solution to bridging the unsightly gap between the roof of the nave and the cupola. In the end, he abandoned the scheme as unworkable, but the lessons learned in this abortive project informed his design at St. Peter's.

Instead of the eight ribs springing from an octagonal drum, Michelangelo doubles the number to sixteen, each set on an entablature supported by pairs of Corinthian columns. Between these paired columns he places rectangular windows with alternating triangular and curved pediments, creating a musical, richly textured play of solid and void, light and shadow. Viewed from the ground and bathed in the bright Roman sun, the dome surges to a satisfying crescendo, billowing ever higher in powerful muscular ripples. Nowhere can Michelangelo's unmatched feeling for sculptural form—for imparting to obdurate matter an almost sexual element of tumescence as stone seems imbued with pulsing life—be seen to greater effect, as the great stone vaults yearn skyward in a climax that is equal parts sensual and spiritual.

Entering the church, one is hard-pressed to discern the same genius at work. Indeed, it is difficult to experience a coherent sense of space at all in the gilded, polychromed, encrusted, bejeweled, and generally overelaborated spectacle that constitutes the most famous church in Christendom. Though the space beneath the dome, as well as the surrounding areas encompassing the transept and the apse, largely reflects Michelangelo's reworking of Bramante's basic scheme, all clarity is lost amid the profusion of decorative elements. The massive piers faced by colossal Corinthian pilasters—the most

* This three-part structure departs from Michelangelo's original conception, which, following Brunelleschi's lead, used only two separate shells.

enduring relics of Bramante's original design—still possess some of the majesty of the original conception, but even here at its most capacious, St. Peter's suffers from surfeit, a horror vacuii in which no surface is left undecorated, no space unencumbered.

If there can be said to be a presiding genius at work here, it would be the great seventeenth-century sculptor and architect Gian Lorenzo Bernini, responsible for the *baldachino*—the gargantuan canopy that sits beneath the dome on spiral columns—and for the magnificent peristyle piazza, as well as much in between. In the years following Michelangelo's death, the basilica continued to creep eastward as three bays and a narthex (porch) were added to the nave, transforming the centralized structure conceived by its first architect into the Latin cross that was always the favored solution of the Vatican bureaucracy.

As the Renaissance faded, so did the infatuation with pure geometry that fifteenth- and sixteenth-century humanists absorbed from their study of Greek texts and Roman buildings. Such abstractions seemed irrelevant to the new passions and new imperatives of the Counter-Reformation. Just as titillating nudes and pagan gods were purged from frescoes and altarpieces, so too were the philosophical conceits of an earlier generation of architects swept aside to make way for built environments that served the needs of the Church Militant. If Alberti believed that a church should reflect the perfection of God, the popes who presided over the later stages of the construction thought like businessmen concerned with getting as many people through the door as possible. Once there, of course, they should be suitably impressed, but architectural space was not an end in itself—any more than beauty in painting or sculpture was an end in itself—but merely a means of heightening spectacle in order to win more converts to the faith.

The new Basilica of St. Peter was finally consecrated on November 18, 1626, more than sixty years after Michelangelo's death, in a solemn ceremony presided over by Pope Urban VIII. It was exactly 1,300 years after the consecration of the first church built atop St. Peter's tomb and 120 years since Pope Julius II laid the cornerstone for its successor. More than 40 years would elapse before the complex received its final form with the completion of Bernini's magnificent piazza, within whose stony embrace tens of

thousands of the faithful still gather to hear Easter Mass or to welcome each new pope as he makes his first public appearance on the second-floor balcony. The church's façade, designed by Carlo Maderno at the beginning of the seventeenth century, bears the inscription of a man every bit as boastful as the one who set the project in motion: IN HONOREM PRINCIPIS APOST PAVLVS V BVRGHESIVS ROMANVS PONT MAX AN MDCXII PONT VII (In honor of the Prince of Apostles, Paul V Borghese, Supreme Roman Pontiff, in the year 1612, the seventh of his reign).

Even on the façade one can find echoes of Michelangelo's work, particularly in the colossal Corinthian pilasters that define the corners. But while Maderno borrows some of his motifs, he lacks Michelangelo's gift for expressive form. The wide, flat entranceway has none of the dynamism of the earlier work. Pompous, stuffy, and ornate, it is built to impress rather than to inspire, more closely resembling the approach to a royal palace or government office building than to the house of the Lord. Lacking all sense of transcendence, this represents the Church at its most corporate, most overstuffed, weighed down by earthly concerns.

Though Bernini's formal borrowings from Michelangelo are less immediately apparent, he shares more of his spirit. The sense of dynamic movement, the eccentricities of form in which a rigid geometry begins to melt into strange serpentines, culminates in Bernini's exuberant version of the Baroque. The wraparound arms of the peristyle and the hip-swiveling columns supporting the *baldachino* are the young master's tribute to the old. Indeed, it is impossible to imagine the full-blown biomorphic frenzy of Bernini—and of the Baroque in general—without those subversive deviations from strict rectilinearity first introduced by an architect who, as Vasari pointed out, "never consented to be bound by any law, whether ancient or modern . . . as one who had a brain always able to discover new things."

IV. O NIGHT, THE SWEETEST TIME

From the time of his appointment by Pope Paul III on the first day of 1547 to his death a little more than seventeen years later, Michelangelo dedicated himself to the work at St. Peter's, putting off a planned homecoming to Flor-

ence and begging Duke Cosimo de' Medici to excuse him on the grounds that he was engaged in a sacred undertaking. Whether or not he really intended to return to his native land or whether citing his work at the Vatican was merely a handy excuse to deflect the importunate duke, the challenge certainly engaged his mind and taxed his frail body; the fact that he was doing the Lord's work also soothed his troubled soul. Indeed, it was a fitting culmination to a career that had begun more than half a century earlier, and which saw him rise from a humble apprentice in the studio of Ghirlandaio to become the most famous artist on earth, a man who could sharply rebuke a prince of the Church or take his ease with popes.

Worldly considerations alone would not have caused him to take on this herculean task. His reputation was secure even without this particularly gaudy feather in his cap, and despite his incorruptibility, he had become financially secure, even wealthy, in the service of popes and other great lords. In 1547 he was seventy-two years old and troubled by the usual illnesses that afflict old men. The difficulty of the work—not to mention the trials of battling with a recalcitrant bureaucracy and fending off ambitious young men eager to push him aside—took a daily toll. Though he remained as much of a perfectionist as always, his diminishing vigor meant that his desire to control every aspect of the project was often a source of frustration. He could not be the hands-on, detail-obsessed tyrant of old; he simply lacked the energy to bully his underlings into submission. His unconventional approach and secretiveness meant that instructions to his workers were easily misinterpreted. On at least one occasion this proved a disastrous combination. In April 1557, Michelangelo discovered that the vault over the southern apse had been built incorrectly, as the overseer, one Bastiano Malenotti, misread his plans, taking the centering structure he had sketched out to be the design for the vault itself. "I am in a state of greater anxiety and difficulty over the affairs of the said fabric than I have ever been," he wrote to the duke. "This is because, owing to my being old and unable to go there often enough, a mistake has arisen over the vault of the Chapel of the King of France, which is unusual and cunningly contrived, and I shall have to take down a great part of what has been done." In reporting the same mishap to Vasari, he concluded, "if one could die of shame and grief I should not be alive."

But Michelangelo persevered, working against time to secure his legacy. Like Pope Julius II, who had decided to rebuild St. Peter's as a monument to God and to himself, Michelangelo assumed that whatever served his art must necessarily serve the Lord. As he approached the end of his life, his piety deepened, but dedicating himself to a higher cause did not mean he was capable of putting ambition aside or that he was inclined to treat his colleagues with greater consideration. He continued to believe that the world was full of mediocre men determined to steal credit for his work, as he explained in a letter of 1557 to his nephew: "[I]f I've delayed in coming [to Florence] as I promised, I've always included this condition, that I would not depart until I had brought the building of St. Peter's so near to completion that no one could ruin or change my design, and to give no opportunity to those who would rob and steal." If he was to invest so much of himself in this final tribute to an awesome God, he wanted to make sure the Lord knew who was making the offering.

Michelangelo was not only beset by technical difficulties but harassed by the deputies of La Fabbrica, who continue to wage guerrilla war against him. In return, he made no secret of his disdain, treating them as nothing more than bean counters who should keep their noses out of his business, while they schemed behind his back to have him replaced. "From the year 1540 when the rebuilding of St. Peter's was resumed with new vigor to the year of 1547, when Michelangelo began to do and undo, to destroy and rebuild at his own will, we have spent 162,624 ducats," the deputies of the Fabbrica complained to the pope:

> [We] *highly disapprove Michelangelo's methods, especially in demolishing and destroying the work of his predecessors. This mania for pulling to pieces what has already been erected at such enormous cost is criticized by everybody; however, if the Pope is pleased with it, we have nothing to say.*

Once again Julius III was forced to choose between the artist and the bureaucrats, and once again he ruled in Michelangelo's favor, issuing a new *motu proprio* (decree by his own will) that not only reaffirmed the authority given to him by Pope Paul, but also named two additional deputies of

unimpeachable loyalty whose sole purpose was to ensure that Michelangelo would not be "disturbed, or hindered, or disquieted in any way. . . ."

If, as he often proclaimed, he had taken on the rebuilding of St. Peter's for the sake of his eternal soul, Michelangelo's dedication to God quickly vanished in the face of a perceived slight. On these occasions he resorted to his favorite tactic—threatening to quit unless he got everything he wanted. In the summer of 1563 his foreman Cesare Bettini was murdered by a jealous husband, and when the deputies of La Fabbrica appointed a new foreman without his consent, Michelangelo immediately sought out the pope (at the time, Pius IV), accosting him in the Campidoglio. "Holy Father," he addressed the startled pontiff, "the Deputies have appointed in my place someone whom I do not know, but if they and Your Holiness think me no longer capable, I will return to take my ease in Florence and to enjoy the favor of the Duke, as he has so much desired, and will there end my days in my own house. I therefore ask for my discharge."

Faced with the loss of the great man's services, Pius reversed the board's decision, but this did little to encourage cooperation between Michelangelo and his supervisors. Vasari, who often visited the aging artist during these years, experienced firsthand the poisonous atmosphere at the Vatican, where backstabbing and slander were the normal forms of social intercourse, recalling that "Michelagnolo's adversaries kept harassing him every day, now in one way and now in another."

But despite the persistence of anti-Michelangelo cabals, work on the basilica progressed, if only in fits and starts. On January 23, 1552, Michelangelo marked an important milestone when the cornice for the base of the drum was completed. Just as the four piers Bramante erected before his death established the dimensions of the central crossing, the completion of the cornice determined for all time the dimensions of the dome. Typically, Michelangelo celebrated not with a formal ceremony attended by princes of the Church but with the humble bricklayers on site. The meal, delivered from the nearby inn of the Paradiso, included on the menu fried pig's liver, wine, bread, and 100 pounds of sausage. As an additional bonus, Michelangelo delivered felt caps to all the workers as a reward for a job well done.

After this burst of activity, however, the pace slowed considerably, ham-

pered by a shortage of funds and distracted leadership. In the spring of 1555, Julius III was replaced by Marcellus II, the former Cardinal Cervini, with whom Michelangelo had clashed five years earlier. Though Julius was personally corrupt—among his more egregious acts was to name the handsome boy who kept his pet monkey, one Fabiano, to the College of Cardinals (some said he was his son, others his lover)—he had proven himself a loyal friend to Michelangelo. The artist could expect no such deference from the new pope, a humorless penny-pincher with little taste for art. "Everything was sad, gloomy, and disheartening," one resident grumbled, and when the pope died after less than a month in office, there was almost universal rejoicing.

From Michelangelo's point of view, however, the election of Gian Pietro Caraffa as Paul IV was hardly any more promising. A founder of the hard-line Theatines, Paul was a zealot who preferred to invest in racks and thumbscrews for use on heretics (a process referred to by the euphemistic term "rigorous examination") than on expensive building projects. He valued art less for its own sake than as a form of propaganda, and it was he who arranged to have the "indecent" portions of Michelangelo's *Last Judgment* painted over.

Despite Paul's doubts as to Michelangelo's orthodoxy, he kept him on as *magister operae* and even consulted him when it came to the vital task of strengthening the city's defenses. The artist no longer enjoyed the intimacy he had had with Paul III or Julius III, but the new pope regarded him with at least grudging respect. In fact, the biggest obstacle to progress was not Paul's distrust of Michelangelo but his lack of political acumen. Under his erratic leadership, the always unsettled international scene became even more perilous, threatening a repetition of the disasters of Pope Clement's time.

Paul—like every pope since Alexander VI at the end of the previous century—was caught between France and the Empire, the two great powers vying for supremacy in Europe. To avoid being crushed by either of these two lumbering giants, the papacy generally adopted a strategy of flexible neutrality, leaning this way or that as circumstances required, usually weighing in on the side of the weaker party but never fully committing to either one. It was a policy dictated by the fact that final victory by either one would almost certainly spell the end of Italian independence. Caraffa, however, was temperamentally incapable of neutrality. Even before his elevation he

made no secret of his hatred for the Empire, and after his election openly declared his preference for the French. His diatribes against the perfidious emperor—whom he labeled a schismatic and a heretic—and his Spanish allies had predictable results. In September 1556, Spanish troops under the Duke of Alba marched across the border of the Papal States, overrunning the Roman port of Ostia and threatening a repetition of the devastating sack of 1527. Work was halted on the basilica as the *scarpellini* scattered, and Michelangelo himself fled the city, galloping off to the mountains to commune with rustic holy men.

For once, Michelangelo reveled in inactivity, apparently finding the bucolic setting a pleasant change from the city. Writing to Vasari, he spoke of "my great pleasure here among the hermits in the mountains of Spoleto," and opined that "peace is truly to be found only in the woods." This is one of the few times he expressed a love for the natural world so common among his contemporaries.* While Lorenzo de' Medici penned sonnets celebrating the simple pleasures of the countryside and while Leonardo, Raphael, and Titian painted glorious landscapes as a backdrop to their sacred narratives, Michelangelo found material enough in the inexhaustible drama of the human form.

In the end, the Duke of Alba withdrew after forcing the pope to sign a humiliating treaty, and Michelangelo returned to the city. But though the immediate crisis had passed, the almost constant turmoil distracted him and placed additional burdens on his time. He had earned a reputation as a military engineer while serving as *governatore generale* of the Tuscan fortifications during the siege of Florence, and throughout this tense period he was often brought in to consult on the rebuilding of the city's defenses, work that drained his already limited stores of energy and embroiled him in quarrels with professionals who resented his interference.†

Under the almost daily threat of invasion, the building of St. Peter's lan-

* A poem of c. 1534 is Michelangelo's one attempt at a Virgilian idyll. Here Michelangelo evokes the pleasures of the "modest little hut of thatch and sod" where an old grandfather "basks in the dooryard sunshine." (See *Complete Poems,* no. 67, p. 51.) Such images appear infrequently in Michelangelo's work and seem more conventional than deeply felt.

† Peace came in April 1559 with the signing of the Treaty of Cateau-Cambrésis—in which the French king Henry II renounced all claims on the peninsula—bringing to a close the

guished. In the winter of 1557, Michelangelo felt compelled to write to Lio-
nardo to dispel rumors that work had ground to a halt: "As regards to the
fabric being closed down there is no truth in this, because, as may be seen,
there are still sixty men working here, counting *scarpellini,* bricklayers and
laborers, and doing so with the expectation of continuing." But while he
insisted to his nephew that everything was going according to plan, he fret-
ted that he would not be able to bring work to a point where it could not be
altered after his death. "To leave now," he told Vasari, "would mean the total
ruin of St. Peter's, a great shame and an even greater sin."

Given the difficulties he faced, it was perhaps fortunate that Michelangelo
was no longer as driven as he had been in his youth. Contemporary accounts
record him riding about town on a small chestnut pony, respectably dressed
in a velvet cloak and leather boots, and apparently in no particular hurry.
While Holanda's account of the artist conversing with his highborn friends
at the cloister of San Silvestro is almost certainly idealized, it is clear that
some of Michelangelo's rough edges had been worn smooth by the passage
of time. The architect's calling was far more refined than the sweaty, dusty
work of the sculptor, and also more respectable—a pastime for gentlemen
and scholars who studied Latin texts and who used brain rather than brawn.

Despite daily aggravations brought about by incompetence, indifference,
and petty spite, Michelangelo had reached a stage in life where he could re-
gard such annoyances from a certain philosophical distance. From time to
time, he made the crosstown journey to inspect the progress on the church,
but he was no longer compelled by an ambition so fierce that it consumed
every waking hour. In his private life he had achieved a measure of calm,
if not exactly contentment. With the death of his brother Buonarroto in
1528 and of his father three years later, the ties that bound him to the fam-
ily hearth in Florence had largely been severed, and with them many of the
emotional entanglements that too often in the past had distracted him from
his work. His passion for Tommaso de' Cavalieri had cooled as well, though

more than sixty-year tragedy that began when Charles VIII's army crossed the Alps in
the fall of 1494.

the young nobleman remained a devoted friend, easing his way into society and defending him against his detractors.

Michelangelo had made a life for himself in Rome that satisfied his professional, emotional, and spiritual needs, but he continued to think of himself as a Florentine. Despite a few close friendships with natives—most notably Tommaso de' Cavalieri and Vittoria Colonna—he spent most of his time and felt most comfortable in the company of his fellow expatriates.* He lived as one of the *fuoriusciti,* the exiles, who resided in Rome but spoke in the dialect of Tuscany, growing wealthy through serving the princes of the Church while never shedding their jingoistic prejudices.

About the only thing all members of the Florentine community in Rome shared was a belief in their superiority to the local population; in every other way they were divided against themselves. While some were supporters of the Medici, many were refugees from Medici tyranny. The able and ruthless Duke Cosimo, who had succeeded Alessandro after his assassination in 1537, proved far more effective than his cousin at consolidating and extending Medici power, but his triumphs—including the conquest of Florence's ancient rival Siena in 1555—made the exiles wax nostalgic for all they had lost. Unlike his fifteenth-century forebears, who held the reins of power while maintaining the fiction they were simple citizens of the republic, Cosimo ruled as a hereditary lord and as a vassal of the hated emperor. His power rested not on the consent of his fellow citizens but on the intimidation of imperial arms.†

Many of Michelangelo's closest friends in Rome were vocal opponents of

* In 1559, Michelangelo was approached by the leaders of the expatriate community to design San Giovanni dei Fiorentini, the Florentine church in Rome. His plans were never executed, but drawings show that he planned a domed, centrally planned structure similar to Bramante's plan for St. Peter's. The ambitious proposal demonstrates the size and wealth of the Florentine expatriate community.

† This alliance was cemented by Cosimo's marriage to Eleanora of Toledo, daughter of the Viceroy of Naples. Perhaps the most despised symbol of their subjugation was the immense Fortezza da Basso at the western edge of Florence. One explanation for Michelangelo's falling out with Alessandro de' Medici had been his refusal to participate in building this instrument of suppression.

the duke, including Donato Giannotti, Machiavelli's successor as Secretary to the Nine of War during the last years of the republic. Exiled since 1539 for his opposition to Medici rule, he now served as secretary to Cardinal Ridolfi, also a critic of Cosimo. Sometime around 1542, Giannotti asked Michelangelo to carve a bust of Marcus Junius Brutus, murderer of Julius Caesar, a not-so-veiled tribute to the assassin of Alessandro de' Medici.* Given Michelangelo's oft-demonstrated reluctance to stick his neck out, it's unclear why he accepted such a potentially dangerous commission. Certainly, he wished to do a favor for his friend; it's also true that he shared, at least in principle, Giannotti's opposition to the current regime. But if Michelangelo shared the ideals of the anti-Medici faction in Rome, he generally chose the path of discretion rather than valor. It's not surprising, then, that he never finished the commission, disavowing the project and handing over the roughed-out bust to his pupil Tiberio Calcagni.†

The abortive bust of *Brutus* is but one more example of Michelangelo's complicated relations with the ruling dynasty of Florence. He had loved his first patron as a second father, and had also faithfully served Il Magnifico's son and nephew. But just as often he joined with their enemies, most notably during the three years of the last republic when his work on behalf of the anti-Medici regime forced him to go into hiding once Alessandro and his thugs regained power. Perhaps his refusal to return to Florence reflected a continuing discomfort with Cosimo's heavy-handed rule, but if so he was always careful to hide his true feelings behind a screen of evasions and excuses.

* Alessandro's killer, his cousin Lorenzino, was dubbed by Florentine exiles "the new Brutus." Giannotti intended to give the bust to his employer, Cardinal Ridolfi.
† The *Brutus* is now in the collection of the Bargello Museum in Florence. A later inscription on the base of the sculpture suggests that Michelangelo abandoned the piece after meditating further on the nature of Brutus's crime. Though the inscription is spurious, the confusion it reflects is genuine. In a dialogue written by Giannotti, the author engages Michelangelo in a friendly debate about whether Brutus was a villain or a hero. Noting that his beloved Dante placed the tyrannicide in the lowest level of Inferno, Giannotti goes on to make a case for Caesar's assassin that is so convincing that the artist finally concedes, "I agree that Brutus and Cassius merit the praise that everyone has heaped upon them." (Giannotti, *Dialogi di Donato Giannotti*, Second Dialog, 90–91.)

Given the bitter suspicions that riled the Florentine expatriate community, it was impossible to avoid controversy entirely. Even though Michelangelo was naturally risk-averse, he showed his sympathies by the company he kept. Perhaps his closest friend during these years was a Florentine expatriate named Luigi del Riccio, a man who, while personally on cordial terms with Duke Cosimo, was closely associated with leaders of the opposition. An agent in the Roman branch of the Strozzi-Olivieri bank, del Riccio had taken over as Michelangelo's business manager after the death of Bartolommeo Angiolini in 1540. Like Angiolini and Jacopo Gallo before him, del Riccio not only handled Michelangelo's accounts, but generally looked after his welfare, fussing over him like a mother hen and attending to the practicalities of life so that the artist could devote himself to more important matters. Twice, in July of 1544 and then in 1546, he proved his devotion when Michelangelo came down with a dangerous fever. On both occasions del Riccio had the artist carried to his own apartment in the stately Strozzi palace where he could be properly looked after and protected from harassment by "all the prelates, the chief gentlemen of Rome, the Pope himself . . . [who] sent daily to enquire about the state of his health." Michelangelo later insisted that del Riccio had saved his life. In appreciation for this and many other services, he presented his guardian angel with the handsome gift of the two *Captives* from the tomb of Pope Julius.*

Del Riccio's act of kindness came back to haunt the artist in 1547 when Cosimo de' Medici issued punitive new measures against the rebellious *fuoriusciti*. Among the most prominent anti-Medici agitators were members of the Strozzi family, some of whom had led a disastrous military expedition against Florence in 1537. It was in the context of these harsh new laws that Michelangelo wrote a desperate letter to his nephew Lionardo: "As regards my being ill, in the Strozzi's house, I do not consider that I stayed in their house, but in the apartment of Messer Luigi del Riccio, who was a very great friend of mine. . . . [I]f I'm greeted in the street I cannot but respond with

*These two magnificent sculptures became obsolete after the tomb was reduced to its present dimensions. After del Riccio's death, Michelangelo presented them to his boss, Roberto Strozzi, who took them to France, where they now reside in the Louvre.

a kindly word and pass on—though, if I were informed as to which are the exiles, I would make no response at all. But as I've said, from now on I'll be very much on my guard, particularly as I have so many other anxieties that life is a burden."

Of course, Michelangelo is being disingenuous. It's impossible to believe that he was unaware of the political views of his various expatriate friends. As always, his inclination was to stand on the side of Florentine liberty as long as neither he nor his family paid too high a price, but as soon as Cosimo turned up the pressure, Michelangelo disavowed his past associations. And, as his relatives had so often done in the past, Cosimo forgave Michelangelo his indiscretions, trying (unsuccessfully) to lure the great man back to Florence, where his presence would add luster to his regime.

Del Riccio's services to Michelangelo went beyond managing his accounts and occasionally playing nursemaid. Not only did he ply him with delicacies like caviar, wine, and fresh melons; he encouraged his poetry and made sure his verses were read and taken seriously in literary circles. After the death in January of 1543 of his fifteen-year-old cousin, the handsome Cecchino de' Bracci, del Riccio badgered Michelangelo until he agreed to write a series of quatrains in tribute to the charming young man. A recurring motif of these short verses is the contrast of eternal beauty with the perishable body:

> My flesh made earth, my bones as well,
> deprived of his shining eyes and comely face,
> enslaved to his grace and his delight
> in that prison where, down here, the soul resides.

Here, Michelangelo explores the usual Neoplatonic image of the body as the prison of the soul, but in a playful note to del Riccio accompanying these lines he offers a telling variation. Instead of the word *diletto* (here translated as "delight"), Michelangelo suggests substituting *nel letto* (in bed), one of the few times he allows us to glimpse the carnal lust that was too easily concealed beneath high-minded rhetoric.

Though Michelangelo had mellowed with age, he was still thin-skinned; even the devoted del Riccio could not avoid provoking a tantrum. The source

of their quarrel has never been fully explained, but it elicited from Michelangelo a bitter reprimand that reveals something of his violent temper. "He who pulled me from the jaws of death also has the power to slander me," he wrote del Riccio in a fit of rage, concluding on this ominous note: "But if you bring me ruin, I will do the same, not to you, but to your possessions."

The two men apparently reconciled before del Riccio's sudden death in October 1546. "Now that Luigi del Riccio is dead," recorded the Bishop of Casale, "he is so stunned that he can do nothing but give himself up to despair." This was far from the only blow Michelangelo had to endure in these years. Like all those who live to a ripe old age, he suffered the steady loss of those he cared about. Many who passed away were far younger than he was, including Vittoria Colonna in 1547 (aged fifty-seven) and his faithful servant Urbino, whose death in 1555 at the age of forty-three caused him such grief. In addition to the gloomy prospect of enduring the slow deterioration of his own body, the passing of beloved friends contributed to that morbid streak so evident in his late poetry. When he was still in his early seventies, with more than a decade and a half left to him, he was already writing in an elegiac vein: "I am old and death has taken from me the dreams of youth. He who knows nothing of old age should await its coming patiently, since no one can conceive it before it happens."

But old age had its compensations, one of which was that it allowed him to rest on his laurels, to look back on a long life well spent and to bask in the adulation of an adoring public. He had defeated or outlasted all his chief rivals, achieving the recognition he always craved as honors were heaped on his graying head. Even the assault on *The Last Judgment* by the newly vigilant upholders of orthodoxy did not succeed in tarnishing his reputation as he continued to enjoy powerful protection. Perhaps the most gratifying tribute came in 1547 when the humanist Benedetto Varchi delivered two discourses on Michelangelo in front of a distinguished company at the Florentine Academy. Surprisingly, the first lecture dealt not with a work of art but with a poem, his *"altissimo Sonnetto"* that begins, "The greatest artist has no concept/not already present in the stone/that binds it, awaiting only/a hand obedient to mind." Referring to him as "our most noble citizen and academician," Varchi treated his rough-and-ready verse with the seriousness

usually reserved for discussion of Dante and Petrarch, offering validation in a field dominated by pedants.

Varchi's second lecture was presented as a *paragone,* a learned discourse on the relative merits of painting and sculpture, taking as its point of departure Michelangelo's oft-stated belief that carving in stone was the most noble of the arts. After receiving a copy of the lecture, Michelangelo sent a reply in which he acknowledged his prior views but confessed that Varchi had opened up to him new possibilities:

> *I admit that it seems to me that painting may be held good in the degree in which it approximates to relief, and relief to be bad in the degree in which it approximates to painting. I used therefore to think that painting derived its light from sculpture and that between the two the difference was as that between the sun and the moon.*
>
> *Now since I have read the passage in your paper where you say that, philosophically speaking, things which have the same end are one and the same, I have altered my opinion and maintain that, if in face of greater difficulties, impediments and labors, greater judgment does not make for greater nobility, then painting and sculpture are one and the same, and being held to be so, no painter ought to think less of sculpture than of painting, and similarly no sculptor less of painting than of sculpture. By sculpture I mean that which is fashioned by the effort of cutting away, that which is fashioned by the method of being built up being like unto painting. It suffices as both, that is to say sculpture and painting, proceed from one and the same faculty of understanding, we may bring them to amicable terms and desist from such disputes, because they take up more time than the execution of the figures themselves. If he who wrote that painting is nobler than sculpture understood as little about other things of which he writes* [a snide reference to Raphael's friend Baldassare Castiglione, who made just such an argument in *The Courtier*]—*my maidservant could have expressed them better.*

In this letter Michelangelo exhibits a surprising intellectual adroitness. Obviously flattered by Varchi's attention and pleased to be welcomed into

the community of writers, he appears to agree with the historian while at the same time making an able defense of the point he has apparently conceded. In fact, Michelangelo had an ulterior motive in conceding Varchi's argument. By claiming that all the arts were equally noble since each had its genesis in the creative mind, "the faculty of understanding," the humanist was conferring on Michelangelo's profession the respectability he had fought for all his life. Michelangelo's apotheosis at the Florentine Academy was further evidence that the humble artisan has joined the poet and the scholar as a member of the cultured elite. Artists work with their minds, not their hands, Michelangelo always insisted, a point driven home by Varchi's eloquent tribute. Thus, while Michelangelo maintains his preference for "relief," he has to agree with Varchi that a true artist is not defined by the medium in which he works: painters, sculptors, architects, poets, and musicians are all alike, shapers of the intangible stuff of the imagination, Man's most noble endeavor and God's greatest gift.

For Michelangelo, such tributes affirmed the path he'd chosen in life, but securing his legacy meant not only securing his status as a great artist but also restoring the faded luster of the Buonarroti name. The two goals were inextricably linked in his mind, and each was vital to his sense of who he was. From a childhood marked by poverty and shame, he had struggled to bridge the chasm between the lofty self-image instilled in him by his father—who claimed descent from the *nobilissimi* counts of Canossa—and the humiliating reality he experienced every day. While Michelangelo's brothers preferred to follow Lodovico's example, leading lives of indolence in keeping with their exalted status, Michelangelo strived to restore the family fortune while simultaneously insisting that he worked not for monetary reward but out of a sense of a higher calling.

Michelangelo funneled much of the money he earned from the sweat of his brow to his relatives, but his generosity came at a steep price. Each gift was accompanied by a sermon as well as an itemized account of every indignity he had been forced to endure so that they could live off the fruits of his labor. After the death of his father and brothers—his last surviving

brother, Gismondo, died in 1555—his nephew Lionardo was the benefi-
ciary of his largesse and the chief target of his ill humor. As the surviving
member of the family tasked with carrying on the Buonarroti name, he
was subject to a constant barrage of advice, complaint, and invective from
his hard-to-please uncle. "I do not want to . . . describe to you the state of
misery in which I found our family when I began to help them, because a
book would not suffice," he scolded Lionardo in a typical letter from 1551,
"and never have I found anything but ingratitude. So give God recognition
for the position in which you find yourself and do not go trailing after airs
and graces."

Reading their correspondence, one sympathizes with the nephew, whose
pathetic attempts to please his uncle were usually thrown back in his face.
Michelangelo was both ill tempered and overbearing. While he occasionally
expressed gratitude for the delicacies Lionardo insisted on shipping from
Florence, Michelangelo would more often dash off a letter grousing that
the wine was sour or the pasta moldy, and that he couldn't use the items in
any case. No act of kindness went unpunished, whether it was a gift of food
or cloth with which to make a new set of clothes, or a trip to Rome to visit
his uncle. In the summer of 1544, when Michelangelo was lying gravely ill
in del Riccio's apartment, Lionardo made a hurried journey to Rome. But
instead of thanking him for his consideration, Michelangelo refused to see
him. Adding insult to injury, he then fired off an angry letter in which he
accused his nephew of hovering over him like a vulture over a dying beast.
"Lionardo," he wrote as soon as he was sufficiently recovered to hold his
pen, "I have been ill and you have come in place of Ser Giovan Francesco to
kill me off and to see if I've anything left. Isn't all that you've had from me
in Florence enough for you? You cannot deny you're like your father, who
turned me out of my own house in Florence. . . . So go with God, and don't
come near me any more and never write to me again. . . ." Del Riccio, adding
to his long list of services that of family therapist, tried to heal the breach by
reassuring Lionardo, "[I] have not failed to commend you to your *Messer*
Michelangelo, who certainly loves you as a son." Del Riccio was right. The
truth is that for all his harsh words, Michelangelo loved his nephew, if only
in his own peculiar and bullying way, and his constant carping was a sign of

how much he had invested in the young man who had to bear the burden of carrying on the Buonarroti name.

Much of their correspondence is concerned with purchasing property in and around Florence and the crucial task of finding Lionardo a suitable bride—the twin pillars upon which the future of the family would rest. As to the first, Michelangelo clung to the old-fashioned belief that land ownership conferred status. Much of his savings were invested in farmland in the *contado*, but he was even more obsessed with acquiring a stately mansion in Florence itself since, he explained to his nephew, "an imposing house in the city redounds much more to one's credit," justifying the expense "since we are, after all, citizens descended from a very noble family."

Michelangelo knew less about women than he did about real estate, and his advice to his nephew in these matters is comical and often grotesque. The process of finding Lionardo a bride, which dragged on for years, shows Michelangelo alternately overly picky and completely bewildered. Given his insecurity about the Buonarroti's status, he was far more concerned with pedigree than wealth. "All you need have an eye to is birth, good health and, above all, a nice disposition," he wrote to Lionardo in 1550, not missing the opportunity to put down his nephew. "As regards beauty, not being, after all, the most handsome youth in Florence yourself, you need not bother overmuch, provided she is neither deformed nor ill-favored."

One of Michelangelo's failings as a matchmaker was his deep-seated misogyny, though in this he was little different from most of his contemporaries. Typical of his hostile attitude is a letter he wrote to Lionardo in 1550 asking him if he could find him a new housekeeper, "[one] who is clean and respectable—which is difficult, because they are all pigs and prostitutes—let me know. I pay ten julians a month; I live poorly, but I pay well." Michelangelo's disdain for women in general and the institution of marriage in particular can be gleaned by a letter he wrote to Lionardo in 1552, when it appeared that his nephew might be getting cold feet. If so, he commiserated, it was a feeling with which he could sympathize:

> Bishop de' Minnerbeti was here recently and . . . he asked me about you and about your taking a wife. We discussed it and he told me that he had a nice girl

to present to you and also that she doesn't have to be married out of charity. . . .
Now you write me that I have no idea who among her relatives talked to you in
Florence and encouraged you to take a wife, and told you that I greatly desired
it. This you know for yourself from the letters I have written you on several
occasions, and this I repeat, to the end that our race may not end here—not
that the world would come to an end on that account. . . . If, however, you
do not feel physically capable of marriage, it is better to contrive to keep alive
oneself than to commit suicide in order to beget others.

In the end, Lionardo overcame his doubts. The search was concluded in April 1553 when he married Cassandra, from the distinguished Ridolfi clan. The following month Michelangelo wrote to his nephew expressing his satisfaction in how things had turned out: "Lionardo, I understand from your last letter that you have taken the young lady to your house and that you are most content . . . but that you have not yet secured the dowry. Your satisfaction gives me the greatest pleasure, and it seems to me we should continually offer our thanks to God. . . . I feel I should mark the happy occasion. I'm told a beautiful pearl necklace would suffice."

Michelangelo finally settled on two fine rings—one diamond, one ruby—an unusual expression of paternal affection and an even rarer vote of confidence in his nephew. Soon, however, his normal pessimism reasserted itself. Responding to a letter from Lionardo expressing his contentment with his new bride, Michelangelo was quick to remind him that life was a vale of tears. "We must give thanks to God, all the more so because it is rare indeed." In April 1554, when he heard news that Cassandra had given birth to a healthy boy, Michelangelo tempered his joy with a discourse on the unpredictability of life. "[S]uch pomp displeases me," he told Vasari after hearing that his nephew had celebrated the occasion with a grand feast. "One ought not to laugh when the whole world weeps; on which account it seems to me that Lionardo hasn't much judgment, and particularly not in making such a feast for the new-born with the rejoicing that should be reserved for the death of someone who has lived a good life." The wisdom of Michelangelo's gloomy prophecy was cruelly demonstrated the following year when

a second son, named after his illustrious great-uncle, died after only a few weeks.*

Death was never far from his thoughts these days. "[I]f life pleases us," he mused, "we ought not to fear death which comes from the same Master." In 1547, at the time of Benedetto Varchi's tribute at the Florentine Academy, Michelangelo had already far exceeded the average life expectancy of a man of the era. Events like this, which seemed to have a commemorative, retrospective element, naturally caused him to dwell on his own mortality. "I am not only an old man," he told Varchi, "but must almost be numbered among the dead." It was his nature to dwell on the melancholy side of life and to see every accomplishment and every misstep in terms of a final reckoning. Soon he would stand before his Maker and answer for his life, and he was still unsure of the verdict. "Before men, I do not say before God, I count myself an honest man," he confessed, and his doubts only grew as he approached the end. He berates himself for having "clung to fantasies," for making "of my art an idol and a king," though, he concludes, "I've come to know my error,/sad emptiness of Man's desire."

But while Michelangelo regretted that so much of his life had been spent pursuing fame and fortune, he could not deny that art also provided him an essential spiritual outlet. Like his passion for Tommaso de' Cavalieri, which combined elements of illicit desire with other, more exalted sentiments, his passion for his art could not simply be dismissed as the sinful pursuit of worldly ambition. However much ego and ambition clouded the purity of the impulse, in the end he believed that his gift was a celebration of God's creation.

Nowhere is the link between the creative and religious impulses more evident than in the two Pietàs he left unfinished at his death. When, approaching the end of his life, Michelangelo picked up his hammer and chis-

* Of Lionardo and Cassandra's many children, only a son named Buonarroto produced heirs. This branch of the family, the direct descendants of Michelangelo's father, Lodovico, died out in the nineteenth century.

els again, it was an act of reverence. Neither work was commissioned; each is the product of his need to pour out the most elemental yearnings of his soul, a motivation that seems entirely natural to us but that was still unusual in the sixteenth century. Like his work at St. Peter's, these sculptures were made for the sake of his immortal soul rather than for worldly glory. Ever since he first encountered Vittoria Colonna and was drawn into the circle of the Spirituali, Michelangelo's faith had expressed itself in ever-more-introspective forms. Poems and drawings provided a more intimate outlet for his religious impulses, allowing him to confess anxieties that would have been inappropriate to larger public works.

The *Florentine Pietà* (c. 1547–55) and the *Rondanini Pietà* (c. 1556–64) represent Michelangelo's final essays in a medium and on a theme that had engaged him from his earliest days. Unlike so many other sculptures that lack the final touches, these are not only unfinished but appear unfinishable. In fact, both are a testament to a still-vivid pictorial imagination no longer matched by equivalent physical powers. The *Florentine Pietà* in particular caused him no end of grief as he found it impossible to realize his vision. In a rage, he smashed Christ's left leg with a hammer and would have destroyed it entirely if a friend, Francesco Bandini, hadn't begged the artist to give it to him.

The *Florentine Pietà*—which he intended for his own tomb—is one of the most complex figural compositions he ever attempted. It consists of four figures: Christ, the two Marys, and Nicodemus, whose cowled, bearded face is an idealized self-portrait. Depicting himself as one of those bearing the burden of the Savior's body is an apt symbol of a life spent in the service of both art and God. Though ultimately unresolved—and perhaps unresolvable—the *Florentine Pietà* contains many profoundly moving passages, above all the lifeless body of Christ slumped in the arms of his mother and his most devoted follower.*

The *Rondanini Pietà* is even more fragmentary. Its attenuated, sticklike forms are eerily reminiscent of Gothic Pietàs with their powerful yet crudely carved forms. The sculpture captured the imagination of many modern art-

* The figure of Mary Magdalene was completed at a later date by an inferior sculptor.

ists who celebrated its deficiencies as virtues. Audiences accustomed to the distortions of Brancusi and Giacometti can easily accept Michelangelo's incorporeal forms, but for all its expressive power, the *Rondanini Pietà* must be regarded as a failure, a heartbreaking last work by a sculptor no longer able to realize in stone the forms he conjured in his mind.

Both these late sculptures memorialize the slow withdrawing from the world that is a natural part of old age, a loss of skill, of energy, of worldly ambition, but also a corresponding engagement with the life to come. "I've reached the end of my life's journey,/a fragile boat swept along on stormy seas/to the port where all debark," he wrote in 1552. At the time he composed this poem, he still had twelve years to live, but his thoughts had already turned to the life to come. Even art, the demanding muse to which he had dedicated his long years, seemed to him but an empty vanity.

As he grew older, Michelangelo had increasing difficulty sleeping and often worked late into the night with the aid of a candle stuck into a paper hat. These final works have a quality of melancholy, of lonely vigils stretching out through the quiet hours when thoughts of mortality cannot be held at bay. "O night, though black, the sweetest time," he wrote years earlier, while working on the Medici tombs,

> to peace converting all our toil. . . .
> O shadow of death, that closeth
> every anguish of the soul, all pain of heart,
> for every ill a blessed remedy.
> You restore to health our failing flesh,
> dry our tears and relieve our burdens,
> so that the good man need not struggle ever more.

In 1557, Giovan Francesco Lottini reported to his master, Duke Cosimo, on the health of the eighty-two-year-old artist: "Michelangelo Buonarroti is, in fact, so old that though he still wishes to do so, he is unable to stir very far and now seldom or rarely goes to St. Peter's, besides which the model [of the cupola] will take months and months to complete and he is obliged and anxious to complete it. When I made him Your Excellency's offer, he

was moved to tears and one could see that he was desirous of serving You if he had the power, but, in fact, he cannot do so, as besides the stone, he has other troublesome disorders."

Resigning himself to the fact that the aged artist would never serve as an ornament in his court, Cosimo did the next-best thing by honoring him *in absentia*. In 1563 he founded the Accademia del Disegno (Academy of Design), an official recognition that painting and sculpture had now achieved parity with the literary arts. Unlike the ancient painter's Guild of St. Luke, this was not a fraternal organization of craftsmen but rather an honorary association of men considered leading lights in the intellectual community. To no one's surprise, Michelangelo was named "second academician" (Cosimo was the first) and designated the "head, father and master" of all the artists, an acknowledgment of his place in the hearts of his countrymen.

By now Michelangelo was so frail he could no longer write his own letters, adding his signature after he had dictated them to an assistant. He was growing increasingly dependent on the members of his small household. Friends and family back in Florence worried that his various assistants and housekeepers were taking advantage of him. Showing he had lost none of his old pugnaciousness, in August 1563, Michelangelo dictated an angry note to his nephew:

> Lionardo—I see from your letter that you are lending credence to certain envious rascals who, being unable either to manage me or to rob me, write you a pack of lies. They are a lot of sharks and you are such a fool as to lend credence to them about my affairs as if I were an infant. Spurn them as envious, scandal-mongering, low-living rascals. As regards allowing myself to be looked after, about which you write me, and about the other things—I tell you, as to being looked after, I could not be better off; neither could I be more faithfully treated and looked after in every way. As regards my being robbed, which I believe you mean, I assure you I don't need to worry about the people I have in the house, whom I can rely on.

On February 12, 1564, Michelangelo took up his tools for the last time, scraping away at the already emaciated forms of the *Rondanini Pietà*. He in-

tended to work some more the following day, until he was reminded that it was Sunday, the day of rest. The following afternoon Michelangelo suffered a minor stroke. Though he rallied a bit, it was clear to him that the end was not far off. Sending for his friend the sculptor Daniele da Volterra, he said: "O Daniele, I am done for; I ask you not to abandon me." Michelangelo then requested Daniele to summon his nephew. "So it would seem to me," Daniele wrote to Lionardo, "that you should not delay in coming here; and when you are here you will be able to arrange things for the future as will seem best to you."

Unfortunately, Michelangelo had waited too long. The following day, the sculptor Diomede Leoni reported: "I left him . . . a little after the third hour of night [about eight], feeling well and in sound mind, but much troubled with continual insomnia . . . between twenty-two and twenty-three in the afternoon, he wanted to go riding as he is used to doing every fine evening. But the seasonal coldness and the weakness of his head and legs prevented him, so he returned to the fireside and settled down in a chair, which he greatly prefers to his bed."

Michelangelo passed away early on the evening on February 18, 1564, "in the attitude of a perfect Christian about the time of the Ave Maria." Present at the end were his servants Antonio Francese and Pierluigi Gaeta, his two physicians, and a few close friends, including the artists Daniele da Volterra and Diomede Leoni. Also at his bedside was Tommaso de' Cavalieri, faithful to the end.

V. THE GREATEST MAN THE WORLD HAS KNOWN

News of Michelangelo's death was greeted with mourning in Rome and in his native Florence, as well as in the courts and capitals of Europe. His physician Gherardo Fidelissimi, writing to Duke Cosimo, described him with more than a hint of exaggeration as "the greatest man the world has ever known." While a bit over the top, Fidelissimi's evaluation reflected the universal sense of loss. The hagiography began almost at once, replacing the flesh-and-blood reality of a flawed, tormented man with the pale ghost of a secular saint.

Like the remains of other holy men or patriotic heroes, Michelangelo's body was fought over by those claiming to represent his true home. Rome's claims could certainly not be ignored: he had spent the greatest part of his career in the Eternal City, and his greatest triumphs had been won in the service of the popes. In 1537, the city had recognized his contribution by bestowing on him the rare honor of citizenship. Florence's claims were equally valid. Florence was the land, if not exactly of his birth, of his ancestors, and the place with which he identified most strongly. Here he had grown to adulthood and to maturity as an artist, following in the footsteps of Donatello, Masaccio, and Brunelleschi.

Most critically, however many years he spent in Rome he continued to see himself as a Florentine, and if he delayed returning to the city late in life, he made no secret of where he wished to be buried: "[Y]ou must know for certain that I desire to lay my feeble bones beside those of my father, as you beg me," he told Vasari a decade before his death, and in the intervening years he never strayed from his intention to find eternal rest in his native land.

The desire to possess the great man's remains touched off a comical competition between the two cities. Shortly after his death, Michelangelo's body was carried in solemn procession, "in the sight of all Rome," to the Church of the Holy Apostles. There, Pope Pius IV proclaimed, he would remain until a more suitable tomb could be prepared in St. Peter's itself. But the pope had not counted on the determination of the people of Florence to retrieve the remains of their most famous son. "Lionardo, his nephew, arrived after it was all over," Vasari reported:

> When Duke Cosimo was informed of the event, he confirmed his resolve that since he had not been able to have him and honor him alive, he would have him brought to Florence and not hesitate to honor him with all manner of pomp after death; and the body was sent secretly in a bale, under the title of merchandise, which method was adopted lest there might be a tumult in Rome, and lest perchance the body of Michelangelo might be detained and prevented from leaving Rome for Florence.

• • •

Michelangelo's body arrived at the customs house in Florence on March 10, where it was taken into custody by Giorgio Vasari, acting on behalf of the Accademia del Disegno. His body was placed in San Pietro Maggiore, before being carried by the artists of Florence in a solemn torchlight procession to the Church of Santa Croce, only a block or two from the artist's boyhood home. Vasari and his colleagues attempted to keep news of his arrival in Florence secret, "lest the report might spread through the city, and there might flock thither such a multitude that it would not be possible to avoid a certain degree of tumult and confusion. . . ." But despite their best efforts, word got out and "in the twinkling of an eye the church was so filled, that in the end it was with the greatest difficulty that the body was carried from the church to the sacristy. . . ."

Indeed, the process of interring the great man soon took on the dimensions of a sacred nationalistic rite. While no actual miracles were attributed to Michelangelo, the stories surrounding the fate of his mortal remains follow a script familiar from the lives of holy martyrs. When the coffin was opened—at the request of Don Vincenzo Borghini, the current Lieutenant of the Academy—the crowd was stunned by what they found:

> [W]hen . . . all the rest of us present thought to find the body already marred and putrefied, because Michelangelo had been dead twenty-five days and twenty-two in the coffin, we found it so perfect in every part, and so free from any noisome odor, that we were ready to believe that it was rather at rest in a sweet and most peaceful sleep.

Years earlier, the poet Ariosto had called him, "Michael, more than mortal, angel divine." The "miracle" of his uncorrupted body turned metaphor into fact.

For the most part, however, claims of divine favor avoided such idolatry. It was not the man himself but his genius that was heaven-sent, as Vasari proclaims at the end of his biography:

> Truly his coming was to the world, as I said at the beginning, an exemplar sent by God to the men of our arts, to the end that they might learn from his

life the nature of noble character, and from his works what true and excellent craftsmen ought to be. And I, who have to praise God for infinite blessings, as is seldom wont to happen with men of our profession, count it among the greatest blessings that I was born at the time when Michelangelo was alive, that I was thought worthy to have him as my master, and that he was so much my friend and intimate, as everyone knows, and as the letters written by him to me, now in my possession, bear witness. . . .

Duke Cosimo had a somewhat different view. As anxious as Vasari to exploit Michelangelo's fame, he was less interested in the metaphysical significance of his life than he was with the propaganda that could be exploited in death. To this end, he graciously agreed to the Academy's request (no doubt arranged beforehand) that the memorial service be held in the Medici family Church of San Lorenzo. Cosimo spared no expense to make the tribute as magnificent as possible. On July 14, 1564, Michelangelo's coffin was placed on an elaborate platform in San Lorenzo surrounded by allegorical figures designed by the leading artists of the day representing Florence and Rome, as well as a statue of Fame and paintings illustrating scenes of his life. Many of these scenes stressed the intimate relations between the artist and the Medici family, including one showing Lorenzo the Magnificent's first encounter with Michelangelo in his sculpture garden, and another showing Pope Clement granting the commission to build the Library of San Lorenzo. A Latin epitaph on the side facing the high altar read:

The Academy of Painters, Sculptors, and Architects, with the favor and assistance of Duke Cosimo de' Medici, their head and the supreme protector of these arts, admiring the extraordinary genius of Michelagnolo Buonarroti, and seeking to acknowledge in part the benefits received from their own hands and from all the affection of their hearts, to the excellence and genius of the greatest painter, sculptor, and architect there has ever been.

In his eulogy, Benedetto Varchi asked: "Who ever lived a more godly life? Who ever died a more Christian death than Buonarroti?" Many of those who actually knew him could have supplied the speaker with a host of can-

didates, but accuracy was not really the point. Varchi began with the premise that art is a noble profession, an expression of a divine spark, from which he derived what seemed to him the logical corollary: that the man who had practiced that profession for so long at the highest levels must himself be something akin to a saint. Commenting on Michelangelo's sonnet, Varchi had written: "The greatest power that can be bestowed upon man is the faculty of soaring to the heavens, while still belonging to earth, and of becoming not just an angel but God himself." All artists traffic in sacred mystery, but it was Michelangelo who led the way, revealing how close a mere mortal could approach to the divine.

Paradoxically, the tributes that poured in even before his death suggest that Michelangelo had already become a relic of a vanished age of giants. The man had become legend, assigned to that distant Olympus where the gods reside largely untroubled by the goings-on of mere mortals.

Like all gods, Michelangelo was more revered than obeyed. Even minor works were treasured as holy relics, while monuments that still played a role in public life were modified by men who paid lip service to his genius but shaped his legacy to suit their own needs. This task became all the more critical as the process of his apotheosis gathered momentum, lest the more impressionable be persuaded that anything he touched had the unassailable status of scripture. The Council of Trent, which concluded its final session two months before Michelangelo's death, declared: "[I]mages shall not be painted and adorned with a seductive charm, or the celebration of saints and the visitation of relics be perverted by the people into boisterous festivities and drunkenness." The following month a commission headed by Cardinal Giovanni Morone decided to have the offending parts of *The Last Judgment* painted over, giving the job to Michelangelo's friend Daniele da Volterra out of respect for the old man.

For Michelangelo it was a bittersweet end to a decades-long battle against the censors and the know-nothings. Unlike the iconoclastic Protestants, the Catholic Church embraced the role of the arts in service of religion, but as conscripts in the pope's army, artists were no longer permitted the freedom of conscience that nurtured Michelangelo's idiosyncratic genius. Even more than *The Last Judgment*, the Sistine Ceiling was a product of a vanished age

when an artist was allowed to follow the dictates of his anarchic muse, without worrying about being hauled before the Inquisition.

When it came to his last major work, the basilica to which he devoted the last decades of his life, a similar process of adaptation took place. After Michelangelo's death, Pope Pius IV refused to hire a replacement without first getting guarantees that his successor would follow Michelangelo's plans to the letter. But Michelangelo's designs were themselves outdated, embodying the Renaissance belief that geometry was itself a sacred value, that divinity could be expressed through the perfect forms of the circle and the square. By the time of his death, such abstract notions seemed quaint as well as impractical. The Church had more pressing needs than to dwell in such ethereal realms. There were souls to be won and enemies to smite. Just as the indecent parts of *The Last Judgment* were painted over so as not to distract from the message of salvation and damnation, so too the most important church in Christendom would have to conform to rituals elaborated over centuries.

In the following decades, the purity of Michelangelo's design for St. Peter's was obscured, suffocated beneath busy veneers, cluttered by elaborate altars, and encrusted with sparkling mosaics. Even had it been possible to follow a precise set of blueprints bequeathed by the great master, it would have been a betrayal of the intuitive, organic process by which he himself operated, responding to the building as it took shape, adapting his original conception to the exigencies of the moment.

In the end, both works of art and legacies must live in the world. As objects, works of art are subject to the vicissitudes of time and of accidents, both natural and man-made. Both the St. Peter's *Pietà* and the *David* were damaged by deliberate acts of vandalism, the *Pietà* in the twentieth century and the *David* in the sixteenth. And neither of them can be seen in the original context that formed a crucial part of the work's meaning. The Medici tombs, while still in place, cannot be regarded as a definitive statement by the artist, but rather as a monument to a process interrupted and frozen in time.

His great frescoes have fared no better. Darkened by soot and then overzealously scrubbed, retouched by both competent craftsmen and ignorant hacks, updated by later generations that assumed they knew what the master

had in mind or could improve on his original conception, they are not the same works Michelangelo saw when he laid down his brushes and stepped back to admire his handiwork.

None of his masterpieces, however, has suffered the indignities of his last great work, the immense Basilica of St. Peter. But while we may regret the loss of Michelangelo's vision, it was never really his in the first place. By its very nature architecture is a collaborative endeavor, involving the labor of thousands and the genius of at least a few—particularly on a work as vast and important as this one. For all its flaws, its bombast, and its gaudy splendor, its mismatched parts and bland affect, it embodies the vast bureaucracy and tortured history of the institution it represents far better than any work derived from the mind of a single man, even one as gifted as Michelangelo.

The meaning of a life is even harder to determine. Fame is a free-floating signifier, able to be harnessed in almost any context and for any purpose. The process began even before Michelangelo's death. Artists basked in his reflected glory, walking through doors he opened that led directly into the elegant salons of society's elite and to the tables of great lords, where a successful painter or sculptor now had an honored place. For Florentines, his fame bolstered their shaken confidence after years of foreign domination, reminding them of their glorious past, while for the lords of that city, the presence of his body—now laid to rest in an ornate tomb in Santa Croce, pantheon of the city's famous sons—conferred a certain legitimacy on a regime still resented by many of its own subjects. For the Church he had served so well for so many years, Michelangelo remained something of a problem, both the brightest star in a constellation of brilliant men whose talents had served to glorify the one true religion, but also a dangerous example of freethinking that was no longer acceptable in an age that valued discipline over originality.

Over the years, Michelangelo has been both beatified and vilified, reinvented in each subsequent age to suit its particular needs. He's been in and out of fashion, but whether he is viewed as an inspirational example of someone willing to defy convention or a monument so imposing as to block all possibility of forward progress, his life and his work changed the world.

He not only transformed the way art was made but the role art plays in our collective consciousness. In fact, he invented the very notion of genius, if by that term we mean greatness that flows from the peculiarities of an individual life and personality, not merely the application of great skill to a given medium.

Before Michelangelo, it was possible to tell the story of art without reference to the artist. The artist was a man possessed of expertise, and his biography might throw an interesting light on his creations, elucidating the evolution of his style or the meaning of certain passages, but his works stood largely on their own. Michelangelo's art refuses such anonymity. His paintings and sculptures can be forceful, strident, even belligerent; they are sometimes arrogantly confident and sometimes convulsed by agonized self-doubt; they can thunder across vast public spaces or communicate in a confessional whisper; in all cases they demand to be heard. More than any artist before him—or perhaps since—Michelangelo projects himself through his work into our lives, a ferocious, unignorable presence. Despite what his friends believed, or pretended to believe, he was no saint, nor are the things he touched possessed of any supernatural power. He was simply a man, mortal and very flawed. But after five centuries, the works he left behind offer something more nourishing than the faint perfume of sanctity. They throb with the earthy, pulsing, difficult stuff of life.

Appendix

A GUIDE TO VIEWING MICHELANGELO'S ART IN FLORENCE AND ROME

Michelangelo's life is a tale of two cities. Florence, cradle of the Renaissance, was his ancestral home, and he always thought of himself as the natural heir to its unmatched artistic legacy. It was in Rome, however—at the court of the popes who funded his most spectacular triumphs—that he achieved his greatest fame.

Almost all Michelangelo's most important works can be found in these two cultural capitals, and in each a host of minor masterpieces helps to flesh out the portrait of the man and his art. The center of Florence looks very much as it did at the beginning of the sixteenth century, and tourists today can walk in the footsteps of genius by wandering the ancient streets and piazzas where Michelangelo felt most at home. Florence owes its remarkable preservation partly to the fact that by the time Michelangelo reached maturity the city was already beginning its long slide into political irrelevance. Its importance would be revived in the eighteenth century when it reinvented itself as a cultural mecca, an essential stop on the Grand Tour.

Rome, by contrast, remained a vital political center. As the seat of the papacy, Rome's building boom continued throughout the seventeenth century, transforming the Renaissance city Michelangelo knew into a showcase of Baroque magnificence. Even so, Michelangelo's vision continues to shape many a Roman vista, particularly through the soaring dome of St. Peter's, visible from almost any neighborhood.

FLORENCE

The historic center of Florence is only a few square miles, and everything is within easy walking distance. A Michelangelo-inspired visit to the city should begin at the **Casa Buonarroti.** This modest palazzo on the Via Ghibellina (among the properties Michelangelo purchased in 1508) is located in the neighborhood of Santa Croce, near his boyhood home. Here one can see his two earliest surviving sculptures, the *Madonna of the Stairs* and the *Battle of the Centaurs,* as well as models for the *Hercules and Cacus* and one of the river gods for the Medici tombs. Across the river, in the sacristy of **Santo Spirito,** hangs Michelangelo's wooden *Crucifix,* the work of the eighteen-year-old sculptor, who donated it to the prior in thanks for allowing him to dissect corpses in the church's morgue.

The **Bargello National Museum** houses one of the world's great collections of Renaissance sculpture. Here one can see the early *Bacchus* and *Pitti Tondo,* as well as two late, unfinished pieces, the head of *Brutus,* and the enigmatic work usually referred to as the *Apollo/David.* A few blocks south is the **Uffizi Gallery,** home to numerous masterpieces of Renaissance painting. The museum contains Michelangelo's only surviving panel painting, *The Holy Family* (aka the *Doni Tondo*).

At the **Piazza della Signoria** visitors can see a life-size replica of the *David,* on the site where it stood as a monument to civic pride. The Hall of the Five Hundred in the palace itself contains Michelangelo's so-called *Victory,* a work of obscure origins and mysterious significance. The young man depicted is said to be his beloved Tommaso de' Cavalieri.

The original *David* is now housed in the **Accademia Gallery** on the Via Ricasoli, just south of the Piazza San Marco. Up close, one can marvel at the delicate carving as well as the heroic proportions of this early masterpiece, but equally compelling are the four unfinished *Captives* intended for Pope Julius's tomb, as well as the unfinished *St. Matthew* for the Duomo. In these works one can follow along as the artist releases the figure from the block.

Just behind the Palazzo Medici, where the young man spent the happiest years of his life, lies the sprawling complex of **San Lorenzo.** Here, Medici patronage and Michelangelo's genius came together to form a remarkable

ensemble. The entrance to the **Medici Tombs** in the **New Sacristy** is at the rear of the building (a separate entrance and separate fee are required to view Brunelleschi's Old Sacristy just across the nave). Though never completed, the Medici tombs represent Michelangelo's most successful attempt to merge the arts of sculpture and architecture. The **Laurentian Library** is located in the cloister on the southern flank of San Lorenzo. With its famous cascading staircase and elegant reading room, the library offers perhaps the best opportunity to study Michelangelo's idiosyncratic approach to architectural form.

In the **Museo dell' Opera del Duomo,** just behind the Cathedral, one can find Michelangelo's late *Pietà,* the unfinished statue the artist originally intended for his own tomb. Michelangelo carved his own features onto the face of Nicodemus.

Beyond these major works, Michelangelo's contributions to Florence are woven into the very fabric of the city, from the so-called kneeling windows of the Medici Palace to his design for a small "reliquary balcony" in the nave of San Lorenzo. As a final tribute, visitors might want to make a pilgrimage to the great man's tomb in the church of **Santa Croce,** where the artist lies alongside such Florentine greats as Machiavelli and Galileo. In no other city is the spirit of the Renaissance master as fully alive as it is here, in the place that he called home.

ROME

Rome in Michelangelo's day was less compact than Florence, consisting of splendid edifices and moldering ruins separated by large tracts of rustic countryside. But despite the city's greater size, Michelangelo's contributions here are more concentrated, clustered for the most part in and around St. Peter's in the Vatican.

The great basilica itself is home to his *Pietà,* though standing before the sculpture can be a disappointing experience. Set into an inappropriately ornate Baroque chapel and behind bulletproof glass, his early masterpiece is all but lost.

The **Sistine Chapel** is part of the **Vatican Museums,** on the northern

flank of the enormous basilica. Visitors should purchase tickets in advance, which will save standing in most, though not all, of the long lines. Once inside the museum, you have the option of heading straight for the chapel or exploring the magnificent papal collections, including the famous *Apollo Belvedere* and the gut-wrenching *Laocoön,* ancient sculptures that had an enormous impact on Michelangelo's work. Also not to be missed are the magnificent frescoes painted by his rival Raphael, including the *School of Athens,* where the painter paid tribute to the sculptor by depicting him as the glowering philosopher Heraclitus.

The Chapel contains not only the famous ceiling with its endlessly re-produced image of God creating Adam, but also the awe-inspiring *Last Judgment.* The ceiling in particular is not easy to take in on a single visit. The space is always jam-packed, but resist the effort to run for the exits. Benches along each wall allow for a more leisurely viewing of masterpieces so rich and complex that sustained viewing is a must.

The best vantage from which to study Michelangelo's architectural work at **St. Peter's** is from the **Vatican Gardens** to the west of the basilica, where one can take in his innovative "hemicycles," the richly decorated drum, and soaring cupola. The interior of the basilica, particularly the area beneath the dome, provides some suggestion of Michelangelo's masterful handling of space, but only if one can avoid the distraction of the later (mostly Baroque) additions, including Bernini's opulent *baldachino.*

Across the Tiber in the church of **Santa Maria Sopra Minerva,** just to the east of the Pantheon, is Michelangelo's *Risen Christ.* For centuries regarded as one of his greatest masterpieces, it is now among his least popular works. A few blocks north of the Colisseum is the church of **San Pietro in Vincoli** containing the tomb of Pope Julius II. Michelangelo himself bemoaned the fact that he had wasted his youth on what he called the "tragedy of the tomb," and visitors might well agree that the finished product does not justify the decades he spent on it. It does, however, contain one great masterpiece, the awesome *Moses,* which, according to Vasari, drew Jewish worshipers who paid homage to the Hebrew prophet.

Tucked behind the nineteenth-century monstrosity of the Victor Em-manuel Monument is the **Campidoglio,** Michelangelo's most successful ar-

chitectural ensemble and one of the world's great urban spaces. This elegant piazza demonstrates not only Michelangelo's sculptural approach to architecture but his unique ability to orchestrate the movement of the human body through space.

Other architectural fragments dot the city, including the peculiar **Porta Pia,** a city gate chock-full of Michelangelo's playful deconstructions of classical forms, as well as the **Palazzo Farnese** (now the French embassy). Michelangelo took over this project after the death of Antonio da Sangallo at the request of Pope Paul IV. He designed the top floor and the ornate cornice that Sangallo's followers complained was so heavy it would crush the structure below, and also designed much of the handsome courtyard.

$\mathcal{N}otes$

I. MICHELANGELO: THE MYTH AND THE MAN

PAGE

1 *"Tell the priest"*: Michelangelo, *Carteggio*, IV, mcix, 299.

2 *"[W]hat greater and clearer sign"*: Condivi, *Life of Michelangelo*, 150–51.

3 *"[H]e is terrible"*: Michelangelo, *Carteggio*, II, cdlxxiv, 247.

3 *"When Buonarroti comes to see me"*: Scotti, *Basilica*, 168.

4 *"I am not obliged"*: Vasari, *Lives*, II, 708.

4 *"If Your Holiness wishes me to accomplish anything"*: Michelangelo, *Letters*, I, 151.

4 *"I have too much of a wife"*: In Goffen, *Renaissance Rivals*, 341.

4 *This savage woman*: In Scotti, *Basilica*, 98.

5 *"[W]hile a man of so great genius"*: Paolo Giovio in Goffen, *Renaissance Rivals*, 146–47.

5 *"he almost withdrew from the fellowship of men"*: Condivi, *Life of Michelangelo*, 161.

6 *"I live to sin"*: Michelangelo, *Rime e Lettere*, 94.

7 *"And certainly I take you to be a God"*: Stephen Campbell, "Fare un Cosa Morta Parer Viva: Michelangelo, Rosso, and the (Un)Divinity of Art," *Art Bulletin,* vol. 84, no. 4 (December 2002): 597.

7 "Michel, più che mortale, Angelo divino": Bull, *Michelangelo: A Biography*, 171.

7 *"that Michelangelo of stupendous fame"*: Campbell, "Fare un Cosa Morta Parer Viva," 597.

8 *"I record that today"*: Michelangelo, *Letters,* I, 272.

8 *"my much beloved and honored kinsman"*: Bull, *Michelangelo: A Biography*, 156.

9 *"once came to visit me in Rome"*: Michelangelo, *Letters,* II, 86.

12 *"This is an age of gold"*: Schevill, *History of Florence*, 416.

13 *"Giorgio, if I have anything of the good in my brain"*: Vasari, *Lives*, II, 643.

15 *"[T]he heavens and his nature"*: Condivi, *Life of Michelangelo*, 40–41.

15 *"[H]is father and his uncles"*: Ibid., 41.

15 *"he has always desired to cultivate the arts"*: Ibid., 169.

16 *"The most blessed Ruler of the Universe"*: Vasari, *Le Vite de' Più Eccellenti Architetti, Pittori, et Scultori Italiani da Cimabue Insino a' Tempi Nostri*, 880.

17 *"received absolutely no assistance from him"*: Condivi, *Life of Michelangelo*, 42, 45.

18 *"he counterfeited sheets"*: Vasari, *Lives*, II, 646.

19 *"dismayed that a child knew more than he"*: Vasari, *Le Vite*, 547.

19 *"showing the excellence of a mere lad"*: Vasari, *Lives*, II, 645.

19 *"Given the great love he had for both painting"*: Vasari, *Le Vite*, 882–83.

19 *"I cannot find any master who satisfies me"*: Hirst, *Michelangelo Buonarroti*, 273.

20 *One day, [Michelangelo] was examining*: Condivi, *Life of Michelangelo*, 12.

21 *"lamenting that his son would be led astray"*: Ibid., 48.

21 *"I have never practiced any profession"*: Ibid., 49.

21 *"not only Michelangelo"*: Ibid., 50.

22 *"a good room in his own house"*: Ibid., 48.

22 *"When he speaks of you"*: Michelangelo, *Carteggio*, II, cdlxxvii, October 27, 1520, 253.

25 *"how much wrong he had done to his nature"*: Condivi, *Life of Michelangelo*, 51.

25 *"very difficult . . . demand[ing] great skill"*: Vasari, *On Technique*, 156.

26 *"[I]t seems to me that painting may be held good"*: Michelangelo, *Letters*, II, no. 280, 75.

26 *"you work with your mind"*: Hughes, *Michelangelo*, 266.

27 *"It is said that Torrigiano"*: Vasari, *Lives*, II, 648–49.

27 *"Buonarroti and I used to go as boys"*: Cellini, *Vita*, 31.

28 *"I know I am ugly"*: Borolsky, *Michelangelo's Nose*, 20.

28 *"I pray my body"*: Michelangelo, *Rime e Lettere*, 176.

28 *So accustomed am I to sin*: Ibid., 95.

28 *[T]he master's constitution was very sound*: Vasari, *Lives*, II, 746–47.

31 *"Before dressing a man we first draw him nude"*: Alberti, *On Painting*, 73.

32 *"turned his stomach"*: Condivi, *Life of Michelangelo*, 157.

32 *"[A]ll sciences are vain and full of errors"*: Leonardo, *Paragone*, I, 26–27.

35 *"O Florence, O Florence"*: Ridolfi, *Life of Girolamo Savonarola*, 80.

35 *"I want to give you some good advice"*: Campbell, "Fare un Cosa Morta Parer Viva," 606–7.

35 *"such a partisan of that sect"*: Vasari, *Le Vite*, 477.

35 *"There was made on the* Piazza de' Signori"*: Landucci, *Diary*, 130–31.

36 *"Whoever was more religious"*: Michelangelo, *Letters*, II, liii.

36 *I want to want, O Lord*: Michelangelo, *Rime e Lettere*, 149.

36 *"I shall spill flood waters"*: Martines, *Fire in the City,* 94.

37 *"his hair stand on end"*: Ibid.

37 *"[I]t is known to all Italy"*: Pastor, *History of the Popes,* VI, 7.

37 *"do as you would in the case of the plague"*: Michelangelo, *Carteggio,* I, 135.

40 *"a god of Love"*: Condivi, *Life of Michelangelo,* 60.

41 *"If you can manage"*: Ibid.

41 *"he admired them for the excellence"*: Vasari, *Lives,* II, 646.

41 *"being made a fool"*: Condivi, *Life of Michelangelo,* 60–61.

41 *"he did not recognize the value of the work"*: Vasari, *Lives,* II, 651.

42 *"without a peer among the works"*: Michelangelo, *Letters,* I, xxx.

42 *"Now this event brought so much reputation"*: Vasari, *Lives,* II, 651.

II. PIETÀ

PAGE

44 *"You may turn all the pages of history"*: Bracciolini, "The Ruins of Rome", in *The Portable Renaissance Reader,* 380–81.

45 *"that sink of all iniquities"*: Ross, *Lives of the Early Medici,* 333.

45 *"[E]very evening"*: Machiavelli et al., *Machiavelli and His Friends: Their Personal Correspondence,* 38.

45 *"If there is a hell"*: Scotti, *Basilica,* 147.

45 *"These are the days of the Antichrist"*: Pastor, *History of the Popes,* VI, 114.

45 *"Flee from Rome"*: Ibid., 13.

47 *"Here one sees chalices"*: Michelangelo, *Rime e Lettere,* 75–76.

47 *"the widest field for a man"*: Condivi, *Life of Michelangelo,* 61.

48 *"the Cardinal di San Giorgio understood little"*: Ibid., 62.

48 *Magnificent Lorenzo, etc*: Michelangelo, *Rime e Lettere,* 307–8.

49 *"a Roman gentleman of good understanding"*: Condivi, *Life of Michelangelo,* 62.

49 *"I have not yet been able to settle"*: Michelangelo, *Letters,* I, 4.

52 *"He has also loved the beauty of the human body"*: Condivi, *Life of Michelangelo,* 166–67.

53 *"[I]t was a strange place and time"*: Castiglione, *The Book of the Courtier,* 248.

53 *"that if I were but to see him"*: Michelangelo, *Letters,* I, 186.

53 *"You are quite wrong"*: Ibid., xlvii.

54 *"not to go out at night"*: Michelangelo, *Carteggio,* II, 337.

54 *"[a]lthough I have very little money"*: Michelangelo, *Letters,* I, 5.

55 *"You must realize"*: Michelangelo, *Carteggio,* I, 4.

55 *"It often happens that the rich"*: Alberti, *On Painting,* 89–90.

56 *Let it be noted and made manifest*: Michelangelo, *Contratti,* I, 5.

57 *"Sculptors, when they wish to make a figure in marble"*: Vasari, *On Technique*, 148.

58 *"white and without any veins"*: Hirst, "Michelangelo, Carrara, and the Marble for the Cardinal's Pietà," *Burlington Magazine*, 154.

59 *We have recently agreed*: Bull, *Michelangelo: A Biography*, 39.

60 *"As to the marbles"*: Michelangelo, *Rime e Lettere*, 417.

60 *"as beautiful"*: Hirst, "Michelangelo, Carrara, and the Marble for the Cardinal's Pietà," 156.

61 *"By sculpture I mean"*: Michelangelo, *Letters*, II, 75.

61 *Just as by removing*: Michelangelo, *Rime e Lettere*, 198–99.

61 *The greatest artist has no concept*: Michelangelo, *Rime e Lettere*, 196–97.

62 *"[O]nce our souls leave this prison"*: Heiser, *Prisci Theologi*, 84.

62 *[I]n a quarter of an hour*: Bull, *Michelangelo: A Biography*, 325.

63 *"he acquired very great fame"*: Vasari, *Le Vite*, 886.

63 *"gained great fame"*: Condivi, *Life of Michelangelo*, 67.

65 *"Virgin mother, daughter of thy Son"*: Hartt and Finn, *Michelangelo's Three Pietàs*, 29.

66 *"[I]t derives from that inventor of obscenities"*: Wang, "Michelangelo's Signature," *Sixteenth Century Journal*, vol. 35, no. 2 (2004): 469.

66 *"Do you not know"*: Condivi, *Life of Michelangelo*, 65.

70 *"At Vespers"*: Ziegler, *Sculpture of Compassion*, 39.

72 *Such were Michelangelo's love and zeal*: Vasari, *Lives*, II, 652.

73 *I should like to be accepted*: Goffen, *Renaissance Rivals*, 114.

74 *"Giovanni carved it"*: Wang, "Michelangelo's Signature," 463.

74 *"Antonio Pollaiuolo, famous in gold"*: Wang, "Michelangelo's Signature," 463.

75 *It was the wont of the finest spirits*: Vasari, *Lives*, I, 13.

75 *O empty glory of human powers!*: Dante, *Purgatory*, 147.

III. THE GIANT

PAGE

79 Michelangelum Lodovici Bonarroti: Michelangelo, *Contratti*, iv, 12.

83 *"You say"*: Donato, "Hercules and David in the Early Decoration of the Palazzo Vecchio," *Journal of the Warburg and Courtauld Institutes*, vol. 54 (1991): 95.

83 *"From Florence"*: Vasari, *Le Vite*, 886.

86 *"Buonarroto tells me"*: Michelangelo, *Carteggio*, I, 9.

86 *"Ascanio, rich man"*: Condivi, *Life of Michelangelo*, 167.

87 *It seems to you that I am unhappy*: Michelangelo, *Carteggio*, I, 7.

88 *"declaring that Michelangelum"*: Michelangelo, *Contratti*, 12.

88 *"they are to be of greater quality"*: Michelangelo, *Contratti*, 8–9.

89 *"men and women"*: Vasari, *Lives*, I, 635.

90 *"an enclosure of planks and masonry"*: Vasari, *Lives*, II, 654.

90 *"Michelangelo began to work"*: Gill, *Il Gigante*, 226.

90 *like a bather rising from the tub*: a sculptor can profit by the simple expedient of a wax model and a pail of water: "Let the artist proceed to carve out the figure from these measurements, transferring them to the marble from the model, so that measuring the marble and the model in proportion he gradually chisels away the stone till the figure thus measured time after time, issues forth from the marble, in the same manner that one would lift a wax figure out of a pail of water, evenly and in a horizontal position. First would appear the body, the head, and the knees, the figure gradually revealing itself as it is raised upwards, till there would come into view the relief more than half completed and finally the roundness of the whole." [*Vasari on Technique*, no. 48, p. 151.] Such a technique would have been helpful in visualizing the form emerging from the block, but on the evidence of his unfinished sculptures, Michelangelo appears to have worked from more than one plane.

91 *"a very mechanical exercise"*: Leonardo, *Paragone*, 95.

91 *"was not so skillful"*: Condivi, *Life of Michelangelo*, 68.

91 *"had been badly blocked"*: Vasari, *Le Vite*, 886.

92 *Michelangelo's bronze*: Not everyone agrees that the drawing is of the lost bronze *David*. Saul Levine believes that it represents Michelangelo's first thoughts for the marble statue. He sets out his argument in "Michelangelo's Marble 'David' and the Lost Bronze 'David': The Drawings" in *Artibus et Historiae*, vol. V, no. 9 (1984): 91–120. In truth, despite the obvious differences between the drawing and the famous *David*, there are also notable differences between the drawing and what we know of the bronze statue.

95 *"Withdraw into yourself"*: Seymour, *Michelangelo's David*, 15.

95 *It happened at this time*: Vasari, *Lives*, II, 654.

97 *"The victor is"*: Sperling, "Donatello's Bronze 'David' and the Demands of Medici Politics," *Burlington Magazine*, 219.

98 *"To those who fight bravely"*: Gill, *Il Gigante*, 235.

98 *"to be placed at a great height"*: Vasari, *On Technique*, 145.

99 *"Seeing that the statue of David"*: Goffen, *Renaissance Rivals*, 124.

99 *"it was made to be placed"*: Parks, "The Placement of Michelangelo's *David*: A Review of the Documents," 560.

99 *"I advise that"*: Levine, "The Location of Michelangelo's David: The Meeting of January 25, 1504," *Art Bulletin*, 44.

99 *"I believe that he who made it"*: Ibid., 43.

102 *"because Judith is a deadly sign"*: Ibid., 36.

102 *"Piero Son of Cosimo Medici"*: Ibid., 38.

102 *"would here be most highly regarded"*: Ibid., 40.

102 *"where some wretch"*: Ibid., 39.

103 *[t]he marble giant was taken out*: Landucci, *Diary*, 213–14.

104 *"It is most foolish"*: Donato, "Hercules and David in the Early Decoration of the Palazzo Vecchio," 94.

105 *"O highest and most wonderful felicity of man!"*: Pico della Mirandola, "The Dignity of Man," in *The Portable Renaissance Reader*, 478.

106 *"Neither an established place"*: Ibid.

109 *"each [in] a white waistcoat"*: Landucci, *Diary*, 218.

109 *"beautiful contours"*: Vasari, *Lives*, II, 655.

109 *"defend her [Florence] valiantly"*: Vasari, *Lives*, II, 654.

111 *"the famous painters and sculptors"*: Vitruvius, *Ten Books on Architecture*, 72.

111 *"the eye must give final judgment"*: Vasari, *On Technique*, 146.

112 *"celestial"*: Vasari, *Lives*, I, 625.

113 *"[S]o great was his genius"*: Vasari, *Lives*, I, 625.

113 *"This man will never do anything"*: Bull, *Michelangelo: A Biography*, 117.

114 *Leonardo . . . was walking by*: Goffen, *Renaissance Rivals*, 148.

119 *"[T]he painter sits in front of his work"*: Leonardo, *Paragone*, 95.

119 *"the beastly madness of war"*: Unger, *Machiavelli: A Biography*, 151.

119 *"[R]age, fury, and revenge"*: Vasari, *Lives*, I, 637.

120 *"Leonardo da Vinci"*: Goffen, *Renaissance Rivals*, 155.

120 *"enacted in the palace"*: Unger, *Machiavelli: A Biography*, 151.

120 *"in competition with Leonardo"*: Vasari, *Lives*, II, 657.

123 *"The reason [Raphael]"*: Vasari, *Lives*, I, 712–13.

123 *"The bearer of this"*: Jones and Penny, *Raphael*, 5.

123 *"with natural sweetness"*: Vasari, *Lives*, I, 710.

124 *"On Friday, 6 June 1505"*: Goffen, *Renaissance Rivals*, 154–55.

124 *[W]hen he sent for me from Florence*: Michelangelo, *Letters*, I, 148.

125 *"a light to all those"*: Condivi, *Life of Michelangelo*, 85.

125 *"preserved with the greatest care"*: Ibid.

126 *"Rome, once queen of the world"*: Klaczko, *Rome and the Renaissance*, 148.

IV. CREATION

PAGE

128 *It is almost impossible to describe*: Pastor, *History of the Popes*, VI, 214.

128 *"We have a pope"*: Bull, *Michelangelo: A Biography*, 63.

130 *"[H]e had gained the reputation"*: Guicciardini, *History of Italy*, 172.

131 *"infinite vexations"*: Condivi, *Life of Michelangelo*, 107.

131 *"the tragedy of the tomb"*: Ibid., 107.

131 *"mirror of all Italy"*: Michelangelo, *Letters*, I, xxx.

133 *"a very merry and likable fellow"*: Vasari, *Le Vite*, 577.

134 *"I think I shall demolish this paradise"*: Bruschi, *Bramante*, 115.

135 *"which in beauty and magnificence"*: Vasari, *Lives*, II, 658.

136 *"[A]gain and again"*: Condivi, *Life of Michelangelo*, 73.

136 *"As to my affairs here"*: Michelangelo, *Letters*, I, 11.

137 *I learn from a letter of yours*: Michelangelo, *Letters*, I, 13.

137 *"One cannot count upon him"*: Pastor, *History of the Popes*, VI, 214.

138 *"[f]ear as well as envy"*: Condivi, *Life of Michelangelo*, 73.

138 *"You may tell the Pope"*: Ibid., 80.

139 *"But overtaking him"*: Ibid., 81.

139 *"that his good and faithful service"*: Ibid.

139 *Michelangelo, the sculptor*: Scotti, *Basilica*, 64.

140 *Giuliano, I understand*: Michelangelo, *Carteggio*, I, 14.

141 *"by fair means or force"*: Condivi, *Life of Michelangelo*, 81.

141 *Dearest, almost as a brother*: Michelangelo, *Carteggio*, I, 16.

142 *"You have braved the Pope"*: Condivi, *Life of Michelangelo*, 82.

142 *"[l]eaving S. Peter's chair"*: Klaczko, *Rome and the Renaissance*, 47.

143 *"Michelangelo is so frightened"*: de Tolnay, *Youth of Michelangelo*, 37.

143 *"The bearer is the sculptor Michelangelo"*: Bull, *Michelangelo: A Biography*, 73–74.

143 *"I was forced to go there"*: Michelangelo, *Letters*, I, 148.

144 *"he had not erred maliciously"*: Condivi, *Life of Michelangelo*, 86.

144 *"[O]n Friday afternoon"*: Michelangelo, *Letters*, I, 21.

144 *"What! a book?"*: Condivi, *Life of Michelangelo*, 87.

145 *"[S]ince I have been here"*: Michelangelo, *Letters*, I, 38.

145 *"I am living in a mean room"*: Michelangelo, *Letters*, I, 19.

145 *"Lapo I threw out"*: Michelangelo, *Carteggio*, I, 22.

145 *"Everyone here is smothered in armor"*: Michelangelo, *Letters*, I, 34.

145 *"[L]et it suffice that the thing has turned out badly"*: Michelangelo, *Letters*, I, 35.

145 *"could have turned out better"*: Michelangelo, *Letters*, I, 37.

145 *"To me it seems like a thousand years"*: Michelangelo, *Letters*, I, 41.

146 *From whom do you flee*: Hirst, *Michelangelo: The Achievement of Fame*, 82.

146 *"peace and quiet"*: de Tolnay, *Youth of Michelangelo*, 41.

148 *After I installed the figure*: Michelangelo, *Rime e Lettere*, 442–43.

150 *"It would please me"*: Alberti, *On Painting*, 90.

154 *"a more formidable task"*: Vasari, *On Technique*, 216.

154 *"which passeth all understanding"*: Philippians 4:7.

154 *"I record how today"*: Michelangelo, *Ricordi*, 1–2.

155 *"[W]hen they have come here"*: Michelangelo, *Ricordi*, 1.

155 *"in any case I will come"*: Michelangelo, *Carteggio*, I, 64–65.

156 *"[S]eeing how their work"*: Vasari, *Le Vite*, 892–93.

156 *"been hired to design certain schemes"*: Michelangelo, *Carteggio*, I, 66.

157 *"Of all the methods that painters employ"*: Vasari, *On Technique*, 221.

157 *"There is needed a hand"*: Vasari, *On Technique*, 221.

158 *"In this manner it seemed possible"*: Vasari, *Lives*, II, 665.

158 *"I've already got myself a goiter"*: Goffen, *Renaissance Rivals*, 218.

159 *"I have already told your Holiness"*: Condivi, *Life of Michelangelo*, 100.

160 *"made [Michelangelo] proceed"*: Ibid.

160 *"Your Michelangelo"*: Michelangelo, *Letters*, I, 45.

160 *"I am still in a bind"*: Michelangelo, *Carteggio*, I, 88.

160 *"Here, I am ill content"*: Michelangelo, Ibid., 91.

161 *"determined to demonstrate"*: Vasari, *Lives*, II, 666.

161 *"a vehement nature"*: Condivi, *Life of Michelangelo*, 103.

162 refused him entry: See Vasari, *Lives*, II, 667. Condivi, by contrast, insists that Michelangelo was happy to show him the work in progress. (See Condivi, *Life of Michelangelo*, 103.) It is likely that both characterizations are accurate and reflect different periods of time and Michelangelo's unpredictable humors.

162 the pontiff threatened to have the artist tossed: Condivi, *Life of Michelangelo*, 104.

162 *"[T]he sight of it"*: Vasari, *Lives*, I, 723.

164 *"He was not obliged like so many other geniuses"*: Scotti, *Basilica*, 90.

169 *"the virtues [who] were the prisoners of Death"*: Condivi, *Life of Michelangelo*, 75.

169 *"the provinces subjugated"*: Vasari, *Lives*, II, 659.

170 *"And thus, from the bad use of free will"*: Augustine, *City of God*, 423.

171 *"[W]e all hold confidently"*: Dotson, "An Augustinian Interpretation of Michelangelo's Sistine Ceiling, Part I," *The Art Bulletin*, vol. 61, no. 2 (June, 1979), 224.

171 God spoke to Noah and his sons: Genesis 1, 9:8–11.

172 *"He preached in the church of Santa Reparata"*: Klaczko, *Rome and the Renaissance*, 282.

174 *"[H]e insisted on having it uncovered"*: Condivi, *Life of Michelangelo*, 103–4.

175 *"[They] are trying to reduce me to nothing"*: Pastor, *History of the Popes*, VI, 326.

175 *"the Rovere are a peasant family"*: King, *Michelangelo and the Pope's Ceiling*, 137.

175 *"I'll see if I've balls as big"*: Jones and Penny, *Raphael*, 50.

175 *"has gone away"*: Michelangelo, *Letters*, I, 55.

175 withdrawing without his permission: See Michelangelo, *Letters*, I, 60.

176 Giovan Simone: Michelangelo, *Carteggio*, I, 95–96.

180 *"a man perfect in his generation"*: Augustine, *City of God*, 516.

180 *"God fashioned man of dust from the soil"*: Genesis 2:7.

182 *"lovely art that, heaven sent"*: Michelangelo, *Rime e Lettere*, 157.

182 "[G]ood painting is nothing else": Holanda, *Dialogues with Michelangelo*, 47.

183 "I work harder than any man": Michelangelo, *Rime e Lettere*, 370.

183 "I expect to finish by the end of September": Michelangelo, *Letters*, I, 71.

183 "so weakened and dispirited": Guicciardini, *History of Italy*, 252.

184 "flying like mist in the wind": Unger, *Machiavelli: A Biography*, 190.

184 "We have won, [Paride]": Pastor, *History of the Popes*, VI, 416.

184 "Never was any emperor": King, *Michelangelo and the Pope's Ceiling*, 274.

185 *You have succumbed to rumors*: Michelangelo, *Rime e Lettere*, 72–73.

186 "I finished painting the chapel": Michelangelo, *Carteggio*, I, 137.

186 "our chapel was opened": Bull, *Michelangelo: A Biography*, 99.

186 "It was seen with great satisfaction": Condivi, *Life of Michelangelo*, 104–5.

V. THE DEAD

PAGE

188 "negotiations are already beginning": Pastor, *History of the Popes*, VI, 434.

188 "I have lived forty years": Ibid., 437.

189 "[a] house of several stories": Michelangelo, *Letters*, II, xxiv.

189 "the son of poor but honest people": Michelangelo, *Letters*, I, 82.

190 "a lamb rather than . . . a fierce lion": Pastor, *History of the Popes*, VII, 26–27.

190 "As God has seen fit": Unger, *Magnifico: The Brilliant Life and Violent Times of Lorenzo de' Medici*, 446.

191 "a pitiable spectacle of calamity": Machiavelli et al., *Machiavelli and His Friends: Their Personal Correspondence*, 216.

191 "although it has given me pain": Unger, *Machiavelli: A Biography*, 194.

192 "evil plight": Michelangelo, *Letters*, I, 71.

192 "[T]here are rumors going about": Michelangelo, *Carteggio*, I, 139.

193 "I know the high regard the Pope has for you": Michelangelo, *Carteggio*, II, 253.

193 "I do not doubt this": Michelangelo, *Carteggio*, II, 247.

194 "[that] judged that in the whole field": Vasari, *Lives*, II, 142.

195 "steal[ing] at least three ducats": Klaczko, *Rome and the Renaissance*, 118.

195 "[c]arry out your vendettas": Goffen, *Renaissance Rivals*, 171.

195 "I remember that when Sebastiano": Goffen, *Renaissance Rivals*, 228.

196 "All the world will know": Bull, *Michelangelo: A Biography*, 229–30.

197 "[T]he scarpellini *from here*": Michelangelo, *Letters*, I, 123.

197 "vexations, annoyances, and travails": Vasari, *Lives*, II, 676.

198 "like flocks of starlings": Vasari, *Lives*, II, 661.

201 "I must make a great effort here": Michelangelo, *Letters*, I, 90.

202 "[H]is entrance was greeted": Bull, *Michelangelo: A Biography*, 130.

204 "all for things of no duration": Landucci, *Diary*, 285.

204 *"Pope Leo X"*: Vasari, *Lives,* II, 676.

205 *"Michael Angelo"*: Condivi, *Life of Michelangelo,* 107–9.

205 *"When, in fifteen hundred and sixteen"*: Michelangelo, *Rime e Lettere,* 426–27.

206 *"in order to give lie"*: Michelangelo, *Letters,* I, 253.

206 *"Now, from your last letter"*: Michelangelo, *Carteggio* I, 219–20.

207 *"The cardinal doesn't put faith in anyone"*: Goffen, *Renaissance Rivals,* 228.

207 *"I'm always ready to risk life and limb"*: Michelangelo, *Letters,* I, 135.

207 *"that he never thought of becoming"*: Goffen, *Renaissance Rivals,* 243.

208 *"a cage for crickets"*: Vasari, *Lives,* II, 57.

208 *"I came to Florence"*: Michelangelo, *Carteggio,* I, 267.

208 *"I am eager to tackle this work"*: Michelangelo, *Carteggio,* I, 277.

208 *"As to your saying how eager"*: Michelangelo, *Carteggio,* I, 281.

209 *"not accept[ing] anyone beyond himself"*: Vasari, *Lives,* II, 677.

209 *"the Pope and the Monsignore [Giulio]"*: Michelangelo, *Carteggio,* I, 315.

210 *"Not having been able to speak with you"*: Michelangelo, *Carteggio,* I, 291.

210 *"[T]he reason [Michelangelo] never supplied"*: Hirst, *Michelangelo: The Achievement of Fame,* 328 (note).

210 *"I have undertaken to rouse the dead"*: de Tolnay, *Medici Chapel,* 6.

211 *"The barges I hired at Pisa"*: Michelangelo, *Rime e Lettere,* 410.

212 *"Dearest father"*: Michelangelo, *Carteggio,* II, 274.

212 *"I have never exerted myself"*: Michelangelo, *Letters,* I, 104.

213 *"I am not charging for the wooden model"*: Michelangelo, *Carteggio,* II, 220.

214 *"Michelangelo refused"*: Vasari, *Lives,* II, 275.

219 *"an old man"*: Michelangelo, *Letters,* I, 106.

219 *"I have a great task to perform"*: Michelangelo, *Letters,* I, 146.

220 *"Yesterday evening"*: Michelangelo, *Letters,* I, 160.

220 *"I live on death"*: Michelangelo, *Rime e Lettere,* 117.

222 *"Different it can be made"*: Vasari, *Lives,* II, 679.

222 *"but with another manner of ornamentation"*: Ibid., 679–80.

223 *"wherefore"*: Vasari, Ibid., 680.

223 *"new fantasies"*: Ibid.

228 more than 100 craftsmen: See William E. Wallace, "Michelangelo at Work: Bernardino Basso, Friend, Scoundrel, and Capomaestro," in *I Tatti Studies: Essays in the Renaissance,* vol. 3 (1989): 235–77.

229 *Now you know that in Rome*: Michelangelo, *Letters,* I, 143.

230 *"I'm dying of anguish"*: Michelangelo, *Letters,* I, 121.

230 with this proviso: Michelangelo, *Letters,* I, 163.

231 If my life is an annoyance: Michelangelo, *Carteggio,* II, 373–74.

231 *"shameful"*: Hirst, *Michelangelo: The Achievement of Fame,* 200.

231 They can't sue me: Michelangelo, *Carteggio,* III, 144.

232 *"Through the first death"*: Goffen, *Renaissance Rivals,* 309–10.

232 *"Death is the end of a dark prison"*: de Tolnay, *Art and Thought of Michelangelo*, 37.

232 *the finished works of lesser masters*: Creighton Gilbert, "What is Expressed in Michelangelo's Non-Finito," *Artibus et Historiae*, vol. 24, no. 48 (2003): 59.

233 *"To the Liberator of the Fatherland"*: Rendina, *The Popes*, 449.

234 *"[A]lthough he had a most capable intelligence"*: Guicciardini, *History of Italy*, 363.

235 *"He talks well but he decides badly"*: Scotti, *Basilica*, 160.

235 *"You will have heard that Medici is made Pope"*: Michelangelo, *Rime e Lettere*, 440.

235 *"If Your Holiness wishes me to accomplish anything"*: Michelangelo, *Letters*, I, 151.

239 *"Time, that consumes all things"*: Condivi, *Life of Michelangelo*, 118.

240 *He who made me*: Michelangelo, *Rime e Lettere*, 163.

240 *Day and Night speak*: Ibid., 80.

240 *"Cease in a moment"*: Ibid., 134.

241 *"did not model either Duke Lorenzo"*: Hirst, *Michelangelo: The Achievement of Fame*, 343.

242 *"the unique Michelangelo Simoni"*: Hughes, *Michelangelo*, 179.

242 *"[N]o one has ever had dealings with me"*: Michelangelo, *Letters*, I, 153.

242 *The night was mine*: Michelangelo, *Complete Poems of Michelangelo*, 75.

243 *"O night, though black"*: Michelangelo, *Rime e Lettere*, 161–2.

243 *"[H]e abstained from pleasures"*: Guicciardini, *History of Italy*, 338.

243 *"A papacy made up of greetings"*: Rendina, *The Popes*, 452.

244 *"the four figures are not yet finished"*: Michelangelo, *Rime e Lettere*, 453.

244 *"I'm working as hard as I can"*: Ibid., 458.

244 *"[T]he times are unfavorable"*: Michelangelo, *Letters*, I, 170.

244 *"There will be war in Italy"*: Unger, *Machiavelli: A Biography*, 321.

245 *"Many were suspended hours by the arms"*: Scotti, *Basilica*, 163.

245 *"dreadful news from Rome"*: Unger, *Machiavelli: A Biography*, 328.

245 *"full of atrocities"*: Guicciardini, *History of Italy*, 376.

247 *"persuaded the Pope"*: Michelangelo, *Letters*, I, 272.

247 *"We had then in Florence"*: Hirst, *Michelangelo: The Achievement of Fame*, 352.

247 *"because it was deprived"*: Goffen, *Renaissance Rivals*, 356.

249 *I left without telling any of my friends*: Michelangelo, *Carteggio*, III, 280.

249 *"reproached him with being a timid man"*: Michelangelo, *Letters*, I, 291.

249 *"Each time, on his return"*: Michelangelo, *Letters*, I, 293.

250 *"we have as our enemy an entire people"*: Najemy, *History of Florence*, 462.

250 *"tortures and persecutions"*: Guicciardini, *History of Italy*, 431.

251 *"[T]he pope having won the peace"*: Hirst, *Michelangelo: The Achievement of Fame*, 367.

251 *"Michelangelo is wrong"*: Michelangelo, *Letters*, I, liii.

252 *"duke of the Florentine Republic"*: Najemy, *History of Florence*, 464.

252 *"Michael Angelo lived in great fear"*: Condivi, *Life of Michelangelo*, 121.

252 *"[H]e works much"*: Bull, *Michelangelo: A Biography*, 224.

252 *"that there are many who believe"*: Hirst, *Michelangelo: The Achievement of Fame*, 369.

254 *"Already burdened with a heavy heart"*: Michelangelo, *Complete Poems of Michelangelo*, 65.

255 *"something that [you] would never dream of"*: Hub, *". . . e far dolce la morte*: Love, Death, and Salvation in Michelangelo's 'Last Judgment,'" *Artibus et Historiae*, vol. 26, no. 51 (2005): 111.

255 *"I see that I am yours"*: Hub, *". . . e far dolce la morte,"* 105.

255 *"I am leaving tomorrow morning"*: Michelangelo, *Letters*, I, 187.

255 *Heaven's only where you are*: Michelangelo, *Complete Poems of Michelangelo*, 62.

VI. THE END OF TIME

PAGE

257 *"[I]f I yearn day and night"*: Symonds, *Life of Michelangelo Buonarroti*, 228.

258 *I realize that I could no sooner forget*: Michelangelo, *Rime e Lettere*, 470–71.

258 *"Thus, loving loyally"*: Symonds, *Life of Michelangelo Buonarroti*, 234.

259 *"commend me to him"*: Michelangelo, *Rime e Lettere*, 472.

259 *"In your handsome face"*: Michelangelo, *Rime e Lettere*, 141–42.

259 *"My eyes are drawn"*: Michelangelo, *Rime e Lettere*, 166.

260 *"Wild desire is not love"*: Michelangelo, *Rime e Lettere*, 164.

260 *"I do not deem myself worthy"*: Michelangelo, *Letters*, II, xviii.

261 *"[A]s far as I can see"*: Michelangelo, *Letters*, II, xix.

261 *"may appear mechanical"*: Castiglione, *The Book of the Courtier*, I, 96, 100–101.

261 *"[I] should confess myself disgraced"*: Michelangelo, *Letters*, I, 183.

261 *"Ganymede, then, would signify"*: Panofsky, *Studies in Iconology*, 215.

262 *"The composition is careful"*: Condivi, *Life of Michelangelo*, 136.

263 *"the hens and master cock"*: Symonds, *Life of Michelangelo Buonarroti*, 227.

263 *"I desire to be rid of this obligation"*: Michelangelo, *Letters*, I, 169.

265 *"In the year 1533"*: Vasari, *Lives*, II, 688.

266 *"[T]hose who have robbed me of my youth"*: Michelangelo, *Letters*, II, 31.

266 *"Painting and sculpture"*: Michelangelo, *Letters*, II, 26.

266 *"supreme architect, sculptor and painter"*: Partridge, *Michelangelo: The Last Judgment*, 158.

267 *"Sometimes"*: Holanda, *Dialogues with Michelangelo*, 42.

267 *"[E]ven his Holiness annoys"*: Ibid., 40–41.

269 *"I'll briefly fill you in"*: Michelangelo, *Carteggio,* II, 227.

269 *"Monsignor, I come to your Most Reverend Lordship"*: Michelangelo, *Carteggio,* II, 232.

270 *"is almost the only topic of conversation"*: Michelangelo, *Letters,* I, 273.

270 *"for lazy people and women"*: Hughes, *Michelangelo,* 244.

271 *"and seeing the greatness of his own name"*: Vasari, *Lives,* I, 593.

272 *"I must tell you"*: Michelangelo, *Letters,* II, 160.

273 *"As to the almsgiving"*: Ibid., 81.

273 *"The news of Mona Margherita's death"*: Ibid., 7.

275 *"in a desperate state"*: Vasari, *Lives,* II, 692.

276 *"He opened out the way to facility"*: Ibid., 691.

276 *"Excellent painting imitates the works of God"*: Barnes, *Michelangelo's Last Judgment,* 89.

277 *[T]he sun will be darkened*: Matthew 24:29–31.

283 *"the pulp in fruit compacted by its peal"*: Michelangelo, *Complete Poems of Michelangelo,* 143–44.

283 *How I wish, my lord*: Michelangelo, *Rime e Lettere,* 154.

284 *"I believe that my Redeemer lives"*: Barnes, *Michelangelo's Last Judgment,* 27.

285 *"I wish to make a complaint"*: Holanda, *Dialogues with Michelangelo,* 40–41.

286 *"[I]t is necessary that [he]"*: Goffen, *Renaissance Rivals,* 356.

286 *"Whenever I see someone"*: Bull, *Michelangelo: A Biography,* 311.

287 *"[A]ll Rome knows"*: Michelangelo, *Carteggio,* IV, 279.

288 *"great desire"*: Goffen, *Renaissance Rivals,* 295.

288 *"Sacred Majesty"*: Michelangelo, *Letters,* II, 61.

289 *"Now who would not be"*: Bull, *Michelangelo: A Biography,* 272.

289 *"Magnificent Messer Pietro"*: Michelangelo, *Letters,* II, 3.

290 *"But why, O Lord"*: Michelangelo, *Carteggio,* IV, 181–82.

290 *"certain Gerards and Thomases"*: Bull, *Michelangelo: A Biography,* 297.

292 *"Lord, do not charge me"*: Hughes, *Michelangelo,* 254.

292 *"The work is of such beauty"*: Barnes, *Michelangelo's Last Judgment,* 78.

292 *"shameful"*: Bull, *Michelangelo: A Biography,* 296.

294 *"Even if my own father"*: quoted in MacCulloch, *Reformation: A History,* 231.

295 *"one of the most illustrious"*: Holanda, *Dialogues with Michelangelo,* 33.

296 *"God has permitted this persecution"*: Scotti, *Basilica,* 156.

296 *"keys to the kingdom of heaven"*: Matthew 16:19.

296 *"The justice of Christ"*: de Tolnay, *Final Period,* 54.

297 *"believe that she could only be saved"*: Michelangelo, *Letters,* II, xxix.

297 *"We hope that you will imitate his charity"*: Bull, *Michelangelo: A Biography,* 288.

297 *"Before taking possession"*: Michelangelo, *Letters,* II, 4.

299 *"Unique Master Michelangelo"*: Hughes, *Michelangelo*, 258.

299 *"Through the cross"*: de Tolnay, *Michelangelo: Painter, Sculptor, Architect*, 105.

299 *O flesh, O blood*: Michelangelo, *Rime e Lettere*, 123.

301 *"sacred images modest and devout"*: Barnes, *Michelangelo's Last Judgment*, 85.

301 *"Is it not ridiculous"*: Hub, *". . . e fa dolce la morte,"* 103.

302 *[A]s a baptized Christian*: Hughes, *Michelangelo*, 250–51.

303 *"Some subjects by their nature"*: Barnes, *Michelangelo's Last Judgment*, 98–99.

303 *"if ten people"*: Barnes, "Metaphorical Painting . . ." *Art Bulletin*, vol. 77, no. 1 (March 1995): 67.

304 *"In the same month"*: Wang, "Michelangelo's Signature," *Sixteenth Century Journal*, vol. 35, no. 2 (2004): 469.

304 *"Suddenly, while he was traveling"*: Acts 9:3–8.

307 *"In reply to your last letter"*: Michelangelo, *Letters*, II, 113.

308 *"In principle"*: Rendina, *The Popes*, 457.

308 *"removing from Rome"*: Barnes, *Michelangelo's Last Judgment*, 82.

308 *"it was not right"*: Ibid., 87.

308 *"[C]ertain persons had informed him"*: Vasari, *Lives*, II, 714.

309 *"[H]e used to tell me"*: Vasari, *Lives*, II, 696.

310 *"I am old"*: Michelangelo, *Rime e Lettere*, 561.

310 *"I've reached the end of my life's journey"*: Michelangelo, *Rime e Lettere*, 284.

VII. BASILICA

PAGE

313 *"[A]s there was much anxiety"*: Klaczko, *Rome and the Renaissance*, 26–27.

314 *"His Holiness shows every happiness"*: Scotti, *Basilica*, 78.

314 *"It's all happening because of me"*: Klaczko, *Rome and the Renaissance*, 22.

314 *"Michael Angelo was the cause"*: Condivi, *Life of Michelangelo*, 79.

315 *"[T]he continual force of the wind"*: Alberti, *On the Art of Building*, 26.

316 *". . . all people are persuaded"*: Scotti, *Basilica*, 123–24.

316 *"The name il Ruinante"*: Scotti, *Basilica*, 75.

316 *"Why did you destroy my temple"*: Klaczko, *Rome and the Renaissance*, 25.

317 *"You are Peter"*: Matthew 16:18–20.

317 *"This material edifice had destroyed"*: Klaczko, *Rome and the Renaissance*, 26.

319 *"encourage piety"*: Alberti, *On the Art of Building*, 194.

321 *"It is obvious"*: Ibid., 196.

321 *"For without order"*: Ibid., 191.

321 *"The design of a temple depends on symmetry"*: Vitruvius, *Ten Books on Architecture*, 72–73.

323 *"raise the dome of the Pantheon"*: Scotti, *Basilica*, 132.

323 *"The New Basilica"*: Ibid., 81.

324 *"Christians should be taught"*: Ibid., 148.

324 *"Everything is for sale"*: Ibid., 144.

324 *"eaten up three Pontificates"*: Pastor, *History of the Popes,* VIII, 102.

325 *"What task can be nobler"*: Ibid., 326.

325 *"[H]e lived"*: Vasari, *Lives,* I, 747.

326 *"Acting more out of pity"*: Scotti, *Basilica,* 137.

327 "Messer *Giorgio my friend"*: Michelangelo, *Carteggio,* V, 105.

328 *"I recall a certain staircase"*: Michelangelo, *Letters,* II, 157–58.

332 *"I was forced to undertake"*: Ibid., 153.

333 *"all the Sangallo faction"*: Ibid., 307.

334 *"Messer Bartolomeo, dear friend"*: Ibid., 69.

334 *"numerous projections and angles"*: Ibid., 307.

335 *Whoever takes delivery*: Ibid., 95–96.

336 *"Forasmuch as our beloved son"*: Ibid., 308.

337 *the artist fretted*: Ibid., 119.

337 *"was constructing a Temple"*: Ibid., 309–10.

337 *"I am not obliged"*: Vasari, *Lives,* II, 708.

338 *"Holy father"*: Michelangelo, *Letters,* II, 310.

338 *"Doubt not that you are gaining good"*: Ibid.

340 *"[n]o-one who has not been"*: Ibid., 129.

343 *"I want you to get"*: Ibid., 78.

346 *"never consented to be bound"*: Vasari, *Lives,* II, 709.

347 *"I am in a state of greater anxiety"*: Michelangelo, *Letters,* II, 174.

347 *"if one could die of shame"*: Ibid., 178.

348 *"[I]f I've delayed in coming"*: Michelangelo, *Carteggio* V, 110.

348 *"From the year 1540"*: Michelangelo, *Letters,* II, 310.

349 *"disturbed, or hindered"*: Ibid., 311.

349 *"Holy Father"*: Ibid., 314.

349 *"Michelagnolo's adversaries"*: Vasari, *Lives,* II, 710.

350 *"Everything was sad"*: Michelangelo, *Letters,* II, 299.

351 *"my great pleasure here"*: Michelangelo, *Rime e Lettere,* 620.

352 *"As regards to the fabric"*: Michelangelo, *Letters,* II, 171.

352 *"To leave now"*: Michelangelo, *Rime e Lettere,* 600.

355 *"all the prelates"*: Michelangelo, *Letters,* II, 245.

355 *"As regards my being ill"*: Ibid., 82.

356 *My flesh made earth*: Michelangelo, *Rime e Lettere,* 228.

357 *"He who pulled me"*: Ibid., 525–26.

357 *"Now that Luigi del Riccio is dead"*: Michelangelo, *Letters,* II, 250.

357 *"I am old"*: Michelangelo, *Rime e Lettere,* 537.

357 *"The greatest artist"*: Ibid., 196–98.

358 *I admit that it seems to me*: Michelangelo, *Letters,* II, 75.

360　　*"I do not want to . . . describe to you"*: Ibid., 133.

360　　*"Lionardo," he wrote*: Ibid., 37–38.

360　　*"[I] have not failed to commend you"*: Ibid., 245.

361　　*"an imposing house in the city"*: Ibid., 64.

361　　*"All you need have an eye to"*: Ibid., 129.

361　　*"[one] who is clean and respectable"*: Ibid., 123.

361　　*Bishop de' Minnerbeti was here*: Ibid., 137.

362　　*"Lionardo, I understand"*: Michelangelo, *Rime e Lettere*, 596.

362　　*"We must give thanks to God"*: Ibid., 598.

362　　*"[S]uch pomp displeases me"*: Michelangelo, *Letters*, II, 146.

363　　*"[I]f life pleases us"*: Ibid., lii.

363　　*"I am not only an old man"*: Michelangelo, *Rime e Lettere*, 540.

363　　*"Before men"*: Michelangelo, *Letters*, II, liii.

365　　*"O night, though black"*: Michelangelo, *Rime e Lettere*, 161–62.

365　　*"Michelangelo Buonarroti is"*: Michelangelo, *Letters*, II, li.

366　　*"head, father and master"*: Bull, *Michelangelo: A Biography*, 412.

366　　*"Lionardo—I see from your letter"*: Michelangelo, *Letters*, II, 207.

367　　*"O Daniele, I am done for"*: Ibid., lii.

367　　*"So it would seem to me"*: Bull, *Michelangelo: A Biography*, 412.

367　　*"I left him"*: Hughes, *Michelangelo*, 313.

367　　*"in the attitude"*: Ibid.

367　　*"the greatest man"*: Michelangelo, *Letters*, II, lii.

368　　*"[Y]ou must know for certain"*: Michelangelo, *Rime e Lettere*, 601.

368　　*"Lionardo, his nephew, arrived"*: Vasari, *Lives*, II, 747.

369　　*"lest the report might spread"*: Ibid., 753.

369　　*"in the twinkling of an eye"*: Ibid.

369　　*[W]hen . . . all the rest of us*: Ibid., 754.

369　　*Truly his coming was to the world*: Ibid., 747.

370　　*The Academy of Painters*: Ibid., 757.

370　　*"Who ever lived a more godly life?"*: Michelangelo, *Letters*, II, liii.

371　　*"The greatest power"*: de Tolnay, *Art and Thought of Michelangelo*, 33.

371　　*"[I]mages shall not be painted"*: Bull, *Michelangelo: A Biography*, 398.

Bibliography

ARCHIVES AND DATABASES

Florence, Archivio di Stato di Firenze, Archivi Digitalizzati, Mediceo Avanti il Principato.

Online Catasto of 1427. Version 1.3. Edited by David Herlihy, Christiane Klapisch-Zuber, R. Burr Litchfield, and Anthony Molho. [Machine-readable data file based on D. Herlihy and C. Klapisch-Zuber, *Census and Property Survey of Florentine Domains in the Province of Tuscany, 1427–1480.*] Florentine Renaissance Resources/STG: Brown University, Providence, R.I., 2002.

Online Tratte of Office Holders 1282–1532. Edited by David Herlihy, R. Burr Litchfield, Anthony Molho, and Roberto Barducci.

MICHELANGELO

Carteggio di Michelangelo. 5 vols. Florence, 1965.

Complete Poems of Michelangelo. Translated by John Frederick Nims. Chicago, 1998.

Contratti di Michelangelo. Florence, 2005.

Letters of Michelangelo. 2 vols. Translated by E. H. Ramsden. Stanford, Calif., 1963.

Ricordi di Michelangelo. Florence, 1970.

Rime. Bari, 1960.

Rime e Lettere. Torino, 1992.

PRIMARY SOURCES

Alberti, Leon Battista. *The Family in Renaissance Florence.* Long Grove, Ill., 1969.

———. *On the Art of Building in Ten Books.* Cambridge, 1988.

———. *On Painting.* New Haven, 1956.

———. *On Painting and on Sculpture,* London, 1972.

Albertini, Francesco. *Memoriale di Molte Statue et Picture di Florentia*. In *Five Early Guides to Rome and Florence*. Westmead, U.K., 1972.

Anonymous. *La Edification de Molti Pallazi & Tempii di Roma*. In *Five Early Guides to Rome and Florence*. Westmead, U.K., 1972.

Augustine, Saint. *The City of God*. New York, 1950.

Beccadelli, Antonio, called Panormita. *The Hermaphrodite*. Translated by Michael de Cossart. Liverpool, 1984.

Bible, King James Version; also, *The Jerusalem Bible*. New York, 1966.

Bisticci, Vespesiano da. *Renaissance Princes, Popes, and Prelates: The Vespesiano Memoirs, Lives of Illustrious Men of the XVth Century*. Translated by William George and Emily Waters. New York, 1963.

Boccaccio, Giovanni. *The Decameron*. Translated by G. H. McWilliam. London, 1992.

———. "The Return of the Muses." In *The Portable Renaissance Reader*. Edited by James Bruce Ross. Middlesex, 1953.

Bracciolini, Poggio. "The Ruins of Rome." In *The Portable Renaissance Reader*. Edited by James Bruce Ross. Middlesex, 1953.

Bruni, Leonardo. *History of the Florentine People*. Translated by James Hankins. Cambridge, 2001.

———. *Panegyric to the City of Florence*. In *The Earthly Republic: Italian Humanists on Government and Society*. Translated by Benjamin G. Kohl. Philadelphia, 1978.

Burchard, Johann. *At the Court of the Borgia*. Translated by Geoffry Parker. London, 1997.

Castiglione, Baldassare. *The Book of the Courtier*. Translated by George Bull. London, 1967.

Cellini, Benvenuto. *Autobiography*. Translated by J. Addington Symonds. New York, 1927.

———. *Vita*. Milan, 1954.

Cennini, Cennino d' Andrea. *The Craftsman's Handbook*. Translated by Daniel V. Thompson, Jr. New Haven, 1933.

Compagni, Dino. *Dino Compagni's Chronicle of Florence*. Translated by Daniel E. Bornstein. Philadelphia, 1986.

Condivi, Ascanio. *Life of Michelangelo*. Translated by Charles Robertson. London, 2006.

Dante Alighieri. *Inferno*. Translated by John D. Sinclair. New York, 1939.

———. *Paradiso*. Translated by John D. Sinclair. New York, 1939.

———. *Purgatorio*. Translated by John D. Sinclair. New York, 1939.

Dati, Gregorio, and Buonacorso Pitti. *Two Memoirs of Renaissance Florence: The Diaries of Buonacorso Pitti and Gregorio Dati*. Translated by Julia Martines. Edited by Gene Brucker. New York, 1967.

Dei, Benedetto. *La Cronica dall'Anno 1400 all' Anno 1500*. Edited by Roberto Barducci. Florence, 1985.

Erasmus, Desiderius. *Julius Exclusus*. Translated by J. Kelly Sowards. Bloomington, Ind., 1968.

———. *Praise of Folly*. Middlesex, 1971.

Esequie del Divino Michelagnolo Buonarroti. Translated by Rudolf and Margot Wittkower. London, 1964.

Ficino, Marsilio. *The Letters of Marsilio Ficino*. Translated by members of the Language Department of the School of Economic Science. New York, 1985.

———. *Commentary on Plato's Symposium on Love*. Translated by Sears Jayne. Dallas, 1985.

———. "The Soul of Man." In *The Portable Renaissance Reader*. Edited by James Bruce Ross. Middlesex, 1953.

Filarete, Francesco. *Libro Cerimoniale of the Florentine Republic*. Translated by Richard Trexler. Geneva, 1978.

———. *Filarete's Treatise on Architecture*. 2 vols. New Haven, 1965.

Ghiberti, Lorenzo. *I Commentari*. Edited by O. Morisani. Naples, 1947.

Giannotti, Donato. *Dialogi di Donato Giannotti, dei Giorni che Dante Consumó nel Cercare l'Inferno e'l Purgatorio*. Florence, 1939.

Giovio, Paolo. *Notable Men and Women of Our Time*. Translated by Kenneth Gouwens. Cambridge, U.K., 2013.

Guicciardini, Francesco. *History of Florence*. Translated by Cecil Grayson. New York, 1964.

———. *History of Italy*. Translated by Sidney Alexander. Princeton, 1969.

Holanda, Francisco de. *Dialogues with Michelangelo*. London, 2006.

Landino, Cristoforo. *Disputationes Camaldulenses*. Edited by Peter Lohe. Florence, 1980.

Landucci, Luca. *A Florentine Diary*. London, 1927.

Leonardo da Vinci. *The Notebooks*. 2 vols. Edited by J. Richter. New York, 1970.

———. *On Painting*. Berkeley, Calif., 1964.

———. *Paragone: A Comparison of the Arts*. London, 1949.

Machiavelli, Niccolò. *Florentine Histories*. Translated by Laura F. Banfield and Harvey C. Mansfield, Jr. Princeton, 1988.

———. *Chief Works and Others*. 3 vols. Translated by Felix H. Gilbert. Durham, N.C., 1965.

———. *Il Principe*. Milan, 1950.

Machiavelli, Niccolò, et al. *Machiavelli and His Friends: Their Personal Correspondence*. Translated and edited by James B. Atkinson and David Sices. DeKalb, Ill., 1996.

Manetti, Antonio di Tuccio. *Life of Brunelleschi*. Edited by Howard Saalman. Translated by Catherine Enggass. University Park, Pa., 1970.

Medici, Lorenzo. *Justification of the Commentary on His Sonnets.* Extract in *The Three Crowns of Florence.* Edited by D. Thompson and P. Nagel. New York, 1972.

———. *Lettere.* 7 vols. Edited by Nicolai Rubinstein. Florence, 1977–2004.

———. *Opere Scelte.* Novara, It., 1969.

———. *Ricordi.* In *Humanism and Liberty: Writings on Freedom from Fifteenth-Century Florence.* Translated by Renée Neu Watkins. Columbia, S.C., 1978.

Palladio, Andrea. *Descritione de le Chiese di Roma.* In *Five Early Guides to Rome and Florence.* Westmead, U.K., 1972.

———. *L' Antichità di Roma.* In *Five Early Guides to Rome and Florence.* Westmead, U.K., 1972.

Parenti, Marco. *Lettere.* Edited by Maria Marrese. Florence, 1996.

———. *Ricordi Storici, 1464–1467.* Edited by Manuela Doni Garfagnini. Rome, 2001.

Parenti, Piero di Marco. *Lettere.* Edited by Maria Marrese. Florence, 1996.

———. *Storia Fiorentina.* Florence, 1994.

Pico della Mirandola, Giovanni. "The Dignity of Man." In *The Portable Renaissance Reader.* Edited by James Bruce Ross. Middlesex, 1953.

Piccolomini, Aeneas Sylvius, Pope Pius II. *Memoirs of a Renaissance Pope: The Commentaries of Pius II.* Abridgment and translation by Florence A. Gragg. Edited by Leona C. Gabel. New York, 1959.

Platina, Bartolomeo. "The Restoration of Rome." In *The Portable Renaissance Reader.* Edited by James Bruce Ross. Middlesex, 1953.

Plato. *Works of Plato.* Translated by Benjamin Jowett. New York, 1936.

———. *The Laws.* In *The Works of Plato.* Translated by Benjamin Jowett. New York, 1936.

———. *The Republic.* In *The Works of Plato.* Translated by Benjamin Jowett. New York, 1936.

———. *Symposium.* In *The Works of Plato.* Translated by Benjamin Jowett. New York, 1936.

Poliziano, Angelo. *Letters.* Translated by Shane Butler. Cambridge, 2006.

———. "The Pazzi Conspiracy." In *Humanism and Liberty: Writings on Freedom from Fifteenth-Century Florence.* Translated by Renée Neu Watkins. Columbia, S.C., 1978.

———. *Stanze per la Giostra di Giuliano de' Medici.* In *The Stanze of Angelo Poliziano.* Translated by David Quint. Amherst, Mass., 1979.

Pulci, Luigi. *La Giostra di Lorenzo de' Medici.* In *Morgante e Opere Minori.* Edited by Aulo Greco. Turin, 1997.

———. *Lettere di Luigi Pulci a Lorenzo ed Altri.* Lucca, It., 1886.

Rinuccini, Alemanno. "Dialogue on Liberty." In *Humanism and Liberty: Writings on Freedom from Fifteenth-Century Florence.* Translated by Renée Neu Watkins. Columbia, S.C., 1978.

———. *Ricordi Storici di Filippo di Cino Rinuccini dal 1282 al 1460 colla Continuazione di Alamanno e Neri, Suoi Figli Fino al 1506.* Florence, 1840.

Savonarola, Girolamo. *Lettere.* Florence, 1936.

———. *Liberty and Tyranny in the Government of Men.* Translated by C. M. Flumiani. Albuquerque, 1976.

———. *Selected Writings.* Translated by Anne Borelli and Maria Pastore Passaro. New Haven, 2006.

Valori, Niccolò. *Vita di Lorenzo il Magnifico.* Palermo, 1992.

Vasari, Giorgio. *Le Vite de' Più Eccellenti Architetti, Pittori, et Scultori Italiani da Cimabue Insino a' Tempi Nostri.* Turin, 1986.

———. *Lives of the Painters, Sculptors, Architects.* Translated by Gason du C. de Vere. New York, 1996.

———. *Vasari on Technique.* Translated by Louisa S. Maclehose. New York, 1960.

Vitruvius. *Vitruvius: The Ten Books on Architecture.* Translated by Morris Hicky Morgan. New York, 1960.

SECONDARY

Acidini Luchinat, Christina. *Renaissance Florence: The Age of Lorenzo de' Medici, 1449–1492.* Milan, 1993.

———. *Treasures of Florence: The Medici Collection, 1400–1700.* Translated by Eve Leckey. Munich, 1997.

Acidini Luchinat, Christina, et al. *The Medici, Michelangelo, and the Art of Late Renaissance Florence.* New Haven, 2002.

Ackerman, James S. "Architectural Practice in the Italian Renaissance." *Journal of the Society of Architectural Historians,* vol. 13, no. 3 (Oct. 1954): 3–11.

———. *The Architecture of Michelangelo.* Baltimore, 1971.

Agoston, Laura Camille. "Male/Female, Italy/Flanders, Michelangelo/Vittoria Colonna." *Renaissance Quarterly,* vol. 58, no. 4 (Winter 2005): 1175–1219.

Ames-Lewis, Francis. "Drapery 'Pattern'-Drawings in Ghirlandaio's Workshop and Ghirlandaio's Early Apprenticeship." *Art Bulletin,* vol. 63, no. 1 (Mar. 1981): 49–62.

Ascher, Yoni. "Michelangelo's Projects for the Medicean Tombs: Rereading of the Story of the Medici Chapel." *Artibus et Historiae,* vol. 23, no. 46 (2002): 83–96.

Baldini, Nicoletta. *Raphael.* New York, 2005.

Barnes, Bernardine. "A Lost Modello for Michelangelo's 'Last Judgment.'" *Master Drawings,* vol. 26, no. 3 (Autumn 1988): 239–48.

———. "Metaphorical Painting: Michelangelo, Dante, and the Last Judgment." *Art Bulletin,* vol. 77, no. 1 (Mar. 1995): 64–81.

———. *Michelangelo's Last Judgment: The Renaissance Response.* Los Angeles, 1998.

Baron, Hans. *The Crisis of the Early Italian Renaissance: Civic Humanism and Republican Liberty.* Princeton, 1955.

Baxandall, Michael. *Painting and Experience in Fifteenth-Century Italy.* Oxford, 1972.

Beck, James. "Cardinal Alidosi, Michelangelo, and the Sistine Ceiling." *Artibus et Historiae,* vol. 11, no. 22 (1990): 63–77.

———. "Connoisseurship: A Lost or a Found Art? The Example of a Michelangelo Attribution: 'The Fifth Avenue Cupid.'" *Artibus et Historiae,* vol. 19, no. 37 (1998): 9–42.

———. *Jacopo della Quercia.* New York, 1991.

———. *The Medici Chapel.* New York, 1994.

———. *Michelangelo: A Lesson in Anatomy.* London, 1975.

———. *Raphael.* New York, 1994.

Becker, Marvin B. *Florence in Transition.* 2 vols. Baltimore, 1967.

Belting, Hans. *The Image and its Public in the Middle Ages: Form and Function of Early Paintings of the Passion.* Translated by Mark Bartusis and Raymond Meyer. New Rochelle, N.Y., 1990.

———. *Likeness and Presence: A History of the Image Before the Era of Art.* Chicago, 1994.

Bennett, B. A., and D. G. Wilkins. *Donatello.* Oxford, 1984.

Bershad, David L. "Recent Archival Discoveries Concerning Michelangelo's 'Deposition' in the Florence Cathedral and a Hitherto Undocumented Work of Giuseppe Mazzuoli (1644–1725)." *Burlington Magazine,* vol. 120, no. 901 (Apr. 1978): 225–27.

Borolsky, Paul. *Michelangelo's Nose: A Myth and Its Maker.* University Park, Pa., 1990.

Bosch, Lynette M. F. "Genesis, Holy Saturday, and the Sistine Ceiling." *Sixteenth Century Journal,* vol. 30, no. 3 (Autumn 1999): 643–52.

Bottari, Stefano. *The Cathedral of Florence.* Bologna, 1965.

Brown, Alison. *Bartolomeo Scala, 1430–1497: Chancellor of Florence.* Princeton, 1979.

Brown, David Alan. *Leonardo da Vinci: Origins of a Genius.* New Haven, 1998.

Brucker, Gene. *The Civic World of Renaissance Florence.* Princeton, 1977.

———. *Florence: The Golden Age, 1138–1737.* Berkeley, Calif., 1998.

———. *Renaissance Florence.* New York, 1969.

Brucker, Gene, ed. *The Society of Renaissance Florence: A Documentary Study.* New York, 1971.

Bruschi, Arnaldo. *Bramante.* London, 1973.

Bule, Steven. *Verrocchio and Late Quattrocento Italian Sculpture.* Florence, 1992.

Bull, George. *Michelangelo: A Biography.* New York, 1996.

Bull, Malcolm. "The Iconography of the Sistine Chapel Ceiling." *Burlington Magazine,* vol. 130, no. 1025 (Aug. 1988): 597–605.

Bullard, Melissa. *Lorenzo il Magnifico: Image and Anxiety, Politics and Finance.* Florence, 1994.

——. "The Magnificent Lorenzo de' Medici: Between Myth and History." In *Politics and Culture in Early Modern Europe: Essays in Honor of H. G. Koenigsberger.* Edited by P. Mack and M. C. Jacob. Cambridge, 1987.

Burckhardt, Jacob. *The Civilization of the Renaissance in Italy.* 2 vols. Translated by S. G. C. Middlemore. New York, 1958.

Burroughs, Charles. "The 'Last Judgment' of Michelangelo: Pictorial Space, Sacred Topography, and the Social World." *Artibus et Historiae,* vol. 16, no. 32 (1995): 55–89.

Butterfield, Andrew. "New Evidence for the Iconography of David in Quattrocento Florence." *I Tatti Studies: Essays in the Renaissance,* vol. 6 (1995): 115–33.

Cadogan, Jean K. *Domenico Ghirlandaio: Artist and Artisan.* New Haven, 2000.

——. "Michelangelo in the Workshop of Domenico Ghirlandaio." *Burlington Magazine,* vol. 135, no. 1078 (Jan. 1993): 30–31.

Cambon, Glauco. *Michelangelo's Poetry: Fury and Form.* Princeton, 1985.

Cast, David. "Finishing the Sistine." *Art Bulletin,* vol. 73, no. 4 (Dec. 1991): 669–84.

Catterson, Lynn. "Michelangelo's 'Laocoön'?" *Artibus et Historiae,* vol. 26, no. 52 (2005): 29–56.

Chamberlin, E. R. *Everyday Life in Renaissance Times.* London, 1966.

——. *The World of the Italian Renaissance.* London, 1982.

Chambers, David. *Patrons and Artists in the Italian Renaissance.* Columbia, S.C., 1971.

Chambers, D. S. "Papal Conclaves and Prophetic Mystery in the Sistine Chapel." *Journal of the Warburg and Courtauld Institutes,* vol. 41 (1978): 322–26.

Cheetham, Sir Nicolas. *Keepers of the Keys: A History of Popes from St. Peter to John Paul II.* New York, 1983.

Cherubini, Giovanni, et al. *Vivere nel Contado al Tempo di Lorenzo.* Florence, 1992.

Clark, Kenneth. "The Young Michelangelo." In *The Penguin Book of the Renaissance.* Middlesex, 1961.

Clarke, Paula. *The Soderini and the Medici: Power and Patronage in Fifteenth-Century Florence.* Oxford, 1991.

Cohen, Simona. "Some Aspects of Michelangelo's Creative Process." *Artibus et Historiae,* vol. 19, no. 37 (1998): 43–63.

Cole, Bruce. *The Renaissance Artist at Work.* Boulder, Colo., 1983.

Connor, James. *The Last Judgment: Michelangelo and the Death of the Renaissance.* New York, 2009.

Cook, James Wyatt. *The Autobiography of Lorenzo de' Medici the Magnificent: A Commentary on My Sonnets.* Tempe, Ariz., 2000.

Cropper, Elizabeth. "Paragoni: Benedetto Varchi's 'Due lezzioni' and Cinquecento Art Theory by Leatrice Mendelsohn." *Renaissance Quarterly,* vol. 36, no. 4 (Winter 1983): 598–601.

Crum, Roger, and John Paoletti, eds. *Renaissance Florence: A Social History*. Cambridge, 2006.

Davis, Charles. *Dante and the Idea of Rome*. Oxford, 1957.

Deane, Herbert A. "The Political and Social Ideas of St. Augustine." In *Essays in the History of Political Thought*. Englewood Cliffs, N.J., 1969.

Deimling, Barbara. *Botticelli*. Cologne, 2000.

D'Elia, Una Roman. "Drawing Christ's Blood: Michelangelo, Vittoria Colonna, and the Aesthetics of Reform." *Renaissance Quarterly*, vol. 59, no. 1 (Spring 2006): 90–129.

Delle Donne, Giovanni. *Lorenzo il Magnifico e il suo Tempo*. Rome, 2003.

Denley, Peter, and Caroline Elam, eds. *Florence and Italy: Renaissance Studies in Honor of Nicolai Rubinstein*. Turnhout, Belg., 1996.

de Tolnay, Charles. *The Art and Thought of Michelangelo*. New York, 1964.

———. *The Complete Work of Michelangelo*. New York, 1970.

———. *The Final Period: Last Judgment, Pauline Frescoes, Last Pietàs*. Princeton, 1960.

———. *The Medici Chapel*. Princeton, 1948.

———. *Michelangelo: Painter, Sculptor, Architect*. Princeton, 1970.

———. "Michelangelo's Pietà Composition for Vittoria Colonna." *Record of the Art Museum, Princeton University*, vol. 12, no. 2 (1953): 44–62.

———. *The Sistine Ceiling*. Princeton, 1945.

———. *Youth of Michelangelo*. Princeton, 1947.

Dixon, John W. "The Drama of Donatello's David: Reexamination of an 'Enigma.'" *Gazette des Beaux-Arts*, vol. 93 (1979): 6–12.

Donato, Maria. "Hercules and David in the Early Decoration of the Palazzo Vecchio: Manuscript Evidence." *Journal of the Warburg and Courtauld Institutes*, vol. 54 (1991): 83–98.

Dotson, Esther. "An Augustinian Interpretation of Michelangelo's Sistine Ceiling, Part I." *Art Bulletin*, vol. 61, no. 2 (June 1979): 223–56.

———. "An Augustinian Interpretation of Michelangelo's Sistine Ceiling, Part II." *Art Bulletin*, vol. 61, no. 3 (Sept. 1979): 405–29.

Elam, Caroline. "Ché Ultima Mano!": Tiberio Calcagni's Marginal Annotations to Condivi's Life of Michelangelo." *Renaissance Quarterly*, vol. 51, no. 2 (Summer 1998): 475–97.

———. "Lorenzo de' Medici's Sculpture Garden." *Mitteilungen des Kunsthistorischen Institutes in Florenz* 36. Bd., H. 1/2 (1992): 41–84.

Ettlinger, L. D. "The Liturgical Function of Michelangelo's Medici Chapel." *Mitteilungen des Kunsthistorischen Institutes in Florenz*, 22. Bd., H. 3 (1978): 287–304.

Ettlinger, L. D., and Helen S. Ettlinger. *Botticelli*. New York, 1977.

Fenlon, Dermot. *Heresy and Disobedience in Tridentine Italy: Cardinal Pole and the Counter Reformation.* Cambridge, U.K., 1972.

Ferrara, Orestes. *The Borgia Pope, Alexander the Sixth.* New York, 1940.

Field, Arthur. *The Origins of the Platonic Academy of Florence.* Princeton, 1988.

Findlen, Paula, ed. *The Italian Renaissance.* Malden, Mass., 2002.

Forsyth, William H. "Medieval Statues of the Pietà in the Museum." *Metropolitan Museum of Art Bulletin,* New Series, vol. 11, no. 7 (Mar. 1953): 177–84.

Franklin, David; Louis A. Waldman; and Andrew Butterfield. *Leonardo da Vinci, Michelangelo, and the Renaissance in Florence.* Ottawa, 2005.

Frazer, Alfred. "A Numismatic Source for Michelangelo's First Design for the Tomb of Julius." *Art Bulletin,* vol. 57, no. 1 (Mar. 1975): 53–57.

Freedburg, Stanley J. *Andrea del Sarto.* London, 1963.

Freedman, Luba. "Michelangelo's Reflections on Bacchus." *Artibus et Historiae,* vol. 24, no. 47 (2003): 121–35.

Friedlaender, Walter. *Mannerism and Anti-Mannerism in Italian Painting.* New York, 1990.

Gage, John. *Life in Italy at the Time of the Medici.* New York, 1970.

Garin, Eugenio. *Italian Humanism: Philosophy and Civic Life in the Renaissance.* Translated by Peter Munz. Westport, Conn., 1975.

———. *Portraits from the Quattrocento.* New York, 1963.

Gentile, Sebastiano. "Ficino e il Platonismo di Lorenzo." In *Lorenzo de Medici: New Perspectives.* Edited by Bernard Toscani. New York, 1992.

Geronimus, Dennis V., and Louis A. Waldman. "Children of Mercury: New Light on the Members of the Florentine Company of St. Luke (c. 1475–c. 1525)." *Mitteilungen des Kunsthistorischen Institutes in Florenz,* 47. Bd., H. 1 (2003): 118–58.

Gilbert, Creighton. *Michelangelo on and off the Sistine Ceiling.* New York, 1994.

———. "What Did the Renaissance Patron Buy?" *Renaissance Quarterly,* vol. 51, no. 2 (Summer 1998): 392–450.

———. "What Is Expressed in Michelangelo's Non-Finito." *Artibus et Historiae,* vol. 24, no. 48 (2003): 59.

Gilbert, Felix. "Florentine Political Assumptions in the Period of Savonarola and Soderini." *Journal of the Warburg and Courtauld Institutes,* vol. 20, no. 3/4 (July–Dec. 1957): 187–214.

———. *The Pope, his Banker, and Venice.* Cambridge, Mass., 1980.

Gill, Anton. *Il Gigante: Michelangelo, Florence, and the David.* New York, 2003.

Giunta, Jacopo. *The Divine Michelangelo: The Florentine Academy's Homage on His Death in 1564.* Introduced, translated, and annotated by Rudolf and Margot Wittkower. London, 1964.

Goffen, Rona. "Friar Sixtus IV and the Sistine Chapel." *Renaissance Quarterly,* vol. 39, no. 2 (Summer 1986): 218–62.

———. "Mary's Motherhood According to Leonardo and Michelangelo." *Artibus et Historiae,* vol. 20, no. 40 (1999): 35–69.

———. "Raphael's Designer Labels: From the Virgin Mary to La Fornarina." *Artibus et Historiae,* vol. 24, no. 48 (2003): 123–42.

———. *Renaissance Rivals: Michelangelo, Leonardo, Raphael, Titian.* New Haven, 2002.

Goldthwaite, Richard A. *The Building of Renaissance Florence: An Economic and Social History.* Baltimore, 1980.

———. *Private Wealth in Renaissance Florence: A Study of Four Families.* Princeton, 1968.

Gombrich, E. H. "A Classical Quotation in Michael Angelo's 'Sacrifice of Noah.'" *Journal of the Warburg Institute,* vol. 1, no. 1 (July 1937): 69.

———. "Renaissance and Golden Age." *Journal of the Warburg and Courtauld Institutes,* vol. 24, no. 3/4 (July–December 1961): 306–9.

———. "The Renaissance Conception of Artistic Progress." Reprinted in *Norm and Form: Studies in the Art of the Renaissance,* vol. 1. London and New York, 1966.

Gottlieb, Anthony. *The Dream of Reason: A History of Philosophy from the Greeks to the Renaissance.* New York, 2000.

Grafton, Anthony. *Leon Battista Alberti: Master Builder of the Italian Renaissance.* New York, 2000.

Grassi, Luigi. *All the Sculpture of Donatello.* 2 vols. Translated by Paul Colacicchi. New York, 1964.

Greenblatt, Stephen. *Renaissance Self-Fashioning: From More to Shakespeare.* Chicago, 1980.

Greenstein, Jack M. "How Glorious the Second Coming of Christ: Michelangelo's *Last Judgment* and the Transfiguration." *Artibus et Historiae,* vol. 10, no. 20 (1989): 33–57.

Grimm, Hermann, and Ida M. Eliot. "Raphael and Michael Angelo." *Journal of Speculative Philosophy,* vol. 13, no. 3 (July 1879): 289–309.

Haines, Margaret. "Brunelleschi and Bureaucracy: The Tradition of Public Patronage of the Florentine Cathedral." *I Tatti Studies,* vol. 3 (1989): 89–125.

Hale, John R. *Florence and the Medici: The Pattern of Control.* London, 1977.

———. *Italian Renaissance Painting from Masaccio to Titian.* Oxford, 1977.

Hall, Marcia B. "Michelangelo's Last Judgment: Resurrection of the Body and Predestination." *Art Bulletin,* vol. 58, no. 1 (Mar. 1976): 85–92.

Hall, Marcia, and Leo Steinberg. "Who's Who in Michelangelo's Creation of Adam, Continued." *Art Bulletin,* vol. 75, no. 2 (June 1993): 340–44.

Hamburger, Jeffrey F. *The Visual and the Visionary: Art and Female Spirituality in Late Medieval Germany.* New York, 1998.

Hankins, James. "Lorenzo de' Medici as a Patron of Philosophy." *Rinascimento,* 2nd ser., 34 (1994): 15–53.

———. "The Myth of the Platonic Academy." *RQ,* vol. 44 (Autumn 1991): 429–75.

————. *Plato in the Italian Renaissance,* 2 vols. Leiden, 1990.

Hartt, Frederick. *David by the Hand of Michelangelo: The Original Model Discovered.* New York, 1987.

————. *History of Italian Renaissance Art.* Englewood Cliffs, N.J., 1975.

————. "Lignum Vitae in Medio Paradisi: The Stanza d'Eliodoro and the Sistine Ceiling, Part 1." *Art Bulletin,* vol. 32, no. 2 (June 1950): 115–45.

————. "Lignum Vitae in Medio Paradisi: The Stanza d'Eliodoro and the Sistine Ceiling, Part 2." *Art Bulletin,* vol. 32, no. 3 (Sept. 1950): 181–218.

————. "Pagnini, Vigerio, and the Sistine Ceiling: A Reply." *Art Bulletin,* vol. 33, no. 4 (Dec. 1951): 262–73.

————. "Raphael and Giulio Romano: With Notes on the Raphael School." *Art Bulletin,* vol. 26, no. 2 (June 1944): 67–94.

Hartt, Frederick, and David Finn. *Michelangelo's Three Pietàs.* New York, 1975.

Hatfield, Rab. "Some Unknown Descriptions of the Medici Palace in 1459." *Art Bulletin,* vol. 52 (1970): 232–49.

Hauser, Arnold. *The Social History of Art.* 4 vols. Translated by Stanley Godman. New York, 1958.

————. *Mannerism: The Crisis of the Renaissance and the Origin of Modern Art.* Translated by Eric Mosbacher. New York, 1965.

Heiser, James D. *Prisci Theologi and the Hermetic Reformation in the Fifteenth Century.* Malone, Tex., 2011.

Hemsoll, David. "The Laurentian Library and Michelangelo's Architectural Method." *Journal of the Warburg and Courtauld Institutes,* vol. 66 (2003): 29–62.

Hibbert, Christopher. *Florence: The Biography of a City.* New York, 1993.

————. *The Borgias and Their Enemies: 1431–1519.* Orlando, 2008.

————. *The House of the Medici: Its Rise and Fall.* New York, 1975.

————. *The Popes.* Chicago, 1982.

————. *Rome: The Biography of the City.* New York, 1985.

Henry, Tom, and Paul Joannides, eds. *Late Raphael.* New York, 2012.

Hilloowala, Rumy, and Jerome Oremland. "The St. Peter's 'Pietà': A Madonna and Child? An Anatomical and Psychological Reevaluation." *Leonardo,* vol. 20, no. 1 (1987): 87–92.

Hirst, Michael. "The Chigi Chapel in S. Maria della Pace." *Journal of the Warburg and Courtauld Institutes,* vol. 24, no. 3/4 (July–Dec. 1961): 161–85.

————. *Michelangelo: The Achievement of Fame.* New Haven, 2011.

————. *Michelangelo and his Drawings.* New Haven, 1988.

————. *Michelangelo Buonarroti.* New Haven, 2011.

————. "Michelangelo, Carrara, and the Marble for the Cardinal's Pietà." *Burlington Magazine,* vol. 127, no. 984 (March 1985): 152, 154–56, 159.

————. "Michelangelo in Florence: 'David' in 1503 and 'Hercules' in 1506." *Burlington Magazine,* vol. 142, no. 1169 (Aug. 2000): 487–92.

———. "Michelangelo in Rome: An Altar-Piece and the 'Bacchus.'" *Burlington Magazine,* vol. 123, no. 943 (Oct., 1981): 581–91, 593.

———. "Michelangelo in 1505." *Burlington Magazine,* vol. 133, no. 1064 (Nov. 1991): 760–66.

Hirst, Michael, and Jill Dunkerton. *The Young Michelangelo: Making and Meaning.* London, 1994.

Holmes, George. *Art and Politics in Renaissance Italy.* Oxford, 1993.

———. *Florence, Rome, and the Origins of the Renaissance.* Oxford, 1986.

———. *The Florentine Enlightenment, 1400–1450.* London, 1969.

Holmes, George, ed. *Art and Politics in Renaissance Italy.* Oxford, 1993.

Hook, Judith. *Lorenzo de' Medici: An Historical Biography.* London, 1984.

Hope, Charles. "The Medallions on the Sistine Ceiling." *Journal of the Warburg and Courtauld Institutes,* vol. 50 (1987): 200–204.

Hub, Berthold. ". . . *e fa dolce la morte:* Love, Death, and Salvation in Michelangelo's 'Last Judgment.'" *Artibus et Historiae,* vol. 26, no. 51 (2005): 103–30.

Hughes, Anthony. *Michelangelo.* London, 1997.

Hughes, Robert. *Rome: A Cultural, Visual, and Personal History.* New York, 2011.

Hupka, Robert. *Michelangelo's Pietà.* New York, 1975.

Jenkens, A. Lawrence. "Michelangelo, the Piccolomini and Cardinal Francesco's Chapel in Siena." *Burlington Magazine,* vol. 144, no. 1197 (Dec. 2002): 752–54.

James, Sara Nair. "Penance and Redemption: The Role of the Roman Liturgy in Luca Signorelli's Frescoes at Orvieto." *Artibus et Historiae,* vol. 22, no. 44 (2001): 119–47.

Janson, H. W. *The Sculpture of Donatello.* Princeton, 1963.

Joannides, Paul. "Michelangelo's Lost Hercules." *Burlington Magazine,* vol. 119, no. 893 (Aug. 1977): 550, 552–55.

Jones, Jonathan. *The Lost Battles.* New York, 2012.

Jones, Roger, and Nicholas Penny. *Raphael.* New Haven, 1983.

Joost-Gaugier, Christiane L. "Michelangelo's Ignudi, and the Sistine Chapel as a Symbol of Law and Justice." *Artibus et Historiae,* vol. 17, no. 34 (1996): 19–43.

———. "Ptolemy and Strabo and Their Conversation with Appelles and Protogenes: Cosmography and Painting in Raphael's School of Athens." *Renaissance Quarterly,* vol. 51, no. 3 (Autumn 1998): 761–87.

Kemp, Martin. *Leonardo.* Oxford, 2004.

Kempers, Bram. *Painting, Power, and Patronage: The Rise of the Professional Artist in Renaissance Italy.* Translated by Beverley Jackson. London, 1994.

Kent, Dale. *Cosimo de' Medici and the Florentine Renaissance: The Patron's Oeuvre.* New Haven, 2000.

Kent, D. V., and F. W. Kent. *Neighbours and Neighbourhood in Renaissance Florence: The District of the Red Lion in the Fifteenth Century.* Locust Valley, N.Y., 1982.

Kent, F. W. "Gardens, Villas, and Social Life in Renaissance Florence." In *Renaissance Gardens—Italy.* Victoria, Australia, 2001.

———. *Household and Lineage in Renaissance Florence: The Family Life of the Capponi, Ginori, and Rucellai.* Princeton, 1977.

———. *Lorenzo de' Medici and the Art of Magnificence.* Baltimore, 2004.

———. "Patron-Client Networks in Renaissance Florence and the Emergence of Lorenzo as 'Maestro della Bottega.'" In *Lorenzo de' Medici: New Perspectives.* Edited by Bernard Toscani. New York, 1994.

King, Ross. *Brunelleschi's Dome.* New York, 2000.

———. *Machiavelli: Philosopher of Power.* New York, 2007.

———. *Michelangelo and the Pope's Ceiling.* New York, 2003.

Klaczko, Julian. *Rome and the Renaissance.* Translated by John Dennie. New York, 1903.

Kohl, Benjamin, and Ronald Witt, eds. and trans. *The Earthly Republic: Italian Humanists on Government and Society.* Philadelphia, 1978.

Krautheimer, Richard. *Rome: Profile of a City, 312–1308.* Princeton, 1980.

Krautheimer, Richard, with Trude Krautheimer-Hess. *Lorenzo Ghiberti.* 2nd ed. Princeton, 1970.

Kraye, Jill. "Lorenzo and the Philosophers." In *Lorenzo the Magnificent: Culture and Politics.* Edited by Michael Mallet and Nicholas Mann. London, 1996.

Kris, Ernst, and Otto Kurz. *Legend, Myth, and Magic in the Image of the Artist.* New Haven, 1979.

Kristeller, Paul. *Eight Renaissance Philosophers.* Stanford, 1964.

———. *The Philosophy of Marsilio Ficino.* Translated by Virginia Conant. New York, 1943.

———. *Renaissance Thought and Its Sources.* New York, 1979.

Kruft, Hanno-Walter. "Antonello Gagini as Co-Author with Michelangelo on the Tomb of Pope Julius II." *Burlington Magazine,* vol. 117, no. 870 (Sept. 1975): 598–99, 601.

Lang, Jack. *Il Magnifico: Vita di Lorenzo de' Medici.* Translated by Alessandra Benabbi. Milan, 2002.

Larner, Jeremy. *Culture and Society in Italy: 1290–1420.* New York, 1971.

Lavin, Irving. "Michelangelo's Saint Peter's Pietà: The Virgin's Left Hand and Other New Photographs." *Art Bulletin,* vol. 48, no. 1 (Mar. 1966): 103–4.

Levey, Michael. *Florence, A Portrait.* Cambridge, 1996.

Levine, Saul. "The Location of Michelangelo's David: The Meeting of January 25, 1504." *Art Bulletin,* vol. 56, no. 1 (Mar. 1974): 31–49.

———. "Michelangelo's Marble 'David' and the Lost Bronze 'David': The Drawings." *Artibus et Historiae,* vol. 5, no. 9 (1984): 91–120.

Lewis, R. W. B. *The City of Florence.* New York, 1995.

Lieberman, Ralph. "Regarding Michelangelo's 'Bacchus.'" *Artibus et Historiae,* vol. 22, no. 43 (2001): 65–74.

Lingo, Estelle. "The Evolution of Michelangelo's Magnifici Tomb: Program Versus

Process in the Iconography of the Medici Chapel." *Artibus et Historiae,* vol. 16, no. 32 (1995): 91–100.

Lombardo, Josef Vincent. *Michelangelo: The Pietà and other Masterpieces.* New York, 1965.

Lubkin, Gregory. *A Renaissance Court: Milan Under Galeazzo Maria Sforza.* Berkeley, Calif., 1994.

Lucas-Dubreton, J. *Daily Life in Florence in the Time of the Medici.* Translated by A. Lytton Sells. New York, 1961.

MacCulloch, Diarmaid. *The Reformation: A History.* New York, 2003.

Maguire, Henry. "The History of Medieval Art Without 'Art': Introduction." *Gesta,* vol. 34, no. 1 (1995): 3–4.

Mallett, Michael, and Nicholas Mann, eds. *Lorenzo the Magnificent: Culture and Politics.* London, 1996.

Mancinelli, Fabrizio. *The Sistine Chapel.* Vatican City, 1993.

Martelli, Mario. "Là Cultura Letteraria nell Età di Lorenzo." In *Lorenzo the Magnificent: Culture and Politics.* Edited by Michael Mallet and Nicholas Mann. London, 1996.

Martin, Thomas. "Michelangelo's 'Brutus' and the Classicizing Portrait Bust in Sixteenth-Century Italy." *Artibus et Historiae,* vol. 14, no. 27 (1993): 67–83.

Martindale, Andrew. *The Rise of the Artist in the Middle Ages and Early Renaissance.* New York, 1972.

Martines, Lauro. *April Blood: Florence and the Plot Against the Medici.* Oxford, 2003.

——. *Fire in the City: Savonarola and the Struggle for the Soul of Renaissance Florence.* Oxford, 2006.

——. *The Social World of the Florentine Humanists, 1390–1460.* Princeton, 1963.

Maude, A. H. "The Cracks in the Ceiling of the Sistine." *Burlington Magazine for Connoisseurs,* vol. 13, no. 65 (Aug. 1908): 288–89, 291–92.

Millon, Henry A. and Craig Hugh Smyth. "Michelangelo and St Peter's-I: Notes on a Plan of the Attic as Originally Built on the South Hemicycle." *Burlington Magazine,* vol. 111, no. 797 (Aug. 1969): 484–99, 501.

Morrogh, Andrew. "The Magnifici Tomb: A Key Project in Michelangelo's Architectural Career." *Art Bulletin,* vol. 74, no. 4 (Dec. 1992): 567–98.

Murray, Linda. *The High Renaissance and Mannerism.* New York, 1967.

Murray, Peter. *Architecture of the Italian Renaissance.* New York, 1964.

——, ed. *Five Early Guides to Rome and Florence,* Kentfield, Calif., 1972.

——, and Linda Murray. *Art of the Renaissance.* New York, 1963.

Nagel, Alexander. "Gifts for Michelangelo and Vittoria Colonna." *Art Bulletin,* vol. 79, no. 4 (Dec. 1997): 647–68.

Najemy, John. *A History of Florence: 1200–1575.* Chichester, U.K., 2010.

——. *Italy in the Age of the Renaissance: 1300–1550.* New York, 2004.

Nickerson, Angela. *A Journey into Michelangelo's Rome.* Berkeley, Calif., 2008.

Norton, Paul F. "The Lost Sleeping Cupid of Michelangelo." *Art Bulletin,* vol. 39, no. 4 (Dec. 1957): 251–57.

Norwich, John Julius. *Absolute Monarchs.* New York, 2011.

Olszewski, Edward J. "A Design for the Sistine Chapel Ceiling." *Bulletin of the Cleveland Museum of Art,* vol. 63, no. 1 (Jan. 1976): 12–26.

Panofsky, Erwin. "The First Two Projects of Michelangelo's Tomb of Julius II." *Art Bulletin,* vol. 19, no. 4 (Dec. 1937): 561–79.

———. *Studies in Iconology: Humanistic Themes in the Art of the Renaissance.* New York, 1962.

Paoletti, John T., and Gary M. Radke. *Art in Renaissance Italy.* New York, 1997.

Park, Katharine. "The Criminal and the Saintly Body: Autopsy and Dissection in Renaissance Italy." *Renaissance Quarterly,* vol. 47, no. 1 (Spring 1994): 1–33.

Parks, N. Randolph. "The Placement of Michelangelo's David: A Review of the Documents." *Art Bulletin,* vol. 57, no. 4 (Dec. 1975): 560–70.

Partner, Peter. "Florence and the Papacy in the Earlier Fifteenth Century." In *Florentine Studies: Politics and Society in Renaissance Florence.* Edited by Nicolai Rubinstein. Evanston, 1968.

———. *Renaissance Rome: 1500–1559: A Portrait of a Society.* Berkeley, Calif., 1976.

Partridge, Loren, et al. *Michelangelo: The Last Judgment: A Glorious Restoration.* New York, 1997.

Pastor, Ludwig. *History of the Popes.* Vols. V–VII. St. Louis, 1902.

Perkins, Charles C. *Raphael and Michelangelo: A Critical and Biographical Essay.* Boston, 1878.

Pernis, Maria Grazia. "The Young Michelangelo and Lorenzo de' Medici's Circle." In *Lorenzo de Medici: New Perspectives.* Edited by Bernard Toscani. New York, 1992.

Pietrangeli, Carlo. *The Sistine Chapel: A Glorious Restoration.* New York, 1994.

Pirolo, Paola. "Su Alcuni Aspetti della Formazione della Legenda Medicea: Da Cosimo a Lorenzo." In *Lorenzo dopo Lorenzo: La Fortuna Storica di Lorenzo il Magnifico.* Edited by Paola Pirolo. Florence, 1992.

Pirolo, Paola, ed. *Lorenzo dopo Lorenzo: La Fortuna Storica di Lorenzo il Magnifico.* Florence, 1992.

Plebani, Eleonora. *Lorenzo e Giuliano de' Medici: Tra Potere e Legame di Sangue.* Rome, 1993.

Plumb, J. H. *The Italian Renaissance.* Boston, 1985.

———. "Rome: Splendour and the Papacy." In *The Penguin Book of the Renaissance.* Middlesex, 1961.

Polizzotto, Lorenzo. *The Elect Nation: The Savonarolan Movement in Florence, 1494–1545.* Oxford, 1994.

———. "Lorenzo il Magnifico, Savonarola, and Medicean Dynasticism." In *Lorenzo de Medici: New Perspectives.* Edited by Bernard Toscani. New York, 1992.

Pope-Hennessy, John. *Donatello: Sculptor.* New York, 1993.

———. *Italian Renaissance Sculpture.* New York, 1971.

———. *Raphael.* New York, 1971.

Ramsey, P. A., ed. *Rome in the Renaissance: The City and the Myth.* Binghamton, N.Y., 1982.

Rendina, Claudio. *The Popes: Histories and Secrets.* Santa Ana, Calif., 2002.

Ridolfi, Roberto. *Life of Girolamo Savonarola.* Translated by Cecil Grayson. London, 1959.

———. *The Life of Machiavelli.* Translated by Cecil Grayson. London, 1963.

Robertson, Charles. "Bramante, Michelangelo, and the Sistine Ceiling." *Journal of the Warburg and Courtauld Institutes,* vol. 49 (1986): 91–105.

Rocke, Michael. *Forbidden Friendships: Homosexuality and Male Culture in Renaissance Florence.* New York, 1996.

Roe, Albert S. "A Drawing of the Last Judgment." *Huntington Library Quarterly,* vol. 21, no. 1, Blake Bicentennial Issue (Nov. 1957): 37–55.

Roeder, Ralph. "Lorenzo de' Medici." In *The Penguin Book of the Renaissance.* Harmondsworth, U.K., 1961.

———. *The Man of the Renaissance: Four Lawgivers: Savonarola, Machiavelli, Castiglione, Aretino.* New York, 1933.

Ronen, Avraham. "An Antique Prototype for Michelangelo's Fall of Man." *Journal of the Warburg and Courtauld Institutes,* vol. 37 (1974): 356–58.

Roscoe, William. *The Life and Pontificate of Leo X.* 2 vols. London, 1893.

———. *The Life of Lorenzo de Medici, Called the Magnificent.* London, 1889.

Roskill, Mark. *Dolce's "Aretino" and Venetian Art Theory of the Cinquecento.* New York, 1968.

Ross, Janet. *Florentine Palaces and their Stories.* London, 1905.

———. *The Lives of the Early Medici as Told in their Correspondence.* Boston, 1911.

Roth, Cecil. *The Last Florentine Republic: 1527–30.* London, 1925.

Rubin, Patricia. *Giorgio Vasari: Art and History.* New Haven, 1995.

Rubenstein, Richard E. *Aristotle's Children: How Christians, Muslims, and Jews Rediscovered Ancient Wisdom and Illuminated the Dark Ages.* Orlando, 2003.

Rubinstein, Nicolai. *The Palazzo Vecchio, 1298–1532: Government, Architecture, and Imagery in the Civic Palace of the Florentine Republic.* Oxford, 1995.

———. *The Government of Florence Under the Medici.* Oxford, 1977.

Rubinstein, Nicolai, et al. *The Age of the Renaissance.* London, 1967.

Ruggiers, Paul G. *Florence in the Age of Dante.* Norman, Okla., 1964.

Ruvoldt, Maria. "Michelangelo's Dream." *Art Bulletin,* vol. 85, no. 1 (Mar. 2003): 86–113.

Saalman, Howard. "Michelangelo: S. Maria del Fiore and St. Peter's." *Art Bulletin,* vol. 57, no. 3 (Sept. 1975): 374–409.

Salmon, Frank. "The Site of Michelangelo's Laurentian Library." *Journal of the Society of Architectural Historians,* vol. 49, no. 4 (Dec. 1990): 407–29.

Schevill, Ferdinand. *History of Florence, from the Founding of the City Through the Renaissance.* New York, 1961.

———. *The Medici.* New York, 1949.

Scotti, R. A. *Basilica: The Splendor and the Scandal: Building St. Peter's.* New York, 2006.

Seymour, Charles, Jr. *Jacopo della Quercia, Sculptor.* New Haven, 1973.

———. *Michelangelo's David: A Search for Identity.* Pittsburgh, 1967.

Shaw, Christine. *Julius II: The Warrior Pope.* Cambridge, U.K., 1993.

Shearman, John. *Andrea del Sarto.* Oxford, 1965.

———. "The Florentine Entrata of Leo X, 1515." *Journal of the Warburg and Courtauld Institutes,* vol. 38 (1975): 136–54.

———. *Mannerism.* London, 1967.

———. *Only Connect: Art and the Spectator in the Italian Renaissance.* Princeton, 1992.

———. "The Organization of Raphael's Workshop." *Art Institute of Chicago Museum Studies,* vol. 10, The Art Institute of Chicago Centennial Lectures (1983): 40–57.

Shrimplin, Valerie. "Hell in Michelangelo's 'Last Judgment.'" *Artibus et Historiae,* vol. 15, no. 30 (1994): 83–107.

Shrimplin-Evangelidis, Valerie. "Michelangelo and Nicodemism: The Florentine Pietà." *Art Bulletin,* vol. 71, no. 1 (Mar. 1989): 58–66.

———. "Sun-Symbolism and Cosmology in Michelangelo's Last Judgment." *Sixteenth Century Journal,* vol. 21, no. 4 (Winter 1990): 607–44.

Sperling, Christine M. "Donatello's Bronze 'David' and the Demands of Medici Politics." *Burlington Magazine,* vol. 134, no. 1069 (Apr. 1992): 218–24.

Staley, Edgcumbe. *The Guilds of Florence.* New York, 1967.

Starn, Randolph. "Reinventing Heroes in Renaissance Italy." *Journal of Interdisciplinary History,* vol. 17, no. 1, The Evidence of Art: Images and Meaning in History (Summer, 1986): 67–84.

Steinberg, Leo. "Who's Who in Michelangelo's Creation of Adam: A Chronology of the Picture's Reluctant Self-Revelation, Part 1." *Art Bulletin,* vol. 74, no. 4 (Dec. 1992): 552–66.

Stephens, J. N. *The Fall of the Florentine Republic: 1512–1530.* New York, 1983.

Summers, David. *Michelangelo and the Language of Art.* Princeton, 1981.

Symonds, John Addington. *The Life of Michelangelo Buonarroti.* London, 1893.

Teunissen, John J., and Evelyn J. Hinz. "The Attack on the Pietà: An Archetypal Analysis." *Journal of Aesthetics and Art Criticism,* vol. 33, no. 1 (Autumn 1974): 43–50.

Thomas, Anabel. *The Painter's Practice in Renaissance Tuscany.* Cambridge, U.K., 1995.

Trexler, Richard. *The Libro Cerimoniale of the Florentine Republic by Francesco Filarete and Angelo Manfidi.* Geneva, 1978.

———. "Lorenzo de' Medici and Savonarola: Martyrs for Florence," *RQ,* vol. 31 (1978): 293–308.

———. *Public Life in Renaissance Florence.* New York, 1980.

———. "True Light Shining vs. Obscurantism in the Study of Michelangelo's New Sacristy." *Artibus et Historiae,* vol. 21, no. 42 (2000): 101–17.

Unger, Miles. *Machiavelli: A Biography.* New York, 2011.

———. *Magnifico: The Brilliant Life and Violent Times of Lorenzo de' Medici.* New York, 2008.

Ventrone, Paola. *Le Tems Revient: 'L Tempo si Rinuova,* 2 vols. Florence, 1992.

Verdon, Timothy, and John Henderson, eds. *Renaissance: Image and Religious Imagination in the Quattrocento.* Syracuse, 1990.

Villari, Pasquale. *The Life and Times of Girolamo Savonarola.* 2 vols. Translated by Linda Villari. London, 1888.

———. *The Life and Times of Niccolò Machiavelli.* 2 vols. Translated by Linda Villari. London, 1898.

Waldman, Louis A. *Baccio Bandinelli and Art at the Medici Court.* Philadelphia, 2004.

Wallace, William E. "Michelangelo at Work: Bernardino Basso, Friend, Scoundrel, and Capomaestro." In *I Tatti Studies: Essays in the Renaissance,* vol. 3 (1989): 235–77.

———. *Michelangelo at San Lorenzo: The Genius as Entrepreneur.* Cambridge, U.K., 1994.

———. *Michelangelo: The Artist, the Man, and His Times.* Cambridge, U.K., 2010.

———. *Michelangelo: The Complete Sculpture, Painting, Architecture.* New York, 1998.

Wang, Aileen June. "Michelangelo's Signature." *Sixteenth Century Journal,* vol. 35, no. 2 (2004): 447–73.

Watkins, Renée Neu, ed. *Humanism and Liberty: Writings on Freedom from Fifteenth-Century Florence.* Columbia, S.C., 1978.

Weinstein, Donald. "The Myth of Florence." In *Florentine Studies: Politics and Society in Renaissance Florence.* Edited by Nicolai Rubinstein. Evanston, Ill., 1968.

———. *Savonarola and Florence: Prophecy and Patriotism in the Renaissance.* Princeton, 1970.

———. "Savonarola, Florence, and the Millenarian Tradition." *Church History,* vol. 27, no. 4 (Dec. 1958): 291–305.

Wilde, J. "The Hall of the Great Council of Florence." *Journal of the Warburg and Courtauld Institutes,* vol. 7 (1944): 65–81.

Wilde, Johannes. "Michelangelo and Leonardo." *Burlington Magazine,* vol. 95, no. 600 (Mar. 1953): 65–75, 77.

———. "Michelangelo's Designs for the Medici Tombs." *Journal of the Warburg and Courtauld Institutes,* vol. 18, no. 1/2 (Jan.–June 1955): 54–66.

Wilkins, David G., and Rebecca L. Wilkins, eds. *The Search for a Patron in the Middle Ages and Renaissance*. Lewiston, N.Y., 1996.

Wind, Edgar. "The Crucifixion of Haman." *Journal of the Warburg Institute*, vol. 1, no. 3 (Jan. 1938): 245–48.

———. *The Religious Symbolism of Michelangelo*. Oxford, 2000.

———. "Typology in the Sistine Ceiling: A Critical Statement." *Art Bulletin*, vol. 33, no. 1 (Mar. 1951): 41–47.

Wittkower, Rudolf. *Architectural Principles in the Age of Humanism*. New York, 1971.

———. "A Note on Michelangelo's Pietà in St. Peter's." *Journal of the Warburg Institute*, vol. 2, no. 1 (July, 1938): 80.

Wittkower, Rudolf, and Margot Wittkower. *Born Under Saturn: The Character and Conduct of Artists*. New York, 1969.

Wölfflin, Heinrich. *Classic Art*. Ithaca, N.Y., 1986.

———. *Principles of Art History: The Problem of the Development of Style in Later Art*. Translated by M. D. Hottinger. New York, 1950.

———. *Renaissance and Baroque*. Ithaca, N.Y., 1966.

Young, G. F. *The Medici*. New York, 1933.

Ziegler, Joanna E. "Michelangelo and the Medieval Pietà: The Sculpture of Devotion or the Art of Sculpture?" *Gesta*, vol. 34, no. 1 (1995): 28–36.

———. *Sculpture of Compassion: The Pietà and the Beguines in the Southern and Low Countries, c. 1300–c. 1660*. Brussels, 1992.

Index

Michelangelo Buonarroti (*cont.*)
 Leonardo's rivalry with, 83–84, 89,
 112–14, 117, 118, 120, 122–23, 124,
 222
 life viewed as struggle by, 200
 Lionardo's correspondence with, 1–2,
 248*n,* 272–73, 307, 310, 348, 352,
 355–56, 360–62, 366
 Lionardo's relationship with, 360–61
 Lodovico and, *see* Buonorroti, Lodovico
 at Lorenzo de Medici's art school, 20–21
 loyalty to Florence of, 89, 95
 Macel de' Corvi house of, 189, 254, 263,
 267, 285
 as *magister operae,* 332*n*
 male beauty celebrated by, 111–12, 179
 Mannerism of, 218–19
 at Medici Palace, 21–25, 29, 62, 134,
 150, 189, 193
 melancholic temperament of, 5, 160,
 219–20, 241–42, 251, 254, 311, 357,
 362, 363, 365
 on merits of painting vs. sculpture, 25,
 358–59
 as military engineer, 351
 misogyny of, 361
 and mother's death, 14
 Neoplatonism and, 94*n*-95*n*, 172, 260,
 284, 356
 paintings of, as essentially sculptural,
 117
 paranoia of, 157–58, 161–62, 174, 314,
 348
 on patrons, 49–50
 patrons' relationships with, 3–4, 96, 110,
 186, 215, 229, 235, 327
 Paul III's relationship with, 267, 304,
 308, 327, 336
 perfectionism of, 58–59, 196, 201, 208,
 228, 242, 347
 personal hygiene of, 5
 Piazza Rusticucci house of, 136, 160
 piety of, 35–36, 53, 181–82, 283, 284,
 295
 poetry of, 4, 6, 28, 36, 47, 61, 112,
 158–59, 184–85, 187, 220, 240,
 242–43, 254, 255, 259–60, 283, 299,
 310–11, 351*n*, 356, 357–58, 365, 371
 portraits of, *iv, xiv*

 property bought by, 177, 361
 quarrelsomeness of, 3, 5–6, 85, 188, 194,
 209–10, 242, 357, 360, 366
 Raphael's rivalry with, 194–96, 222,
 269
 religious struggles of, 283, 294–95,
 299–300, 310–11, 364
 and Renaissance concept of artist, 366,
 371–72
 in return to father's house, 29–30
 in Roman society, 287
 St. Peter's rebuilding and, 327–28,
 332–38, *339,* 340–44, 346–52, 372,
 373
 sculpture as metaphor in poetry of, 61
 secretiveness of, 62, 90, 113, 162, 173,
 335–36, 347
 self-confidence of, 174
 self-doubt of, 6, 15, 36, 157–58, 160
 sexual desire seen as sinful by, 36, 53,
 112, 220, 260, 284, 294
 social snobbery of, 9
 solitude prized by, 5
 stonecutters admired by, 13
 on subtractive process of sculpture, 61
 terribilità of, 4, 39, 194, 200, 285
 tomb of, 373, 377
 unfinished work of, 231–33
 unrealistic promises made by, 6, 55–56,
 89, 201, 229–30
 Vasari and, *see* Vasari, Giorgio
 working methods of, 62–63
 workshop of, 228
 see also specific works
Michi, Giovanni, 156*n*
Milan, Duchy of, 12
Mini, Antonio, 272
Mini, Giovan Battista, 252
modello, 57*n*
models, for sculpture, 57–58
Mona Lisa (Leonardo), 63, 113
Monciatto, Francesco, 99
Montelupo, Raffaello da, 237
Montorsoli, Giovanni, 236–37
Morone, Cardinal Giovanni, 371
Moses (Michelangelo), 39, 197, 198, *199,*
 200, 266*n,* 378
Museo dell' Opera del Duomo, Florence,
 xii, 377